MAKING NO COMPROMISE

MAKING NO COMPROMISE

Margaret Anderson, Jane Heap, and the Little Review

HOLLY A. BAGGETT

NORTHERN ILLINOIS UNIVERSITY PRESS
AN IMPRINT OF
CORNELL UNIVERSITY PRESS
ITHACA AND LONDON

First published 2023 by Cornell University Press

Library of Congress Cataloging-in-Publication Data

Names: Baggett, Holly A., 1957– author.
Title: Making no compromise : Margaret Anderson, Jane Heap, and the Little Review / Holly A. Baggett.
Description: Ithaca [New York] : Northern Illinois University Press, an imprint of Cornell University Press, 2023. | Includes bibliographical references and index.
Identifiers: LCCN 2023009986 (print) | LCCN 2023009987 (ebook) ISBN 9781501771446 (hardcover) | ISBN 9781501771453 (pdf) | ISBN 9781501771460 (epub)
Subjects: LCSH: Modernism (Literature)—United States. | Anderson, Margaret C. | Heap, Jane, 1883–1964. | Gurdjieff, Georges Ivanovitch, 1872–1949—Influence. | Little review (Chicago, Ill.)
Classification: LCC PS228.M63 B34 2023 (print) | LCC PS228.M63 (ebook) | DDC 070.5092 [B]—dc23/eng/20230511
LC record available at https://lccn.loc.gov/2023009986
LC ebook record available at https://lccn.loc.gov/2023009987

This book is dedicated to
the memory of Kelly L. Baggett, loyal sister, and
to Anne M. Boylan, faithful mentor

CONTENTS

ACKNOWLEDGMENTS

This project has been many years in the making, and many people and institutions have been vital in making it a reality.

I want to thank Karen Clark, the late niece of Jane Heap, who met with me in Heap's old stomping grounds in Chicago and shared photos and letters along with family stories of her iconoclastic aunt. I have interviewed the students of George Gurdjieff, the Armenian mystic whom Anderson and Heap followed, in Oregon communes, Utah canyons, New Jersey suburbs, and the United Kingdom. Anna Lou Stalevey, Dr. John Lester, Eleanor Hudson, and Nesta Brookings, all former students of Jane Heap from the London blitz of World War II until she died in 1964, sat down with me in London for many conversations. James Moore, author of *Gurdjieff: Anatomy of a Myth*, who also knew Heap, shared conversations and correspondence over several years. The role of Jane Purse in donating her private collection of Heap letters to the University of Delaware lead to the publication of my book *Dear Tiny Heart: The Letters of Jane Heap and Florence Reynolds*, which I still mine as a resource for this current work.

Those letters and other valuables can be found in Special Collections and Archives at the University of Delaware. Thank you to Rebecca Johnson Melvin for her assistance over the years.

Purse, Moore, Brookings, Hudson, Lester, and Stalevey were all elderly during my interviews, and all have since passed away. However, I treasure the time they spent with me and hope they would find this project a fitting exploration of the entire life of their spiritual mentor.

Dr. Hugh Ford, the author *of Four Lives in Paris*, knew Margaret Anderson and met with me in his book store in Bernardsville, NJ, where Anderson and her partner Georgette LeBlanc spent a memorable summer. In addition, Dr. Jackson Bryer, who wrote his dissertation on the *Little Review* in 1965, recounted his memories of meeting Anderson in her later years and shared her personal correspondence with me.

Many libraries made research materials available to me, including Beinecke Library, Yale University; Houghton Library, Harvard University; the New York Public Library; the Library of Congress; Butler Library, Columbia University; Newberry Library; the Indiana State Library; and the libraries of the University of Wisconsin-Milwaukee, the University of Texas-Austin, the University of Maryland, Cornell University, Northwestern University, the University of Chicago, the Art Institute of Chicago, Kansas State Historical Society, Topeka State Hospital, and Western College for Women Alumnae Association.

Dr. Kathleen Kennedy, head of the Department of History of Missouri State University, has been extraordinarily patient and supportive both as a boss and a friend. She has been a stalwart ally over many upheavals and challenges. I am also happy to be able to deliver this book to Dean Victor Matthews. He has gone above and beyond in his role as dean with innumerable acts of kindness as well. I want to thank the College of Humanities and Public Affairs and Missouri State University for funding two sabbaticals and multiple conferences and research trips to England and France.

Margaret von der Heide and Jordan Bolin Endicott provided much needed support during the beginning of this project. Glena Admire was crucial in organizing the final stages of the manuscript. Michele Lansdown of Nelrod Publishing was a diligent copyeditor who sharpened my style and saved me from errors. Cara Jordan of Flatpage and her crew, Elizabeth Stern, James Toftness, and Kaylee Alexander, did a superb job

of securing permissions and editing and formatting the final manuscript. Thank you to Rubi Rose Siblo Landsman of Rubi Rose Photography of Kingston, NY, for her creative input. Thank you to Nancy Stokes for her technical savvy.

A special thank you to Gayla Graven, Marybeth Primm, Sara Newhard, and the late Susan Wilder for their special type of insight and reassurance. Thank you to the rainbow folks of Light at the End of Tunnel for listening to me rant about this project for years. Thank you to Avigayil Landsman for a lifetime of friendship.

Thank you to Amy Farranto of Northern Illinois University Press, for her tireless support and insightful observations. Thank you to Jennifer Savran Kelly of Cornell University Press for her expertise.

Thank you to my mother Bonnie Baggett for her unconditional love and for coming to the rescue more times than I can count.

This book is dedicated to two significant people in my life. First, my late sister Kelly was always a special bulwark of support. Along with our brother Curtis J. Baggett, she was always in my corner. Anne M. Boylan, professor emeritus of the University of Delaware, has been a paragon of encouragement. I was her first Ph.D. student, and she has remained an advisor for decades. Over the years, into her retirement, she continued to counsel, reassure, and act as a much-needed beacon of hope and faith.

MAKING NO COMPROMISE

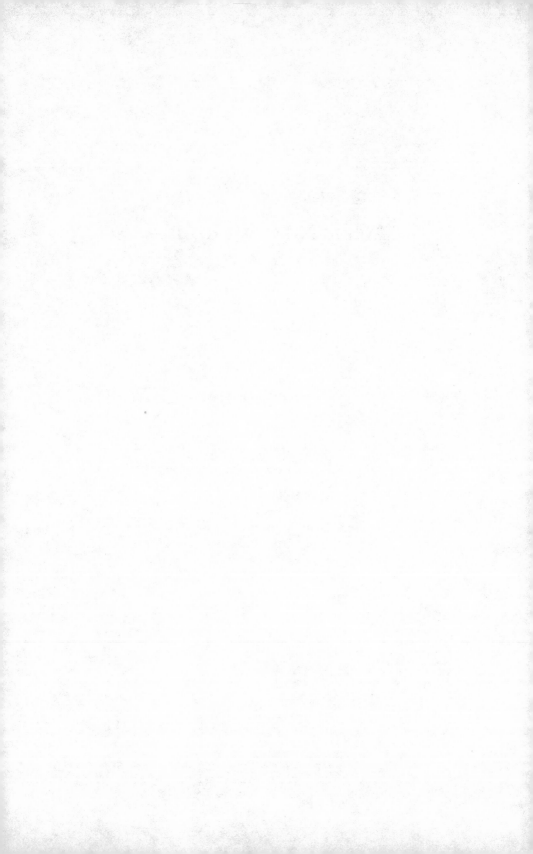

INTRODUCTION

The story of Margaret Anderson and Jane Heap is often told in snippets, small fragments in the larger tapestry depicting the celebrated masters of modernism whom the women published and promoted in their journal, the *Little Review* (1914–29). Although they are perhaps best known for serializing James Joyce's *Ulysses* and subsequently enduring a 1921 obscenity trial, Anderson's and Heap's careers extended far beyond that noteworthy moment. To be sure, the *Little Review* published male modernists such as Joyce, Ezra Pound, and T. S. Eliot and championed the early work of female modernists—H. D., Djuna Barnes, Dorothy Richardson, and Gertrude Stein. Other talented women such as May Sinclair, Dorothy Richardson, and Mary Butts, rediscovered decades later by feminist literary scholars, found their first champions in Anderson and Heap. However, the women worked on a larger canvas, bringing attention to every major movement in early twentieth-century literature and art, including Imagism, Dada, surrealism, constructivism, and Machine Age aesthetics. In the pages of their magazine, they introduced to American audiences the

works of Brâncuşi, Picabia, Tzara, and Le Corbusier, among many others of the European avant-garde. The *Little Review* was, "without question, the finest collection of modern writing in the country at the time."[1]

How did two women born in the late nineteenth-century American Midwest become arbiters of twentieth-century modernism? What propelled them from their parochial origins into experimental art, radical politics, and lives of personal liberation in the avant-garde circles of Chicago, Greenwich Village, and Paris? Finally, and most germane to this book, how did their interest in modernism pave the way for their lifelong immersion in the opaque, complex, and largely misunderstood esoteric philosophy of George Ivanovich Gurdjieff? An Armenian mystic (some say charlatan), Gurdjieff appears sporadically in studies of modernists who were seeking answers beyond what artistic expression could offer. Anderson and Heap shared that quest, as evident in the evolving editorial decisions they made for the *Little Review*. The allure of this controversial teacher for the two editors emerged from their enthusiasm for the intellectual underpinnings of modernism and their dissatisfaction with its limitations. Despairing about the state of art, the two women eventually gave up the *Little Review* in 1929 but remained steadfast to Gurdjieff's philosophy until their deaths. I argue that it was their embrace of modernism that paved the way for their Gurdjieffian conversion. Key to this book is a facet of modernism that until recently has been neglected: the role that spirituality, specifically Western esotericism, played in modernism.

The adventure of Anderson, Heap, and the *Little Review* began in Chicago. Transplants from Indiana and Kansas, respectively, the two women were among a generation of young midwesterners longing for intellectual stimulation, artistic exploration, and personal liberation. Although they came from similar backgrounds and they both saw in art their deliverance from a moribund culture, their personalities were markedly distinct. Anderson, a comely feminine woman who talked and wrote with a certain breathless quality, came to Chicago to find her way as a writer. While living at the YWCA, she got her training by writing book reviews for the *Literary Review* of the *Chicago Evening Post* and learned typescript from the *Dial*. Heap, a masculine sometime crossdresser, was an artist who traveled to Chicago to attend the Art Institute. Where Anderson was cheerful and brimming over with enthusiasm, giving the sense of writing

with exclamation points, Heap was pessimistic and often cynical, writing with a sly humor that impaled her targets.

Pre–World War I Chicago had a vibrant LGBTQ subculture on both the south side, where bohemians moved into vacant storefronts leftover from the 1893 Chicago Exposition, and the north side's "Towertown," where artists, bohemians, and queer Chicagoans gathered. In Chicago, Anderson and Heap, who were self-identified and out lesbians, encountered kindred spirits. Floyd Dell, Sherwood Anderson, Ben Hecht, and Maxwell Bodenheim, among others, challenged Victorian beliefs on art, religion, politics, gender, and sexuality. This constellation of radical talents was the nucleus of the Chicago Literary Renaissance, a moment of artistic revolution that catalyzed the city's form of modernism. Chicago was also where the two women met Emma Goldman, an early supporter of LGBTQ people, who gave them a crash course in the principles of anarchism that they would enthusiastically celebrate in the pages of *Little Review*.

Anderson, however, was not satisfied with what she found in Chicago. Her review of Theodore Dreiser's *Sister Carrie* in the small Chicago magazine the *Continent* had embroiled her in a controversy over "immorality" in letters, a fate she would endure again later in the *Ulysses* obscenity trial. Feeling stymied by what she saw as an ever-present conservative dominance in the arts, Anderson launched her own journal. She set up an office in the Fine Arts Building on Michigan Avenue and announced her new venture; shortly thereafter, the *Little Review* began publishing writers of the Chicago Literary Renaissance. Anderson's decision to declare her frustration by starting her journal was, on the face of it, not an uncommon impulse for radicals of the day. Goldman herself founded *Mother Earth* in 1906, Harriet Monroe started *Poetry* in Chicago in 1912, and Margaret Sanger established the *Woman Rebel* in March of 1914, the same month and year of the *Little Review* debut. Little magazines were the major transmitters of modernism, and women were central to their creation and survival.[2] Among the women filling significant roles in editing modernist magazines were H. D., Harriet Weaver Shaw, Marianne Moore, Dora Marsden, Jessie Fauset, and Katherine Mansfield. Anderson and Heap joined this cohort of women as founders, publishers, editors, writers, readers, critics, and patrons of these small radical journals.

Anderson focused on the relationships among literature, sexuality, and politics during the first two years of the *Little Review*. Anarchism

and the new movement in poetry, Imagism, were among the main philosophical themes preoccupying the editors, contributors, and readers, and sometimes the legal authorities. From 1914 to 1916, the pages of the *Little Review* were also full of articles referencing the philosophies of the late nineteenth- and early twentieth-century icons of the intelligentsia, such as Friedrich Nietzsche, Henri Bergson, Ralph Waldo Emerson, Walt Whitman, Walter Pater, and Oscar Wilde, among others. The equality of women, acceptance of same-sex attraction, and a conviction of the artist's superiority were all topics that Anderson and her colleagues were burning to redefine within the politics and culture of their milieu. Sometimes contradictory but always interrelated, the ideas that appeared in the *Little Review* provide insight into American rebels in general and their own specific personal sojourns. Two years after Anderson launched the *Little Review* she met Jane Heap, who soon became a provocative contributor and cheeky spirit in the pages of the journal. She originally wrote under pseudonyms until signing her contributions with the lowercase initials "jh."

In 1917 the two women moved to New York, settling in Greenwich Village during the height of World War I anti-war activism. No longer able to depend on their Chicago Renaissance friends to provide content for the journal, they relied on their new Village network, including Djuna Barnes, Hart Crane, William Carlos Williams, and the Dada poet the Baroness Freytag-Loringhoven among many others. More critically, however, Anderson's goal was to make the *Little Review* "an international concern" by accepting Ezra Pound's offer to serve as their foreign editor. Their success in becoming a transnational phenomenon exceeded their expectations; within months they published not only Pound but also Wyndham Lewis, W. B. Yeats, T. S. Eliot, and James Joyce. Their serialization of Joyce's *Ulysses* (in 1918) cemented the *Little Review's* place in literary history. Bombarded by public disgust and legal attacks, in 1921 they were convicted of obscenity charges, the first salvo in the long litigious history of that modern masterpiece.

Anderson and Heap's partnership had been under strain since leaving Chicago, and the *Ulysses* trial led to the unraveling of their romantic relationship, which had begun in 1916 shortly after they met that year. Infuriated and distraught, Anderson wanted to bring her scrappy little journal to an end. Heap, however, was adamantly opposed and became

the primary editor from 1921 onward. Heap increased the presence of visual art in the pages of the journal as well as publishing works of Surrealism, Machine Age aesthetics, and Bauhaus, elevating the *Little Review* to greater prominence by promoting an international cross-fertilization in the fields of modern literature and art, theater, architecture, and design. Despite the radical directions Anderson had undertaken in the early years of the *Little Review*, the Heap era was the most revolutionary period in the history of the journal.

In late 1923 Anderson and Heap and a group of other Villagers met with A. R. Orage, the British editor of the *New Age*, a literary and political journal that had much in common with the *Little Review*. Orage was a former Theosophist, the author of two books on Nietzsche, and a highly regarded literary critic. His task was to introduce Americans to an Armenian mystic whose self-enlightenment system had already attracted European—especially British—spiritually inclined artists and writers. George Gurdjieff was due to arrive in New York City early the following year with a troupe of students from his newly established Institute for the Harmonious Development of Man outside Paris. In January of 1924 the two women attended demonstrations of Gurdjieff students who performed dances reminiscent of those practiced by Sufi dervishes. Gurdjieff himself cut an enigmatic and charismatic figure. More than one person who met him commented on his penetrating gaze and mysterious demeanor.

Anderson and Heap were captivated. Among those who found themselves just as enamored with Gurdjieff were Katherine Mansfield, Gorham Munson, Hart Crane, Mabel Dodge Luhan, Jean Toomer, Muriel Draper, Waldo Frank, and Herbert Croly. Though no longer a couple, Anderson and Heap traveled to France in the spring of that year to study at Gurdjieff's Institute. They were joined by Anderson's new love, the French opera singer Georgette Leblanc (a former partner of the Belgian playwright Maurice Maeterlinck), who was also intrigued by Gurdjieff's philosophy. After this expedition, *Little Review* readers could see the influence of Gurdjieff in the pages of the journal. There were also contributions from other Gurdjieff followers, most notably Jean Toomer and Muriel Draper.

In 1929, after developing the journal into an international forum for the work of the most avant-garde artists of the early twentieth century,

Heap reunited with Anderson in Paris to publish the last issue of the *Little Review*. By then, Gurdjieff's influence had changed both women's view of art as a path to spiritual enlightenment. In her farewell editorial, poignantly entitled "Lost a Renaissance," Heap mused, "For years we offered the *Little Review* as a trial-track for racers. We hoped to find artists who could run with the great artists of the past or men who could make new records. But you can't get race-horses from mules. I do not believe that the conditions of our life can produce men who can give us masterpieces. Masterpieces are not made from chaos. If there is a confusion of life, there will be a confusion of art."[3] In her own parting editorial, Anderson wrote she did not want to hear any more about "it's the artist who transforms life. I know it. But I'm not particularly interested at the moment in transformation. I want a little illumination."[4]

Throughout the thirties, Anderson and Heap continued their Gurdjieffian studies in Paris with the master himself and an all-women, mostly lesbian group who called themselves "The Rope." They included Katherine Hulme, author of *The Nun's Story*, and Solita Solano, lover of the writer Janet Flanner. Anderson published her first autobiography, *My Thirty Years' War*, and remained in France with Leblanc until the outbreak of World War II. Gurdjieff dispatched Heap to London in 1939 to lead study groups; she carried on sharing his teachings during the wartime blitz and soon became one of the most prominent of his disciples. The war brought extraordinary hardships for Anderson and Leblanc as it coincided with Leblanc's diagnosis of breast cancer. Their attempts to escape Europe were repeatedly thwarted, and they remained in France until Leblanc's death in 1941. Anderson returned to America alone, with her passage paid for by *Little Review* contributor Ernest Hemingway. On the ship voyage back she met Dorothy Caruso, widow of the opera singer Enrico Caruso, with whom she embarked on a long relationship until Caruso also died of breast cancer in 1955.

Anderson returned to France where she wrote two more autobiographies, an anthology of her favorite *Little Review* contributions, and *The Unknowable Gurdjieff*, her salvo to defend Gurdjieff against his critics. She unsuccessfully attempted to publish an autobiographical lesbian novel *Forbidden Fires*, eventually issued by the lesbian imprint Naiad Press after her death. As the years passed Heap stopped communicating with her ex-lover, but Anderson's wider circle of friends, including members of the

Rope, supported her until her death. Heap died a revered and beloved teacher of Gurdjieff's thought in 1964; Anderson's death followed in 1973.

Scholarship on the lives and careers of Anderson and Heap has run the gamut of interpretation and portrayals—as "midwives" to modernist male geniuses; as clueless dilettantes and sexually suspect women; as brilliant editors, early feminists, and lesbian icons. In his coverage of the *Ulysses* trial, for instance, Hugh Kenner framed them in condescending terms when he depicted their defense attorney John Quinn as a man who was "subjecting himself to the tedious bohemianism of one editress, Jane Heap, out of admiration for Margaret Anderson, the other."[5] The admiration was sexual until Quinn discovered that Anderson was involved with Heap. (Quinn responded by penning an outpouring of misogynic letters to Ezra Pound.) More recent scholarship has been increasingly insightful and nuanced. Jayne Marek, in her study of gender and modernism, argues that Anderson's and Heap's styles of editing relied heavily on interactive forms of conversation with *Little Review* readers and that their privately coded exchanges with each other represented "a form of critical exchange reflecting the multifaceted nature of modernism itself."[6]

Placing Anderson and Heap's editorial practices within modernism's "multifaceted nature" is crucial, but their story is also a more complex fusion of both modernism and modernity. Modernism is often described as a reaction to modernity through both negative and positive lenses. The revolution in everyday reality (trains, planes, and automobiles), a waning belief in God, scientific discoveries such as the atom, and the emergence of new theories of physics altered people's perceptions of time and space. Artists' reactions varied. While some welcomed technological changes, others saw the subsequent disjointed experience of daily life as jarring and viewed art as the primary vehicle to recover a sense of wholeness. In editing the *Little Review*, Anderson and Heap addressed the challenge of seeking an organic whole or synthesis of vision via fragmented depictions of nonrepresentational reality. That quest also explains their later conversion to Gurdjieff.

The record of the *Little Review* alone would guarantee Anderson and Heap a prominent role in the history of modernism and of little magazines. Through the emerging field of New Modernist Studies we have gained a new and more discerning lens through which to examine little magazines and their role in promoting modernism in the first three decades of the

twentieth century. In addition to the *Little Review*, magazines such as *Poetry*, the *Dial*, the *Masses*, the *Freewoman*, the *New Freewoman*, the *Egoist*, the *New Age*, and others were key to transporting radical innovation throughout the Anglo-American landscape. The rise of Periodical Studies likewise endorses the fundamental premise that these journals were responsible for establishing modernism. As Andrew Thacker writes, "Without magazines from *291* to *The Little Review*, or *Poetry* to *Pagany*, the contours of American modernism, and indeed also the transnational character of modernism, would not be as we know it."[7] The founding of digital archives such as the Modernist Journals Project has allowed scholars to research complete issues of little and mass culture magazines and has been responsible for many innovative interpretations of their missions. Questions of gender, sexuality, and race as well as transnational and postcolonial categories expand the area of inquiry while editorial theory, including the scrutiny of both linguistic and bibliographic codes (typology, covers, advertisements, etc.), gives us tools to focus on little magazines as primary texts. The fields of New Modernist Studies and Periodical Studies demonstrate how the *Little Review* was "the quintessential modernist magazine."[8]

Matters of gender and sexuality are important in modernist scholarship as a counterpoint to the often-told tale of male modernists, particularly the "men of 1914." Since Anderson and Heap were a rare example of two women living openly as lesbians during this period, it is crucial to examine, as this book does, how sexuality intersects with art and spirituality. The Oxford reform movement of the late nineteenth century, which paved the way for a less draconian view of sexuality than that of the Victorians, inevitably led to authors who profoundly influenced Anderson, including Walter Pater, Edward Carpenter, Oscar Wilde, and Walt Whitman. Some women writers of the *Little Review*—Gertrude Stein, Djuna Barnes, H. D., Amy Lowell—were also lesbians, and their work in the *Little Review* contained lesbian themes. Anderson's editorials and Heap's critical reviews, among other work submitted to the journal, included both overt and covert themes about women loving women. In addition, in their work Mina Loy, May Sinclair, Mary Butts, and the Baroness Freytag von Loringhoven were also all interested in esoteric questions that overlapped with Anderson's and Heap's interests in their pre-Gurdjieff days.

Central to the fresh eye that this book brings to the modernist inquiry is the somewhat tangled, often obscure, and frequently misrepresented topic of modernism and spirituality. As Robert Crunden writes in *Body and Soul: The Making of American Modernism*, the "interest in Theosophy, Vedanta, the Wisdom of the East," and other forms of spiritual belief systems "turns out to be the greatest missing patch in the crazy quilt of modernism."[9] As everyday people found themselves bombarded by a dizzying array of sights and sounds, modernist artists reflected that in their work. Esoteric spiritual questions served as a channel for new ways to think about creativity and the cosmos. Crunden points out that literary critics have long noticed the spiritual obsessions of two *Little Review* contributors, T. S. Eliot and W. B. Yeats, observing that they duly recorded Eliot's creative reliance on religion and "noted with alarm the wildly imaginative notions of William Butler Yeats . . . but even the most devoted and long-winded biographers have been known to neglect the role of spiritualism, the occult, hermeticism, Rosicrucianism, and the rest in writing up their subjects, or else passed by such things with scarcely a nod."[10] These spiritual philosophies captured the imaginations of other contributors to the *Little Review*, including Joyce, Pound, H. D., May Sinclair, and Mary Butts. Pound's critical analysis of modern French poets, such as Jules Laforgue and Jean de Bosschere, some of them self-described mystics—or described by others as clearly esoteric in their preoccupations—were relevant to Gurdjieff's thought and were among Pound's best contributions to the journal. The poems of H. D. and W. B. Yeats, the mystical novels of Mary Butts, the "uncanny" short stories of May Sinclair, all published in the *Little Review*, further make the case. Finally, the *Little Review's* serialization of James Joyce's *Ulysses*, underscores the mythological, metaphysical, and esoteric themes that predated their interest in Gurdjieff. But Gurdjieff was the one who brought them closer to the surface.

Similar esoteric traditions and religions, most notably Sufism, Tibetan Buddhism, and Theosophy, were important influences on Gurdjieff. His autobiographical accounts of his youthful travels seeking wisdom throughout Central Asia are difficult to verify, but we know he was in Moscow in 1914 and engaged in attracting a modest group of followers among the Russian intelligentsia. Notable among them was P. D. Ouspensky, a mystically inclined mathematician who dabbled in various esoteric schools, particularly Theosophy, which was much in vogue

with Russian intellectuals and artists. When World War I and the Russian Revolution erupted, Gurdjieff led his small band of disciples across Russia, first to London, then to France, establishing his Institute for the Harmonious Development of Man outside of Paris in 1922. Gurdjieff's influence extended well into the twentieth century, inspiring such diverse figures as the architect Frank Lloyd Wright, the cofounder of the New York City Ballet Lincoln Kirstein, the jazz composer Sun Ra, the British director Peter Brook (who made the 1979 film of Gurdjieff's autobiography, *Meetings with Remarkable Men*), and Pamela Travers (who wrote the *Mary Poppins* series). They all agreed with Roger Lipsey, who wrote in *The Spiritual in Twentieth Century Art* that art and spirituality are "two streams" and that what they "have in common is more important than what distinguishes them."[11]

Gurdjieff has always been a mystery figure to those who have tried to trace his origins and the influences that merged to produce what he called "the Fourth Way" or simply "the Work." The novelist Henry Miller described him as "a cross between the Gnostics of old and the latter day Dadaists."[12] He was a practitioner of Western esotericism and positioned himself as a teacher with knowledge from ancient and hidden sources of wisdom. His "Wisdom Tradition" posits that over the centuries "masters" passed down knowledge through oral or written transmission. That knowledge had its origins in ancient Egypt and Greece, particularly the Hermetic tradition—the identification of the Greek God Hermes with the Egyptian God Thoth, ultimately configured as Hermes Trismegistus or "Hermes the Thrice Great"—whose manuscript *Hermetica Corpus* was viewed as a significant source of secret wisdom. While knowledge of this tradition remained in Eastern Byzantium during the Middle Ages, the Byzantine empire's fall to the Ottoman Turks led to the dissemination of various ancient manuscripts that reemerged in western Europe during the Renaissance. Later mystical ideas such as Jacob Boehme's "signatures" and Emmanuel Swedenborg's "correspondences" served as roadmaps to connect with the divine. Freemasonry, Rosicrucianism, the Christian Kabbalah, and Neo-Platonism were other movements and groups promoting the secrets of an ancient wisdom.

From 1880 to 1920 the revival of occult schools of thought led to a burgeoning interest in mysticism among artists. This revival harkened back to the same sources of the Wisdom Tradition—ancient Egypt and

Greece, especially Hermes Trismegistus. Hermes's best-known aphorism from *The Emerald Tablet,* "as above, so below," was the mantra of occult practitioners, validating the correspondence of the material world to the Absolute.[13] While the reputation of occultism during this era is often associated with the infamous Aleister Crowley (founder of the religion of Thelema, a precursor to modern Wicca), more moderate expressions were the norm. The emergence of secret societies that practiced magic was best typified by The Hermetic Order of the Golden Dawn, led by *Little Review* contributor William Butler Yeats. The Golden Dawn attracted artists and poets associated with the advent of the Symbolist literary movement. As proclaimed by Arthur Symons, the symbol was to "spiritualize literature and to free it from the bondage of materialism."[14] Authors were mystics whose task was to communicate to the reader their perceptions of the soul as it sought divine integration. Poetry was the conduit to self-transfiguration. This particular form of esotericism was the foundation for the aesthetics of certain practitioners of modernism.

Anderson and Heap were clear from the beginning that art was an intermediary to the otherworldly. Their youthful quests in art and literature were inseparable from deeper metaphysical matters. Anderson was remarkably well-read in esoteric literature as a young woman. In 1915 she wrote in the *Little Review,* "I enjoy reading Greek Mythologies in the Spring, Hindu legends in the Summer, the Bible anytime, Norse sagas in Winter nights."[15] As a student at the Art Institute of Chicago, Heap's youthful letters were full of ruminations on God, truth, and beauty— frequently expressed by her love of Symbolists poets. Speaking for both of them Anderson later wrote, "We had never thought of art simply as painting, poetry, music, sculpture. We thought art was an expression, through the arts, of a need of something else."[16]

Given the variety of spiritualist trends circulating during the early twentieth century, how do we explain Anderson and Heap's conversion to Gurdjieff in particular? Some of their compatriots in the literary world saw him as little more than a money-grubbing, morally reprehensible fraud. His constant efforts, in his words, to "shear the sheep" (his followers) of money or ply his students with excessive alcohol struck some as less than holy. His belief that women are examples of "passive" energy and that same-sex attraction and masturbation were unnatural sexual offenses was enough to quell the enthusiasm of many. Edmund Wilson wrote that

he was a "Russo-Greek charlatan . . . who undertook to renovate the personalities of discontented well-to-do persons."[17] According to this narrative, a ditzy Anderson and morbid Heap succumbed to this Armenian exile who took them on a magic carpet ride to the end of their lives. Taking their conversion seriously enables us to recognize the compelling personal and significant social and cultural issues that led to their path. The *Ulysses* trial inflicted a powerful blow. Anderson believed it precipitated her nervous breakdown, an event real enough that other Villagers noted it in their correspondence. Anderson and Heap, whose relationship had been previously strained, broke up. Moreover, the political and artistic chaos of the period raised broader questions that left scores of other American radicals feeling a keen need for alternatives to existing philosophies. Intellectuals and artists were floundering after the "Great War"; it appeared to be the ultimate act of madness, and they were now looking into a future that appeared as a dark enveloping abyss. The deep necessity of seeking meaning in the face of unprecedented catastrophe sparked a postwar search for answers to assuage the hunger for the sacred and holy. The failure of Versailles, the Red Scare, the reemergence of nativism and fundamentalism, and the advent of Harding, Coolidge, and Hoover all left thoughtful Americans with a sense that their country was floundering. The Progressive-era emergence of a bureaucratic managerial business sector and an ethos of consumer culture did little to inspire confidence among the artist class. Turning away from politics, many wondered how they could cope with the onslaught of the conservative, even reactionary trends dominating the nation's political and social agenda. As the writer Malcolm Cowley noted in his memoir *Exile's Return*, even the committed politicos of the era were searching elsewhere for relief. Cowley writes, "Most radicals who became converted to psychoanalysts or glands or Gurdjieff gradually abandoned their political radicalism."[18] These trends, taken together with evidence that the two women were capable of separating Gurdjieff's less desirable qualities from his system of thought, were crucial elements in their turn to that system. They trusted his admonition that his teachings must be "verified" by their own experience; no one should blindly accept any dictum he espoused.

Gurdjieff's system of thought had both cosmological and psychological tenets. Like many of their contemporaries in the Chicago Renaissance and Greenwich Village, the two women immersed themselves in

Freudian analysis. "Psyching" one another and their friends became a sort of sport, but the true goal was to understand themselves on a level that seemed revolutionary. The road from Freud to Gurdjieff was mediated by Darwin. Under Gurdjieff's tutelage, Darwin's theory of evolution also applied to individual spiritual progress. This concept of evolution was based on an interpretation of Darwin that permeated the late nineteenth-century occult revival and had a profound influence on the emergence of twentieth-century modernism. Gurdjieff has been described, along with Madame Blavatsky and Rudolph Steiner, as an "occult evolutionist" who implemented "the first Western effort to ground psychotherapy in the evolutionary image."[19] Once committed to, however, their path was not an easy one. Gurdjieff's approach required intellectual discipline, uncomfortable insights, and physical labor, or what Theodore Roszak calls "therapy by ordeal."[20] Those who dismissed Anderson as a ditzy lightweight underestimated her essential fortitude. The fierceness she used to stand up to censors, reactionaries, and other wrongdoers was evident in her lifelong allegiance to Gurdjieff's thought.

That thought was, and still is today, challenging for many to understand. His writings are convoluted and difficult to decipher. It took a prolonged effort by his students to understand his views. Nor was his thought particularly optimistic. Since only an elite few could begin to comprehend the "absolute" truths he promulgated, it meant humankind would fail to evolve to a "super consciousness" anytime soon. As much as Anderson and Heap's interest in achieving this form of enlightened consciousness was a search for God, like many seekers, they claimed it was not incontrovertibly opposed to science. The Victorians grappled with a crisis of faith but could reconcile the march of science with religion in various ways. In Max Weber's phrase, science became a "method of legitimation" for those who argued that it could prove the existence of the divine.[21] While various esoteric and occult teachers, including Gurdjieff, accepted evolution on earth as a physical phenomenon, they also believed that it could explain the soul's development from the material world to the Absolute. The imprimatur of science, spiritual seekers believed, would allay the perceptions of others about odd or bizarre beliefs concerning the esoteric or occult. The Society for Psychical Research, established in London in 1882, was created to scientifically explain (rather than dismiss) otherwise inexplicable experiences such as mediumship, telepathy, and

apparitions, among others. An American Society was founded two years later in New York.

By the late nineteenth century, the American Society for Psychical Research could look back on a rich history—one not only of unexplained phenomena but also of a nation that enticed both religious seekers and freethinkers from the beginning. The Jesuit missions in the Southwest, Puritanism, and the Great Awakenings were all unique in their American applications. By the mid-nineteenth century, the "Burnt Over District" of religious revivals in upstate New York gave way to a fascination with Spiritualism, or communicating with the dead.[22] The Transcendental movement expressed in the works of Ralph Waldo Emerson was based on Platonic idealism and perennial philosophy (also found in Gurdjieff) and marked the evolution of American philosophy as congruent with Western esotericism. Theosophy, another school of thought based on communication by spirit masters, was established in 1875 by Madame Helena Blavatsky in New York. Mary Baker Eddy's Christian Science was a formidable church by this time. The late nineteenth and early twentieth centuries saw the emergence of the New Thought movement, which also promoted a psychological approach to faith. By the early twentieth century, Anderson and Heap's contemporaries such as Waldo Frank, Gorham Munson, and Hart Crane "were all preoccupied with a mystical interpretation of American history in which America appears as a visionary place where the spiritual regeneration impossible in the old world is a real possibility and they wondered whether Gurdjieff might not be the agent of this spiritual renewal."[23]

For too long, scholarship on Anderson and Heap has ignored, minimized, or ridiculed the questing, spiritual aspect of their lives. Perhaps that approach is understandable given the difficult and often impenetrable quality of Gurdjieff's thought and the problematic nature of his personal conduct. Nevertheless, if we are to comprehend their legacy fully, we must understand how their later commitment to the esoteric philosophy of life had its origins in their passion for modernist art and literature. To dismiss or look down on modernists who attended séances, studied the tarot, or read medieval mystics risks obscuring the more erudite comprehension of these artists and hence the depth of the influence of the esoteric in their work. To avoid some of these pitfalls, I have chosen in particular to rely on Arthur Versluis's reminder that "in the field of Western esotericism, as

in that of religious studies more generally, it is important to balance on one hand the virtues of scholarship that strives to achieve a standard of objectivity, and on the other hand the virtues of an approach that seeks to sympathetically understand one's subject, to understand it from the inside out, so to speak."[24] In other words, while I am a Gurdjieffian agnostic, Anderson and Heap were true believers, and I respect their journey.

The concentric rings of modernism, sexuality, and spirituality reveal an intriguing and untold story of the journey of Anderson, Heap, their historic journal, and their mysterious search for the sacred. This book, the first full-length account of their lives, brings these topics together in ways that raise provocative questions and reevaluations of the intersection between esotericism and art. The arc of their story, including their turbulent inner and outer lives, adds another layer to the quest to understand both them and their cohorts, the intriguing rebels of early twentieth-century modernism.

1

THE BUZZ AND THE STING

On the face of it, two women could not be more different. Margaret Anderson was a breathless, dreamy, pretty girl pulsating with big ideas, so optimistic that one of her friends, Janet Flanner, wrote in a *New Yorker* profile that hers was "A Life on a Cloud."[1] A supremely lively young woman whose rebellious nature flouted convention, she cavalierly decided to start a radical literary magazine with no doubts about immediate success (and the *Little Review* would exceed her expectations). Jane Heap was a stellar conversationalist who was also a pessimistic, most likely clinically depressed artist who despaired of making a place for herself in the world. One embodied an optimistic flurry of activity; the other was an introvert whose scornful wit rarely missed its mark. While Anderson overflowed with uninhibited romanticism, Heap resorted to a caustic realism. While Heap tolerated Anderson's flights of fancy, Anderson reveled in Heap's brilliant repartee. The two of them were, in Heap's words, "the Buzz and the Sting."[2]

Margaret Anderson had a wild dream of a journal that would awaken the nascent revolutionary impulses of American arts and letters. She soldiered on with uneven results for two years before meeting Heap in 1916. Anderson was often caught up in the moment, embracing any artist whose work she deemed new and fresh, with predictable results. Not everyone published in the *Little Review* from 1914 to 1916 was an avatar of modernism. It was Heap's discerning eye that helped to harness Anderson's energy into a more discriminating force when it came to editorial decisions. Their partnership catapulted the *Little Review* into its place as the premiere avant-garde journal of international modernism in the twentieth century.

When Margaret Anderson founded the Little Review in 1914, two years before she met Heap, she was confident she could build it into an international journal by sheer force of personality. Essential to her self-conception was a resistance to authority that, she claimed, transcended not only economic and cultural barriers but metaphysical ones as well. "I have," she wrote, "always held myself quite definitely aloof from natural laws."[3] The repeated themes throughout her editorials and three autobiographies consist of the stupidity of the world and of reality itself, and Anderson's endless battles to illuminate others. "It isn't that I'm antagonistic," she insists on the first page of her autobiography, "but life is antagonistic." She continues,

> You spend a few years fighting your family because they want you to be what you don't want to be . . . You make friends who love your ideas and lose them because they don't know what an idea is. You fight the mob because they want to make or break you. You fall in love and soon find out what that is—giving to one human being the opportunity to invade and misunderstand you that you wouldn't dream of giving to the mob. So then you fight the individual. And finally, you find your stride . . . and from then on everything goes just as badly as ever. So then you fight the whole system again from the beginning.[4]

Anderson's family "wanted [her] to be Aimee McPherson," an evangelical leader of Pentecostal revivals.[5] No doubt they saw similarities; both women were beautiful and theatrical. Anderson would later be described by several sources as an evangelist for objects of her enthusiasm, including Nietzsche, anarchism, James Joyce, and later, George I. Gurdjieff.

Our view into Anderson's early life and *Little Review* career comes from the first of three autobiographies, *My Thirty Years' War: Beginnings and Battles to 1930*. The book is replete with satirical accounts of wars Anderson fought with prima donnas of literature, conservative political forces, and a public oblivious of the necessity of a revolution in the arts. She introduces her book with a salvo. "My greatest enemy is reality. I have fought it successfully for thirty years. What have I been so unreal about? I have never been able to accept the two great laws of humanity—that you're always being suppressed if you're inspired and always being pushed into a corner if you're exceptional. I won't be cornered and I won't stay suppressed. This book is a record of refusals." [6] This bravado remains throughout the book and breaks through margins of the genre. Anderson's departure from traditional women's accounts, particularly her self-assurance, is clear to students of feminist biography. As Julia Willis writes, "For me, Anderson's sense of self-worth is what is most astonishing and valuable about her autobiography. Call it egoism if you like, but I can think of few women with such unswerving faith in her own perceptions." [7] Edna Levy gave the ultimate compliment that would have pleased Anderson: "She reminds you of Mary Garden, Isadora Duncan, Lysistrata, Sappho, all packed into one dynamic personality." [8]

Nevertheless, her breezy chatter in *My Thirty Years War* has opened her to charges of being a clueless dilettante who skirted on the reputations of the modernists she published. Her autobiography was an unusual foray into a field that is often marked by the "female virtues" of self-effacement and modesty. Anderson was often cryptic in her writing, using hyphens, asterisks, ellipses, and epigrams while jumping around in time and repeating long conversations. While on the one hand she seems brazenly honest, on the other there is an impersonal quality, leaving the reader unsure of the real Anderson. As most autobiographers do, she constructs a self, and in her case it was a self that believed wholeheartedly in her own judgement and destiny—she had little interest in those who saw her as an opinionated prima donna.

Anderson spoke of her new mission with a passion that swept others into her vision of the *Little Review* as a revolutionary magazine dedicated to the arts. Eunice Tietjens, a Chicago poet present when Anderson announced her new venture, vividly recalled the effect she had on the group. "She stood pouring out such a flood of high-hearted enthusiasm

that we were all swept after her into some dream of a magazine where Art with a capital A and Beauty with a still bigger capital B were to reign supreme, where 'Life itself' was to blossom into some fantastic shape of incredible warmth and vitality." Tietjens concluded that anyone "who could resist Margaret Anderson was granite and cold steel."[9]

Anderson's good looks were noted with frequency by her contemporaries. Her friend Janet Flanner commented that her physical beauty and seeming air of distraction disguised another reality. She wrote "Her profile was delicious, her hair blonde and wavy, her laughter a soprano ripple, her gait undulating beneath her snug tailleur. The truth was that within her lay the mixture and mystery of her real consistence, in no way like her exterior." "Her visible beauty" wrote her friend of decades "enveloped a will of tempered steel."[10]

Floyd Dell described Anderson as "austerely idealistic, matching her starry-eyed, unearthly young loveliness which was too saint like."[11] To *Little Review* contributor Ben Hecht her face was "Scandinavian," and she was "as chic as any of the girls who model today for fashion magazines."[12] Anderson was aware of her beauty and pronounced with unashamed swagger, "It would be unbecoming of me not to know that I was extravagantly pretty in those days—extravagantly and disgustingly pretty." Echoing Hecht, she said, "I looked like a composite of all the most offensive magazine covers."[13]

Those who knew Anderson may have seen her as she saw herself—as totally unique—but in fact she was representative of the "New Woman" of her generation. Breaking free of the Victorian middle-class parlor, the New Woman was independent and increasingly college educated. Margaret Anderson was born on November 24, 1886, in Indianapolis, Indiana, the eldest of three girls. Her father, Arthur Aubrey Anderson, was raised by a single mother and rose in the ranks to become president of the midwestern Interurban Electric Lines. Her mother, Jessie Shortridge Anderson, was from a prominent Indiana family.[14] As an adult, Margaret Anderson would record dramatically different feelings about each parent. The household as she described it in her first autobiography was a place of tension dominated by her mother's mood swings. "Mother was a nervous woman . . . she liked being a victim of nerves because it made everything disagreeable, and she was one of those people who get infinite pleasure out of making things disagreeable." In *Thirty Years,'* Anderson portrayed

her father as a gentle, submissive man trying to conciliate his demanding, self-centered wife. Anderson's critical view of her mother as someone who forced her family to perpetually move and buy new furniture tells us very little of the actual Jessie Shortridge. She was a class-conscious woman who, Anderson tells us, extolled the "joys of country clubs and bridge."[15] Yet Anderson's dismissive portrait of her mother reveals a more complex dynamic.

Jessie Shortridge Anderson was a Christian Scientist. The mind cure or New Thought movement of the late nineteenth century that attracted many women with similar backgrounds has an interesting connection with Margaret Anderson's own spiritual quest later in life.[16] Recent scholarship plausibly suggests a direct link from Gnosticism to Theosophy to Christian Science—and in fact, Christian Science parallels some of the basic beliefs espoused by George Gurdjieff. Like Mary Baker Eddy, the founder of Christian Science, Gurdjieff also proclaimed that his work was based on the falseness of material reality, the power of the mind to lead to individual transformation, and the direct correlation between individual enlightenment and a correction of a universal trajectory gone awry. Many of these beliefs were also shared by Madame Blavatsky, whose Theosophical views later influenced Gurdjieff. Eddy's and Blavatsky's books were published within years of one another in the late nineteenth century. Anderson's mother, clearly an assiduous reader of Eddy's works, could argue the finer points of Christian Science for hours. Regardless of Anderson's exasperation with and condemnation of her mother's views, many of those arguments contained beliefs she would later embrace.

As a child and young adult Anderson was relentlessly searching and questioning spiritual truths presented to her by her family, church, and education. In her second autobiography, *The Fiery Fountains*, she reflected, "My first thoughts about the universe, and man's place and function in it, trace back to an American Sunday-school." The class was taught by Anderson's aunt, who was "very important in her religious authority." At the age of seven or eight Anderson argued with her aunt over the possibility that the world had been created in six days. "All week I tried to argue her out of this fallacy and when Sunday came I went to Sunday school early and sat in the front row where I would stare at her unpleasantly, daring her to tell the class this untruth. She always dared and no one ever objected."[17]

After a childhood following her father's assignment to various mid-western towns, Anderson entered the 1903 junior preparatory class of Western College for Women in Oxford, Ohio. "The Western," as it came to be known in later years, was founded in 1855 as the Western Female Seminary under the supervision of Daniel Tenney, a friend of the famous Presbyterian minister, Lyman Beecher, who encouraged Tenney in his project for furthering women's education. Anderson's internal division and spiritual questioning continued to haunt her throughout her time at the college. She recalled, "My only feeling of relation to a conscious universe was my consciousness of personal privilege—I always seemed to get what I wanted. My abstract distress had quieted into a periodic brooding, purely nostalgic, over the questions: What is the mystery of the universe and what is the meaning of God. But I remember one day in college when an emotional minister made a speech in the chapel, urging us to think of the meaning of life." When the minister asked "who wanted a higher life," she stood up. "When I saw that I was the only one of our lawbreaking group on her feet I held my head higher and stood more firmly. The group jeered me afterward—I, the leading lawbreaker, standing up for an evangelist's pleadings. I was rather ashamed of having been so emotionalized so I asked them defiantly what anyone else could want."[18]

As much as she was drawn to spiritual questions, her main interest in college was the piano. Music was a primary passion her entire life—close to her death she was still writing letters enthusing about the latest classical records sent to her by friends. She loved the opera and the *Sturm und Drang* of the Romantics, particularly Rachmaninoff, Schumann, Chopin, and Liszt. She had an encyclopedic knowledge of music and could write with authority on the performances of noted pianists. Throughout the history of the *Little Review* she wrote rapturous reviews of the concerts she attended—those she approved of. Lesser talents were accorded their due. And her love of music would be a segue to Gurdjieff, who used music and dance as vehicles for learning his system and who wrote melancholy piano pieces that moved Anderson's (in Gurdjieffian terms) "emotional center."

Anderson left Western after three years without a degree, claiming boredom. Now floundering without direction, she returned home where tensions with her mother increased. Between arguments, she spent most of her time ensconced in her room planning her escape and writing her father twenty-page letters "exposing the criminality of our family life."[19]

She wrote to Clara Laughlin, a Chicago writer known for her book *The Work-a-Day Girl* that encouraged young women to be self-supporting. Laughlin wrote Anderson back and invited her to Chicago for a visit. At this time, Laughlin was the literary editor of the *Interior*, a religious magazine founded by Cyrus McCormick. Anderson met her in her office on the corner of Randolph and Clark streets; they hit it off and spent the day together, later attending the play *The Easiest Way* with Frances Starr, the theatrical hit of the Chicago season. After returning home to Columbus, Anderson received a letter from Laughlin offering her a job reviewing books for the *Interior*. After much consternation, Anderson's parents agreed that she could go—with the condition that her younger sister Lois join her. The job paid nothing. For income Anderson took the books she reviewed to A. C. McClurg's on Wabash—advertised as "The Biggest Bookstore of the World"—and sold them for seventy-five cents. Anderson's early career with the *Interior* was hectic; Laughlin would call, informing her she needed a review of fifty books by Monday.

Laughlin had arranged for the two sisters to live in the YWCA. She felt that it "would be wise for [them] to live under the protection of Christianity." Anderson was not happy with the choice, recalling that "it smelled (the institution—also the Christianity) like a laundry."[20] Anderson was employed and busy, but her extravagance with money made self-support increasingly difficult. Among the apparent necessities of life were Oriental rugs and a Steinway piano for her room. She opened charge accounts at the likes of Marshall Fields and bought clothes and travel luggage (despite the fact that she had no plans to travel). Every day she bought herself a yellow rose and "depleted" the YWCA candy shop. Her debts accumulated. Anderson's real trouble began when Clara Laughlin discovered that the sisters had not only taken up smoking but had also initiated other women of the Y into the habit. Arthur Anderson retrieved his renegade girls, but after months of cajoling his eldest daughter returned to the Y alone.

Anderson returned to Chicago with newfound financial realism and a new job as a clerk in Browne's Bookstore, located on the seventh floor of the Fine Arts Building on Michigan Avenue. Built in 1887 as a seven-story showcase for the Studebaker Co, it was rechristened as the Fine Arts Building in 1889. It was reconfigured to house Curtiss Hall and the Auditorium Theater for performances by the Chicago Symphony

as well as offices, music studios, and small stages. Tenants at one time or another included the noted Chicago sculptor Larado Taft, Harriet Monroe, and Frank Lloyd Wright. Wright designed Browne's Bookstore for Francis Browne on the main floor of the building. Browne was also the publisher of the *Dial* and he hired Anderson to work on the *Dial's* printing staff, where she learned the basics of typesetting, proofreading, and make-up—skills that would be essential when she started the *Little Review*. She also began supplementing her income by writing occasional reviews for the *Literary Review* of the *Chicago Evening Post*. Despite earlier tensions, Clara Laughlin recommended Anderson to replace her as literary editor of the *Interior* (renamed the *Continent* in 1912). Her job at the *Continent* was a step up in the Chicago literary world, but Anderson soon became restless. "For a year everything went well on the *Continent*, but inevitably that paper began to suffer under my administration and I had to chafe under its restrictions."[21] She ran into difficulties when complaints poured in over a favorable review she had given to Theodore Dreiser's *Sister Carrie*. She was inundated with angry letters from subscribers who argued the book was immoral and was enraged when the general editor told her that "one thing everyone knows" is when a book is immoral. On hearing this, her "paralysis changed to a St. Vitus dance."[22] By the time she faced the same charge over the *Little Review's* publication of *Ulysses* years later, she was seasoned (if not successful) in arguing the "impossibility" of immoral literature. However, in 1913 the uproar over *Sister Carrie* and the arrival of the fall publishing season, which required reviews of three hundred books, understandably discouraged Anderson. Her response was to simply start her own literary journal.

In *Thirty Years' War*, Anderson described the decisive moment that launched the *Little Review*. "I had been curiously depressed all day," she wrote. She awoke in the night. "First precise thought: I know why I'm depressed—nothing inspiring is going on. Second: I demand that life be inspired every moment. Third: The only way to guarantee this is to have inspired conversation every moment. Fourth: Most people never get so far as conversation; they haven't the stamina and there is no time. Fifth: If I had a magazine, I could spend my time filling it up with the best conversation the world has to offer. Sixth: Marvelous idea—salvation. Seventh: Decision to do it. Deep sleep." [23] Feeling her endeavor was already "an accomplished

fact," Anderson began boasting to everyone she was "about to publish the most interesting magazine that has ever been launched."[24]

The literary "renaissance" in early twentieth-century Chicago was in large part responsible for Anderson's success in establishing the *Little Review*. In the previous century Chicago's reputation had revolved around its stockyards more than its culture. Still, the city had established itself as a publishing base. After the Civil War, the Western News Company sponsored several publications distributed via the railroad. Magazines such as the *Chicago Ledger*, the *Little Corporal*, the *Lakeside Magazine* and, later, the *Chapbook* and *the Dial* were distributed in Chicago and throughout the Midwest. This in turn attracted many midwesterners, particularly those interested in a literary career, to Chicago.

Chicago had been the object of a sustained campaign of cultural improvement. Concerned by the powerful commercial forces in Chicago and the city's image as a meatpacking "Porkopolis," several citizens sought to alter the image of the city as something other than a midwestern cesspool of materialism. In her study of charity and cultural philanthropy in Chicago, Kathleen McCarthy points out that the Gilded Age sponsors of culture who were concerned with ameliorating the negative effects of rampant growth were often the same individuals who had made fortunes from the cities' industries. Given the tensions arising from the inequities of the era, patronage of cultural institutions was in certain respects self-serving.[25] In the beginning of the twentieth century, the wealth of Chicago's millionaires had constructed huge cultural and educational institutions such as the Chicago Symphony, the Newberry Library, the Art Institute, and the University of Chicago. Accompanying this was the creation of various small groups, societies, and clubs that revolved around literary discussions and cultural topics. The two most famous of these groups were the Little Room, which met in the Fine Arts Building on Friday afternoon after symphony concerts, and the Cliff Dwellers, which met in the penthouse of Orchestra Hall. Both were composed of patrons, artists, and writers engaging in dialogues that emphasized the genteel tradition of high culture. Anderson found this milieu unwelcoming. The social world of women like Laughlin and Harriet Monroe, meeting for teas and literary luncheons and attending popular dramas in the Chicago theater, was too staid—or, in one of Anderson's favorite epithets, "unstimulating."

Anderson was able to undertake the *Little Review* because of more recent radical developments. By the turn of the century the appreciation of the arts was superseded by the Chicago Literary Renaissance, a far more revolutionary movement. The change in the artistic world of Chicago was in part formed by the economic and social transformation of the city's landscape. The emergence of three rooming house districts on the West, South, and North sides of the city, populated mostly by wage laborers and transient lodgers, led to the creation of social networks and peer subcultures that tolerated a fairly liberated lifestyle. Two of these working-class districts helped to forge an urban bohemia in Chicago: the South Side between 57th Street and Stoney Island Avenue and the North Side in the area surrounding a water tower known as Towertown. Both areas were known for "strong assertions of individuality-artiness, intellectuality, radical politics, anti-religion, free love, and homosexuality."[26] Drawing on the tolerance of working-class neighborhoods, young intellectuals translated their newfound freedom into artistic, social, and political creeds. As one historian has observed, "Outside the web of family and hometown, the young writers lived in the heady atmosphere of creative friends seeking new personal and aesthetic definitions. Sexual liaisons and friendly separations were accepted; open collars, scarves, and capes took the place of neckties and jackets; socialist economics were the norm."[27]

Amid the inhabitants of the South Side bohemia, Anderson found herself in the literary vortex of the Chicago Renaissance. Her peers there lived in vacated storefronts left over from the 1893 Colombian Exposition. Single rooms with one large window in front, and often without plumbing, their buildings did have the advantage of being across from Jackson Park and near a railroad stop that went to the Loop. Among the area residents were Floyd Dell and his wife Margery Currey, who created an informal salon for other writers and artists in their storefront home. Dell, who met Anderson when he took over as editor of the *Friday Literary Review*, invited her to the gatherings. There she met many of the writers who were a part of the literary revival including Sherwood Anderson, Dreiser, Maurice Browne, Ben Hecht, and Maxwell Bodenheim. Like Anderson, many of the participants of the Chicago Renaissance came from midwestern towns, anxious to escape their provincial backgrounds.

In his study of the Chicago Renaissance, Bernard Duffey traces the birth of Chicago's literary transformation to a series of pivotal events. The

first was the founding of the *Friday Literary Review* in 1909 by Francis Hackett, an Irish Fabian who used the paper to praise the work of Henrik Ibsen, Walt Whitman, H. G. Wells, and George Bernard Shaw and to attack the artificiality of the genteel tradition. When Hackett left Chicago in 1911, he turned the editorship over to Dell, who continued Hackett's approach. The second event of importance was the founding of *Poetry* by Harriet Monroe. Monroe, a member of the Little Room, had one foot in the genteel tradition but nevertheless became a major promoter of modern poetry. Uncomfortable with the "dry conservatism" of contemporary poetry, Monroe was interested in experiments of free and blank verse. Not a bohemian herself, she financed the magazine with a guarantor system of contributions from wealthy Chicagoans, including the scions of the International Harvesting Company farm tractor corporations, the Deerings and McCormicks. But Monroe's openness to new trends and young minds led her to publish the best of modern poets such as Ezra Pound and T. S. Eliot.[28] Other events that led to a new wave of high culture in Chicago included the 1913 arrival of the New York Post-Impressionist Armory show to the Art Institute and the founding of the Little Theater by Maurice Browne, which helped to foster a nationwide little theater movement from the Fine Arts Building.

It was this movement that inspired Anderson to call her journal the *Little Review*. Although many of her colleagues were doubtful about raising the necessary funds, Anderson was unconcerned. "I knew someone would give me the money," she later wrote. "This is the one kind of natural law I always see in operation. Someone would have to. Of course someone did." That person was Dewitt C. Wing, a journalist who met Anderson at a Dell party. Wing, called Dick by Anderson, was a writer for the rather unbohemian journal *Breeder's Gazette*. Although professionally concerned with agricultural matters, Wing was involved with writers and artists of the South Side assemblage. He was, according to Anderson, the only person who really "saw" the *Little Review*. Wing put aside money from his salary to pay for office rent and printing bills. On Wing's suggestion, Anderson went to New York and Boston to get advertising revenue from major publishers. She was successful and returned to Chicago with four hundred and fifty dollars' worth of ads from publishers such as Houghton Mifflin and Scribner's. While at Scribner's she met a young F. Scott Fitzgerald who was going over the proofs for his first novel, *This*

Side of Paradise. Describing Fitzgerald as "smiling, blond, and nervous," she claims he "regretted with blushes that his stuff was too popular to be solicited by a magazine of new prose."[29]

Back in Chicago, Anderson established an office for the *Little Review* in Room 917 of the Fine Arts Building. In spite of her extreme confidence and the apparent good timing of her venture, she began her career as editor in March of 1914 amid a personal life marked by grief and tension. Anderson's parents had moved to Chicago, and Anderson, broke, lived with them. Only months after she moved in, however, Arthur Anderson died, weakened from a stroke and showing signs of dementia.

After her father's death, Anderson's life with her rigid and anxious mother was too much for the both of them. Jessie Anderson left Chicago, taking with her all the furnishings with the exception of two beds, two forks, two knives, and two spoons. Left with the problem of coming up with a hundred dollars a month for rent, Anderson was nevertheless delighted to be free of her mother. She preferred the apartment in its new incarnation, "nude as the day it was built." The only piece of furniture she added was a baby grand piano that she solicited from the Mason-Hamlin company in exchange for a year of free advertising in the *Little Review*. She initiated a subscription campaign for her magazine and feverishly solicited contributions from individuals. Some rather large donations came as a welcome surprise: Eunice Tietjens gave Anderson her diamond engagement ring to sell (she was divorced), and Frank Lloyd Wright sent her one hundred dollars. The excitement of these events and the camaraderie of the new bohemians created an atmosphere charged with promise. Sherwood Anderson wrote in his memoirs, "Something which had been very hard in American life was beginning to crack, and in our group we often spoke of it hopefully. And how exciting it was. Something seemingly new was in the very air we breathed."[30]

One of the things beginning to "crack" was the attitude towards homosexuality, which would be crucial for Anderson personally as someone who decided to live openly and, as editor of the *Little Review*, whose treatment of same sex attraction would help earn the journal its radical reputation. As Chad Heap (no relation to Jane) wrote in *Slumming: Sexual and Racial Encounters in American Nightlife, 1885–1940*, "a nearly identical process" existed in the creation of Chicago's Towertown working class and bohemian alliance, and those in New York's

Greenwich Village. "Even as bohemian fashion provided a public marker of the transgression of gender norms, its evocation of popular stereotypes of gender inversion and sexual deviance created an atmosphere where lesbians and fairies felt relatively comfortable mingling in public with the districts' artists and radicals. To some extent, this sense of comfort was simply a product of the presence of numerous 'third sex' types among the creative women and men of Towertown and the Village." Chicago's Towertown was welcoming as well because, "as regular Ben Reitman noted, they accepted [homosexuals] 'in full fellowship . . . No one insults them by calling them queer or kids them for being sissies.' "[31] Chicago had a number of saloons and tea rooms such as the Green Mask, Blue Fish, and Red Lantern of Towertown where queer denizens and radical literati mingled. The Dill Pickle Club became one of the most famous of such spots, with one visitor describing the club as a place where "pale girls with daring bobbed heads . . . and tortoise-shelled glasses discuss Nietzsche and Prudhomme [sic] and Havelock Ellis with boys whose eyes dreamed and visioned."[32]

The British sexologist Havelock Ellis was an early and vocal empathetic supporter of sexual inverts, as he termed them. To contemporary readers Ellis's book *Sexual Inversion* may seem a hodgepodge of modern empathy and conventional myths, yet to an early-twentieth-century audience his views were radical, even contemptible. More important to people like Anderson, however, was the fact that Ellis noted the contributions of many famous homosexuals in history, and even more crucial was his argument that "inverts" were born with their condition, hence attempts to cure them were inappropriate and futile.

Members of the 57th Street bohemian circle in Chicago in which Anderson traveled, influenced by such modern thinkers as Ellis, approached female and male same-sex attraction with a mixture of openness and anxiety. Floyd Dell wrote in his autobiography (with ambiguity), "We were in love with life, and willing to believe almost any theory which gave us a chance to live our lives more fully."[33] In his autobiographical novel about his Chicago contemporaries, *The Briary Bush*, the hero, based on Dell, learns much to his disgust that the director of a little theater group is a gay man. His girlfriend points out, however, that the definition of "queers and freaks" is relative according to the values of any given place or time. She tells her boyfriend that his rebellion against most of the standards of

society also make him a freak and yet such an unorthodox status is really a positive accomplishment.

Part of the bohemians' attempt to come to terms with the subject came with their fascination with Freud and psychoanalysis. Sherwood Anderson recalls in his memoirs the constant efforts of members of the 57th Street colony to "psyche" everyone. An "unfortunate moment" occurred one evening when they were gathered at Dell's house came and he "brought up the subject of homosexuality." He told the group of his confusion and fear in observing "homosexuality that was unashamed" years before when he had worked in a Chicago warehouse. His colleagues informed him that his fear was a sign that Anderson himself was a homosexual. Later as he walked in Jackson Park with a friend who had been at that gathering, Anderson picked up a twig and broke it in two. His friend excitedly informed him that by breaking the twig, Anderson was trying to "destroy the phallic" in himself and "had secretly desired to be a woman."[34]

As Estelle Freedman and John D'Emilio tell us, subcultures of sexual minorities in major urban areas were located in places exhibiting "either moral ambiguity in American society or of a transient relationship, such as red light districts, theaters, clubs, military bases, YMCAs and bohemian communities."[35] The 1911 report of the Chicago Vice Commission, which was originally assigned to study the problems of prostitution, child labor, and venereal disease, also addressed the perception of Chicago judges and police that there existed an "increase in sex perversion." The commission concluded,

> It appears that in this community there is a large number of men who are thoroughly gregarious in habit; who mostly affect the carriage, mannerisms, and speech of women; who are fond of many articles ordinarily dear to the feminine heart; who are often people of a good deal of talent; who lean to the fantastic in dress and other modes of expression, and who have a definite cult when it comes to sexual life. They preach the value of non-association with women from various standpoints and yet with one another have practices which are nauseous and repulsive . . . They have a vocabulary and signs of recognition of their own which serve as an introduction to their own society.[36]

What about Margaret Anderson herself? When did she first recognize her own lesbianism? Since Western was an all-female school, one wonders to what extent her college life contributed to her self-knowledge.

Women's colleges from their beginnings in the mid-nineteenth century until Anderson's day were known to foster close relationships between students resembling crushes, something that often caught the attention of school committees.[37] These relationships were interpreted as sexually innocent and in some respects thought to be a harmless rehearsal for marriage. Information on Anderson's time at Western is sparse and any conclusion about the nature of her friendships would be speculative, but it seems likely her years there raised questions in her own mind concerning her orientation. That is difficult to say precisely, of course, but we can surmise that she achieved some level of self-awareness early on given the fact that she made a point to read Havelock Ellis before she left home for Chicago. Doing so was not easy; in a *Little Review* article in 1915 she commented, "It is worth your life to get Havelock Ellis's six volumes from a bookstore or a library. You can only do it with a doctor's certificate or something of that sort."[38]

We know that she also read the sexologist Otto Weininger and sexual radical Edward Carpenter, but whether she read them before going to Chicago is not clear. In the same 1915 article, she complained of "how difficult it is for the mass to become educated about sex." She related an incident most likely from her own experience: "Even if you ask about Weininger you are taken behind locked doors, forced to swear that you want it out of no 'morbid curiosity,' that you will keep it only a week, and above all that you won't let anyone else read it."[39] Anderson's only comment on her first relationship in *Thirty Years'* reads as follows: ". . . and I was in love. My first love—I should say, my first real love. And it was a great love—great in everything including disappointment. But oh, how I was in love . . ."[40] We know, however, from a letter she wrote fifty years later that this affair, which occurred when she was writing book reviews for the *Continent*, was with a married woman. Anderson was "consumed with jealousy" and the affair was apparently short-lived.[41] Her second love was Harriet Dean, a native of Indianapolis who had attended Vassar and was part of the *Little Review's* early staff. In writing about her first meeting with Anderson, Emma Goldman took note of Dean and contrasted the personal styles of the two women. "Harriet Dean was as much a novel type to me as Margaret, yet the two were entirely unlike. Harriet was athletic, masculine looking, reserved, and self-conscious. Margaret, on the contrary, was feminine in the extreme, constantly bubbling over

with enthusiasm."[42] According to other accounts, the two were insepa-
rable and Dean idolized Anderson. Anderson herself described Dean as
"worshipful about the *L.R.*" and as someone who went around "hurling
at everyone quotations from what I said on page so and so."[43]

One of the most fascinating, if condescending, portraits of Anderson
and Dean comes from Maxwell Bodenheim's autobiographical novel,
Blackguard. The book was a thinly veiled account of the literary scene
during the Chicago Renaissance. Anderson is Martha Apperson, the edi-
tor of a magazine called *Art and Life,* whose office is a gathering place
for young rebels. Martha's nickname is Mart (Anderson's was Martie)
and she is described by Bodenheim as a "tall, sturdily slender woman
with a blithely symmetrical swerve to her body . . . Life to her was a rap-
idly taunting mixture of glints, hints, undertones, surface blooms, fleeting
tints, portentous shadows with little shape to them, broken images, and
misty heights, and she was forever trying to lure them all into a cohe-
sive whole by striding from one philosophy and creed to another, adding
another stride every three or four months."[44] Dean was Helen Wilbur,
"a young disciple who scarcely ever left her side." Although Anderson
was the first person to publish Bodenheim's poems, his description of the
two women is patronizing and even callous. Dean, he wrote, "had made
a fine art of her determination to persuade herself that she was mascu-
line, giving it the intense paraphernalia of stolen words and gestures, but
beneath her dubiously mannish attire and desperately swinging limbs
the desires of an average woman were feebly questioning the validity of
her days." Bodenheim's admission that he was attracted to Anderson is
also made in a deliberately insulting manner. He wrote that "he wanted
her body because it was the only mystery that she seemed to possess and
because he wondered whether it might not be able to make her thoughts
less obvious."[45]

Bodenheim was not the only one of Anderson's male contempo-
raries who simultaneously expressed admiration and contempt for her.
Dell described her as "beautiful in a cool and standoffish way," and
Maurice Browne of the Little Theater referred to her "cool and cameo-like
beauty."[46] This perceived coolness, of course, was frequently translated
into frigidity. Ben Hecht wrote in his autobiography that one friend of
his was "a little embittered by her beauty and chastity" and he "called
her Diana, the frigid huntress." Hecht personally "forgave her chastity

because she was a genius." Her genius, he continues, "consisted of making young writers want to please her rather than a larger, more lucrative audience."[47] In a comment directed to Hecht, the same friend also referred to Anderson as "your idiot friend Sappho."[48]

The depiction of Anderson as cold, cool, frigid, chaste, and virginal—a characterization that conflicts with other descriptions of her, by men and women alike, as fiery, passionate, and intense—reveals the sexual tensions that existed even amongst the most enlightened of the early twentieth-century bohemians. Her attractiveness and femininity probably made it even more difficult for her male contemporaries to accept her lesbianism, and the borderline angry tone of some descriptions no doubt stemmed from their incredulity that such a woman would have no interest in them.

Anderson's treatment of gender and sexuality in her first autobiography is unusual for autobiographies by women in the early twentieth century. Her trademark bravado is in full force when she identifies herself to her readers on page four as "a fairly attractive woman in her thirties." She says that "such a human being falls inevitably into one or more human categories . . . I am not a daughter: my father is dead and my mother rejected me long ago. I am not sister: my two sisters find me more than a little mad, and that is no basis for a sisterly relationship. I am certainly not a niece; (. . .). I could almost be called an aunt . . . but my two nephews don't find me convincing: so I'm not an aunt. I am no man's wife, no man's delightful mistress, and I will *never*, never, never, be a mother."[49] For a woman in the late twenties this was heresy.

In all three of Anderson's autobiographies, she swerves from being transgressive to a stranger in the larger scheme of things. "I have no place in the world—no fixed place. I don't know just what kind of thing I am. Nobody else seems to know either." Going further, she claims, "I have been called a lovely freak of nature."[50] Here she is launching a preemptive attack, reclaiming the stigmatizing language of "freak" and owning the label of being queer. Nina Van Gessel examines Anderson's book as a direct contrast to Radclyffe Hall's *Well of Loneliness*, published one year earlier. Instead of the "bitter self-loathing" of Hall's protagonist, Anderson employs "wholesome self-satire." Van Gessel contends that, "discarding the tragic scripts thrust upon her in favor of self-directed comedy, Anderson employs laughter as a weapon with which to counter clichés of the

lesbian as a tortured misfit." Anderson presaged later lesbian culture to the point of reconfiguring "stigma into superiority," which could be the motto for her life.[51]

Anderson's early time in Chicago was an adventure that she described as her "beautiful life" there. She had broken free of the expectations of her parents and was undertaking a journey that would lead to liberation from larger constricting norms. She started a radical journal that would flourish amid an artistic revolutionary milieu. However, the *Little Review* of 1914–16, while promulgating free verse, feminism, and acceptance of homosexuality, was a hodgepodge of the new and old in the arts. The *Little Review* would begin to mark its beginning as a truly avant-garde journal after 1916, when Anderson met Jane Heap. They were to form, wrote Anderson, "a consolidation that was to make us much loved and even more loathed."[52]

Jane Heap is somewhat of a mystery woman to historians of the avant-garde. Unlike Anderson, who wrote three autobiographies lauding her own adventures and accomplishments, Heap retained a low profile. In many ways she deliberately sought anonymity while working with Anderson; she strongly resisted Anderson's pleas that she write for the *Little Review* and, on relenting, signed her contributions with her initials, "jh." As a cross-dressing lesbian, she did stand out and is mentioned in most of the autobiographies of the Chicago Renaissance and in accounts of Greenwich Villagers and expatriate Paris in the teens, twenties, and thirties.

Jane Heap was born in 1884 in Topeka, Kansas, the second of four children of Emma and George Heap. After graduating from Topeka High School in 1901, she immediately went to Chicago, where she studied at the Art Institute. Finishing her studies in 1905, she earned thirteen Honorable Mentions for "outstanding work in figure drawing and composition."[53] After graduation she studied in Germany, learning tapestry, weaving, and mural decoration while living at an artist's colony near Munich.[54] Returning to Chicago, she took evening classes at the Art Institute from 1909 to 1911, teaching at the Lewis Institute in Chicago where she had at one time studied jewelry making and participated in theatrical productions.

The only sense we have of Heap's early years are from letters she wrote to a Chicago native, Florence Reynolds, in the summers of 1908 and 1909 while living with her parents in Topeka to save money. Heap's letters to Reynolds are an interesting preview of the woman who would

later make a decisive impact on the *Little Review*; she was preoccupied with art, literature, love, and God. It is clear that Heap tried to spend as much time as possible sketching, painting, and writing poetry and stories in the free time she had from doing household chores. "Coming home always upsets me—here it is the Real," she wrote Reynolds. "In Chicago it is Love and Art and Play—as soon as I find time to start a composition or to read a lot of poetry the Real will lose some of its power to stun one's soul."[55] During this period Heap often felt a sense of despair about her life, and the letters she wrote to Reynolds indicate what might have been clinical depression. In 1908 she wrote, "O I had such a bad night last night—such doubt and despair—all the glorious years going and I doing nothing—because I never can and was never meant to—I never did see things as they are, so I know I have deluded myself into thinking I could do something big even."[56] There is little doubt that her father's employment for the Topeka State Insane Asylum, which was adjacent to the Heap home and on whose grounds she played as a child, had an unsettling impact on her into adulthood. One letter she wrote Reynolds in the early autumn of 1908 described an excursion she and her sister Edna had taken to the asylum grounds to sketch trees. She related an encounter with a patient who had known both of them as children: "He had such beautiful, clear, sad eyes. It hurt to think of his life there."[57] Years later in the *Little Review* she would argue, along with the surrealists she admired, that insanity was a sacred source of creativity. As a young woman Heap demonstrated a spiritual introspection that she directly connected to art. On hearing the news that Reynolds' sister Hattie had given birth to a baby daughter, she wrote, "I hope Hattie does not bring her up a Christian. If we could get a chance at her, we would have her know no God but Beauty, would we? I have been thinking very much these days of Beauty—(poor name is it not for anything so Holy). I know that if everyone felt Beauty strongly, felt that everything beautiful was God and all things not beautiful not God. That woman was the nearest Symbol for Beauty. If one could see this—there would be no sin, or squalor, or unhappiness in the whole world."[58]

While Anderson's youthful religious queries dealt with Sunday school, family doctors, and ministers' sermons, Heap's early questions are mostly referencing literature, theater, and poetry. As a young woman Heap was attracted to the shadowy, mysterious work of the Symbolists, writers who

are important in understanding her intellectual evolution, her career as a critic for the *Little Review*, and her eventual conversion to George Gurd-jieff's belief system.

During the period she was writing to Reynolds she often indulged in an almost post-adolescent self-pity about being misunderstood by the world—an alienated artist questing for solace in exploring God and Beauty, all themes germane to the work of the Symbolists. As the next chapter will show, modernism's roots developed from the nineteenth century; Symbolists like Yeats were important conduits to the later work of High modernism. Heap, as a young woman, read Arthur Symons' 1899 *The Symbolist Movement in Literature*, and the book was highly influential to Eliot, Pound, and Joyce, all of whom who had prominent publications in the *Little Review*. As a literary critic Heap made explicit connections between these generations of artists.

In addition, her early interests presaged her correlation between sexuality and art—Symons, Ernest Dowson, and another writer, Mary Robinson, whom Heap often invoked, were noted translators of Sappho as well. Heap's letters to Reynolds included her own stories and poems, often invoking fairy-tale-like legends of knights and ladies riding proud stallions in fantastical natural surroundings. The hero is always a young man on a mission enveloped in a mystery, with Heap, who began signing her letters to Reynolds "Lancelot," clearly identifying herself with the male character. "Can we keep our love as it is?" she wrote in the summer of 1908. "Like our knight and lady on the white horse, forever riding in a flowered meadow, in the sunlight, never arriving—we can. I know a way."[59] In another letter she explicitly identifies herself as the hero of her poem "Vagabond," in which she writes, "Over my shoulder I bear my pack / Fancies and dreams and memories / Love of women and Beauty / A wonderful crowded pack."[60]

Heap was distressed to be in Topeka, not only because of the household drudgery she experienced—she clearly pined for Reynolds. "Dear little Delight the days are passing," she wrote in August of 1908, "soon we will have each other again—We will do so many things together—We will love so that we will never at any time to come regret not having loved enough."[61] The following year, Heap's ardor remained strong. In July 1909 she wrote Reynolds, "I have always felt that I was a good lover, but since I have loved you I feel how utterly impossible it is to convey my

idea of love to you. . . . I wish you were here tonight and every night to go to sleep on my arm."[62] The following month Heap wrote again, "Sometimes I lie quite still at night and imagine you close, touching me all along until it becomes so real I nearly cry of emptiness." She also reflected about the reticence she felt concerning any public perceptions of their relationship. "It seems to me now as if I did not 'love you up' often enough when we were together. Why did I always feel conscious when there were people present—as if it were not fair to you or something to love you publicly or what was it?"[63]

The physical references in Heap's letters to kissing, touching, and sleeping together, or even the use of the word "lover," cannot in themselves be conclusive evidence that Reynolds and Heap maintained a sexual relationship. Women in the nineteenth century frequently used passionate language in their correspondence with female friends. What does indicate that this was not a platonic friendship was the fact that Heap was cross-dressing at the time she was writing these letters, and in one of her letters she refers to a mutual friend, Marie Blanke, nicknamed James. "I have just written to James," Heap wrote, "She has been visiting at some very 'swell' houses. She said she had been doing some of my stunts dressing up in men's clothes and making love to girls— I wonder how near a representation she could give of me."[64] There are photographs from this period showing Heap in men's suits, ties, and hats. Her cross-dressing emerged at a pivotal point in changing notions of women's sexuality. Heap, of course, was not the only future member of the female avant-garde who cross-dressed; clothing for many women in the early twentieth century was the key to emancipation in both a literal and figurative sense. Adopting male attire gave them simultaneously physical freedom from the constraints of female clothing and symbolic freedom from the narrow constraints of gender. Heap's image as it was to develop was as the "mannish lesbian" that attracted the attention of early twentieth century sexologists. Her letters to Reynolds suggest that she and other women found each other partially from the practice of cross-dressing. They repeatedly mention particular names, like James, that suggest a community of friends, some of whom may have had romantic involvements with each other. Photographs exist not only of Heap but also of other women she knew from Chicago, such as Olive Garnet and Elsa Koop, dressed in men's clothing as well. Heap's letters

and the photos suggest that this was a self-conscious lesbian community in America in the early century, predating earlier estimations of when such communities existed.

An interesting aspect of Heap's cross-dressing was her involvement in little theater productions in Chicago in which she appeared to play only male roles, similar to Willa Cather in her amateur Nebraska productions. Photographs of her in unnamed productions show her dressed as a bellboy and a man in traditional Arabian garb. Exactly what these productions were is difficult to say, although we do know that Heap joined Maurice Browne's Little Theater in Chicago, where she acted in the company's production of W. B. Yeats' *On Baile's Strand*. Her interest went beyond acting to scenery, costume design, and writing.

Among her early papers exists a bill—largely a collection of jokes— of "Blanke and Heap's Nickel Theatre" presenting "American History I" at the Lewis Institute in 1910. Also among her papers is the play "Pyg-male-one" written by "O. Pshaw, A. Hammer, and Monkey Wrench." The takeoff on Shaw's *Pygmalion* reverses the story line and sex roles; the professor is Vera Still Bible, "Professor of Neurotics," and the flower picker is William Albert Grabbed-for. In the play Professor Still Bible, referring to Grabbed-for, states "I'll wager that I can make a nervous and financial wreck of him in six months."[65] The play give us early evidence of Heap's iconoclastic humor that readers of her work in the *Little Review* would come to know well.

Aside from her interest in theater, Heap was gaining attention as a visual artist. As early as 1911 her work had been noticed in the *Sunday Tribune* with a favorable review from Harriet Monroe, the editor of *Poetry*.[66] She later had an exhibit at the American Architecture Exhibit and the Municipal Art League and was featured in two articles by the *Topeka Capitol*. The paper reported on her success in Chicago and noted that she did mural paintings in the homes of "two midwestern prominent citizens" as well as preparing murals for two public schools. By 1914 Heap had another exhibit of watercolors at the Artist Guild's gallery, and the work was given accolades by Ferdinand Schevill. "Her method is simplicity itself and consists in reducing and eliminating until she gets the billowy line of hill and stream, and foliage enveloping the fewest possible shades of olive, umber or mauve. Her filmy work is in perfect keeping with her light medium, which is always

water-color, and one is impressed that it would lend itself admirably to reproduction."[67]

Since the Artist Guild Gallery and the Little Theater were both in the Fine Arts Building, the home of the *Little Review*, it was only a question of time before the paths of Jane Heap and Margaret Anderson would cross. They met in early 1916 when a mutual friend brought Heap to the *Little Review* studio. Heap's impact was immediate and profound.

In later years Anderson would write pages trying to describe Heap's extraordinary influence over her. The *Little Review* editor felt that Heap was a "genius" who provided the most fascinating conversation she had ever encountered. Anderson, who had started the *Little Review* with the idea that it would be based on conversation, found Heap's talent in this area an unexpected godsend. She often had difficulty in expressing what it was about Heap's conversation that was so riveting. "There is no one in the modern world whose conversation I haven't sampled, I believe, except Picasso's. So, I can't say it isn't better than Jane Heap's. But I doubt it in spite of his reputation. I felt in 1916 and feel to-day that Jane Heap is the world's best talker." She struggled on in her explanation: "It isn't a question of words, facility, style. It isn't a question of erudition. It isn't even a question of truth. (Who knows whether what she says is true?) It is entirely a question of ideas. No one can find such interesting things to say on any subject. I have often thought I should like to give my life over to talk-racing, with my money on Jane. No one else would ever win—you can't win against magic . . . No one can find such interesting things to say on any subject. What it is exactly—this making of ideas—I don't know. Jane herself doesn't know. Things become known to me she says."[68]

Others shared the sense of Heap as a sparkling yet puzzling talker. Robert MacAlmon, the American expatriate publisher who travelled in the same circles as Heap and Anderson during their Paris years, wrote in his memoirs of overhearing a conversation between Heap and Mina Loy. They were, he recalled, "both talking brilliantly . . . Jane, her breezy travelling salesman of the world tosh which was impossible to recall later. But neither of these ladies needed to make sense. Conversation is an art with them, something entirely unrelated to sense or reality, or logic . . ."[69] Anderson recalled one woman saying to Heap, "You're the best talker I've ever listened to. I don't understand a word you say." One reason Anderson was attracted to Heap was the chance to engage in a genuinely

challenging argument. She loved what she called "the discussibility" of "the ideas Jane offered, the challenge and the opportunity for argument—agreement or resistance: ideal conditions for [her] temperament, [her] nature, [her] mind." "At last," she wrote elsewhere, "I could argue as long as I wanted. Instead of discouraging Jane, this stimulated her. She was always saying that she never found enough resistance in life to make talking worthwhile—or anything else for that."[70] Anderson always felt frustrated that most people wanted to drop a conversation if it became too heated or controversial. For her, this process was energizing and liberating.

Heap and Anderson were, in Anderson's words, "as different as two people could be. Temperamentally, we were almost never in accord, intellectually we had taken different routes."[71] One basic difference was that while Heap enjoyed talking with Anderson, she did not like to perform in front of groups when Anderson wanted to show off her talents. Anderson would make up arguments at parties so that Heap could demonstrate her conversational powers. Heap did not appreciate this and told Anderson she put her in an awkward position. "Margaret," she told a friend, "carries me around like a fighting cock and throws me into every ring she sees. And she sees nothing but rings."[72] Anderson was clearly mesmerized by Heap. Decades later she would recall their meeting as leading to "a new, unexpected extra life that to me was like a second birth." "Here" she continued "was my obsession—the special human being, the special point of view." Her "mind was inflamed" by Heap's ideas—"this was what I had been waiting for, searching for, all my life."

Despite their obvious differences, however, there were underlying similarities. Both women were rebels with a taste for the theatrical. Like Heap, Anderson had felt alienated by her middle-class midwestern family and had sought refuge in art and literature. Both had known of their sexuality as young women and had moved to Chicago to break free from their provincial homes. Both had minimally supportive families somewhat bewildered by their daughters' unconventional interests but unwilling to stand in the way of their drive for self-fulfillment. While Anderson recorded her feelings for Heap in multiple publications, we have no public utterances about her from Heap that would explain their partnership from her perspective. We can only speculate, but perhaps Heap saw in the *Little Review* her early dream, as she put it to Reynolds, "to do something big." In addition, as depressed as Heap seemed to

be, perhaps Anderson's sunny demeanor provided some respite from her darker moments.

Anderson launched the *Little Review* in March of 1914. Although she would not meet Heap until two years later, the journal made an astonishing debut that amazed her contemporaries. It would become the most radical symbol of the Chicago Renaissance. Bernard Duffey, referring to the Renaissance as "the Liberation," asserts that the *Little Review* was first among equals. "If *Poetry* marked for the Liberation an achievement of status, and the *Friday Literary Review* supplied a rationale for it, the *Little Review* may be said to have held up a mirror to its soul."[73]

2

TEMPLES OF TOMORROW

Anderson and the Little Review, *1914–1916*

Anderson's editorial in the March 1914 debut issue proclaimed her enthusiasm and confidence in the mission. "If," she wrote, "you have ever read poetry with a feeling that it was your religion, your very life; if you've ever come suddenly upon the whiteness of Venus in a dim deep room; if you ever felt music replacing your shabby soul with a new one of shining gold; if in the early morning, you've watched a bird with great white wings fly from the edge of the sea straight up into the rose colored sun—if these things have happened to you and continue to happen till you're left quite speechless with the wonder of it all, then you'll understand our hope to bring them nearer to the common experience of the people who read us." Anderson later admitted the sentimentality of the editorial embarrassed her, but she still believed in the essence of her statement. She wrote forty years later, "The emotions I expressed in it were basic, laudable, and identical to those I feel today; my expression of it was incredible."[1]

An in-depth examination of the first issue of the *Little Review* delineates the major themes of the first two years, incorporating an evident

spiritual proclivity that pervades the early issues of the journal alongside the subjects of literature, sexuality, and politics discussed in their pages. Central to Anderson's blueprint for her creation was the concept of the *Little Review* as a "personal magazine" where she dictated the form as well as content, a form that encompassed a magazine "based on conversation." In her debut editorial, she wrote, "Since the *Little Review*, which is neither directly nor indirectly connected in any way with any organization, society, company, cult, or movement, is the personal enterprise of the editor, it shall enjoy that untrammeled liberty which is the life of Art."[2] By declaring the journal her own project, Anderson was staking her claim. However, doing what she pleased did not enforce conformity to any particular school or approach among her contributors. In fact, what she formulated from the beginning throughout the history of the journal was the antithesis of a party line. Anderson announced her intention to use her magazine as a forum for vigorous debate. She wrote, "Our point of view shall not be restrictive; we may present several judgments of our various enthusiastic contributors on one subject in the same issue. The net effect we hope will be stimulating and what we like to call releasing."[3] Not only did different contributors debate each other on current artistic controversies, Anderson and Heap weighed in as well, along with readers who wrote letters that were then often treated to parenthetical responses by the editors, including their retorts to one another. This approach signifies what both new modernist and periodical studies point to as the "dialogics of modernism."[4] The precise method of conversation in the *Little Review* by all involved mirrored the intricate and comprehensive spirit of the entire movement of modernism. Anderson's zest and Heap's cynical wit often engaged in simultaneously boisterous and derisive jousting with nearly everyone who had a relationship with the magazine. It is one reason the *Little Review* stood out, both then and now, as one of the most robust and revolutionary little magazines of the era. Although the journal went through many permutations from its debut in 1914 until the final issue in 1929, the intramural conversation never ended.

The first article Anderson published in the debut issue was a letter of good luck she solicited from the Edwardian novelist John Galsworthy. He good-naturedly responded, "My DEAR MADAM: You ask me to bid your magazine good speed, and so far, as I have any right I do indeed. It seems you are setting out to watch the street of Life from a high balcony,

where at all events the air should be fresh and sunrise sometimes visible. I hope *you* will decide to sleep out there under the stars, for what kills most literary effort is the hothouse air of temples, clubs, and coteries that, never changed, breeds in us by turn febrility and torpor."[5] Although she published it, Anderson stated later that she was "disconcerted" by Galsworthy's response. "A temple," she ruefully reported, "was what I wanted. Not the *petite chapelle* of the aesthetes," she explained, "but a temple of the great, the permanent, versus the transient, the exquisite; the special versus the typical; not the discriminations of the connoisseur but those of the creator; not the taste nor the standards of taste, but the perception of the masters." With her typical self-referential perspective, she wrote, "Instead of avoiding all temples because of the risk of finding myself in the wrong one, I knew there was no risk involved—I was in the right one."[6]

Immediately following Galsworthy's good speed letter, Anderson launched into a laudatory review of Galsworthy's novel, *The Dark Flower*, which seemed to some readers to advocate free love and adultery. Anderson's review, entitled "The Dark Flower and the Moralists," began with an assault on the "ignorant, naive, and stupid condemnation." *The Dark Flower*, asserted Anderson, had no "moral. It simply offers you the truth about a human being and lets it go at that." Marguerite Swawite wrote a counterresponse in a later issue, arguing that the novel was merely "a procession of futile experiences."[7] Galsworthy's contemporary H. G. Wells was the subject of a more intense debate. One writer, identified only as M.M., criticized the novelist's view of morality by writing, "He's like a child who says, 'Here's a very dangerous beast in a flimsy inadequate cage. Let's abolish the cage and let the beast run around openly and do what he wants.' And the good old-fashioned word for that beast is lust, and it should be caged." Frances Trevor responded with a somewhat personal riposte printed immediately following M.M.'s comments: "It is natural enough that the old lady should dislike Wells, for he's found her out. He discloses to her scandalized eyes various unfortunate facts which she has done her best to conceal, as for instance there is such a thing as sex."[8] In the second issue, Anderson printed all the letters she received in response to the *Little Review*'s debut. "What an insouciant pagan journal you have," wrote one reader.[9] Later Anderson established the regular feature of "Reader Critic," where letters to her and Heap became the subject of

energetic, frequently humorous, and sometimes quite caustic exchanges between editors and readers, which then often evolved into a back and forth based on the letters themselves. As someone who loved a good argument, Anderson assured herself of always being in the midst of one—or many at the same time.

Nevertheless, while these dialogic debates were an earmark of modernism, the suggestion that the *Little Review* came bursting out as an unequivocal force for modernism is contradicted by several of Anderson's choices as editor.[10] While there were bold decisions and harbingers of what was to come, Anderson and her *Little Review* seem to have simultaneously floated in all three dimensions of past, present, and future. The chronology of modernism, endlessly debated by scholars, is evident in Anderson's inconsistency in selecting "modern" topics and contributors. Her editorial choices were in perfect accordance with the disputes scholars have over the moment that modernism arrived and, as such, indicate several contradictions. As Michael Levenson has pointed out in his study of English modernism from the brief period of 1908 to 1922, the definition, manifestos, and understandings of the new movement were ever-shifting, often contradictory, and not even apparent to its progenitors. As Levenson puts it, modernism was "a movement of false starts, reversals, hesitations, resolutions."[11] The fact that Levinson's study of modernism's vacillations is limited to one country over a span of fourteen years demonstrates the challenge of defining modernism's precise beginnings. The *Little Review* was somewhat evolutionary in the early years, still planted in Victorian roots of incipient rebellion and following the flourishes of an emerging Edwardian Modernism. From 1914 to 1916, the *Little Review* repeatedly referenced mid- to late Victorian dissidents such as Walter Pater and Oscar Wilde alongside their Edwardian successors Galsworthy and Wells while simultaneously engaging in the modern Imagist poetry wars of the early twentieth century.

Anderson's view of the *Little Review* as a personal enterprise extended to her philosophy of the function of criticism. It, too, was meant to be personal in approach and tone. Anderson reinforced her natural proclivity toward this stance with advice from Floyd Dell, who told her when she was writing book reviews under his editorship for the *Friday Literary Review*, "In heaven's name don't tell the story of the book! Bring to bear upon the book, in aesthetic terms, your attitude toward life." Noting how

Anderson took his guidance to heart, Dell later concluded, "She wrote well, if more enthusiastically than anybody had ever written before in the whole history of book reviewing."[12] Dell's suggestion may seem to reflect the tenets of the Chicago Renaissance but in fact had deeper roots in the writings of the Victorian dissidents, specifically Pater and Wilde, against the Arnoldian view on the purpose of criticism. Anderson was exposed to Pater's work early; her family read it out loud to one another, and she loved his writing for the musicality of his language. She referred to Pater in her debut editorial and related in *Thirty Years' War* how she and Dell spoke of Pater and living life, in Pater's famous phrase, like a "hard, gem-like flame." Anderson saw herself as Pater's Aesthetic Hero, "a person who makes his art his life."[13] In her debut editorial, Anderson wholeheartedly shared Pater's view that the role of the critic was as a conveyer of subjective perception: "Criticism that is creative is our highest goal. And criticism is never merely an interpretive function; it *is* creative: it gives birth!"[14] We know that Anderson also read Wilde's "The Critic as Artist," where his essential message was not only the primacy of criticism but also the view that art had no moral purpose—as Anderson herself argued earlier in the Dreiser *Sister Carrie* and Galsworthy *Dark Flower* debates, foreshadowing her ultimate stance in the *Ulysses* trial.

In the first two years of the *Little Review*, Anderson's mainstay contributors consisted of the 57th Street bohemians—Floyd Dell, Margery Currey, Sherwood Anderson, Arthur Davidson Fiske, Eunice Tietjens, Dewitt C. Wing, and Nicholas Vachel Lindsay. The interests of these writers varied greatly, but the influence of the Chicago Renaissance in literature was unmistakable. However, were they modernists? Some of Anderson's other early contributors recruited from Chicago did sometimes venture far beyond the verbose sentimentality of the Victorians—doing their version of linguistic time travel—nevertheless, they were still more mired in the past than the future. It was often the case of two steps forward and one step back as *Little Review* contributors struggled to define what and who was to be included in the "new." Anderson herself was one of the biggest culprits in misreading contemporary currents. In her review of the novel *Succession* by the now largely forgotten Ethel Sidgwick, she proclaimed, "Ethel Sidgwick is the next great women's novelist." Not content to leave it there, Anderson careened on in her gushing prediction that Sidgwick will "soon find herself in the company of George Eliot and

the Brontës."[15] The first issue and subsequent two years included notable midwestern writers such as Vachel Lindsay, William Vaughn Moody, Edgar Lee Masters, and Sherwood Anderson—not generally categorized as giants of modernism. However, one of the strongest acknowledgments of the emergence of change in American arts and letters was Sherwood Anderson's article, "The New Note," in the *Little Review* debut issue. Sherwood wrote, "In the craft of writing there can be no such thing as age in the souls of the young poets and novelists who demand for themselves the right to stand up and be counted among the soldiers of the new. That there are such youths is brother to the fact that there are ardent young cubists and futurists, anarchists, socialists, and feminists; it is the promise of a perpetual sweet new birth of the world; it is a strong wind come out of the virgin west."[16]

Like Galsworthy and Anderson, Sherwood Anderson also makes use of a "temple" in "The New Note," describing two examples of temples: those of Galsworthy, "priests of falling temples, piling on stone to build a new temple, that they exact tribute as before," and those of Anderson— "Among the voices of the old priests who weep are raised, also the voices of the many who cry, 'Look at us! We are the new! We are the prophets; Follow us.' "[17] The common vocabulary of religious terms such as temple and others were ubiquitous in the early years of the journal.[18] The *Little Review's* religiously suggestive titles during the first two years, based on Christian, ancient Greek, and pagan themes, included "Paderewski and the New Gods," "The New Paganism," "The Revolt of the Once Born," "The Crucified Dionysus," "A Great Pilgrim Pagan," "The Prophecy of Gwic'hian," "Heaven's Jester," and "A Mischievous Rhapsody of the First Occurrence."[19] As in the case of Pater and Wilde, as much as they may have seen themselves as proclaimers of the "new," Anderson and her contemporaries drank deeply from the well of other European (and American) nineteenth-century writers, philosophers, and poets who essentially served as their guides to the new—or not so new—applications of their thoughts. Implicit in all their philosophies, however, were spiritual assumptions that were both overt and covert, demonstrating an early hunger on behalf of Anderson, and later Heap, for transcendent explanations via art in the pages of the *Little Review*.

The major European influence on Anderson and the moderns in general was, not surprisingly, Nietzsche. As the historian Jennifer

Rosenhagen-Ratner points out in *American Nietzsche,* "Interest in Nietzsche grew so rapidly that by the 1910s observers could, without hyperbole, refer to the 'Nietzschean vogue.' "[20] Using the language of the devotee, Anderson wrote, "Since we were a revolutionary magazine, naturally Nietzsche was our prophet."[21] The first two years of the *Little Review* amply illustrated the far-reaching grasp of Nietzsche over the spirits of young Chicago intellectuals. Each issue from 1914 to 1916 contained a lengthy article devoted to Nietzsche, requested explicitly by Anderson and written by George Burman Foster, a theology professor at the University of Chicago and a former Baptist minister. Foster was a part of Dell's gatherings on 57th Street and was described by a contemporary as someone perpetually surrounded by youthful admirers. Foster's first article in the debut issue was entitled "The *Prophet* [italics mine] of a New Culture," in which he declared, "Down with the Bible; Up with the Anti-Christ."[22] Among his other articles solely concerning Nietzsche over the next two years were "Man and Superman," "The Will to Live," "The New Idol," and "The Nietzschean Love of Eternity." "Once in the horizon of his power," Foster wrote in the first issue, "and you are held there as if by magic."[23] As Rosenhagen-Ratner has observed, "For Foster, the yearning Nietzsche awakened in moderns is the redemption not found in belief in miracles, in sacred scripture; it is created ever anew in the dynamic exchange of personality with personality."[24] Since Anderson stated the *Little Review* was the "personal" enterprise of the editor and saw herself as the epitome of personality creating its own reality, Foster's interpretation of Nietzsche reinforced both her self-image and world view.

In addition to Foster's essays, Anderson published reviews of books about Nietzsche and printed aphorisms by the philosopher in several issues. Articles on various topics espousing a Nietzschean perspective, both artistic and political, appeared regularly from 1914 to 1916. As many scholars have pointed out, Nietzsche's reliance on aphorisms and his seemingly contradictory statements have led to widespread debates on his body of work—the same fate of the work of Anderson's later "prophet" Gurdjieff. The question here is what common elements of Nietzsche's work appealed to American intellectuals in this period and to what extent these themes appealed to Anderson. For many writers, journalists, and political activists, Nietzsche was attractive for his dynamic way of criticizing society's moral values, religious ideas, social arrangements, and

political structures. Melvin Drimmer, who has written about the impact of Nietzsche on American intellectuals in this period, observes, "In different ways and for different reasons, Nietzsche found a ready response among the young, the avant-garde in the arts and literature, the free thinkers and religious liberals, the left-wing socialists and syndicalists, the champions of intellectual freedom, the debunkers of middle class mores, and from all those who were in revolt against their times."[25]

Nietzsche was first and foremost a rebel against convention, obviously, in the same way the young intellectuals of the Chicago Renaissance viewed themselves. His iconoclastic attack is on Christianity, sexual norms, economic materialism, and art that was stale and uncreative—the same issues attacked by young Americans who flocked to the urban bohemia searching for like-minded people. More specifically, Nietzsche's "yea-saying" optimism and his belief in the "will to power" rang a bell for people like Anderson, who truly believed they could transform their lives through the force of their strong and superior personalities. Despite the radical politics of many of these bohemians, Nietzsche's concept of the Superman and the importance of the aristocratic personality in contrast to the common herd was a tenet that figured prominently in their embrace of his philosophy. It can be argued that certain characteristics of Nietzsche's philosophy resembled traditional patterns of American thought. Claiming that most of the Chicago intelligentsia were prepared for radical thought in the agrarian Midwest, Bernard Duffey asserts such areas were ripe for Nietzsche, among other modern thinkers. "As the far seeds of Nietzsche, Freud, and Marx fell on the Midwest during the second decade of the century," Duffey wrote, "they took ready root in the already prepared native ground of dissent and rebellion."[26]

Perhaps the most attractive aspect of the Superman for such young Americans was the emphasis on rigorous and uncompromising individualism. For Anderson, the feeling of being different—apart from the desires and needs of other humans—was supported by Nietzsche's vision of a unique race of individuals. In *Thirty Years' War*, Anderson described herself as someone "aloof from natural laws," meaning she was not restricted by realities that chained others. The conscious creation of her new "beautiful" life in Chicago and her view of the *Little Review* as an "accomplished fact" the moment she decided to establish a magazine testify to her faith in herself as someone who was the sole

master of a unique destiny.[27] The sense of "feeling different" accounts for the prominence of Anderson's references to conflict and struggle in her writing; it was, after all, a fundamental theme of the Superman's path. This tension resulting from a feeling of difference in relation to inferiors also extends to fellow aristocrats. Hence, the Superman is always alone; even fraternizations on an elevated level with other superior types are unwelcome. "The instinct of born masters" wrote Nietzsche, "is at bottom irritated and disquieted by organization."[28] Reinforcing this proclamation Anderson wrote, "I have always felt a horror, a fear, and a complete lack of attraction for any group, of any kind, for any purpose," adding she was only willing to socialize with Dell's coterie because she enjoyed the conversation so much.[29] Anderson's insistence that the *Little Review* remain a personal magazine to free herself from any organizational ties reflected this self-image. She wrote in the 1915 June–July issue, "Individuals are persons who can stand alone. There ought to be individuals coming out of a generation raised on Nietzsche. Such an upbringing has taught us at least two things—first, that he who goes forward goes alone and second, that it is weakness rather than nobility to succumb to the caterpillars."[30]

Nietzsche's comments on art struck a chord with young writers who saw themselves as serious artists and those like Anderson who were critics. In *The Birth of Tragedy*, Nietzsche wrote, "The essential thing in art remains its consummation of existence, its production of perfection; art is essentially benediction, deification of existence."[31] As in the case of Pater and Wilde, the appreciation of art by a critic was not considered by the German philosopher as a lesser station. The status of the critic is elevated further for Anderson through the lens of Nietzsche. Obviously, according to this view, only the few can determine what is art and what is not—a sentiment that Anderson unreservedly advocated. In the pages of the *Little Review* Anderson frequently lambasted nonartists and noncritics who presumed to make artistic judgments. In her 1920 editorial, "An Obvious Statement (for the Millionth Time)," Anderson proclaimed, "Only certain kinds of people are capable of art emotion (aesthetic emotion). They are the artist himself and the critic whose capacity for appreciation proves itself by an equal capacity to create."[32] Whether addressing art, personality, or the lone wolf distant from the herd, Nietzsche deeply touched a chord in a generation of artists and critics. His witty aphorisms

and published works were to cast a long shadow over their intellectual, artistic, and spiritual lives.

Second only to Nietzsche, the French philosopher Henri Bergson hovered over the first year of the *Little Review*. Described as the philosopher of artists, Bergson was essential to the moderns on several fronts; his philosophy of the continuous duration of time influenced the concept of stream of consciousness so crucial to the work of James Joyce, Virginia Woolf, and Dorothy Richardson. In addition, Bergson's attack on logic resonated for Anderson. The importance of accentuating intuition over intellect was a philosophy Anderson argued from the earliest days of the *Little Review* until her final autobiography. In her second autobiography, *The Fiery Fountains*, Anderson wrote, "I don't consider intellectuals intelligent; I don't like them or their thoughts about life. They have," she dismissively wrote, "opinions, but no point of view."[33] Central to her interest in Bergson was his concept of the "élan vital." The creative impulse, he argued, coursed through pure energy that unlocked the intuitive eye. It was, in essence, a life force that "short circuits the intellect and liberates the imagination."[34] In the first issue of the *Little Review* Llewellyn Jones describes 'élan vital' in "The Meaning of Bergsonism," as an "urge with endless potentialities and no fixed goal."[35]For Anderson that was half true. She saw the endless potential, writing in her debut editorial, "We take certain joyous pride in confessing our youth, our perfectly inexpressible enthusiasm, and our courage in the face of a serious undertaking—for those qualities mean freshness, reverence, and victory!"[36]However, Anderson had a fixed goal. Writing forty years later, she maintained, "My conviction in founding the *Little Review* was that people who make Art are more interesting than those who don't; that they have a special illumination about life; that this illumination is the subject-matter of all inspired conversation; that one might as well be dead as to live outside this radiance. I was sure that I could impose my conviction by creating a magazine dedicated to Art for Art's sake. I see, today, that I succeeded."[37]

Anderson wrote that she meant to publish works that were "vital" (a term she stated was "a much-abused adjective"), perhaps because she agreed with Jones's assertion that Bergson's ideas could be used by a multiplicity of philosophical perspectives.[38] It also demonstrated that Anderson was among the number of cultural figures who joined, in the words of Frederick Burwick and Paul Douglass, "the critical vitalism of

Bergson" with the "aesthetic and social vitalism of Nietzsche."[39] Key to Anderson's later conversion to Gurdjieff were two elements within Nietzsche's and Bergson's thought—the primacy of the superior individual and her initiation into a select group through the intuitive gleaning of knowledge.

While Anderson was well versed in the works of European theorists who she felt informed modern trends, she was also grounded in home-grown theorists of criticism and élan vital, demonstrated mainly by her repeated references to Ralph Waldo Emerson and Walt Whitman. As with Nietzsche and Bergson, aphorisms from Emerson and Whitman were scattered among the pages of the early *Little Review*. More important, the Chicago and American Renaissances had much in common—primarily an attack on materialism and conformity and the emphasis on intuition and language as vehicles for changing consciousness. Nietzsche experienced a profound connection to Emerson in many ways that also galvanized young American intellectuals. Nietzsche read Emerson in his teens, and the New England transcendentalist served as a model for the rest of his life. Despite her admiration for Emerson, Anderson displays much more confidence in her place in the universal scheme of things than does the revered transcendentalist. Her exclamation that she was "aloof from natural laws" is a sharp contrast to Emerson's more modest claim that he often found himself "aloof from all moorings."[40] Nevertheless, both Emerson and Anderson had a fascination with transient moments—moments of aesthetic reception, intense and edifying conversations, and inspired reading. Transcendentalists also believed, as Bergson argued, that the mind must be accessed through intuition. Nietzsche was attracted to the Emersonian emphasis on individualism, and his attack on institutions in addition to his religious skepticism was an attitude Anderson and the Chicago literati shared. At the bottom of the page on Anderson's debut editorial was an aphorism from Emerson's essay *Nature*, "Poetry is in Nature, just as much as carbon is."[41] The first issue also contained a laudatory review of Emerson's recently published *Journal IX* by Dewitt Wing, using the same temple analogy of Galsworthy and Anderson. Emerson, Wing contended, "composed the bricks which thousands of builders have used in fashioning beautiful temples." Emerson's "vitality" demonstrated a "spiritual universality" and was "talismanic." "Those who are trying to achieve a personal religion which acknowledges God as an immanence instead of

a proposition," wrote Wing, "hail with a quiet joy every extraction from the great mine in which Emerson stored the jewels of his life."[42]

Walt Whitman was one of the most quoted writers in the aphorisms that intermittently dotted the pages of the magazine in the early years and he influenced Anderson on a level that transcended Nietzsche and Emerson. One of the narratives of the early years of the *Little Review* was the story of the evolving American character and how it was reflected in the arts. In addition to Vachel Lindsay, Sherwood Anderson, Carl Sandburg, and Edgar Lee Masters, both Emerson and Whitman were placed in a higher realm by Anderson as quintessentially American and simultaneously responsible for America's growing reputation abroad.[43] Whitman's strong ego, even narcissism, was suited to Anderson's self-perception. Her choice of self-laudatory Whitman aphorisms to put in the *Little Review* ("I am that which unseen comes and sings, sings, sings . . .") underscored her healthy sense of self-worth.[44]

Whitman was not simply an inspired poet or democratic chanter; he was a figure in whom sexuality and spirituality were intertwined. In *Worshipping Walt*, Michael Robertson makes a case that this was the firm belief of most of the disciples of Whitman. Researching the works of John Addington Symonds, Edward Carpenter, and R. M. Bucke, Robertson states that Bucke (Whitman's biographer) "devoted more than twenty years of his life to the service of what he often referred to simply as 'the Cause'—that is, promoting Walt Whitman as the greatest religious figure in history." [45] John Addington Symonds was one of the many well-known Oxford students who benefitted from the famed tutor Benjamin Jowett's attempt at reform by establishing Hellenistic studies that, though perhaps inadvertently, resulted in his students' less repressive perspective on homosexuality. This reform movement had the unintended consequence of allowing Oxford gay men to see their sexuality as the descendant of a noble and pure tradition exemplified by the conservatism of Pater and connect them to a later more direct expression of sexuality exemplified by Wilde.[46] For figures such as Symonds, *Leaves of Grass* was a crucial link in this "purer" and "more innocent" expression of male love. For Symonds, Whitman "weaved homoeroticism into the divine fabric of a God-permeated universe, implicitly sanctioning the sexual desires that so tormented him." Robertson describes how Symonds constructed his "Cosmic Enthusiasm," as a "combination of immanence theology, Whitmanism, and Hellenism."

"Cosmic Enthusiasm" had in Symonds' view a need to tackle the earthly pedestrian subject of a political campaign—specifically, he wanted to change the 1885 British law that criminalized sodomy or "gross indecency." To educate the public, Symonds collaborated with Havelock Ellis on the book *Sexual Inversion* to enlighten public opinion and lead to a political transformation regarding homosexuality. As Symonds argued there was a connection between sexuality and democracy and that Whitman's work was the "recognition of the divinity of things" that "is the secret of the democratic spirit."[47]

Edward Carpenter was an example of an even more extreme political, sexual, and spiritual radical than Whitman. An anarchist, socialist, women's rights advocate, and environmentalist, Carpenter was most notably someone who went beyond his predecessors and contemporaries in searching for links between sexuality and spirituality. A student of Hinduism, Carpenter had a self-described mystical experience in 1881. He felt indebted to Whitman as an artist and gay man and later became the father of the cult of the simple life. Though he was involved in a plethora of political movements, Carpenter saw his politics, including anarchism and socialism, like Emerson and Whitman, as more of a religious experience than immersion in earthly social reform.[48] Anderson was an admirer of Carpenter and referenced him in her famous editorial on Edith Ellis's Chicago talk on sexuality. Edith Ellis in turn was married to the famed sexologist Havelock Ellis, author of *Sexual Inversion*, a book considered by some to be a path-breaking sympathetic treatment of homosexuality, and a disciple of Carpenter's.[49] Ellis had a mystical experience as a young man while rereading James Hinton's *A Life in Nature* that inspired him to be a physician. As a result, Ellis joined the Fellowship of New Life, described by Antony Copley as "one of those utopian groups in the 1880s sustained by a quasi-religious belief in the enhancement of the interpersonal."[50] Edith Ellis met Havelock Ellis at a Fellowship meeting; Edith was a lesbian herself and a part of Havelock's research. Indeed, one of Ellis's biographers argues that the sexologist's studies of lesbianism "were perhaps as much personal therapy as scientific investigation" because of his "tangled marriage."[51] Edward Carpenter was also a member of the Fellowship as well as Margaret Hinton, wife of the physician James Hinton who so influenced Ellis. The Hintons' son, Charles Hinton, was the author of many books and articles on the Fourth Dimension, including

The Fourth Dimension, What is the Fourth Dimension, and *An Episode of Flatland Or How a Plane Folk Discovered the Third Dimension.* The Fourth Dimension, explored in the fiction of H. G. Wells, was a staple of the thought of both P. D. Ouspensky and George Gurdjieff.

The various strands of tolerance for homosexuality, spiritual progress, and practical activism came together when Edith Ellis was on her second speaking tour of America to promote her husband's research.[52] Her lecture, "The Love of Tomorrow," was attended with great anticipation by Anderson, who was sorely disappointed as it turned out. In the March 1915 issue of the *Little Review* Anderson expressed her displeasure with the address. The talk, which Anderson believed would discuss "love, spirituality, sex abnormalities, and many other matters," fell far short of her expectations. Because Edith Ellis emphasized spirituality as the nexus of love and sex, Anderson had reason to think she might give a more exciting speech than she delivered. In keeping with her ideal that the *Little Review* serve as a forum for stimulating conversation, Anderson printed two reviews of the talk, a positive response by Mary Adams Stearns and Anderson's own less favorable notice. In "Mrs. Ellis's Gift to Chicago," Stearns wrote that the personality of the speaker "gleamed through every word she spoke and blazed into a pure white flame that seemed by its very intensity to create a new heaven and earth where love shall rise Phoenix-like from the ashes of souls and bodies consumed by a misunderstood and misused passion."[53]

For once, Anderson was the more restrained party. In "Mrs. Ellis's Failure," Anderson complained that the speech was one "which was beautifully and charmingly delivered and which said nothing at all. She said in brief that there should be no war between body and soul and that Oscar Wilde should have been understood rather than sent to jail. These things are not ideas; they are common sense." Showing a thorough knowledge of recent theories of sexuality, Anderson complained that in Ellis's "reference to intermediate types, she didn't mention homosexuality; she had nothing to say about the difference between perversion and inversion, nor did she even hint at Carpenter's social efforts in behalf of the homosexualist. What does Mrs. Ellis think about Weininger's statement that the intermediate sexual forms are normal—not pathological phenomena—in all classes of organisms, and their appearance is no proof of physical decadence? It is not enough to report that Shakespeare

and Michelangelo and Alexander the Great and Rosa Bonheur and Sappho were intermediates: How is the science of the future to meet these issues?"[54] In her closing paragraph Anderson returned to her passionate self, decrying the cruelty of society's misunderstanding of the invert. "With us," she wrote, "love is just as punishable as murder or robbery. Mrs. Ellis knows the workings of our courts; she knows of boys and girls, men and women, tortured or crucified every day *for their love*— because it is not expressed according to conventional morality."[55] Jonathan Katz argues that Anderson's editorial was "the earliest militant defense of homosexuality known to have been published by a lesbian in the United States."[56]

As dominant as spiritual concerns, prominent dissident philosophers, and the topic of sexual freedom were in the very first year of the *Little Review*, the issue of feminism was perhaps most dear to Anderson's heart. In her debut editorial she wrote, "Feminism? A clear-thinking magazine can have only one attitude; the degree of ours is ardent!"[57] If parts of her debut editorial embarrassed her years later, her commitment to feminism only became more robust. "Feminism," appearing in dictionaries in the 1910s, was a recent addition to the lexicon; however, Anderson and women like her seized on it with a zeal her editorial made clear. Unlike the feminism of Jane Addams, Crystal Eastman, or Alice Paul, the feminism of Anderson and her contemporaries belonged to a category that eschewed interest in legal or economic rights in favor of a more expansive focus on relief from archaic mentalities and the burden of the past. Anderson's advocacy of feminism as she expressed it in the pages of the *Little Review* clearly places her in this category. For Anderson, feminism was, as Nancy Cott describes, "the joyfully self-important motive to flout convention" in addition to "other contemporaneous forms of cultural blasphemy."[58] The published references to feminism in the *Little Review* were eclectic and rarely political. From 1914 to 1916, only two articles addressed suffrage. The vote did not engage Anderson's interest, though she did comment once in the *Little Review* on the silliness of "someone who still believes in the antique theory that a woman must choose between her charm and the ballot."[59] Though there were a few articles on political issues important to women such as prostitution and the education of girls, most of the articles with a feminist perspective dealt with literature, sexuality, and the idea of feminism as a "new religion."

In the first issue of the *Little Review,* Anderson printed two articles about Rachel Varnhagen, who conducted an early nineteenth-century salon in Berlin attended by Heinrich Heine and Georg Wilhelm Friedrich Hegel, among others. Varnhagen made public statements equating marriage with slavery, among other scandalous pronouncements. In Margery Currey's review of Ellen Key's biography of Varnhagen, Currey (who was at the time recently divorced from Floyd Dell) wrote, "The woman who has been filled with joyful amazement on finding that her only reliance is on herself—that she may depend not on this person or that convention to preserve her happiness—will know how to value her."[60] The second article, written by Cornelia Anderson (married to Sherwood), described Varnhagen as "a true Feminist" who advocated "liberation through self-development."[61]

Also in the first issue was a review by Dell of Olive Schreiner's book *Woman and Labor,* which he praised as a "wise and beautiful book." "She does not," wrote Dell, "refer to the makeshift masquerade under the term 'social usefulness.' She means work done with the hands and the brain, work done for money, work that sets the individual free from dependence on any other individual."[62] The "Critic's Critic" column by M. H. Partridge, a professor at Cornell, debuted in the March issue with a piece on "The Feminist Discussion," where she lambasted an anti-feminist article in the *Atlantic,* asking, "Who has given men the power and the right to decide about woman's errand in this world? For lo! these many years we have been letting husbands, fathers, and brothers decide for us just what it was best for us to do, and if the new idea has any significance at all it is just this: That we feel able to decide for ourselves what we most want and need."[63] The second issue of the *Little Review* contained a review of C. Gasquoine Hartley's book *The Truth About Women,* written by none other than Clara Laughlin, the woman responsible for Anderson moving to Chicago. Laughlin's article, which demonstrated knowledge of the writings of Mary Wollstonecraft, Olive Schreiner, and Charlotte Perkins Gilman, was lukewarm toward *The Truth About Women* because she considered the author too tepid a feminist.[64]

Anderson herself expressed her views on feminist literature, women's fashion, and the modern family in several early articles. Her most enthusiastic article was a review of the novel *Angel Island* by the New York feminist Inez Haynes Gilmore. An early feminist fantasy tale, *Angel Island*

tells the story of five shipwrecked men who realize that the large birds circling the island are actually women with wings (with whimsical names such as "Peachy" and "Chiquita"). The men capture the women, marry them, and clip their wings because "a woman's place is in the home not the air."[65] The birdwomen have children, daughters with wings and sons without. To leave their husbands they secretly practice a combination of walking and pseudo-flying until escaping. The leader of the birdwomen, however, genuinely falls in love with one of the men and bears a son with wings. Anderson, a naturally effervescent reviewer, could hardly contain her joy at the novel's message, which she proclaimed "original, profound, flaming. It leaves you with a gasping sense of having been swept through the skies, and also with a feeling of new life which comes with a plunge into cold deep seas."[66]

Anderson gave a more direct and detailed account of her views of American women, sexuality, and freedom in an animated piece entitled "Incense and Splendor." Here she discussed the current theory that modern women had become "oversexed," arguing that in fact "the American woman is pathetically undersexed. The critics who keep lecturing us on our oversexedness don't realize that what they're really trying to get at is our poverty of spirit, our emotional incapacities, our vanities, our pettiness— any number of qualities which spring from anything but too much sex." She continued: "One thing is for certain; until we become conscious that there is something very wrong with our attitude toward sex, we'll never get rid of the hard, tight, anemic, metallic woman who flourishes in America as nowhere else in the world." Responding to the claim that "oversexedness" was manifested in the more revealing fashions of the early twentieth century Anderson wrote, "There has never been a time when women had such an opportunity to be beautiful physically. With the exception of the foolish and unnecessary restrictions in walking, women have such a splendid chance to look straight, unhampered, direct, lithe."[67]

The following month, Anderson revealed her position on some of the more controversial questions of the feminist movement in her era— birth control, motherhood, and family. Her article, "The Renaissance of Parenthood" (the title taken from Ellen Key's book *The Renaissance of Motherhood*, published that same year), discussed the transitions occurring within the twentieth-century family, including the decline of parental authority and a public debate on the rights of children. The "distress" of

the current American home, she wrote, might be "heralding a wonderful new conception of family potentiality."[68] In this article, Anderson referred to an ongoing debate between Ellen Key and Charlotte Perkins Gilman concerning the solutions to the family's future. Gilman's argument that women should become economically independent while professionalizing domestic duties clashed with Key's belief that change within the family, with a different perspective on women's sexuality and motherhood, was essential to female liberation. Like Havelock Ellis (to whom she dedicated *The Renaissance of Motherhood*), Key was a contradictory thinker in many respects, incorporating radical sexual views with conservative implications. Key was above all an advocate of female sexual freedom, but she also believed that motherhood was the supreme fulfillment for women. They were not, as they may appear on the surface, contradictory goals; Key wrote that one of the ultimate responsibilities of motherhood was to counsel daughters on "their scientific sexual enlightenment."[69] As Nancy Cott points out, Key's linking of maternity and sexual desire made the latter "itself sacred and self-validating." Yet Key's insistence that women had a "sex-specific" destiny rather than a "human" one made many feminists uneasy. Anderson's article sided with Key. "Her insistence is strongly upon the education of the feelings as the most important factor in soul-life. In her vision of the renaissance of motherhood, she begins with Nietzsche's dictum that 'a time will come when men think of nothing except education.' "[70]

Key, like Anderson, did indeed quote Nietzsche—though the philosopher and feminists seem strange bedfellows. How did Anderson, Key, and other women reconcile the obvious tension between Nietzsche and feminism? We do not have any direct statement from Anderson, but perhaps her contemporaries can shed some light. In her biography of the anthropologist Ruth Benedict, Margaret Caffrey asserts that the misogynist statements of Nietzsche were simply ignored because Benedict saw herself as "different from the mass of women and his words did not apply to her."[71] It is easy to see Anderson, forever proclaiming she was different from others, assuming this attitude. Margaret Sanger, Ida Rauh, Mabel Dodge, Margery Currey, Elsie Clews Parsons, and Isadora Duncan were among other women who found a valuable message in Nietzsche. No doubt rationalizing much of his message, radical feminists of the day could envision themselves as an independent, strong, and forceful Superwoman. One obvious

attraction for these modern women was Nietzsche's critique of sexual and moral values. Criticizing loveless marriages, chastity, and silence about sex, Nietzsche resonated with the emerging "New Woman." Margaret Sanger, in particular, found a role for the Superwoman in "the aspirational idea for achieving a woman's right to bodily self-sovereignty." The slogan she used for her journal *Woman Rebel* was "No Gods, No Masters."[72]

Agreement on the value of Nietzsche aside, it might seem puzzling that Anderson would prefer Key's argument to Gilman's given the fact that Anderson was a lesbian who had no interest in having children as well as a career woman in many ways adhering to Gilman's view that women be economically independent. The answer may be that when considering the oppressiveness of the traditional family, Anderson still identified with the role of the subjugated daughter rather than that of the parent. As a free spirit who chafed under her mother's prim conventionality, Anderson missed few opportunities to blast the restrictions placed on children. Key's idea, wrote Anderson in her article, "means the elimination of all kinds of domestic follies—for one, the ghastly embarrassment of growing up to discover that you're different from the rest of your family, and for that reason something of a criminal."[73] For someone like Anderson, Key's statement that "the family has often been a torture chamber for individuality" could strike a deep chord.[74] As with Ellis and Carpenter, there was a spiritual dimension to sexuality in Key's scheme of human nature, including homosexuality. In her 1912 book *The Woman Movement*, she wrote she had never met the "Sapphic" women who were the frequent topic of conversation, but she had "often observed that the spiritually refined men of Hellas find most easily in their own sex the qualities which set their spiritual life in the finest vibration of admiration, inspiration, sympathy and adoration."[75] Given Anderson's rhapsodic feelings for Whitman and her review of Edith Ellis's talk, she no doubt applauded Key's linking of homosexuality with spirituality.

In *The Renaissance of Motherhood*, Key extrapolates beyond her philosophy of feminism to attack organized religion. She was dismissive, if not scathing at times, towards Christianity, using the scandalous George Eliot as a model of a true Christian. Key wrote of Eliot, "She demonstrated Nietzsche's satirical words as to the lack of consistency of the Englishman who when discarding Christian faith holds closer than ever to Christian morals." The "love of humanity," Key continued, "has been practiced

with more consistency by many so called heathens than by most confessors of the Christian faith."[76] Pointing out that only two women, Mary Baker Eddy and Madame Blavatsky, had founded their own religions—neither one of which she endorsed—she called for a "new religion," one that would not be a 'refined Christianity' but would rather remain ambiguous in nature. The key was that women subscribe to "individualism" since, Key argued, they can only be "converted" to "a new religious belief, namely that every human being 'lives his own life' in the greatest and most beautiful sense when his will is in harmony with that mighty will to create of the whole evolution-of culture as well as of nature-bears witness."[77] Vague and distinctly unhelpful as these pronouncements are in ascertaining any truly insightful attributes of this "new religion," two particular elements could almost have been crafted by Anderson herself: the romantic sensibility and the lack of rigorous definitions or sophisticated theology meshed with generalizations. Key and Anderson wanted freedom for women to express their individuality, and these freedoms included sexual and spiritual exploration, no matter where those paths took them.

A strong proponent of Key was Margaret Sanger, and some of Anderson's most passionate editorials were written in defense of Sanger and contraception. Calling birth control "one of the milestones by which civilization will measure its progress," Anderson wrote that she "prayed" Sanger would not return from England for trial in the United States. "Why," she asked, "should she go to jail for ten years because we haven't suppressed Anthony Comstock?" Noting that Sanger's legal problems arose when her husband gave a copy of the pamphlet to a detective, Anderson stated she had read the pamphlet and gave it to everyone she knew "well enough to be sure they are not Comstock detectives." "Margaret Sanger," she argued, "couldn't be obscene—she's a gentle, serious, well-informed woman writing in a way that any high-minded physician might." Significantly, Anderson managed to avoid the trap of the eugenics movement popular among many defenders of birth control. She wrote, "The science of eugenics has always seemed to me fundamentally a sentimentalization, because there is no such thing, really, as the scientific restriction of love and passion. These things don't belong to the realm of science any more than one's reactions to a sunrise do. But the restriction of the birth-rate does belong there, and science should make this one of its big battles."[78] Anderson ended her article with a plea for funds to help William Sanger

with his legal fees to be sent in care of the *Little Review*. When Margaret Sanger returned to face trial, Anderson and other Chicago notables wrote an open letter to President Wilson asking him "to use his powerful office to help Mrs. Sanger in the interest of free speech and the betterment of the race."[79]

The first two years of the *Little Review* were a veritable smorgasbord of topics and influences; Anderson was finding her way in terms of both content and quality for the magazine. Years later, she would admit that as an editor she "knew nothing of the art of writing in those early years."[80] Yet she established two constants from 1914 to 1916 that would flourish as the *Little Review* matured: basing the magazine on raucous conversation and investigating spiritual themes among its contributors. Nevertheless, during these same years two movements, Imagism and anarchism, came to the fore and helped to crystallize, if not solidify, her entry into the more radical wings of art and poetry and also increased her confidence in real obstacles that were about to appear in her path. When she later became disenchanted with these movements (especially anarchism), Anderson demonstrated that her seemingly uncompromising passions could in fact waver. As she would discover by the end of 1916, the adventure of the *Little Review* was a journey, not a destination.

3

POLITICAL AND LITERARY RADICALS

While Anderson was navigating her way through the explosive minefield of emerging modernism from 1914 to 1916, two major themes—one literary and one political—emerged to dominate the discussion. Anarchism and imagism, which overtook the early years of the *Little Review*, were movements that may appear to represent contrary impulses. However, in this phase of her life and career, Anderson believed politics and art could co-exist. She would later conclude that her hopes were misplaced, but anarchism and imagism in the pages of the *Little Review* made for some of the journal's most impassioned writing.

In the *Little Review*, anarchism and imagism were reflected by Anderson's friendship with the high priestesses of the two respective movements, Emma Goldman and Amy Lowell. At first glance, the Boston Brahmin poet and the immigrant revolutionary seem to be polar opposites, and Anderson's involvement with both raises certain questions. Differences aside, however, aspects of Goldman's and Lowell's philosophies dovetailed. Both Goldman and Lowell shared (in spirit if not always in

practice) Anderson's interest in Nietzschean philosophy, feminist politics, and lesbian sexuality. Goldman was a fierce admirer of Nietzsche, a dedicated feminist and promoter of birth control, and someone (like Anderson) who saw suffrage as irrelevant to the liberation of women. We do not know Lowell's view of Nietzsche, but as a poet she embodied his concept of the artist who demonstrated superiority over others, and Anderson clearly saw her as one of the best poets of the day. An independent, wealthy, cigar-smoking woman whose poems were often about the beauty of women, Lowell was anything but cowed by gender restrictions of the late nineteenth and early twentieth centuries. Lowell was a lesbian, and Goldman was one of the earliest defenders of homosexuals.

Each woman, however, had her own cause and promoted it with Anderson's energetic help in the *Little Review*. Goldman, who edited her own journal, *Mother Earth*, was delighted by the calls for revolution, labor uprisings, and pacifism that appeared repeatedly in Anderson's magazine. For Lowell the cause was imagism, which she planned to capture under Ezra Pound's leadership; the *Little Review* figured prominently in her strategy, and Anderson was happy to comply. Goldman and Lowell each touched something deep within Anderson. She responded to both of them with her characteristic enthusiasm, but at the same time retained firm control of the *Little Review* when their ardor jeopardized her magazine.

In May of 1914, while she was preparing the third issue of the *Little Review*, Anderson attended two of Goldman's lectures, one on drama given to a group of wealthy Chicago women, another addressed to a gathering of anarchists and syndicalists. She was so awestruck by the famous radical, she wrote, that she "had just time to turn anarchist before the presses closed."[1] In the May issue Anderson published her editorial, "The Challenge of Emma Goldman," lauding the anarchist as a "practical Nietzschean" and stating, "Zarathustra kept running through my mind."[2] Anderson quoted extensively from Goldman's essays "The Failure of Christianity" and "The Victims of Morality," demonstrating that she had quickly submerged herself in the thought of America's foremost anarchist. Goldman was "fighting for the repudiation of such 'spooks' as Christianity, conventional morality, immortality, and other 'myths' that stand as obstacles to progress, freedom, health, truth, and beauty. One thus achieves that position beyond good and evil for which Nietzsche had

pleaded."[3] It is interesting to note that Anderson was willing to disagree with Goldman on the topic of religion. Referring to her philosophy as her "gospel," Anderson argued that Goldman's assertion that "she had no use for religion" was similar to saying "that one has no use for poetry; religion is not a mere matter of Christianity, or Catholicism, or Buddhism, or any other classifiable quantity. Also, if it is true that the person to be distrusted is the one who has found the answer to the riddle, then Emma Goldman is to be discounted." Nevertheless, she concluded that Goldman is a "prophet who dares to preach that our failures are not in the wrong application of values but in the values themselves."[4]

One major source of the interest in anarchism among the American intelligentsia was Russia, and as a result the *Little Review* devoted considerable space to all things Russian. References to Dostoevsky and Tolstoy were numerous in addition to articles on other Russian writers, some famous and others less known to an American audience, including Anton Chekhov, Nikolai Gogol, Maxim Gorky, Leonid Andreyev, Mikhail Lermontov, Vladimir Korolenko, Aleksandr Kuprin, Maximilian Voloshin, and Boris Artzybasheff. In addition, there were articles about the Russian ballerina Anna Pavlova and her dance troupe's tour of the United States, with a discussion of Russian innovations in ballet due to the contributions of Sergei Diaghilev and Nikolai Rimsky-Korsakov.[5]

Many *Little Review* articles dealt with the political earthquakes that had shaken Russia since the late nineteenth century. It was an era when a burgeoning fascination with various strains of occultism seemed to explode. In her study of this period, Maria Carlson writes that "all sorts of mysticism were popular" and notes that spiritualism led the way in sheer numbers of followers while Theosophy attracted a smaller cadre of intellectuals.[6] Carlson argues that scholars have "erroneously disdained them [Theosophists and spiritualists] as trivial," yet they were a key factor in the cultural and intellectual course of the era.[7] According to Carlson, "Occultism . . . has not received its due as a contributing factor to the aesthetic and philosophical consciousness of the times."[8] Between 1881 and 1918, thirty-five registered groups, hundreds of nonregistered circles, and more than thirty publications were dedicated to various aspects of the occult. As revolutionary political movements mushroomed and were compounded by the looming Great War, the artist and intellectual looked to a spirituality that was aesthetically appealing, thus attempting to combine

culture and religion into one fold. One notable Russian Theosophist was Wassily Kandinsky, whose *Concerning the Spiritual in Art* was quoted in aphoristic forms in the *Little Review*. Among those profoundly affected was the mathematician P. D. Ouspensky, whose 1919 book, *Tertium Organum*, introduced Anderson and Heap to esoteric thought, leading them to George Gurdjieff.

One of Anderson's most frequent contributors in the first two years of the *Little Review* was Alexander Kaun, a Russian émigré who in 1914 was an instructor at the Chicago Hebrew Institute; he later became a professor of Slavic languages at the University of California-Berkeley. Kaun wrote impassioned articles about his native land describing the profound political and social changes occurring during the early years of the twentieth century. In his review, "Two Biographies: Verlaine and Tolstoy," Kaun quotes Tolstoy on the leaders of the 1905 Revolution. "Our consciousness of the law of God demands from us only one thing—moral self-perfection; i.e., the liberation of oneself from all those weaknesses and vices which make one the slave of governments and participants in their crimes."[9] Yet Kaun is mocking Tolstoy—he believed Tolstoy was a hypocrite, much in the same fashion Lenin did. The Bolshevik leader wrote of the Christian anarchist, "On one hand we have the great artist, the genius who has not only drawn incomparable pictures of Russian life but has made first-class contributions to world literature. On the other hand, we have the landlord obsessed with Christ. On the one hand the remarkably powerful, forthright and sincere protest against social falsehood and hypocrisy; on the other the 'Tolstoyan,' i.e., the jaded, hysterical sniveler called the Russian intellectual, who publicly beats his breast and wails: 'I am a bad wicked man, but I am practicing moral self-perfection.'"[10]

Although Tolstoy never actually used the phrase "Christian anarchism," in the *Kingdom of God* he used the word "anarchism" as synonymous with "freedom" and "God." Goldman, who had a picture of Tolstoy hanging in her home, seemed more forgiving. She argued, "Tolstoy was the last true Christian, and as such he undermined the stronghold of the Church with all its pernicious power of darkness, with all its injustice and cruelty.[11] Anderson addressed the Tolstoyan paradox in her second article on Goldman, "The Immutable." She wrote of one of Goldman's Chicago lectures, "She mixed her sources from the positivist Comte to the Christian Tolstoy."[12]

Nevertheless, Anderson's personal friendship with Goldman developed and established the genuine feeling of a comradeship. Goldman read Anderson's first glowing review of her speech and wrote to thank her for her supportive remarks. When Anderson discovered that Goldman would be returning to Chicago soon, she invited the anarchist to stay in her apartment overlooking Lake Michigan. Goldman responded with gratitude but declined due to the fact that she could not tolerate "bourgeois lifestyles" even for a few days, and instead invited Anderson to visit her at the Lexington Hotel. Goldman was genuinely impressed by the *Little Review*. As she later wrote in her autobiography, "I felt like a desert wanderer who unexpectedly discovers a stream of fresh water. At last, a magazine to sound a note of rebellion in creative endeavor!"[13] The anarchist was looking forward to meeting the editor of the *Little Review*, but when they met in the hallway Goldman was taken aback by Anderson's "chic society girl appearance."[14] Rather than greeting her visitor, the anarchist turned around and began to walk away. Anderson later wrote that she was "amazed and hurt" by the reception but pursued Goldman down the hallway. Goldman, in a self-admitted "cold tone," invited Anderson into her room and was greeted by a breathless invitation to visit Anderson's apartment to rest and relax. "I was so overwhelmed," Goldman wrote later, "by the wordy avalanche and I felt remorseful at the frigid reception I had given the generous girl."[15]

Goldman went to the apartment and felt so at home in the empty space that she called anarchist comrades who were traveling with her and told them to join her. They included Ben Reitman, whom Anderson characterized as "not so bad if you could hastily drop all our ideas as to how human beings should look and act," and eye-patch wearing Big Bill Haywood of the Wobblies.[16] At the apartment the group talked, listened to Anderson play the piano, and took long walks along the lakeshore. As they became more relaxed both women felt surprised by one another's character. Anderson recorded that Goldman was "more human than she appeared on the platform . . . in private she was gay, communicative, tender."[17] The small group sang Russian folk songs and quoted Walt Whitman—prompting Big Bill to weep, Anderson noted, out of his one eye. After a few hours, Goldman later admitted, Anderson had "entirely changed [Goldman's] first impression and made [her] realize that under her apparent lightness was depth and strength of character to pursue whatever aim in life she might choose."[18]

Anderson turned the *Little Review* office over to Goldman. "The girls were as poor as church mice, never sure of their next meal much less able to pay the printer or the landlord. Yet there were always fresh flowers on my desk to cheer me," wrote the anarchist. "Something new and precious had grown up between us."[19]

The next two years witnessed what may have seemed to readers like a never-ending flow of laudatory articles about anarchism in the pages of the *Little Review*. Anderson's article after meeting Goldman, appearing in the November 1914 issue, was just as flattering—if not more so—than her first summation of the anarchist's greatness. She wrote, "A great sense of her humanity sweeps upon you, and the nobility of the idealist who wrenches her integrity from the grimmest depths . . . A mountain top figure, calm, vast, dynamic, awful in loneliness, exalted in its tragedy— this is Emma Goldman."[20] Anderson's newfound political radicalism expressed itself in concern about a variety of issues; the most pressing was the outbreak of war in Europe in the fall of 1914. Anderson's lead article of the September 1914 issue was given the biblical title "Armageddon." "The greatest war of history," she wrote, "flames away all other concerns." In her view, the "terrific human waste" of the war was clear. It consisted of "twenty-odd million men flying at each other's throats and destroying the bitterly won triumphs of peace, without any good reason." These sentiments culminated in 1915 with a plea for action: "For God's sake, why doesn't someone start the Revolution?"[21] As a result of this editorial, detectives appeared at the *Little Review* office. Anderson was not there, but a new admirer—"an influential person" visiting from New York—convinced the agents that she was "a flighty society girl who meant nothing she said."[22] Anderson made sure Goldman remained a constant presence in the *Little Review* into the next year. She published Louise Bryant's article describing Goldman's arrest and trial in Portland, Oregon, on charges of distributing birth control information. Goldman's essay on the war, "Preparedness: The Universal Slaughter," appeared in the December 1915 issue.

That December issue of the magazine captured the attention of legal authorities and marked the high tide of Anderson's most radical pronouncements under the influence of anarchism. In "Toward Revolution," she addressed the funeral of Joe Hill, asking, "Why didn't someone shoot the governor of Utah before he could shoot Joe Hill?" She followed this

with, "There are Schmidt and Caplan. Why doesn't someone see to it they are released? Labor *could* do it. And there are the Chicago garment strikers. Why doesn't someone arrange for the beating up of the police squad? That would make a good beginning; or set fire to some of the factories or start a convincing sabotage in the shops?"[23] In "The Labor Farce," an article that addressed the arrests of five individuals for the bombing at San Francisco's 1916 Preparedness Parade, she berated the internal divisions within the left wing over strategy to help the defendants.[24] In a complaint familiar to anyone well versed in the internal strife of left-wing politics, she traced the efforts of Goldman, Alexander Berkman, and a "few other anarchists" to raise money for lawyers, followed by "three weeks of argument and hesitation" among their comrades over how to proceed.[25] Still, Anderson was more generous than Goldman, who in her autobiography decried "radicals and liberals" who "at the first sign of danger ran to cover like a pack of sheep at the approach at the storm."[26] Anderson described watching "Emma Goldman and Berkman brooding over this strange and awful spectacle, two prophets whose souls are slowly petrifying under the antics of their disciples." Always coming back to the "artist," the figure who would precipitate her ideological break with Goldman, she wrote, "The propagandist can't think. But for that matter only one kind of mind really does *think* and that is the artist kind."[27]

Under the influence of Goldman, Anderson began to explore the writings of other American anarchists. She published a review by Lilian Heller Udell of *The Selected Works of Voltairine de Cleyre*, a little-known Philadelphia anarchist who died in 1912. In the article, Udell described de Cleyre as an "Amazon of the spirit" who formulated "the most comprehensive exposition of philosophical anarchism that has appeared since the days of Proudhon and Stirner."[28] Anderson's own language in addressing anarchism in general and Goldman specifically was clearly religious in nature; she repeatedly referred to Goldman as a "prophet" who was at times "crucified."[29] She wrote that Goldman's "mere presence is a benediction," and portrayed herself as Goldman's most devoted disciple.[30] Anderson's choice of words portrays the Jewish atheist as a Christ-like figure; even though Anderson intellectually abhorred Christianity, it was her most common expression of spiritual thought.

As a result of her admiration for Goldman, Anderson found herself facing serious financial setbacks. Her very first article on anarchism in the May issue of 1914 lost her the backing of her original source of funds, De Witt Wing, who feared his association with Anderson would cost him his job at the *Breeder's Gazette.* By the end of 1914 the death of her father, the expense of the lakeside apartment, and the falling subscriptions—which Anderson claimed, most likely correctly, were a direct result of her interest in anarchism—brought financial and personal problems together in a pressing fashion. To solve them, she decided that moving was a priority, so she hustled Harriet Dean (her lover), her sister Lois, and Lois's two young sons, Tom and Fritz, off to a house in Lake Bluff. The house was unheated (Alexander Berkman cut his visit short, claiming the house was "too Siberian"), and the three women and two children soon moved to another house nearby.[31] They remained at this location from the winter of 1914 to the spring of 1915, when the fallout from Anderson's anarchist reputation made it difficult for her to pay the rent for either the house or the *Little Review* studio. Her solution was to move everyone to a secluded strip of beach near Braeside and to camp there during the summer of 1915.

The people Anderson referred to as her family by now included Clara Crane, an African American woman, and her small son; Crane worked as a cook and nursemaid for the children. This may seem a curious addition for people who were so poor they could not afford shelter. But Crane (who was recommended by Goldman) may have been equally down on her luck and entered into a compact of mutual help with the down and out collective. On the beach the entire menagerie set up tents, each equipped with a cot, deck chair, and Oriental rug. In spite of her economic and political problems, Anderson later wrote that the six months on the beach were "the most lyrical of my life."[32] Despite the rustic circumstances, her contemporaries were surprised at how well-coiffed the new revolutionary was. In his memoirs, Harry Hansen wrote, "She was always exquisite as if emerging from a scented boudoir, not a mildewed tent."[33]

Among the visitors to the campsite were *Little Review* contributors and supporters, including Ben Hecht and Maxwell Bodenheim, who walked out from the city to pin poems on her tent; Sherwood Anderson, who told stories; and the radical playwright Lawrence Langner, who visited, according to Anderson, "to extol group action and socialism."[34] Langner

left the most vivid portrait of the beach site. Invited to spend the weekend, he found the surroundings somewhat less than utopian:

> Cooking utensils, furniture, newspapers, and books littered the beach, while sitting on a kitchen chair outside a tent sat the dignified, matronly Emma Goldman, wearing a heavy black gown and looking like a tragedy queen dispossessed from her rightful throne. "I don't know what I'm doing out here" she remarked to me, savagely killing a mosquito which had settled on the back of her neck. "I have a nice, cool, comfortable hotel room in Chicago, and I let Margaret drag me away for the weekend." "But don't you feel free here?" said Margaret, looking like Adriane in a baby blue bathing suit. "Why don't you take off some of your clothes?" "The flies and mosquitoes are eating me alive," grumbled Emma. "I need more clothes, not less." [35]

The camp and its illustrious visitors soon caught the attention of the local press, much to Anderson's annoyance. Articles described the settlement as "a Hellenistic revival, a freak art group, a Nietzschean stronghold." [36] The *Little Review* beachhead did have its problems. Lois decided the bohemian life was not for her and left. And in spite of the newly tried economies, the magazine still struggled to survive financially. In the June–July 1915 issue, Anderson, frustrated at not being able to convince more local businesses to advertise, tried putting the name of a potential advertiser's company in a box in the middle of a blank page with comments designed to cajole the potential client into action. One of her victims was the publishing firm of Mitchell Kennerley, which had halted business with the *Little Review* because of Anderson's anarchism. Kennerley was subjected to the following admonition: "This page might have been used very profitably by Mr. Mitchell Kennerly to announce the publication of poems by Florence Kiper Frank. I think it is to be out this summer—though of course I can't pretend to give the details accurately, not having been provided with the 'ad.' But the *Little Review* readers will want the book nevertheless." [37]

Anderson's financial reversals were temporarily halted in the fall when she received an unexpected contribution of seventy-five dollars from a local poet, Hi Simmons. Simmons had read about the struggles of the *Little Review* in the *Chicago Tribune*; he wrote to Anderson that he was "shocked and deeply hurt to learn the *Little Review* is in such straits." Simmons was not a wealthy patron of the arts; he was offering Anderson

seventy-five dollars out of a savings account that totaled one hundred. "I believe," he wrote, "that the New Word must be said. I believe in your magazine. I would consider it a great loss to Literature if your paper should be compelled to suspend. We Young Men need the *Little Review*. I am willing to do my share to keep it alive."[38] Anderson's thank you letter to Simmons reflected both the difficulties she was experiencing and her determination to continue. "Your letter is such a miracle that it has left me speechless; and it came at the very minute when everything seemed so black. I didn't know where to turn. If you can really afford to do such a thing and will let me return it when the *Little Review* has got on its feet, I shall be so glad to accept your offer." She went on to complain that the newspapers "have said such *horrible things!*"[39] And though she admitted the accounts of her financial problems and the hostility she had received as a result of her "terrible ideas" were true, she wrote, "They've cheapened what we're trying to do with such ridiculous comments that I'm really afraid to read any more papers."[40] Anderson added that due to Simmons' contribution, the September issue could be printed. Harriet Dean, she wrote, "trots around every day holding up as many people as possible."[41] She concluded her note to Simmons, "May something wonderful happen to you soon!"[42]

Though extremely determined, Anderson faced one inevitability—the impossibility of living on the beach during the winter. Once again, she began to look for shelter and came upon an abandoned cottage whose long porch and many fireplaces made it "the most sympathetic house anyone had seen."[43] Anderson found the owner who, charmed by her enthusiasm for the property, agreed to have the group take it over rent-free for a year. Unfortunately, Anderson's reputation as an anarchist radical once again interfered. When Harriet Dean visited the landlady to make final arrangements, she was told that if Anderson was the same person appearing in the newspapers, the agreement was withdrawn. The woman kept repeating to Dean that it had been "a great shock to her to discover that anyone who appeared so charming could be so depraved."[44] Anderson was crestfallen. Revealingly, she later wrote, "To one of my intense inter-uterine nature there is no measuring the shock that a loss of a house can cause."[45]

Anarchism was merely a new label for a philosophy Anderson already possessed as a young woman; individualism and flouting authority were in her DNA. Bernard Duffey writes in his study of the Chicago Renaissance, "The writer-intellectual of the nineties in the Midwest could have scarcely

identified himself with anarchism—a criminal, unwashed and totally foreign affair—but to Margaret Anderson in 1914 anarchism was only a rephrasing of the central Emersonian ideal."[46] The central Emersonian ideal, of course, was the expression of one's true individual self. Anderson, like Emerson, was in the same vein as the American anarchist Benjamin Tucker, who espoused a philosophy that was anarchism based on individualism. In spite of her pronouncements on Joe Hill, strikes, and revolution, Anderson's espousal of anarchism had more to do with individual self-expression than a sustained critique of political or economic inequities in American society. Emma Goldman clearly recognized Anderson's and Dean's lack of a systematic analysis of social ills when she first met them at Anderson's lakeside apartment. "The girls were not actuated by any sense of social injustice, like the Russian intelligentsia, for instance. Strongly individualized, they had broken the shackles of their middle-class homes to find release from family bondage and bourgeois tradition. I regretted their lack of social consciousness, but as rebels for their own liberation, Margaret Anderson and Harriet Dean strengthened my faith in the possibilities of my adopted country."[47] Anderson in this period was the incarnation of the angry rebel engrossed with militant movements.[48] Although she "was always pretending that [she] was a poor working girl, always forgetting that [she] was really poor—also a working girl," she nevertheless saw herself not as a member of the collective revolt but rather a member of a select society.[49] Nevertheless, in her article "Art and Anarchism," which had very little about art, Anderson used some of her most forceful language, intertwining feminism with anarchism to launch a withering attack on the criminalization of birth control and the consequences of illegal abortion.[50]

Anarchists were in sympathy with Anderson's views on a number of points—most notably homosexuality. They were practically alone in their defense of Oscar Wilde. Goldman's *Mother Earth* and other journals such as *Lucifer*, the *Light Bearer*, and the *Light*, saw the Wilde trial as a wakeup call that spurred an anarchist critique of state-sanctioned criminalization of homosexuality. Whitman was another artist with whom Goldman and other anarchists felt a deep kinship. As discussed in the previous chapter, the evolution of current criticism of Whitman's homoerotic poems has developed from a nineteenth-century understanding of his work as "comradely love," but in the early twentieth century, others (including Goldman) clearly saw his work as homoerotic and felt Whitman's own mixed

messages were due to a deliberate "obfuscation" because of contemporary prejudice. Goldman's biographer Candace Falk maintains that Goldman's observation about Anderson and Dean breaking their "shackles" was specifically referring to their lesbianism.[51] Goldman was a lonely defender of Wilde and was also an admirer of Edward Carpenter for his allegiance to anarchism. Goldman's lectures were "unprecedented in their scope and reach and were a critical part of the politics of homosexuality."[52] The anarchists were alone in "successfully articulating a political critique of American social and legal rules, and the cultural norms that regulated same sex relations."[53] Goldman had many lesbian acquaintances and may have had a sexual encounter with one such friend, Almeda Sperry. The friendship between Sperry and Goldman was enough to make Goldman's longtime lover, Ben Reitman, uneasy. When Sperry was planning to visit while Reitman was away, he wrote to Goldman, "I love you and am completely yours. I hope you enjoy your visit with Sperry and I trust you will not develop any new TECHNIQUE whereby you can displace me."[54] Goldman had to assure Reitman about Anderson when she informed him Anderson was coming for a visit. "Yes, Margaret is coming," she wrote, "and I am glad of that. But I do not incline that way."[55]

However, in spite of her protests, Goldman may have been sexually attracted to Anderson and vice versa. It was clear that Goldman was charmed by Anderson and that the *Little Review* editor worshipped the famous anarchist. Reitman saw this himself when he wrote Goldman, "She is crazy about you. This will be another case of Sperry. Oh, your women." Alice Wexler, another of Goldman's biographers, suggests that Goldman may have hinted at feelings deeper than friendship for Anderson when she wrote of "the stirrings as a result of my friendship with Margaret—expressive of my previous theoretic interest in sex variation."[56] Goldman's views of homosexuality were deeply informed by the writings of Havelock Ellis, Richard von Kraft-Ebbing, and other sexologists. While twenty-first-century historians see much of their work as conservative and even damaging, to Anderson's contemporaries there was much that was liberating, especially in the writings of Carpenter and Ellis, whom Goldman took pains to refer to as anarchists. In Goldman's view, Ellis in particular deserved the label because *Sexual Inversion* was published by the same company that published works by the Legitimation League, "an anarchist sex radical" organization.[57]

Like good Nietzscheans who believed society viewed them as insignifi-
cant, artists and bohemians of this era saw their trivialization as a badge
of superiority. Anderson linked Goldman to Nietzscheans, writing that the
anarchist was fighting for "the same things concretely that Nietzsche and
Max Stirner fought for abstractly."[58] Max Stirner may have been an even
larger influence on Anderson during this period. It is clear from her arti-
cles she had read Stirner's *The Ego and His Own*, a widely read piece of
work in anarchistic circles. In *My Thirty Years' War* she wrote, "Even the
waiter at Pittsburgh Joe (where we ate when funds were low) talked Max
Stirner with me." Perhaps the waiter at Pittsburgh Joe was an artist anar-
chist, or simply a workingman talking Stirner and Nietzsche as well with
the other diners; according to Stirner there was no contradiction between
being a destitute bohemian/proletariat and exalting one's anarchism as
the mark of supremacy. In fact, the exalting of oneself was the road to the
anarchist state—the crux of Stirner's philosophy was an extreme form of
egoism that clearly fit Anderson's matrix of radicalism. And she was not
alone—her fellow feminist anarchist editor Dora Marsden founded *The
Freewoman*, *New Freewoman*, and finally *The Egoist* based on Stirner's
values.[59] Stirner's egoism was more complex than simple self-interest.
It is rather a sense of autonomy—from government as well as the end
of one's subservience to social norms, leading to individuals cultivating
their own "unique egos." "Governments may come and go," Anderson
wrote in "Art and Anarchism," "may change or cease to be and nothing
remains forever except your 'type.'"[60] When an individual achieved self-
realization, it led to self-consciousness and awareness of the state and its
oppression. This process reinforced Anderson's own belief in her unique-
ness, giving her a philosophical view rather than a dry political and eco-
nomic creed and allowing for the possibility of a conversion experience
(thus paving the way for her later sojourns into mysticism). Again, though
Christianity was her most abhorred example of religion, she consistently
used, as David Weir describes, an "evangelist" idiom urging her readers
to follow anarchism to the promised land. She writes, "Clean out your
minds . . . If you believe these things—no, that is not enough; if you live
them—you are an anarchist. You can be one right now. You needn't wait
for change in human nature, for the millennium, or for the permission of
your family. Just be one!" This full-throated exclamation was reminiscent
of a "Christian camp-meeting."[61]

The question for Anderson and the *Little Review* concerned the nexus of anarchism and modernism. Anarchists such as Goldman, Anderson was to discover to her chagrin, saw art as the handmaiden of revolution. Modernist aesthetics for them could not be further from the anarchist agenda. Anderson recounted her argument in *Thirty Years' War*: "When I used the black swan in Amy Lowell's 'Malmaison' to illustrate a certain way of pointing to emotion there was a general uprising. E. G. [Emma Goldman] was a little beside herself. 'The working-man hasn't enough leisure to be interested in black swans,' she thundered. 'What's that got to do with the revolution?' 'But that isn't the argument,' I groaned . . . 'We're talking art, not economics."[62] Anderson concluded, "I have never known people more rabid about art than the anarchists. Anything and everything is art for them—that is, anything containing an element of revolt. We tried in vain to divorce them from their exclusive preoccupation with subject matter."[63]

However, the division between art and politics was not always so clear. Anarchism, particularly Stirner's egoism, *could* be adapted to modernism. Individualism could easily be as aesthetic as it was political; in fact, the fragmented form of modernism expressed through the distinctiveness of the artist was a more likely outcome of individualism than a political collective of egoist anarchists. As political anarchism declined into the twentieth century, modernism based on egoistic aesthetics began to flourish. Anderson's modernism connected ego and art with her statement, "I have always accepted or rejected manuscripts on one basis—art as the person. An artist is an exceptional person."[64] The exceptional person is the extreme individualist—in itself, to Anderson, a political statement. The artist, like the anarchist, is an outlaw, as Anderson and Heap would all too literally find out in the *Ulysses* trial. The fact that the high modernist aesthetics of Joyce hurtled two American editors into a courtroom over the right of the state to censor art ultimately, Anderson felt, vindicated her belief that the individualism of the "exceptional person" was the only way to change society.

At the same time, there is more than adequate evidence that Anderson clung to the comforts of her bourgeois middle-class upbringing, and she saw no contradiction in trumpeting them in the *Little Review*. Though she braved empty apartments with cots, "Siberian" rentals, and beachfront camps, her paean to a Christmas visit to her parents' suburban home in

"country club country" in her article "Home as an Emotional Adventure" was as ecstatic as any pro-Goldman anarchist editorial she penned.[65] Later in the *Little Review* Anderson would admit to a certain embarrassment about her anarchist enthusiasm. Nevertheless, although these political/artistic disputes caused tensions, she remained a warm admirer of Goldman and was supportive of her during the criminal charges, trials, and imprisonments that were yet to come.

Ironically, Anderson's arguments with Goldman began over an Amy Lowell poem. Lowell at one point threatened to withdraw her support of the *Little Review* if Anderson kept publishing political radicalism; in fact, Lowell thought she might be a target of anarchists as a symbol of undeserved inherited wealth and kept a revolver in her house. Between 1914 and 1916, at the same time Anderson was enamored of Goldman, she was also embroiled in a radical artistic debate over the meaning and proprietorship of imagism. While the poetry wars were fought out on the pages of the *Little Review*, Anderson and Lowell exchanged letters revealing a complex story of art, politics, and sexuality.

Lowell has become a figure of renewed interest. Contemporary critics attribute sexism, homophobia, and repulsion over Lowell's obesity as reasons for her marginalization as a minor poet. Those familiar with Lowell's work know it was her reading of an H. D. (Hilda Doolittle) poem that led her to the epiphany that she belonged to the new school of poetry known as imagism. The story of Lowell and Ezra Pound's battle over imagism, with H. D. and Richard Aldington (who was married to H, D,) wedged somewhat in the middle, has been well documented. It was a classic power struggle between two self-appointed leaders of a modernist movement.[66] Imagism was a new theory of poetry originating in England around 1910 as a reaction to the Georgian and Romantic schools; it demanded a precise rendering of a poetic image rather than a wordy or flowery description. It also, though not necessarily, advocated free verse instead of a rhymed meter. Pound became the first self-acknowledged leader of imagist poets in London and used his influence to promote the publication of H. D. and Richard Aldington in *Poetry*. In 1914 Pound released an anthology, *Des Imagistes*, which included along with his own work that of H. D., Aldington, James Joyce, William Carlos Williams, and Amy Lowell. Lowell, however, attempted to have her poem, "In the Garden," withdrawn from the anthology before publication. While visiting London in 1914 Lowell

approached H. D. and Aldington with the idea of a second anthology, which would be more "democratic," with everyone deciding who would be included and each contributor given equal space, and the pair agreed to Lowell's suggestion. Pound was invited to participate but scoffed at the idea of a poetry anthology created by committee.

Lowell had prepared the groundwork for assuming command of the imagists in London before she left America, and the *Little Review* figured prominently in her plan. In the spring of 1914, Lowell wrote Anderson informing her of the second trip to England and offering to write a "London Letter" for the *Little Review*. Anderson responded that she would be "happy beyond words" to accept Lowell's offer or "anything else you may feel like sending us."[67] This letter marked the beginning of an intense correspondence between Anderson and Lowell over the next two years. Lowell often wrote several times within one month suggesting that Anderson publish certain works of her imagist group as well as sending over a dozen poems of her own in the same period. Lowell's first contribution to the *Little Review* was an essay in the June 1914 number issue entitled "Miss Columbia: An Old-Fashioned Girl," which criticized the lack of innovation and artistic experimentation in American letters. "The United States," wrote Lowell, "is hopelessly fettered in the strings of tradition" and suffers from "the shallow and frivolous optimism which hangs like an obscuring fog over practically all our writing."[68] The following month Anderson wrote Lowell, "What you've said is very true; it needed to be said, and the *Little Review* is proud to print it. Thank You!" She then invited Lowell to visit her in Chicago and to "send . . . another arrangement."[69] When the First World War broke out in August 1914, temporarily stranding the poet in England, Anderson wrote to Lowell first exclaiming her concern—"I do hope you're safe!"—and describing the war as "an impossible H. G. Wells story." She implored Lowell to "tell us something of what really is going on."[70] Anderson also thanked Lowell for two poems she had sent, "Clear, With Light Variable Winds" and "Fool's Moneybags," informing her they would appear in the September issue.

After Lowell's return to the United States in October, she wrote "at once" to Anderson to know when she would be coming to Boston: "I have a great many things I should like to say to you and you can imagine that I should be glad to shake the hand of the person who has been

so appreciative of my work."[71] Anderson had informed Lowell that she would be in the east trying to secure advertising revenue from major publishers; no doubt Lowell expected her to come to Boston. Lowell began her concentrated campaign in the same letter to use the *Little Review* as a springboard for her own imagist group. She offered Anderson a Richard Aldington translation of a Remy de Gourmont essay, writing, "[Aldington] is one of the very most delightful prose writers as well as a poet whom we have, and if you can attach him to your regular contributors I think you will have done an excellent thing for yourself and a very good thing for him."[72] In a letter the following month, Lowell informed Anderson that she might be in Chicago in December and hinted at her plans for a closer alliance with the *Little Review* as well as her quarrel with Pound. "I have some things I should like to talk over with you which I think may be to our mutual advantage," she wrote. "I am a good deal amused at Ezra Pound's advertisement of *The Egoist* on your book page, leaving me out as a contributor when they have published a number of my poems, all owing to a simple difference of opinion which I had with him this summer and which I tried so hard to avoid. Certainly the jealousy of poets is quite equal to the proverbial one of Opera singers."[73] Several weeks later Lowell wrote Anderson again, sending her a "batch" of her poems.[74] Anderson was more than happy to encourage Lowell's interest in the *Little Review*, but she was not ready to permit Lowell's leadership in the imagist movement to overshadow her own autonomy in deciding what would go into the journal or to ignore criticism of the movement itself.

Imagism was the sounding board for some of the most energetic dialogues in the pages of the *Little Review*. The month after Lowell's debut, Anderson published a somewhat qualified review of Pound's *Des Imagistes* by Charles Ashleigh. Ashleigh wrote that while the imagists "have done some beautiful work as such," he was put off by the stance of those who "claim monopoly of inspiration or art as some of them appear to do."[75] It is interesting that the debate was over the similarity of language used by both proponents and opponents of the new movement. It was generally couched in spiritual language drawing on an esoteric vocabulary. This is evident in Ashleigh's review when he wrote about his reaction to poetry: "If in me there is that responsive vibration—then you are a poet."[76] Aldington, in writing about H. D. in "A Young American Poet" (without mentioning that the young American was his wife), suggested

that her poem "Hermes of the Ways" could only be explained as a "paradox . . . [It] is kind of an accurate mystery."[77]

The very month Lowell began making specific suggestions concerning articles, poems, and contributors, Anderson published an attack on imagism by Eunice Tietjens, interestingly entitled "The *Spiritual* [emphasis mine] Dangers of Vers Libre." The article suggested that free verse encouraged "mental laziness," a "tendency to the grotesque," and "the immediate enlargement of the ego" of the poet.[78] Tietjens pointed to Pound as the clearest example of these abuses, describing him as "the young self-expatriated American who wails 'that ass my country, has not employed me.'" Tietjens thought Pound's pre–free verse poetry was beautiful, but his imagist efforts represented a "spiritual and cerebral degeneration."[79] These attacks on imagism apparently did not put Lowell off, most likely because Anderson treated Pound with equal severity. Pound had derided Lowell's leadership of the movement by calling it "Amygism," and no doubt Lowell was glad to see Pound get his comeuppance in print. Anderson was trying to use the controversy raging within the poetry world to emphasize her dialogic approach, which propelled this movement forward. The December 1914 issue made clear that all viewpoints were permitted in the *Little Review*. That number contained two poems by Richard Aldington, "On a Motorbus at Night" and "Church Walk, Kensington," as well as four articles arguing the merits of imagism. Two of the essays were critical. Arthur Davison Ficke wrote in "In Defense of Vers Libre" that there was "something sickly and soul destroying about earlier verse forms." Ficke, like many other defenders and contemporary scholars, saw the origins of free verse in Whitman.[80] In "Aesthetics and Common Sense," Llewellyn Jones wrote a critique of imagism, ending his article with a strange paragraph that sharply foreshadowed Anderson's interest in esoteric spirituality. Jones had "heard there was a book on the fourth dimensions," which if read, he asserted, would help him understand imagism. Jones may have been referring to Charles Hinton's book *The Fourth Dimension* (1904).[81] These articles were followed by an impassioned defense of the movement by Maxwell Bodenheim in "The Decorative Strait-Jacket: Rhymed Verse." True to her principles, Anderson also continued to publish criticism of imagism by Ficke, Witter Bynner, and Huntley Carter. Carter's article, "Poetry versus Imagism" (September 1916), so aroused Anderson's sensibilities that she could not

publish it without an editor's preface—one of her favorite devices—to add fuel to her magazine's conversational fires. Anderson wrote, "I entirely disagree with Mr. Carter's point of view—as much of it as I can fathom. But I hope his article will provoke discussion that will provoke a clearer understanding of the Imagist's art in a country where even poets are blind to it."[82]

There was no question of where Anderson stood in the controversy. The same issue contained her review of Lowell's new book of poetry, *Sword Blades and Poppy Seeds*, in which she proclaimed that Lowell's work "refutes all the critical disparagement of vers libre, imagism, or 'unrhymed cadence,' as Miss Lowell herself chooses to call her work." "Her poems," she wrote, "will put to shame our hackneyed and slovenly 'accepted' poets."[83] In the May 1915 issue, a Mr. "George Lane" reviewed Lowell's *Some Imagist Poets*, the anthology she organized in response to Pound. The review evaluated the six poets in the book—Lowell, John Gould Fletcher, H. D., Aldington, D. H. Lawrence, and F. S. Flint. "George Lane" was actually Lowell and Fletcher, who cowrote the review with Anderson's blessing. The most specific critiques concerned H. D.'s work. Anderson published two H. D. poems, "Late Spring" and "Night," in the January–February 1915 issue of the journal; she also announced a "Vers Libre Contest" in which H. D.'s "Sea Poppies" emerged a winner.[84]

H. D. was well known for her interest in mysticism, hermeticism, and other esoteric studies. However, unlike others who employed esoteric themes in her work, she was one of the few "practicing occultists."[85] Timothy Materer in *Modernist Alchemy: Poetry and the Occult* writes that H. D. "embraced equally the knowledge from classical Greek texts to table-tipping séances" and was "the least self-conscious about occultism."[86] Her Hellenic interests included classical Greece and the Alexandrian strain of Hermes Trismegistus, a touchstone of George Gurdjieff's thought. Four years after her poems were published in the *Little Review*, H. D. had her famous visions on the wall of her hotel room in Corfu. The criticism in the *Little Review* of her poems in *Des Imagistes* and *Some Imagist Poets* direct their attention to her esoteric orientation. The review by "George Lane" of *Some Imagist Poets* in the May 1915 issue baldly stated, "If one believed in reincarnations one could say, and be certain, that H. D. was the reincarnation of some dead Greek singer."[87] John Gould Fletcher in his review, "Three Imagists Poets," wrote that H. D.'s poems were "like

a series of hymns of some forgotten and primitive religion . . . purely and frankly pagan."[88] H. D. was a lesbian; she maintained a lifelong relationship with heiress and novelist Winifred Bryher. Her poetry and lesbianism intertwined; she was not simply a translator of Sappho, but as Diana Collecott argues, "Her entire oeuvre can be read as a creative dialogue with Sappho, and it is most vivid when so read." This collaboration, writes Collecott, "is not purely imaginary, but persistently textual."[89]

In spite of her enthusiasm for Lowell's work, Anderson found herself in the position of resisting Lowell's growing interest in the *Little Review*. The same month that imagism was being debated so vigorously in its pages, Lowell wrote to Anderson proposing that in exchange for "a certain sum yearly toward your magazine," she would be appointed poetry editor.[90] Lowell explained: "To be sure, you have always welcomed the things of mine which I have sent most cordially, and also those of other people which I have sent. I have nothing whatever to complain of, therefore, in the handsome manner in which you have treated me, but I have been looking out for a long time for a magazine the editorial staff of which I could join. I cannot afford to run one totally alone, but I could quite easily purchase a certain interest in your magazine and receive in return certain privileges."[91] Lowell said that if Anderson was interested she would travel to Chicago after Christmas to discuss the arrangements, insisting that any agreement must be "put on paper."[92]

We do not know Anderson's written response to this offer, but Lowell did travel to Chicago in January of 1915; their meeting was not a propitious one for the poet's ambitions. Anderson's description of her first meeting with Lowell as a cigar-smoking woman dressed "in the mode of Godey's Lady's Book," with the nose "of a Roman emperor and a manner somewhat more masterful" is one of her more droll portraits of artists she met during these years.[93] Anderson had spoken to Lowell over the phone before their meeting, and because of Lowell's high-pitched and rapid voice she imagined "a slender and imperious blond."[94] Anderson was taken back when Lowell appeared at the *Little Review* office and was "of such vastness that she entered the door with difficulty."[95] In *Thirty Years' War*, Anderson wrote that Lowell made her an offer of money in exchange for control of the "poetry department" at the time of her visit rather than in a letter prior to her trip to Chicago. Anderson was clearly

anticipating Lowell's suggestion, however, and was prepared to turn her down. Lowell's first topic of conversation was her dispute with Pound and her own attempts to gather attention for the imagists in America. She renewed her offer, this time suggesting one hundred and fifty dollars a month with Anderson remaining in charge and Lowell working as poetry editor. "You can count on me," Anderson recalled Lowell saying, "never to dictate." Anderson, however, instinctively felt that "no clairvoyance was needed to know that Amy Lowell would dictate, uniquely and majestically, any adventure in which she had a part." She declined the offer, telling Lowell she could not "function in 'association.' "[96] According to Anderson, Lowell was "furious," but when she saw she could not sway Anderson she changed the subject and never brought it up again. Lowell and Anderson corresponded for another year with no evidence that their lack of a formal partnership strained their relationship. The following spring Lowell wrote Anderson about various literary matters and made a point of praising the *Little Review* by writing to Jane Heap, "It is the only magazine which I ever really read . . . Perhaps you were right to refuse my offer, although in spite of being 'businesslike' I am so much in sympathy with everything you are trying to do that I do not think you would have found me quite the fish you imagine."[97] Anderson's perspective on Lowell was stated directly in an April 1916 article entitled "The Poet Speaks." "There is one type of person," she wrote, "we always eject promptly from the office of the *Little Review*. He is the person who says that Amy Lowell's poetry has no feeling in it."[98] The article was a defense of Lowell from criticisms by a local poet and an unfavorable review of a personal reading of poetry Lowell gave that appeared in the *Chicago Tribune*. "Lots of people," complained Anderson, "have been splitting hairs over Amy Lowell's work, but no human being has been heard to remark: 'A beautiful thing is happening in America; Amy Lowell is writing poetry for us.' "[99] Anderson quoted Lowell's poem, "Vernal Equinox," which was one of her personal favorites. When Anderson made another revenue-raising trip to New York, Lowell again hoped that Anderson would travel to Boston for a visit. Anderson wrote to the poet stating she was unable to see her but asking, "Aren't you by any chance coming here? I should so love to see you. Your things in the Sept. *Poetry* are—beyond words. They live with me every day." She then quoted a line from "Vernal Equinox"—" 'That scent of hyacinths like a pale mist—there is nothing like you!' "[100] Lowell

responded with appreciation, writing, "Your whole attitude is a joy to us poets. No wonder we send you our best things."[101]

Lowell and Anderson had a long and philosophical discussion concerning the nature of love during Lowell's trip to Chicago. After Lowell returned to Boston, she wrote to Anderson in April and referred to their "conversation on the difference between love and lust," reminding Anderson how well they agreed: "Now you see love on the purely physical side is as unpleasant as raw beefsteak. It is the combination of the two which is perfection."[102] The poet then complained to Anderson that some of the stories published in the *Little Review* displayed "brute animal appetite" which was "doing [Anderson's] own point of view quite as much injustice as if [she] were to write the goody-goody stories of the ordinary magazines."[103] Lowell was often uncomfortable with the frankness of some of the fictional material in the *Little Review* as well as Anderson's anarchist tendencies. In this same letter, Lowell offered Anderson a one-hundred-and-fifty-dollar contribution with "a string attached"—that Anderson publish at least one number of the *Little Review* "which would not advocate violence."[104] The most interesting section of this letter was a postscript in which Lowell thanked Anderson for a hyacinth flower reminiscent of "Vernal Equinox" that Anderson had given her in Chicago. The "beautiful hyacinth, and the card," wrote Lowell, "was so sweet a tribute to my little poem. I don't know when anything has touched me as your giving me that hyacinth did." She told Anderson that she put the flower on the windowsill of the train during the "long, tiresome journey" back to Boston and then put it on her bookcase at home.[105] It seems that Lowell's thank you was not mere politeness but rather genuine gratitude for the thoughtful gesture. She mentioned the flower again four months later in a letter to Anderson thanking her for the care taken on the proof of her poem "Malmaison," which appeared in the June–July issue. Lowell pointed out that there were no mistakes in the proof, an unusual condition for many pieces published in the *Little Review*. "I think perhaps," wrote Lowell, "your care with that proof has touched me more than anything except the hyacinth. You remember the lovely white hyacinth you gave me when I was leaving Chicago?"[106]

The episode raises the question: To what degree did they acknowledge between themselves the fact that they were lesbians? Biographies of Lowell deal sparingly with her sexuality, referring to her having "bi-sexual

tendencies without knowing it" or as a woman "troubled with psycho-sexual conflict."[107] Her orientation was described in such terms while acknowledging the importance of her thirteen-year relationship with Ada Dwyer Russell who lived with Lowell and whom Lowell nicknamed Peter. The lesbian poems in *Sword Blades and Poppy Seeds* (1914), *Pictures of the Floating World* (1919), *What's O'Clock* (1925), and *Ballads for Sale* (1927) comprise one of the most detailed records in literature of an emotional and erotic relationship between two women.[108] Beyond the hyacinth episode and conversations on love and lust, it is difficult to determine whether Lowell and Anderson recognized one another as lesbians. Lowell did make a point of writing Anderson after her bold review of Edith Ellis's talk concerning the defense of inversion to say she agreed with Anderson's views, but it was a brief statement in the midst of imagist business. Their correspondence could be interpreted to display a certain flirtatious quality, with the occasional use of nicknames such as "Angel" and "Fairy Godmother," even though nearly all begin with the salutations of "Miss Lowell" and "My dear Miss Anderson." It is safe to say that some sense of distance other than the geographical separated Anderson and Lowell; one was a Boston Brahmin with an inescapable air of patrician culture, the other a middle-class firebrand intent on upsetting established tastes. Their frequent and intense correspondence, however, suggest a brief intimate comradeship.

The April 1916 letter in which Lowell offered "a string attached" raises the question of how this Boston Brahmin could fit in with the *Little Review* at a time when Goldman dominated the pages. The same month Lowell wrote that letter, however, she published a poem in *The Masses* and was bragging to Anderson that she was getting her social peers interested in the *Little Review*.[109] She continued, "Your May number came some time ago and I think that it quite fulfills my conditions. Certainly it does on the sexual side. I am not quite sure that printing Emma Goldman's letters fulfills the condition on the political side—in theory, that is, not immaterial, for her letters are interesting, tender and pathetic."[110] Lowell was a more complicated political creature than might be supposed; like most of her artistic contemporaries, she was horrified by the Great War. The first sentence in *Tendencies in Modern American Poetry* reads, "It is impossible for anyone today not to be affected by the war. It has overwhelmed us like a tidal wave."[111] Lowell wrote anti-war poems in

which she attacked the war's needless bloodshed, waste, and human savagery. One of her most famous poems that appeared in the pages of the *Little Review* was "Malmaison," in which Josephine (Napoleon's wife) herself is a scarred casualty of the Napoleonic wars.

We see ample evidence that Lowell was indeed an exemplar of radical poetic and cultural visions. Unlike Pound, who looked to Europe and the past for a foundation, Lowell looked to America and the New World. While Pound saw imagism and every form of art as an elite preoccupation of high modernism, Lowell broke free of patrician mores and fought for poetry in general, and imagism in particular, to be promulgated by and exposed to as many people as possible. Lowell saw the Victorian heritage as a dead weight threatening America, which had taken in her view "the most advanced step" in poetry.[112] She was a woman among other artists of her generation who related more to younger women of modernism than to her Victorian peers. In *Tendencies in Modern Poetry* Lowell wrote, "It is not my intention here to combat the opinions of the conservatives. Conservatives are always with us; they have been opposing change ever since the days of the cave men. But, for this reason, the symbol has taken on a new intensity and is given much prominence. Fortunately for mankind, they agitate in vain."[113]

Celeste Schenck's account of the British poet Charlotte Mew holds compelling similarities with Lowell; Schenk asks, "The radical poetics of canonized 'modernism' often masks a deeply conservative politics, might it also be true that the seemingly genteel, conservative poetics of women poets such as Mew, whose worth even feminists have overlooked, would pitch a more radical poetics than we considered possible?"[114] Mew, May Sinclair, and H. D. are described by Diane Collecott as forming "another Bloomsbury" of literary networks among women in London during this period. We have already seen how H. D.'s work was given exposure in the *Little Review*, and it was through Lowell that H. D.'s first volume of poems, *Sea Garden*, came out from her own London publisher. H. D. took over as editor of the *Egoist* in 1916 for a single year and published only three reviews—of works by Lowell, Mew, and Marianne Moore.[115] Collecott argues convincingly that "these Women of 1916" took their cue not from the "Men of 1914" but rather from the late romanticism of Oscar Wilde and W. B. Yeats. Anderson highly praised and published Yeats during the same period of the *Little Review* when Wilde was a

revered figure (1914–16), and she would later emulate Yeats's immersion into mysticism.

Goldman and Lowell, the main figures of this period of the *Little Review*, were both inheritors of Wilde and Henri Bergson, and even Walter Pater, if we assume an anarchistic spirituality, a heterogeneous expression, and aesthetic values that eschew morals. Anderson's personal and professional relationships with the two women illustrate several things about Anderson and her editorship of the *Little Review*. She did not hesitate to proclaim, at times with obvious hyperbole, her advocacy of individuals and movements regardless of their controversy. In fact, it is safe to assume that the more volatile the person or topic, the greater potential it held for promoting the *Little Review*. This is not to say Anderson was cynically manipulating her readership; the sincerity of her position was clear. However, with such issues as anarchism and imagism, Anderson had found what she had hungered for—intelligent and spirited exchanges on important questions. Anderson's actions also illustrate that in spite of the outcry that resulted from public discussion of these topics in the pages of the *Little Review*, she was determined to retain control of the magazine regardless of the consequences. The financial crisis precipitated by her support of anarchism that led Anderson to live on a beach rather than give up the journal changed nothing. When Lowell offered to donate some much-needed support in exchange for editorial input, Anderson declined.

On Lowell's death in 1925, Heap and Anderson printed her name and dates in a black-draped memorial image of her silhouette drawn by Heap inside the *Little Review*, a gesture they made with no other contributor. As with Goldman, differences did not destroy their mutual respect. In each case, Anderson held her ground. Her next challenge, taking on Ezra Pound as foreign editor, would present opportunities for the journal that would catapult it into history and lead to an uncertain future.

4

INTERREGNUM: CHICAGO, SAN FRANCISCO, NEW YORK

Between 1916 and 1917, Margaret Anderson would undergo a transition in both her personal and professional lives that would have significant consequences for the future of the *Little Review*. She met Jane Heap, took the *Little Review* on the road, printed some of its more memorable issues from San Francisco, and decided to move the *Little Review* permanently to New York. There she, Heap, and their new foreign editor Ezra Pound would create what Anderson called the most vital period in the journal's history.

In Anderson's account, Heap's arrival at the *Little Review* was accompanied by some commotion. According to Anderson, "An erratic rich woman with a high temper"—Aline Barnsdall, nicknamed "Nineteen Millions" because it was reputed to be the size of her fortune—was considering giving a generous contribution to the *Little Review*.[1] She met Heap at the *Little Review* office and took an instant dislike to her. Later, in her first autobiography, Anderson described the unpromising scenario:

> We were talking of Duse and D'Annunzio. The millionairess hated *Fire*
> and felt that D'Annunzio was ignoble to have exposed Duse to such inti-
> mate treatment. She worked up her theme with sentimental abandon. Jane
> regarded her with interest and then gave a loud and tender laugh. "God love
> Duse," said Jane; "she has always given me a large pain." Nineteen Mil-
> lions was furious. She left the studio saying that she disliked frivolity. She
> had always felt that the *Little Review* was a sanctum one could depend on
> for serious and inspiring conversation. My reaction was different. I felt that
> I could never henceforth dispense with Jane Heap's frivolity.[2]

Anderson's efforts to recruit Heap to write for the magazine took
months of badgering. When Heap would groan that "she had no interest
in life," followed by "I'm a talker; I'm no writer," Anderson knew her
exertions were beginning to pay off. However, the titanic battle was far
from over. Anderson would lock Heap in a room for hours to give her
uninterrupted time to think. "I would do all the marketing—which was
just as well in any case, as Jane disliked divulging to trades people the
perfectly private matter of what food she was going to consume." The
process included Anderson taking Heap's thoughts down in longhand,
"touching such a range of subjects that it was impossible to decide which
one would be of greatest news value for the *Little Review.*"[3]

One of Heap's first articles was a paragraph criticizing her alma mater,
the Art Institute of Chicago, comparing it to a trade school. This did not
please the Chicago art establishment; Heap received considerable con-
demnation for her critique of the beloved local institution. Her response
was the provocatively entitled article "Potatoes in the Cellar," written
under the pseudonym "R.G." Her first sentence proclaimed, "I AM not
here to harry institutions, to prod up mummies swathed in red tape and
embalmed in routine and respectability, nor am I here to bury the unburied
dead." Getting directly to the matter, she wrote, "People say, 'Why do you
jump on the Art Institute for becoming a trade school? It is only following
the tendencies of the times. Art is like everything else.' There you have
it!—the whole trouble. There is no consciousness of art, no consciousness
that art is beyond all these things—that it is as the sun to the earth, and if
it were to fail us we should grow like potatoes in a deep cellar."[4] Heap's
comments reveal her sense of despair, even failure, in her desire to pursue
the path of a fulfilled artist. "An artist almost disgraces the family into
which he is born," she wrote. "He is pitied little by outsiders; he is left

alone. At last, when he can stand it no longer, he breaks the parent's heart and goes out full of high hope to find his own kind and to keep his own faith. After a short time he finds the art school very much like a factory; he learns to do his piece when he had thought to create a new beauty, and he finds, too, that he is still an outcast for his beliefs and desires."[5] What is clear from the outset of this article is that Heap shared with Anderson the same belief in the connection of art and spirituality, although, also like Anderson at this stage, she was ambiguous rather than precise in her beliefs. In the same article, Heap wrote, "The Artist knows as surely as though he walked with God upon those six days of creation that this He made and nothing more—but here He made all. Other men fill in the gap between what they are and what they feel they could be, what they long for and cannot find, what they attain and aspire to, with Religion."[6] However, what God had on his mind concerning other inexplicable mysteries, Heap left to others. She was not, we know, a Christian Scientist, a Theosophist, a New Thinker, and certainly not yet Gurdjieffian, but she was a Believer. As she wrote in one letter to Florence Reynolds, "Everything beautiful is God and all things not beautiful not God."[7] Like her private letters, her public articles reveal a woman who, though she may have been sharp-tongued and jaundiced, had not given up on the ultimate question. She was not afraid to lay bare in front of any audience the inherent contradictions with which she struggled.

When writing criticism, Heap also was not reluctant to let her rawer emotions show. More often than not, these occasions were when Heap herself—rather than the artist she was critiquing—was the center of her article. In an October 1916 article ostensibly about a concert by Ignacy Paderewski, the pianist shared the limelight with Heap and a famous member of the audience, the Bengali poet Rabindranath Tagore. Heap wrote, "we speculated prayerfully" that he would be in the audience since he was known to be in town.[8] Even though Anderson and Heap were jammed standing in the back of the theater and Tagore occupied the first seat in the first row, somehow all four of the principles, along with members of the feline species, seem to figure somewhat seamlessly in Heap's tale of an enchanted evening. She began her review of Paderewski's performance with a curious opening: "THIS morning I lay in bed looking at the ceiling and thinking about cats. How elegant they are, and impenetrable,—and with what narrow slant-eyed contempt they look out upon

the world. Perhaps that's the way it looks through little black perpen-
dicular slits . . . Anyway I thought of cats, and of violin strings made of
catgut, and wondered about cats and music. Is it because violins are made
of living things—wood and catgut and mother-of-pearl and hair—that
they make the most beautiful music in the world?"[9] Preparing for the
beginning of Paderewski's concert, she looked indifferently at the crowded
house. There were too many people. "Then, with tears hurting my eyes
and an ache in my throat choking me," she pointed out Tagore to her
friends "and made them look quickly so they wouldn't see [her] cry. There
he sat in the first chair in a robe the color of grass-cloth and a pale violet
cap upon his head. From where [they] stood, it looked like a high forage
cap, but soft; and he wore great glasses made of horn." She continues,
"[I] watched him until I was almost in a trance—the angle at which his
head was put on, the cheekbones that were like an extra feature . . . Every-
thing that lies beyond the reach of thought and wonder seemed concen-
trated in that dark Stranger. I trembled, frightened by my imagination
and a little melancholy. At last Paderewski came out to his piano, elegant
and impenetrable. I seemed to see him quite differently beside Tagore—a
bright heaven beside a still universe. I was so filled there was no room left
in me for the music."[10] Although Heap appreciated Paderewski's perfor-
mance, she gave his actual playing few sentences. The reader might con-
clude that Heap was attending a Tagore poetry reading as opposed to a
Paderewski concert. Nevertheless, the fact that she contrasted the "bright
heaven" of the pianist with the "still universe" of Tagore indicates she
saw the dimension for art and the mystic within the same realm, though
through different prisms.[11]

When she was writing more traditional criticism, Heap tended to go
for the jugular. In what became a regular column called "And"—a few
paragraphs on current books, plays, music, etc.—Heap wrote brief, sharp
observations on her subjects. Despite her midwestern background, or per-
haps because of it, Heap was curtly dismissive of writers such as Sherwood
Anderson—whom she once called a "pre-natal foetus"—and Theodore
Dreiser, stating that "these writers want their books to be homely—the
great American vice; made from the people, by the people, for the people.
It's merely another form of glorification of sockless senators, etc." As
if references to sockless senators were not insulting enough, she added,
"They all sound as though they had been written in the morning."[12]

Shortly after Anderson met Heap, Aline ("Nineteen Millions") Barnsdall invited Anderson to spend the summer in Mill Valley, California. Anderson was delighted; she conceived a plan to publish the *Little Review* from nearby San Francisco for the duration of her stay. She was also determined to bring Heap along in spite of the scene in the *Little Review* office. Anderson later claimed that her typically stringent sense of etiquette fell victim to her fascination with Heap; she informed Barnsdall that Heap would also be arriving. When Barnsdall telegraphed Anderson, insisting she visit alone, Anderson threw the telegram away and proceeded with her plans. Anderson's entourage also included Harriet Dean and Caesar Zwaska, a teenager and aspiring poet/ballet dancer from Licking, Missouri, who had enthusiastically read the *Little Review* and asked to be an office boy. When the entire group arrived, Barnsdale was predictably angry and refused to accommodate them. Anderson wrote in her autobiography that "Nineteen Millions" was so infuriated it was a wonder "she didn't strike me. I once saw her strike a man in the face simply because he wouldn't answer her. But then is there anything so exasperating as not being answered?"[13] Zwaska and Dean were put in charge of finding an office in San Francisco; Heap and Anderson went off to find an affordable mountain cabin. The pair headed into the Muir Woods near Mill Valley. They found an empty ranch house, three miles from the sea and surrounded by eucalyptus trees; Anderson wrote that it "fulfilled all demands—it was old, simple, homely, deserted, isolated, sympathetic." The two women broke in, discussed their redecorating judgments, and went off to find the proprietor. They confessed to this individual, one Mr. Chase, that they had broken into his home in order to familiarize themselves with its potential. Mr. Chase then identified himself as the sheriff of Mill Valley and wondered out loud how he should handle such a crime—nevertheless he rented the house to them.[14]

Anderson would repeatedly recall the summer of 1916 as one of the happiest of her life. Heap constructed and painted furniture in a part of the cabin she appropriated as an artist studio and carpentry shop. Anderson, whose ingenuity in procuring free pianos for unlikely dwellings seemed inexhaustible, wrote to the president of the Mason-Hamlin firm in Boston requesting a complimentary piano for her mountain home. In her letter, she stated that "it was [her] intention to become one of the world's greatest pianists and since the Mason-Hamlin was

the world's most beautiful piano, [she] didn't see how [she] could live without one for the whole summer. Could he tolerate this situation?"[15] Incredibly, Mason of Mason-Hamlin arranged for Anderson to select a baby grand from his San Francisco store and sent it to Mill Valley at his expense.[16] Anderson's routine was to practice the piano in the morning, ride a rented horse through Muir Woods to buy provisions from an inn, have lunch, then address *Little Review* business. With Heap she would have tea in the afternoon, then "walk under the misty eucalyptus trees, chiefly for the comfort of returning to a fire lit room." In the evening, she recalled, "We dressed elaborately in pajamas, discussed sensuous plans for dinner, and prepared it in a kitchen lighted only by a kerosene lamp." She continued, "There was nothing to do after dinner but push the table away, light another cigarette, and then fall off to sleep under the impression that we hadn't stopped."[17] In describing the physicality of their talk, the "spell" they were under, the fire and mist of the California rainy season, the rustic setting in the company of someone who "inflamed her mind," Anderson renders a highly romantic account of her stay in Mill Valley. In her accounts of their talks, we see a foreshadowing of the type of intellectual exchanges they would find again when they began to investigate the teachings of Gurdjieff.[18] A few years later, when they explored Freud and other psychological thinkers—most notably the Russian Theosophist P. D. Ouspensky—they engaged in "the psychology of combat," as Anderson termed it, mainly with the intent of winning debates. A similar process can be seen years later in their attempts to lead others by verifying the truth of Gurdjieff's teachings through their own experiences. "Jane taught me," Anderson wrote, "new ways to defend myself, taught me to develop my powers of speech instead of placing myself guilelessly in the enemy's hands, taught me that revenge induces respect. She taught me how to gauge an audience, how to give what was desired or merited but no more, that giving too much was as bad as giving too little. I pounced on this knowledge. I assimilated it." Although Anderson conceded that she had "almost never been able to use it"—no doubt due to her preference for her own idiosyncratic form of engaging in debate (in which she was perpetually exasperated that her opponent would not simply give in)—it does give credence to Heap's teaching.[19] Many Gurdjieff students of Heap in the 1930s and 1940s maintained that she had a rare gift as a teacher of his ideas because she

employed intellectual techniques that they felt encouraged them to think for themselves.[20]

In spite of Anderson's joyful description of the summer of 1916, there existed another reality. As she came to know Heap better, Anderson realized Heap's complex and somewhat dark side. The despair that would arise in Heap's earlier letters to Florence Reynolds became apparent to Anderson, who in fact worried that Heap was deeply depressed. Much to Anderson's dismay, Heap would "brood" and "sulk," "retreat into silences," and occasionally "implement her favorite device," the threat of suicide. Heap would blurt out to Anderson, "The light is too brutal for me here. I am going back to the grave from which I came."[21] The discord caused by Heap's moods was exacerbated by the fact that she had brought a gun to Mill Valley, keeping it in a trunk. Anderson decided to ignore the suicide threats but later recalled that the summer was full of extreme tension. She would come to see Heap's threats as an attention-getting device and feel angry over the manipulation they entailed. Heap, she concluded, was someone who required constant small doses of high drama in life to feel alive. This no doubt was especially irritating to Anderson because she was guilty of the same behavior.

Anderson also thought, however, that the "burden of Jane's unhappiness was an integral part of her genius," and she "wanted that genius for the *Little Review*."[22] The June–July 1916 issue was the first of several future *Little Review* issues combined into two months instead of the standard monthly edition. In this issue, which she called "The Migratory Magazine," Anderson explained to her subscribers that the financial costs of the *Little Review*'s temporary visit to San Francisco necessitated the combined volume. It would be the first but not the last time Anderson was forced into such a corner. Complaints from readers, however, were rare. The trip to San Francisco was more than a youthful adventure or an opportunity to secure Heap's agreement to write for the *Little Review*. By the time she landed in San Francisco, Anderson had been undergoing a stern reevaluation of what she was trying to accomplish with the magazine. She was increasingly unhappy with the content and quality of the contributions. In the second *Little Review* issue published from San Francisco (August 1916), she led with an editorial, entitled "A Real Magazine," that began as follows: "I am afraid to write anything; I am ashamed. I have been realizing the ridiculous tragedy of the *Little Review*.

It has been published for over two years without coming near its ideal . . . I wanted Art in the *Little Review*. There has been very little of it, just a very little . . . it is tragic, I tell you."[23]

She then threatened to stop publishing the magazine altogether and proceeded to criticize the value of the contributions of the current issue. Directly addressing the writers she had accepted, Anderson wrote, "Helen Hoyt, you have a poem in this issue called 'The Tree.' It is not Art. It is merely a rather good poem. You could have made it Art. Do it every time, for the love of the gods!" She went on, "Sue Golden has one about Jim and Arabella. It is an interesting idea that many people need to understand. Why not make Art of it? I loathe compromise, and yet I have been compromising in every issue by putting in things that were 'almost good' or 'interesting enough' or 'important.' There will be no more of it. If there is only one really beautiful thing for the September number, it shall go in and the other pages will be left blank. Come on, all of you!"[24]

Despite her general dissatisfaction with the quality of art and literature in her magazine, political events on the ground in San Francisco were giving the *Little Review* plenty of fodder for publication. On July 22, 1916, Emma Goldman was scheduled to give her lecture "Preparedness" (against the Preparedness Movement, which advocated US entry into World War I), a version of which was published in the *Little Review* as "Preparedness: The Road to Universal Slaughter." When a bomb went off in the city at a pro-Preparedness parade on the same day, Goldman, Anderson, and local activists became embroiled in the resulting hysteria. Five labor leaders were rounded up, falsely linked to anarchism and charged with the bombing. Both Goldman and Anderson were furious with the "railroading" of the labor leaders. However, their greatest animus was reserved for "the lack of Courage" of both liberals and radicals, other union leaders, and lawyers who would not touch the case.[25] In the September 1916 issue of the *Little Review* Anderson ran two articles, "The San Francisco Bomb Case" and "What is a Poor Executioner to Do Against a Man Who is Willing to Die?" In her editorial "The Labor Farce," Anderson backed up Goldman, particularly her criticism of "friendly" allies who stood aside and watched as their comrades were making their way to a death sentence. When local authorities warned Anderson and Heap's landlord, Sheriff Chase, to be on the lookout because Goldman was in his area, he ruefully replied he already knew that—the infamous outlaw was a visitor in his house.[26]

Although her differences with Emma Goldman were bubbling to the surface, Anderson still considered the famous anarchist a friend. The events occurring in San Francisco in the summer and fall of 1916 were given comprehensive and supportive coverage in the *Little Review*. Nevertheless, this dramatic time did lead to several examples of both comradeship and conflict. The first snag was Anderson's excitement in introducing Goldman to Heap. She was convinced that the two "geniuses" would hit it off immediately; unfortunately, however, Goldman's response to Heap was similar to that of Anderson's capitalist nemesis, "Nineteen Millions" Barnsdall. While Alexander Berkman and Heap were "congenial," with Goldman it was "rather less so." Goldman complained that she found Heap "too aggressive." When Anderson protested, "But I'm twice as violent as Jane," Goldman responded, "It doesn't matter. No one can get angry with you. We all know your bark is worse than your bite."[27] Once again Goldman and Anderson delved into an imbroglio over art and politics. Goldman mentioned an artist who had done excellent portraits of her and Berkman. "He's a great artist," Anderson recorded the anarchist as saying. "And so of course he and his family will starve to death." Such arguments drove Anderson wild with fury, which she promptly reported in the *Little Review*. Goldman, however, was not the only follower of the *Little Review* who ran afoul of Anderson. Anderson recorded an exchange with Upton Sinclair who sided with Goldman and Berkman. " 'Please cease sending me the *Little Review*,' he wrote. 'I no longer understand anything in it, so it no longer interests me.' " Anderson replied, "Please cease sending me your socialist paper. I understand everything in it; therefore it no longer interests me."[28]

The culmination of the San Francisco sojourn was what came to be known (misleadingly) as the famous "Blank Issue" of the *Little Review*. Anderson and others claimed that, with the exception of a cartoon drawn of Anderson by Heap at their mountain vigil, the rest of the issue consisted of sixty-four blank pages. The myth of the "Blank Issue" began when Anderson reported it in *My Thirty Years' War*, and this was simply accepted by historians. Those who have looked at the September 1916 issue see that while there are indeed many blank pages and Heap's cartoon, there are also labor strife articles. Anderson did admit that only a few manuscripts were arriving at the *Little Review* San Francisco office,

and no doubt the logistics of taking a magazine on the road, few funds, and slow mail service contributed to a dearth of material.

The September 1916 issue was the last published in San Francisco. With the start of the California rainy season, Heap and Anderson returned to Chicago. It appears that on returning there, Anderson had made up her mind to pursue a dramatic new direction for the *Little Review*, one that involved moving the magazine to New York. The last two issues from Chicago were November 1916 and January 1917. The decision to leave Chicago was "inconvenient" for one rather monumental reason—Heap did not want to go. The two of them walked at night in the familiar snowy streets, summoning their feelings about a city they both loved with a passion; goodbyes were bestowed on elevator boys and corner flower women. On one of her last days in the *Little Review* office, Anderson ran into Ben Hecht, who told her that after she left, he would put up an electric sign across the Fine Arts Building asking, "Where is Athens now?" Anderson had ambitions for the *Little Review* she felt could not be realized in Chicago; New York was the only city in America where she could make the journal "an international organ."[29] She also hoped that the move would provide a solution to improving the artistic merit of the work she was receiving. It is highly likely that Anderson was motivated by other literary Chicagoans who had already left for New York, such as Dreiser, Bodenheim, and especially Dell.

New York, like Chicago, had been undergoing its own "Little Renaissance" during roughly the same period, 1908 to 1917. Comparisons between the two urban responses to modernism have put Chicago in a lesser light, usually portraying it as a regional and even primitive example, although defenders of the Windy City argue that little magazines such as the *Little Review* and *Poetry* had a disproportionate impact despite their midwestern origins. However, partisans of New York saw a much more sophisticated, organized, and internationally connected movement.[30] Discussions of New York's Renaissance usually revolve around the influx of artists and writers into Greenwich Village after the turn of the century. Although the Village in the nineteenth century had been a locale for aristocrats, by the 1890s working-class and immigrant tenements were pressing on the area south of Fourteenth Street. The eventual decline in property values attracted impoverished artists and political radicals who created the famous bohemian quarter of the Village. Those who moved there

would later become the giants of American literature, drama, criticism, and activism: Eugene O'Neill, Marianne Moore, Djuna Barnes, William Carlos Williams, John Reed, Lincoln Steffens, Max and Crystal Eastman, Mabel Dodge, Edmund Wilson, Malcolm Cowley, Edna St. Vincent Millay, and Randolph Bourne. They would express themselves in a variety of little magazines, small galleries, and experimental theaters, as well as formal and informal clubs and meeting places. Such institutions as *The Masses*, the Provincetown Players, the 291 Gallery, Polly's restaurant, the Hell Hole bar, and Mabel Dodge's salon were the most famous, among many other meeting places. Precisely what this group of individualists hoped to find in coming to the Village has been discussed extensively. Was it to find a sense of belonging amid a turn-of-the-century breakdown of traditional communities, to escape an increasingly regimented economic order, or to fight the Victorian boogeymen of religion and patriarchy? Whatever the motivation, these young radicals have been seen as creating a golden moment of "lyrical" leftism whose creeds included socialism, feminism, free love, and modernism in art and literature. While Anderson saw the move to the center of the American modernist universe as essential to the *Little Review* and was determined to do what it took for the success of her magazine, Heap was another question. According to Anderson, Heap accepted the decision to move "in a coma of regret and indecision."[31] When the pair made the actual move to New York in January 1917, they checked in at the Brevoort Hotel, a favorite gathering place of Villagers when they were feeling flush, hanging out in the basement cafe. On entering their hotel room Heap threw herself down on the bed and refused to move. After unsuccessfully trying to cheer her up, Anderson left to search for permanent housing, returning later to find that Heap had not moved. She stayed in that position until the next morning.[32]

In spite of this dismal beginning, the couple found a home at 24 West Sixteenth Street. They rented four rooms on the second floor of the house, which had once belonged to William Cullen Bryant, a fact that pleased Anderson. Their happiness with the house was not diminished when they discovered they shared it with a funeral parlor and an exterminating business. To publish the *Little Review*, Heap and Anderson rented a separate studio at 31 West Fourteenth Street. As was always the case with Anderson's moves, the first order of business was interior decorating. In *My Thirty Years' War*, she lovingly recalls the design, colors, and textures of

their New York home. In the room set aside for conversation with visiting writers and artists, "the woodwork was pale cream, the floor dark plum, the furniture old mahogany . . . between the windows was a large reading table with a yellow lemon lamp." The most distinctive feature of the room was a large bed hanging from the ceiling by four black chains. This bed was mentioned in other autobiographies; William Carlos Williams wrote, "We poor males would stare at it timidly."[33]

Although their interior decorating seemed a nice fit with the bohemian style, Anderson went to great lengths to claim that she and Heap were "a great disappointment to the literati" and their fellow Villagers. They did not, she claimed, patronize bohemian "haunts," and were more interested in their private domestic realm. They began to "create a hearthstone . . . dedicated to the ceremonies of living." By "the ceremonies of living," Anderson meant keeping the house in the most perfect order. "We cleaned, scrubbed, dusted, cooked, washed dishes. We made our own fires, cleaned our hearths . . . did our own shopping—chose our own meats and vegetables—and as Jane had an intelligent old-fashioned prejudice against canned foods, hulled our own peas. We washed and ironed our own clothes. We cut our own hair—very well too." She and Heap did most of their housework because, as Anderson proclaimed without any sense of self-consciousness, "we could never afford a charwoman."[34] The women were so assiduous in their housekeeping that Djuna Barnes complained they washed their soap.

Cleanliness aside, evidence suggests that Anderson and Heap may not have been all that different from their Village neighbors. Scholarly studies and autobiographies point out that a large number of these young rebel bohemians were actually over the age of thirty, from middle and upper-middle-class backgrounds. In her memoir Susan Glaspell sums up a sentiment that could have easily come from Anderson's account of those years: "It seems to me we were a particularly simple people, who sought to arrange life for the things we wanted to do, needing each other as protection against complexities, yet living as we did because of an instinct for the old, old things—to have a garden, and neighbors, to keep up the fire and let the cat in at night."[35] Heap's impressions of her fellow Villagers include anything but dashing bohemians—many to her were frauds. It was a place, she wrote, invaded by "hundreds of little Cézannes, Yeats, Nijinskies and Bernhardts, boys and girls from all over the country who

couldn't pass school." Savaging the posing of the pseudo-bohemians, Heap charged they were driving up rents for real artists and were only interested in the Village as a place where they could "come upon the thrill of some yet undiscovered license."[36] She wrote Florence Reynolds, with whom she stayed in touch, that John Reed "looks like a fat fortyish version of your chauffeur Sam."[37]

As Anderson points out herself, however, by the time they moved there in 1917 the heyday of Greenwich Village was over. The entry of America into the First World War, four months after Anderson and Heap's arrival in New York, would harm the lyrical idealism of their generation's rebellion. Anderson and Heap would publish several antiwar editorials and articles. In one of the first, Anderson relied on her success in gaining attention for the San Francisco "Blank Issue" with a one-sentence editorial simply entitled "War." The page was blank except for one sentence at the bottom stating, "We will probably be suppressed for this."[38] Interestingly, Heap would emerge as the more active political voice, and the war was not her only concern. Her two-sentence review of Theodore Roosevelt's *The Foes of Our Household* illustrated her ability to write sly dismissals of what she viewed as silly or irrelevant. "This is an invaluable book," she wrote. "It is a compilation of all the outworn thought of the last two generations."[39] In a rare prose poem, "The War, Madmen!" Heap addressed not only the war but also other social ills with words that Goldman could have written. She wrote of "misery, forced famines, sweatshops, child labor," and "suppression of freedom of speech, leaks, lynchings, frame-ups, prisons." War, she wrote, meant "Millions for munitions. Starvation for millions," and the "glory" of war meant "Parades, cheers, flags: Wooden limbs, blindness, widows, orphans, poverty, Soldiers'-Homes, asylums."

In the same number, under the title "The Price of Empire," Heap informed readers that the two Richard Aldington poems in the issue, "Thanatos" and "Hermes of the Dead," "with their frail reticent sadness, were sent to [them] from the trenches. Why do poets keep on singing in a world that doesn't value them?"[40] A disgruntled reader complained to her, "These are times for men to be attending to more serious things than aesthetic oddities." Heap responded with a sneering put-down of establishment figures who fancied themselves supporters of the arts without understanding the meaning of art. "The above letter was written to us by

one of the front citizens of a large city, on his club stationery—a men's club where old Betties gossip and criticize women's clothes. . . ."[41]

One of Heap's articles, "Push-Face," contrasted an Emma Goldman anti-draft rally with a Red Cross fundraiser, prompting several furious responses and subscription cancellations. Heap recorded how police charged into the anti-conscription crowd "with raised clubs, teeth bared, and snarling . . . Nasty little Fords with powerful searchlights raced up and down and about the hollow square." "How much of this treatment," she asked, "will it take to obliterate every element of individuality amongst us?" She then described the Red Cross function attended by "plutocrats and artists" in Greenwich Village. "You can easily pick out the pluts; they look like figures from the wax works." The "artists" or people who were "costumed" as artists, clearly Greenwich Village slummers, did not fare better in Heap's view. She described one woman who "had short hempy hair; she was dressed in street gamin clothes; she was at least forty; her cheek bones were on line with her nostrils. No human head should be made that way; it's intolerable except in fish, frogs or snakes." Children from the slums behind Washington Square "were pushed in the face and told to get out, to move on, by policemen and some more rough fellows in khaki . . . because this was a fete for humanity."[42]

When America entered the war and Congress passed the Espionage Act of 1917, Anderson and Heap watched in dismay as fellow antiwar critics ran afoul of the new law. In July of that year the U. S. Postmaster officially deemed *The Masses*, a strongly antiwar socialist journal, as not fit for distribution in the mail. In August the *Little Review* ran a full-page ad from *The Masses* that urged readers to continue to buy the magazine from newsstands until their mailing rights were restored. In the fall of 1917, the editors of *The Masses* (including Anderson's Chicago mentor Floyd Dell) were indicted (leading eventually to two trials and two hung juries).[43]

While they bemoaned the experience of *The Masses*, Anderson and Heap were about to run into a censorship problem connected with the war but with a somewhat different twist. In October 1917 they published "Cantleman's Spring-mate," an antiwar short story by the British author and painter Wyndham Lewis concerning a soldier who loses his humanity through war, seduces a young woman, and ignores her subsequent pregnancy. The Post Office confiscated the issue, unbeknownst to Anderson and Heap until they started receiving complaints about undelivered *Little*

Reviews. Although the story was antiwar—it portrayed the brutal conse-
quences of war—the Post Office did not charge Anderson with violation
of the Espionage Act. Instead, the charge was a violation of Section 211
of the United States Criminal Code, otherwise known as the "Comstock
Law," which banned from the mail any "lewd, obscene, or lascivious, and
filthy book, pamphlet, writing or other publication." The law was notable
for including "literature" in the same category banning information con-
cerning conception and abortion.[44] Judge Augustus Hand, District Judge
of the Southern District of New York, upheld the decision of the Post-
master, stating, "The young girl and the relations of the man with her are
described in a degree of detail that does not appear necessary." When the
decision was handed down, Ezra Pound wrote "The Classics Escape," a
scathing commentary published in the *Little Review*, stating he found it
amazing that the law saw literature through the eyes of "Dr. Condom."[45]

In spite of the obscenity decision, Judge Hand did cite in a periph-
eral way the case of *The Masses*, indicating that the court must uphold
the decision of the Post Office as "conclusive" unless it appeared that "it
was completely wrong."[46] Anderson, Heap, and their lawyer, John Quinn,
believed the magazine was caught up in the government's crusade against
antiwar messengers. In the December issue of the *Little Review* Ander-
son printed the entire decision in her article, "Judicial Opinion (Our Sup-
pressed October Issue)." The article began with the claim that the law was
incompatible with art and literature. As she would in her later *Ulysses*
trial, she argued that there was no place for consideration of good or bad
morality in art. She insisted the *Little Review* "would have no function or
reason for being if it did not continually conflict [with] the prevalent art
values in America."[47] She further asserted that discussing art in a court-
room was inane because inhabitants of the halls of justice did not under-
stand that the artist "is a master of the mysterious laws by which words
are made into patterns or rhythms, so that you read them for the spirit
contained in the rhythms, which is the only way at getting to the context."
Finally, she concluded that the fact she was called "an iconoclast" for
making the arguments she did was a "measure of contemporary fatuity."[48]

Aside from exasperation over the confiscated issue of the *Little Review*,
Anderson and Heap's most personal and emotional wartime political
experience had to do with Emma Goldman, Alexander Berkman, and their
trial for violation of the Conscription Act the very same year. They went

to the courtroom where Goldman's trial took place and were angered by the hostility towards their friend. Heap's description of the trial in a long letter to Florence Reynolds demonstrates how personally the two women took the proceedings. "Mart," she wrote of Anderson, "is so crazy about the trial I can't even get her attention." When they went outside for the lunch break Heap stated, "Hod carriers working in the street yell out to us, 'I hope you are deported;' 'I hope you hang.' You know, the working men—the wolves that E. G. is trying to keep out of wolves clothing."[49] Once again, as in the San Francisco bomb case, their real ire was for so-called radicals who refused to show support by attending the trial. "Max Eastman won't do anything—makes excuses . . . Deansie [Harriet Dean from Chicago] never went near the court—is off for a week up the river—turned artist and cautious overnight."[50]

Heap and Anderson went to both jury selection and the trial itself, describing dramatic tensions in the courtroom. "We got into a fight. Far away down in the street somewhere a band played star-spangled. Mart, David Hochstein [Goldman's nephew] and I refused to stand. The Marshal yelled out, 'Stand up, everybody!' When we wouldn't, he grabbed David by the arm and threw him into the hall. Mart went up and told the District Attorney, Mr. Content, what had happened; he said, 'Well, that was too good for him—I think he should be shot.' And I made a speech to the bystanders who had sneered. I said, "You poor fools; must a man cheer at his relative's funeral?"[51]

Heap made other such speeches and penned a public letter to circulate within the city asking citizens to "PROTEST" by contacting the Assistant Attorney General and judge in the case. She signed the letter with Anderson's name, believing it would have more impact. Heap was earnest and forthright, shedding her droll *Little Review* persona for her friends: "Dear American Citizens!" her letter began. She pointed out that while "millions of other people in this country" were against the conscription bill, "Protesting became a crime overnight. They kept on protesting. Emma Goldman and Berkman are not conciliators nor will they be conciliated. The Government will have its way with them unless something is done at once. This is not an anarchist issue; it is the fight of every individual. They should be saved if for no other reason than for the conservation of courage in this country."[52] The letter led to Anderson's and Heap's eviction from their *Little Review* studio. Heap wrote to Reynolds, "If I were not so

mad I'd cry, but I am not mad; I am resigned. They have taken our studio away from us because of the letter, which was published in all the New York papers. I went to see John Quinn this morning; of course, there is nothing to do. I have just returned from the agents. No, we must go. The owners are good Americans and won't have that kind of publicity about their building."[53]

In addition to writing public letters and attending the trial, Heap wrote to friends for money to fund Goldman's and Berkman's defense. As much as they might have wanted to, Anderson and Heap were in no position to help financially. On top of losing their *Little Review* office, the question of money—both for the *Little Review* and their own living expenses— was a constant issue. In 1917 the journal had three thousand subscribers in the United States and Canada, not enough to keep the operation afloat. It is clear from Heap's letters to Florence Reynolds that she was sending the two editors money—most likely quite a considerable amount since Anderson wrote Reynolds directly promising they would repay their debts. No doubt after her long relationship with Heap, Reynolds was willing to help out in any way she could; she was also given tasks such as delivering *Little Reviews* to bookstores and collecting payments. To supplement subscriptions, Anderson opened a bookstore in the front room of the new *Little Review* office—"Sit by a fire and choose your books and perhaps even drink a cup of tea during your selection," she announced. "It will have all the books you want, or if you are the kind of person who wants books nobody else wants we can guarantee to get them for you within half a day."[54]

Anderson claimed that several people offered her endowments, but she was always on guard against editorial designs by the donor and therefore declined them. However, a few individuals made sporadic significant contributions without expecting any influence over the *Little Review*. J. S. Watson of the *Dial* would drop by the bookstore and offer a hundred-dollar bill for his purchase, declining any change. Anderson, nevertheless, became uncharacteristically shy about soliciting friends for help. "People," she wrote, "were very kind and had helped too often to be asked again."[55] Her Greenwich Village friends did try to help by holding a benefit concert at the Provincetown Theater. The event was a memorable night for those who attended, but so many impoverished artists were admitted free that it was not a lucrative evening. Rather than rely on her equally

poor associates, Anderson took a new approach and canvassed wealthy strangers. She bluffed herself past the secretaries of prominent business-men on Wall Street and asked for their support of "the most interesting review of modern art published in America today." Even Anderson was surprised that she actually had some success with this tactic but soon felt uneasy with what she called "these hold-up methods."[56]

The two editors tried to economize the expenses of publishing the *Little Review*. Anderson saved money by hiring the cheapest printer she could find in New York, a Serbian immigrant named Popovitch. They further reduced the fee by folding pages and doing the proofreading themselves. Such chores were necessary not only because of money but also because of Popovitch's poor command of English. The *Little Review* was plagued by typographical errors, which enraged Ezra Pound. He angrily asked Ander-son, "What the ensanguined lllllllllllllll is the matter with this BLOODY goddamnedblasted bastardbitchbornsonofaputridseahorse of a foetid and stinkerous printer????? Is his Serbo-Croatian optic utterly impervious to the twelfth letter of the alphabet???? JHEEZUSMARIAJOSE!!!"[57]

There were at least two occasions when the editors did not have adequate food and subsisted on only potatoes and biscuits for days at a time. The constant struggle for money eventually wore down Ander-son, impacting both her energy and her self-image. In *My Thirty Years' War* she wrote, "Tired of having no clothes, tired of being continually ugly, I dressed for dinner in the apartment in the only becoming garment I had left—a crepe de chine chemise. Draped in an old scarf and installed before the fire, I enjoyed the décolleté and talked better for the illusion of charm."[58] Without the close-knit circle of friends and contributors they had in Chicago, Anderson and Heap were also struggling to find provoca-tive material to publish. What they did publish was limited by their inabil-ity to pay for work or even to publish the *Little Review*.

Adding to the desperation of the situation, Anderson and Heap's rela-tionship once again became volatile. The tensions were apparent by the spring of 1917 when a wealthy Chicago woman invited them to spend the weekend at her Long Island home. One day while walking in the nearby town of Brookhaven, Anderson came upon the shell of a century-old house and was determined it would serve as the temporary quarters of the *Little Review*. She found the owner, rented the house for twelve dollars a month, and proceeded to make it livable. Her description of Brookhaven

was in some ways reminiscent of Mill Valley. The house, which was near the sea and had a garden, was to function as her special space for inspiring conversation. In her second autobiography, *The Fiery Fountains*, written forty years later, Anderson wrote, "Under the blue locust trees, in shadows of sun and mist, we continued our shadowy speculations."[59] However, the tone of the conversation in Brookhaven was sharper and more biting than in Mill Valley. At the time the two women were immersing themselves in psychoanalytic theory and, according to Anderson, "We could find the Achilles heel in everybody's psychic set-up—the psychoanalysts were inferior sleuths compared to us. We stuck pins into people."[60] It seems clear, however, that it was Heap primarily who was interested in sticking pins into Anderson. Attacking Anderson's character, both in speech and in writing, Heap seemed angered when she failed to provoke her partner. As Anderson recalled, "When she resorted to analyzing me and came upon facts too scathing to be spoken she would put them in a letter, under my door. It is certainly more painful to be pinned in a letter than in conversation—the telling phrase leaps out at you in a way that takes your breath. I always liked this. Jane still tells how, hoping to have reduced my self-esteem to a pulp, she would see a look of exaltation spread over my face. . . ."[61]

This rather curious statement suggests that Anderson was singularly unfazed by Heap's attacks. Years later she wrote to Djuna Barnes, asking, "Remember my cerebral excitement over the cruel critical letters Janie used to slip under my door?"[62] Perhaps she enjoyed Heap's volleys as an intellectual performance, while also exacting her revenge by not taking her seriously. In 1959 Anderson wrote to her friend, the pianist Allen Tanner, who was often a guest of the two women during those years, "There has never been anything reasonable about Jane, as you know. Remember one day in Brookhaven when you and I were seized with hysterics about one of her rages, and laughed all morning, unable to stop, which added to her fury?"[63] Whatever the reasons for her cool reactions, it is clear that Anderson had begun to distance herself from Heap, both professionally and personally. Anderson's loss of interest in the *Little Review* seemed apparent to Heap by 1918, as she assumed the burden of its work. Whereas in the summer of 1917 Anderson shared with her partner the long hours required for the magazine, by 1918 the situation had clearly changed. "Such a week as we have had," wrote Heap to Florence

Reynolds in 1917, "up about 7:30 and at it until one and one thirty—we addressed—wrapped & mailed the magazine here in my room—besides we got out 480 letters to prospective subscribers and pleas for renewals."[64] By the following summer, however, Anderson was avoiding their joint labor and Heap was growing angry. "Mart won't look at the magazine," she complained, "so I read proof and made the cover, etc. and went back and forth to the post office with it all—No meals—no practicing—such a mockery——such sickening pretensions."[65]

Anderson's indifference to the *Little Review* and her abandonment of Heap were both precipitated by the fact that she was seeing another woman. The affair with "Gladys" seems not to have been the first of Anderson's infidelities, but it affected Heap so dramatically that it threatened their life together as nothing else had. According to Heap, Anderson had betrayed their love by her attraction to Gladys. "If she were not born in the sex in which she was," wrote Heap bitterly, "she would go from one Gladys to another—whenever she is thrown with those people she has an affair. This summer she has dragged me into a situation where the lowest values of the mind have been operating."[66] By early fall of that year Anderson's behavior had left Heap feeling exhausted, hurt, and alone. "Where do I go next?" she asked Reynolds. "This summer I have suffered— I have worked harder than I have ever suffered . . . I have written nothing—made nothing—but I have lost something. I cannot lose much more? I am more of an exile than it is good to tell." She had decided "to cut out the whole connection," to leave both Anderson and the *Little Review*.[67] Anderson, unsurprisingly, viewed her affair with Gladys differently. Only through some "long talks" during which Heap expressed a desire "to be done with it all" did she come to realize the depth of Heap's devastation. To Anderson, what she felt for Gladys was "only . . . tenderness . . . [that] would pass." She distinguished between her feelings for Gladys—"only an attraction"—and "her love for [Heap, which] was the big thing." Heap was not mollified; she described Anderson's proclamations as "rotten talk."[68]

As time went on, Heap seemed to grow more philosophical about Anderson's new relationship. This suggests there may have been truth in the widely held belief that Heap and Djuna Barnes had an affair sometime between 1918 and 1920. Barnes kept a picture of Heap on her mantle and years later confided to a friend that she had feelings for Heap for a long

time.[69] Given her own unfaithfulness, it is hard to say how Anderson reacted to Heap's relationship with Barnes. It does shed light on her description in her first autobiography of feeling distant from Barnes, however, and indicates that it was Heap and not Anderson who was responsible for publishing Barnes in the *Little Review*.

Their first meeting in Chicago, their California sojourn, the move to New York, the vicissitudes of financial penury, and relationship contretemps contributed to an exceedingly tumultuous year. Despite this turmoil, things were about to take a dramatic turn for the better. Ezra Pound, the expatriate poet, would serve as their foreign editor and procure some of the finest modern writing from abroad. Imagism and anarchism would give way to the high modernism of Pound and Joyce, among others, and the next three years would be among the high points in the journal's entire history. The subject matter would increasingly become centered on literature embroiled in questions of esoteric philosophies and thought, pushing Anderson and Heap closer to what they would see in retrospect as the most critical influence in their lives.

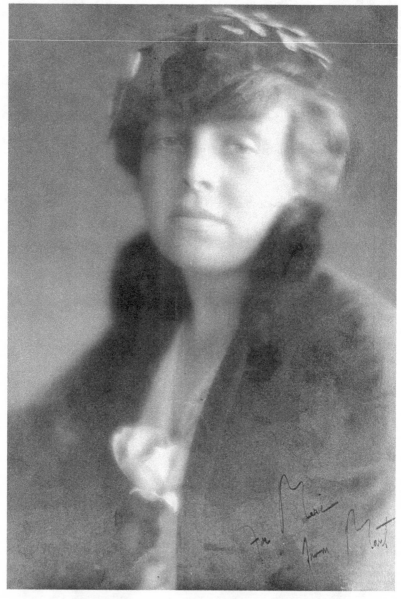

Figure 1. Eugene Hutchinson, Photograph of Margaret Anderson, ca. 1916. The Elizabeth Jenks Clark Collection of Margaret Anderson. Yale Collection of American Literature, Beinecke Rare Book and Manuscript Library [YCAL MSS 265, Box 18, folder 329–331].

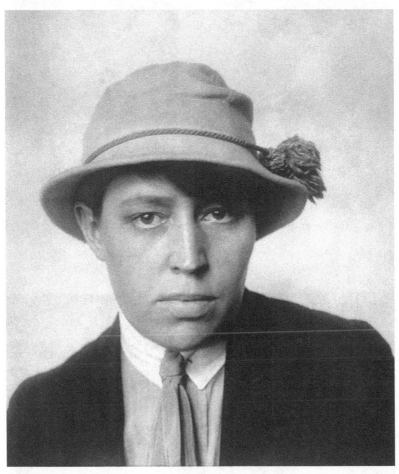

Figure 2. Photograph of Jane Heap, ca. 1908–1918. MSS 258 Florence Reynolds collection related to Jane Heap and *The Little Review*, Special Collections, University of Delaware Library, Museums and Press, Newark, Delaware.

Figure 3. Photographs of Margaret Anderson (left) and Jane Heap (right), 1918. Private Collection.

Figure 4. Photograph of the Heap Family, n.d. Author's collection.

Figure 5. Photograph of Jane Heap in costume for the Little Theatre, Chicago, n.d. [1912–1917]. Author's collection.

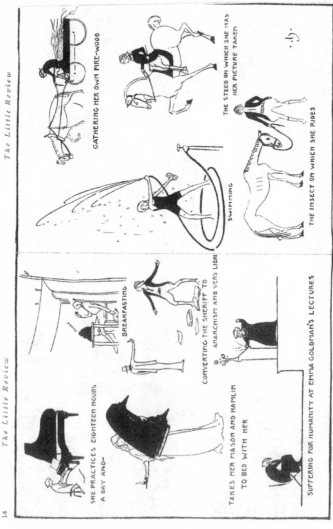

SHE PRACTICES EIGHTEEN HOURS
A DAY AND—

GATHERING HER OWN FIRE-WOOD

BREAKFASTING

THE STEED ON WHICH SHE HAS
HER PICTURE TAKEN

TAKES HER MASON AND HAMLIN
TO BED WITH HER

CONVERTING THE SHERIFF TO
ANARCHISM AND VERS LIBRE

SWIMMING

THE INSECT ON WHICH SHE RIDES

SUFFERING FOR HUMANITY AT EMMA GOLDMAN'S LECTURES

"Light occupations of the editor [Margaret Anderson] while

Figure 6. Jane Heap, "The Light Occupations of the Editor while There is Nothing to Edit" [cartoon of Margaret Anderson in Mill Valley, CA]. Published in *The Little Review*, September 1916, 14–15.

Figure 7. Photograph of Margaret Anderson and Jane Heap in Brookhaven, NY, 1918. Collection of the University of Delaware Special Collections, Newark.

Figure 8. Photograph of Jane Heap in Brookhaven, NY, 1918. Collection of the University of Delaware Special Collections, Newark.

Figure 9. Photograph of Margaret Anderson in Brookhaven, NY, 1918. Collection of the University of Delaware Special Collections, Newark.

THE LITTLE REVIEW

A MAGAZINE OF THE ARTS

MAKING NO COMPROMISE WITH THE PUBLIC TASTE

"ULYSSES"

by

JAMES JOYCE

Figure 10. Cover of *The Little Review* featuring "Ulysses" by James Joyce, March 1918.

STELLA NUMBER.

Figure 11. Cover of *The Little Review*, "Stella Number," September 1922.

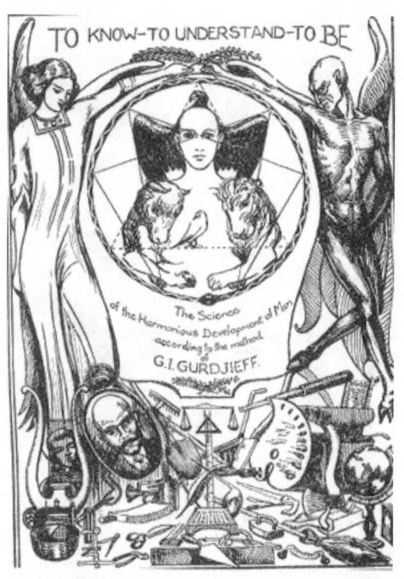

Figure 12. Alexander De Salzmann, cover design for the prospectus of George Gurdjieff's Institute for the Harmonious Development of Man, 1922.

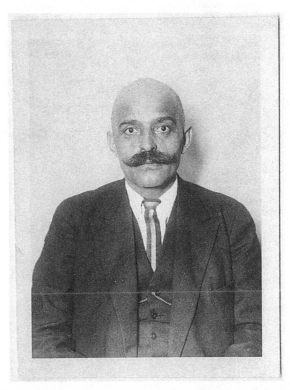

Figure 13. Photograph of George I. Gurdjieff. Elizabeth Jenks Clark Collection of Margaret Anderson, Yale Collection of American Literature, Beinecke Rare Book and Manuscript Library.

To obey is the way to self command

Postures = positions of rest

Style of Movements + postures = forms of Thinking and Feeling Must change mental and emotional postures in order to change moving

Fear, etc. can be created by change of posture

External command takes place of Mental and Emotional centres and thus enables weak Will to control moving centre

Cinema as an aid –
Break circle and go somewhere

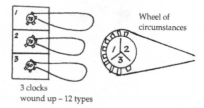

Wheel of circumstances

a – Eternity
b – Recurrence
c – Succession

3 clocks
wound up – 12 types

Struggle between "it wishes" and "I wish".

4 Elements: Yes: No: Dispute: Result

i.e. resolution of 2 into 4

Every such dispute in us must lead to Development i.e. new function of the mechanism

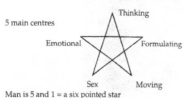

5 main centres

Thinking

Emotional

Formulating

Sex Moving

Born 1896

Snake
tail in mouth

Man is 5 and 1 = a six pointed star

7 basic notes in octave

8 including top "Do", = 2 X 4

7 + 2 special interventions = 9

7 + Do + 2 = 10

A Symbol 1) Summarises for one who knows
2) Awakens knowledge.

Your life a circle in Time –
Death merely a sign that wheel has turned past and future chairs. See oneself in future as well as in past –

Figure 14. Heap's notes on George Gurdjieff's "fourth way." Reproduced from *The Notes of Jane Heap* (Reading, PA: Two Rivers Press, 1994), 95.

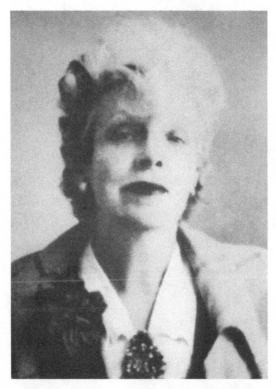

Figure 15. Margaret Anderson's passport photo, 1942. Private collection.

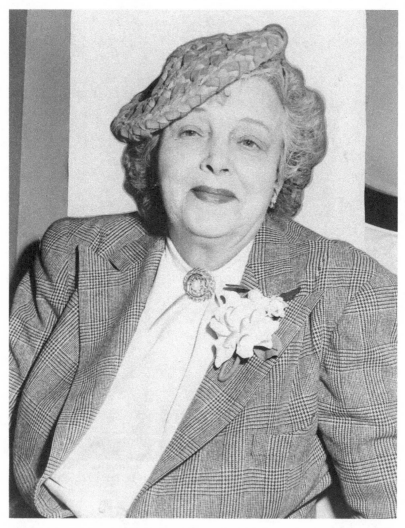

Figure 16. Photograph of Margaret Anderson by Dick Demarsico for the *New York World Telegram & Sun*, 1951. Library of Congress, Prints and Photographs Division, NYWT&S Collection [LC-USZ62–112044].

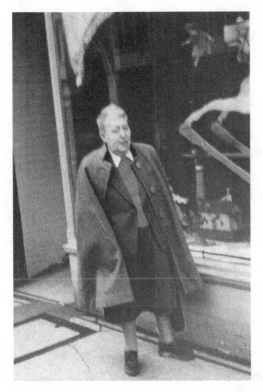

Figure 17. Photograph of Jane Heap in London, n.d. Author's collection.

Figure 18. Cover of *The Little Review*, "Exiles' Number," Spring 1923.

Figure 19. Cover of *The Little Review* advertising the International Theatre Exposition, Winter 1926.

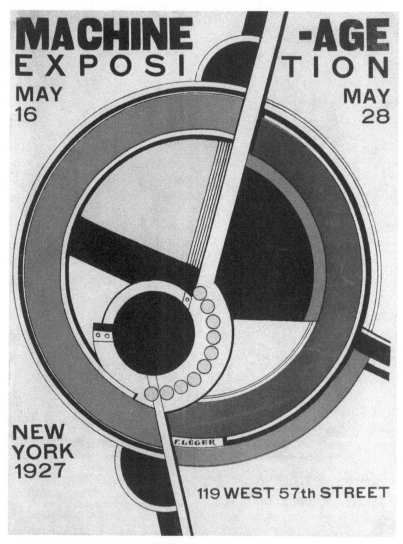

Figure 20. Cover of *The Little Review* advertising the Machine-Age Exposition, May 1927.

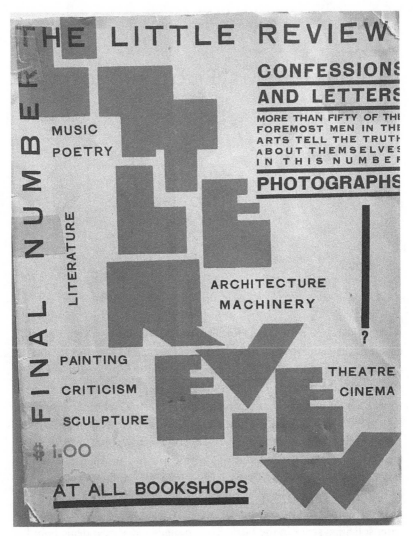

Figure 21. Cover of *The Little Review*, "Final Number," Spring 1929.

5

POUND, YEATS, ELIOT, AND JOYCE

Margaret Anderson and Jane Heap had mixed feelings about Ezra Pound's tenure as the *Little Review* foreign editor between 1917 and 1919. On the one hand, to Anderson, this "middle phase" of the three eras of the *Little Review* was the most vital stage of the magazine. It culminated in Pound's forwarding of Joyce's *Ulysses*, which was responsible in her view for making the journal a "legend."[1] On the other hand, even the most loyal *Little Review* subscribers were strongly put off by Pound's contributions, arguing that, in an almost rabid fashion, he fostered an anti-American tilt that was decidedly obnoxious. Heap both defended Pound and piled on her own criticism. In their introduction to the published Pound-Anderson correspondence, Thomas Scott and Melvin Freidman noted that Pound's first letter soliciting space in the *Little Review* suggested a great deal about his view of Anderson as an editor. "In his words," they wrote, "we glimpse his perception of the *Little Review* and its editor: 'sporting,' willing to risk the irritation of those readers who were unable to read French, open to the experimental, flexible to adjust the magazine's format to the material to

be printed, and indifferent to accusations of appearing 'too European.' "[2]
Pound's assessment was for the most part accurate. On November 29,
1916, he sent Anderson a proposal to serve as the *Little Review's* foreign
editor. Remarking on her impending move to New York, he asked, "Why
stop at New York? London and Paris are quite as interesting, even in war
time." The following sentence admits, "I am writing really to ask whether
there is any use [in] my trying to help the L. R. If you want me to try, etc."[3]
Anderson and Heap hailed the offer.

In January 1917, shortly after the two had met in New York to out-
line the conditions of their arrangement, Pound wrote Anderson again.
"I want an 'official organ' (vile phrase). I mean a place where I and T. S.
Eliot can appear once a month (or once an issue) and where James Joyce
can appear when he likes, and where Wyndham Lewis can appear if he
comes back from the war." He pressed for five thousand words per issue
and a pledge from Anderson that the *Little Review* would be published at
least eight times a year. In exchange, he offered a "prospective guarantor,"
a "Mr. X," who would donate money to pay the contributors that Pound
could secure.[4] Mr. X was John Quinn, a New York attorney, collector,
and patron of the arts who agreed to provide financial backing for the
Little Review. Quinn was a significant presence in New York art circles
and Democratic politics. He contributed to the 1913 Armory Show and
persuaded Oscar Underwood to exempt modern art from the 1913 Tariff
Act. Although some have portrayed Pound and Quinn as plotting a "take-
over scheme" of the *Little Review*, Pound was exceedingly candid about
the extent of his desired involvement. He conceded that all his conditions
sounded "very dictatorial" but added, "I don't mean it that way."[5]

Anderson and Heap did not feel threatened that Pound might assume
too large a role within the *Little Review*. Their move to New York left a
vacuum in their pool of contributors; they no longer could rely on a ready-
made circle of friends such as they had in Chicago. One of Anderson's
reasons for moving to New York was to make the *Little Review* "an inter-
national organ," and Pound was just the person to make that happen.[6] In
her announcement of Pound's addition to the magazine in the April 1917
issue, she wrote that it was "the most stunning plan that any magazine has
had the good fortune to announce for a long, long time. It means that a
great deal of the most creative work of modern London and Paris will be
published in these pages."[7]

An assessment of pre-*Little Review* influences on Pound, his contributions, and the material of others he forwarded, particularly that of French poets as well as of W. B. Yeats and T. S. Eliot, begs the question of how much sway the occult as a topic held for him.[8] The year he became foreign editor in 1917, Pound was already under the sway of Joséphin Péladan, a French Rosicrucian of the late nineteenth and twentieth century who traced Greek drama from its beginnings in the mysteries of Eleusis Orphism, Dionysus, and Pythagoras.[9] The word "alchemist" often arises in conjunction with Pound—Timothy Materer in *Modernist Alchemy* argues that Pound's "use of alchemy has been less explored (than Yeats), even though it was one of his longest continuing occult interests. Through the tradition of alchemy, he developed his conception of 'master of the soul' as poet as well as magus."[10] It is also possible to glean the influence of Allen Upward's works, *The New Word* (1908) and *The Divine Mystery* (1913), where he argues the existence of a superior caste of the enlightened living among commonplace souls. Pound was influenced not only by Upward but also by G. R. S. Mead, the founder of The Quest Society.

Pound's interest in the esoteric influenced his view of modernism as parallel to ancient secret societies of initiates protected from the unknowing unwashed outside. Leon Surette argues that *The Cantos* are intended for initiates "or perhaps more accurately for those whom the poem itself can initiate into the mysteries it obscurely manifests."[11] Between 1917 and 1919 Pound was in a creatively dry period.[12] His *Little Review* contributions included criticism, poems, prose pieces, and one drama, basically all considered weak by contemporary scholars. Anderson found his criticism in this period to be better than his poetry, writing in *The Little Review Anthology*, "I usually prefer Pound as a critic to Pound the creator."[13] She had written him that his prose piece "Jodindranath Mawhwor's Occupation" was "no good." In response Pound wrote that he was sorry she did not like it, but he was trying to "put [his] prose stuff into some sort of possibly permanent form."[14] Four pages later in the same letter he returned to the subject: "I wonder if the beastly Jodindra [sic] goes too fast on paper, and if it is only good when read with a very retarded utterance (as I read it). If that's the bloody matter."[15] Nevertheless, he was defensive about Anderson's criticism, protesting, "Still, the first [paragraph] in section 3 is yes, hang it all, IS an excellent paragraph, and the fourth sentence is

an excellent sentence. The beginning of that section is at least decently written."[16]

The February 1918 issue, entitled "A Study of Modern French Poets," was dedicated to the work of fourteen poets accompanied by Pound's critical commentary. It is considered one of Pound's more nuanced pieces of criticism, responsible for introducing important poets to American audiences; the issue gained notice (if not notoriety) for his and Anderson's willingness to print the poems entirely in French. Although Pound addressed the work of dozens of poets, a few shed light on his debt to the esoteric: Jules Laforgue, Jules Romains, Remy de Gourmont, and Jean de Bosschere. Pound also used half of the February–March issue of 1919 to further concentrate on de Gourmont and de Bosschere and published translations of Romains in other issues. Arthur Rimbaud was also clearly a hero of his. Though Pound's comments about him were brief in the "Modern French Poets" issue, he translated Rimbaud's "Six Illuminations" in a later issue of the magazine.

Jules Laforgue was a French Symbolist, an admirer of Walt Whitman, and a poet who greatly influenced Pound and T. S. Eliot. Known for his pessimistic sense of irony and his certainty in the power of the subconscious, he was also appreciated as an artist who demonstrated a reflective understanding of modern aesthetics. He was, wrote Pound, "an angel whom our modern poetic Jacob must struggle with."[17] Jules Romains was the founder of the Unanimism movement, which advocated the existence of a collective consciousness and viewed individual artists as part of a "collective soul" that influenced their work. Prior to World War I, Romains founded the Abbaye, a community of artists based on Unanimism. Unanimism was similar to Pound's idea of artists as a particular group of initiates. Like Gurdjieff's Institute for Harmonious Development for Man, Romains's Abbaye was in a Paris suburb. Both Romains and Gurdjieff concentrated on the complexities of the intersection between individual personality and communal society. Pound paid the French poet the ultimate compliment when he wrote, "The group centering in Romains is the only one which seems to me any where nearly so energized as the Blast group in London."[18] While similar in style to Laforgue and Romains, Remy de Gourmont was a poet who was most influential as a critic. One of the *Mercure de France* founders, de Gourmont was also a close friend and associate of Joris-Karl Huysmans, a personal favorite of

Heap. Like Anderson, de Gourmont believed that the professional critic should be individualized and passionate; he argued that criticism is analogous to other art forms. Particularly of interest to Anderson and Heap were his essays in the *Lettres à L'Amazone* (*Letters to the Amazon*, 1914), written about his conversations with the American lesbian expatriate Natalie Clifford Barney.

Pound had met the author and painter de Bosschere in London where he was escaping World War I. De Bosschere's work was marked by an enthrallment with the occult that combined spiritual and sexual elements; his erotic illustrations included the works of Ovid and Oscar Wilde. Accused of Satanism, de Bosschere proudly entitled his 1933 autobiography *Satan l'Obscure*. Two other poets Pound selected for the issue have particularly intriguing connections to the occult: the American symbolist poet Stuart Merrill, who mainly wrote in French, was a follower of Whitman and a public supporter of anarchism and Wilde; and the poet Stanislas de Guaita undertook a resurrection of the Rosicrucian Brotherhood by founding the Cabalistic Order of the Rosicrucian in 1888.

Like many of the moderns, Pound was influenced by Eastern culture and art. His major contribution came in 1919 when he published the sinologist Ernest Fenollosa's notes on "The Chinese Written Character as a Medium for Poetry" in four installments at the end of the year. Pound wrote in the *Little Review*, "Like nature, the Chinese words are alive and plastic because *thing* and *action* are not formally separated."[19] He read Confucius as he put the finishing touches on Chinese style poems he would publish in *Des Imagistes* (1914) and dug into "oriental esoteric" reading such as Japanese and Chinese history and literature.

It was only natural that Pound would forward the poems of W. B. Yeats to the *Little Review* given their history together. Pound had served as Yeats's private secretary in the south of England during the winters from 1913 to 1916, and at Stone Cottage in Sussex they developed a relationship of mutual respect. Anderson and Heap had been great admirers of the Irish poet since their youths and were delighted to have his work appear in their journal. Anderson's first reference to Yeats came in the second issue of the *Little Review* as he was touring America. She reprinted parts of "William Butler Yeats to American Poets," his speech during a Chicago visit originally printed in Harriet Monroe's *Poetry*. In a brief introduction, Anderson reported, "He took occasion to warn his

confreres in America against a number of besetting sins."[20] The particular selections of his speech that she chose to reprint foreshadow Pound's later tenure as foreign editor, including passages in which Yeats went to great lengths to laud French poets. As we know from her letters, Heap was a follower of Yeats as a young woman, and she played King Conchobar in Yeats's "On Baile's Strand" for Chicago's Little Theater. Pound secured a total of twenty-one poems from Yeats for publication in the *Little Review*, including "Upon a Dying Lady," "In Memory of Robert Gregory," and the play "The Dreaming of Bones," all published between 1917 and 1918. Anderson included "The Wild Swans at Coole" and "Presences" among her favorites in *The Little Review Anthology*.

Yeats's history with the occult is well documented. After reading A. P. Sinnett's *The Occult World and Esoteric Buddhism*, he became a Theosophist and began a pattern of joining and then quitting a variety of esoteric organizations. At various times he was a member of the "inner lodge" of the Esoteric Section of London's Theosophical Society, the Dublin Lodge of the Hermetic Society, and The Order of the Golden Dawn. While the Hermetic Society was based on the teachings of Hermes Trismegistus, The Order of the Golden Dawn practiced theurgy, the practice of magic by soliciting the aid of the supernatural for one's everyday life. Under official tutelage, the Golden Dawn gave Yeats an insight into practical magic, ritual, and ceremony. In Yeats's universe, the poet was the conduit between the spiritual realm and earth. In 1890, the same year he was formally initiated into the Golden Dawn, Yeats co-founded The Rhymers' Club with Ernest Rhys. Other prominent members included Arthur Symons, Lionel Johnson, and Ernest Dowson, the latter a favorite of the young Heap. Oscar Wilde occasionally attended their meetings. While the club was a venue for poets to read their work to one another, the major attraction was their mutual belief in the autonomy and superiority of the artist as argued by the Pre-Raphaelites, Wilde, and Walter Pater. Like Pound's notion of an artistic community as a secret society of sorts, Yeats's vision of the Rhymers' Club had them as an illustrative embodiment of the same circle of kindred spirits. In his book on the three winters Pound and Yeats spent in Stone Cottage, James Longenbach argues that while it has long been posited that "Pound transformed Yeats from the whispering poet of 'The Wind among the Reeds' to the stark modern poet of 'Responsibilities,'" new interpretations suggest that Yeats was a significant influence

on the younger poet rather than the reverse.[21] Longenbach claims that "the occult studies Yeats shared with Pound provided the younger poet with confirmation of his own esoteric doctrine of the Image."[22] He points out that "the metaphors of secret societies serve to characterize the Stone Cottage writers well because Pound and Yeats used the metaphors themselves. No matter what their interests or activities, one keynote echoes throughout the work: the opposition of the artist's aristocratic 'state of mind' . . . to the unpurged sensibility of the 'mob.' "[23] Pound in his *Cantos* later looks back with fondness on a small circle of men and women he saw as such a privileged society; Yeats delivered the dream.

Nevertheless, Pound's interest in Eastern literature and philosophy, particularly his study of the Chinese ideogram and Japanese Noh plays and other such sources, would profoundly affect the elder poet. At Stone Cottage, his translations of Japanese Noh plays introduced Yeats to the form and inspired him to undertake his own attempt to write Noh plays. "The Dreaming of the Bones," published in the January 1919 issue of the *Little Review*, was generally regarded as the purest expression of Yeats's Noh plays and of his "belief in the soul's dreaming back through the most passionate moments of its past life." Heap wrote to Florence Reynolds that it contained "lines to make you weep."[24] During the same period, Yeats studied Irish folklore and spiritualist literature, producing the two essays, "Witches and Wizards in Irish Folklore" and "Swedenborg, Mediums, and the Desolate Places." Pound and Yeats realized that their studies were linked; correspondences between folk legends could be found not simply within the Western tradition but with the traditions of the East as well. "Everything Pound and Yeats studied at Stone Cottage was chosen for its esoteric value: Noh plays, Chinese poetry, Western demonology, even Lady Gregory's folklore, in their efforts to separate themselves from what they perceived as an ignorant public."[25] They were the esoteric elite.

At the same time Yeats appeared in the *Little Review*, Pound sent Anderson and Heap the work of T. S. Eliot, including most of the poetry he wrote during that period. The magazine published a total of eight poems by T. S. Eliot, including "Sweeney among the Nightingales," "Mr. Eliot's Sunday Morning Service," and "Lune de Miel." His 1919 volume, *Poems*, was composed of all the work he had published in the *Little Review*. The influence of Eliot's religious conservatism on his work has been noted at length. However, several scholars now endorse the notion

that while he publicly rejected the occult, he was nevertheless fascinated, if not obsessed, by it. Eliot acknowledged the profound influence of Arthur Symons' *The Symbolist Movement in Literature* on his creative development, particularly introducing him to the work of the French poets Laforgue and Verlaine, whom Pound triumphed in the pages of the *Little Review*. In his book, Symons discusses Auguste Villiers de l'Isle-Adam, Pythagoras, Hermes, Boehme, and Swedenborg—all direct influences on Gurdjieff's philosophy. Eliot's short story "Eeldrop and Appleplex," published in two *Little Review* issues (May and September 1917), was one of Anderson's favorite works; she later republished it in the *Little Review Anthology*. Although not considered by critics to be anywhere near his best work, the story—whose characters are said to be based on Eliot (Eeldrop) and Pound (Appleplex)—gives us a glimpse into Eliot's mystical leanings and his view of Pound. His Eeldrop/Eliot is "reflective, with a taste for theology and mysticism," while Appleplex/Pound is the materialist.[26] Between 1910 and 1922, Eliot had a number of experiences that led him to further investigations of spiritualism, mysticism, and the occult. As an undergraduate at Harvard, he read closely books that dealt with the metaphysical and mystical, including William James's *The Varieties of Religious Experience* and Evelyn Underhill's *Mysticism: A Study in the Nature and Development of Man's Spiritual Consciousness*; he also wrote graduate papers on Henri Bergson. According to Lyndall Gordon, in 1910 Eliot experienced a "vision" in the streets of Boston; people were "shrinking and dividing" before his eyes, an experience he recorded in his poem, "Silence."[27] Donald J. Childs argues that Eliot deliberately engaged "Theosophists, psychical researchers, fortune tellers, astrologers, therapeutic spiritualists—Eliot had personally met examples of them all by 1917."[28]

In 1914, he met Yeats in London and they discussed the occult. By 1920 he had attended séances sponsored by Lady Rothermere; his wife Vivien Eliot scornfully described Lady Rothermere a year later as living "in that asylum for the insane called La Prieuré where she does religious dances naked."[29] The séances were conducted by P. D. Ouspensky, who became George Gurdjieff's indispensable acolyte. Anderson and Heap were introduced to Ouspensky's book *Tertium Organum* shortly before they became aware of Gurdjieff. Another Gurdjieffian connection Eliot made in his early years in London was A. R. Orage, editor of *The New Age*, a journal of literature and politics that was the British version of

the *Little Review*—provocative and radical. Orage was a Theosophist and Fabian who became a follower of Gurdjieff during this same period. He was universally admired for his erudition in political, literary, and mystical subjects. Eliot's 1934 obituary for Orage is revealing. He admits "disdain" for Orage's mystical beliefs and at the same time writes, "Perhaps my own attitude is suggestive of the reformed drunkard's abhorrence of intemperance."[30] In addition to the work of French poets, Yeats, and Eliot, Pound sent Joyce's *Ulysses* manuscript to the *Little Review*, an effort that proved controversial and exhausting for all involved. Pound would announce his departure from the *Little Review* before all the *Ulysses* chapters were published and before the resulting trial of Anderson and Heap for publishing obscenity. His departure was due in part to his exasperation with American attitudes toward literature and art—many of them expressed by faithful *Little Review* readers. Anderson had liked Pound's debut editorial in the May 1917 issue for its attack on the genteel tradition, including strong criticism of Harriet Monroe and *Poetry* for "unflagging courtesy to a lot of old fools and fogies whom I should have told to go to hell."[31] His colorful tirades included arguing the lack of American appreciation for Jules Romains. "Certain fusty old crocks have pretended to look after 'culture,' they have run fat, dull, and profitable periodicals for their own emolument, or emollition, and is for the cardboardizing of the American mind."[32] Anderson and Heap were strong supporters of Pound, yet nevertheless dismayed by some of his more vitriolic pronouncements. Eventually, like their *Little Review* followers, they were happy to see him go.

Though some *Little Review* readers had appreciated Pound's efforts, most of the letters published in the "Reader Critic" section shortly after his arrival lambasted the new addition. Mrs. "O. D. J.," wrote in the June 1917 issue, "I have great faith in the artistic life of America and I don't think Ezra Pound's notions of it are very healthy. I sincerely hope the trend of it will not emulate the 'smart' or dissipated literature which seems to please London and which can hardly come under the head of 'good letters!' "[33] The following month, Louis Puttelis of Cambridge, Massachusetts, wrote that Pound was "below your earlier standard—almost below zero. What sympathy can the majority of readers feel for the foreign editor, Ezra Pound, with his contemptuous invective against the vulgus?"[34] In the same issue, "I. E. P." from White Plains, New York, wrote,

"Your magazine is rubbish, disappointingly insipid, heavily stupid." The crux of most of the complaints was the predominance of writers from abroad."[35] "H. C. L." from Chicago wrote, "I wish you didn't have such a craze for foreigners and self-exiled Americans. I think you have missed your chance right here in your own country."[36] "V. H." from Maine protested, "It's so damned British!"[37]

The emerging debate over the role and ability of American artists versus those from Europe dated back to the early republic. Its equivalent in the early twentieth-century struggle between "literary nationalists" and European partisans was played out on the pages of the *Little Review* with genuine passion. However, this debate had another component—challenging or "incomprehensible" art as opposed to art that was accessible to the average reader. This dichotomy raises the question of modernism as a reactionary or progressive force. Although Anderson tended to side with Pound in these debates, Heap exercised more independent judgment. Heap did come to Pound's defense when *Little Review* readers and other critics first attacked him, but as time went on she began to note her displeasure with what she saw as his more obnoxious statements. Moreover, though she would later energetically procure the work of European painters and sculptors for reproductions in the journal, she was also responsible for the two "All American" numbers of the *Little Review* published in June and December of 1918.

The argument has persisted that Pound dominated the *Little Review* by dictating to Anderson and Heap from across the Atlantic. There is no question that he was tireless and sincere in promoting the work of talented writers and in exposing their literature to the American reading public. However, Anderson and Heap often turned down his suggestions for publication, including his own work. Many letters reveal the depth of loyalty *Little Review* readers had for the pre-Pound publication. One fan, identified only as "An Old Reader," proclaimed that after reading the debut issue in 1914, "The *Little Review* was my religion; it converted me to a faith in a New America; it inspired me to dreams and creative work. It was my First American sweetheart." Then one night the Old Reader was "awakened by an apparition wailing, 'Help! Margaret Anderson is murdering me!'. . . Was it the spirit of the *Little Review*? For surely the spirit of the old *Little Review* is dead." Pound was, of course, the reason. "An Ezraized *Little Review* will have no

appeal to Young America," the Old Reader predicted. "I hope that you will soon tire of your over-sophisticated associates and drive them out of the sanctuary."[38]

Even American contributors to the *Little Review* were unhappy about the new turn. Maxwell Bodenheim wrote a letter in the June issue, complaining that Pound's statement that T. S. Eliot was "the only really creative poet brought forth during recent times" was "absurd." Bodenheim named H. D., John Gould Fletcher, Marianne Moore, Carl Sandburg, William Carlos Williams, and Wallace Stevens as "not inevitably below Eliot in quality of work."[39] As may be expected, Pound's old adversary, Amy Lowell, was less than happy to see his influence over the *Little Review*. When Anderson wrote her in the summer of 1917 soliciting poetry for future issues, Lowell's reply was blunt: "I am awfully sorry to disappoint you, but I am going to tell you the truth. I do not want to put anything in your magazine while you are running those men so hard. Much as I admire Ezra Pound's work, I do not like his attitude, and I feel the same about the other contributors, only in most cases without the admiration." Lowell told Anderson, "[I] always had a strong feeling of friendship for you and an interest in the 'Little Review,' and I wanted to do all I could for it, but when you went over bodily to my bitterest enemies, although it in no sense disturbs my feeling of friendship nor my relations with you, it does disturb my relations to the magazine, and so long as you continue to give such prominence to these men, I do not feel like appearing in it." She added, "Should you ever change your policy, I should of course, reconsider my point of view."[40]

What was the response of Anderson and Heap to this onslaught of criticism by previously loyal readers and contributors? Heap replied directly to some negative letters in the Reader Critic section. In her response to Mrs. O. D. J. in the June number, she wrote, "Fear not, dear ones. We have learned to be penny wise; we will not be Pound foolish. We agree with Pound in the spirit; if we don't always agree with him in the letter be sure we will mention it. And Pound didn't slip up on us unaware. A mutual misery over the situation brought us together."[41] Responding specifically to Mrs. O. D. J.'s worry that Pound's notions of the artistic life in America were "unhealthy," Heap wrote, "The unhealth is in the artistic life of America, and whatever the ailment, bitter and acid medicine seems necessary to cure it."[42]

In the same issue, Anderson devoted an entire article, "What the Public Doesn't Want," to critics of the new *Little Review*. Anderson acknowledged that in the first few years of publication the magazine had only "irregularly" attained her goal of "Art and good talk about Art." She conceded that the journal might have suffered due to the distraction caused by "my concern about various matters," a specific reference to her previous dedication to anarchism. She saw Pound's influence as instrumental to the salvation of her original goal. "And now, after working through unbelievable aridness the *Little Review* has at last arrived at the place from which I wanted it to start. At least we are printing stuff which is creative and inventive and, thank heaven, not purely local." The audience's reaction, she stated, was resentment. She reported that the circulation of the *Little Review* was actually growing "in spite of criticism and misunderstanding."[43]

As time went on, however, it appears the unhappiness of their readers with Pound's influence did have some influence on Anderson and Heap. Heap was the driving force behind issuing an "All-American" number; by the spring of 1918, both women were writing to American artists soliciting contributions. Their letters suggest they were quite sensitive to the charges that they were biased toward European artists. Anderson wrote Amy Lowell once again pleading for some poems. "Please don't think I'm trying to be a pest," she began apologetically, "but I can't avoid asking you if you'd like to appear in our All-American number. The June issue is to contain *none* of the Englishmen (with the possible exception of Joyce, whose novel is to appear serially), but is to be turned over entirely to work that we can get on this side. Pound and Lewis and the rest won't have a line in!—the object being to prove that as good or better work can be found here. If the thing's a success we shall have American numbers at regular intervals."[44] Lowell agreed and sent her the poem "Dreams in War Time." Heap went so far as to write Mitchell Dawson, who was busy training in the U. S. Ambulance Service during World War I, for a contribution. "Can you send us some work? Those English are putting it all over us."[45]

Other contributors to the All-American number included William Carlos Williams, Carl Sandburg, Wallace Stevens, Ben Hecht, Sherwood Anderson, and Djuna Barnes. The reactions to the number ranged from tremendous enthusiasm—"simply superb" and "the best yet"—to disdain

from devotees of European writers who saw it as evidence that American artists were indeed inferior. "X. T." wrote, "Cut out the American stuff, please!" Morris Reisen described it as "very nondescript. Highlights mixed with the weirdest sort of rubbish. I wondered if you conceived the number because you knew it would be a humorous answer to those who criticize you for printing too much foreign stuff?"[46]

By June of 1918, Pound had served as foreign editor for a little over a year and was keenly aware of the controversy he inspired. The following month he wrote an article entitled "Cooperation," which reviewed his contributions, addressed his critics, and threatened his departure if his role as foreign editor did not prove more lucrative. In his article, Pound complained that though he had managed to publish the work of Eliot, Yeats, Joyce, Lewis, and Ford, the American reading public was unimpressed. "The response has been oligarchic. The plain man in his gum overshoes, with his touching belief in W. J. Bryan, Eddie Bok, etc. is not with us."[47] Pound informed *Little Review* readers that he was making little money for his efforts on behalf of the journal, and his editing kept him from his own creative work. "There are," he wrote caustically, "plenty of voices ready with the quite obvious reply that nobody wants me to continue my hideous career as either author, editor, or journalist. I can, in imagination, hear the poluploisbious twitter of rural requests for my silence and extinction." However, he felt there were also people who valued his talents as a poet. He concluded his article: "Either the *Little Review* will have to provide me with the necessities of life and a reasonable amount of leisure, by May 1, 1919, or I shall have to apply my energies elsewhere."[48] Pound had complained to Anderson before that he was feeling overwhelmed sponsoring the work of others and was unable to devote time to his poetry. When he sent Anderson the "Cooperation" article, he explained it was a "harangue to the plebiscite" and a plea for additional subscriptions to help "pay for our piping."[49]

From the fall of 1918 to the spring of the following year, the time of his threatened departure, it became clear that Pound was losing the support of Heap. The evidence for this can be found in a controversy over an article about Chicago poets entitled "The Western School" by the British critic Edgar Jepson. Harriet Monroe initially commissioned the article for *Poetry*, then refused to print it. Monroe stated she would not publish the article because it was not criticism but merely

"opinionating."[50] Pound printed a condensed version of Jepson's article in the *Little Review* and added in a postscript that Monroe had turned it down because of Jepson's "lack of flattery" in reviewing the works of such Chicago based poets as Vachel Lindsay, Edgar Lee Masters, and Carl Sandburg.[51] Pound, who felt Jepson was a superior literary critic, concurred with his low assessment of most American poets. When Monroe read Jepson's condensed article in the *Little Review* with Pound's postscript, she was livid. In an editorial printed in *Poetry*, Monroe wrote she rejected the article not because Jepson denigrated Chicago poets but rather due to "its cheap incompetence." Monroe felt that by reprinting the Jepson article and adding a snide postscript, Pound was attacking her magazine. This she found somewhat strange since Pound was also acting as the foreign editor of *Poetry*. "Evidently," wrote Monroe, "this poet obeys the scriptural injunction not to let his right hand know what his left hand is doing." As for the *Little Review*, it was "now under the dictatorship of Ezra Pound."[52] Heap entered the argument by reprinting Monroe's editorial and following it with an article of her own entitled "The Episode Continued." The piece defended Pound's ability as an editor but also savaged him. "Miss Monroe," she wrote, "is not the first to tell us that the *Little Review* is under the dictatorship of Pound. Our idea of having a foreign editor is not to sit in our New York office and mess up, censor, or throw out work sent to us by an editor in London. We have let Ezra Pound be our foreign editor in the only way we see it. We have let him be as foreign as he likes—foreign to taste, foreign to courtesy, foreign to our standards of Art."

Heap went on to say she agreed with Monroe's judgment of the quality of Jepson's critical abilities. "Mr. Jepson," she wrote, "uses all the threadbare terminology of half-baked aesthetic criticism." She also blasted the patronizing attitudes of those in Pound's British literary circle: "Cursing, endless repetitions of abuse of all outsiders, a mutual advertising agency for themselves, seem to be a popular kind of indoor sport of the literary lizards in London. They call it criticism." Heap's distaste for this condescension extended to Pound's work on the August 1918 number devoted to Henry James. She commented, "Neither can I quite see literature reduced to a profession of the mind in just the way these men do it. Among other things, I am thinking of the Henry James number with its legal smell; step into my office and I will tell you of Mr. James."[53]

She called out Pound's strident tone and xenophobic outbursts.
"Pound's animadversions of his own countrymen include a sullen bore-
dom and a greater inattention of the arts, while his 'slurs' and 'insults'
of foreign races and nationalities living here arouse anger and bewilder-
ment." She went on to say that she "had countless letters from Jews, Letts,
Greeks, Finns, Irish, etc. protesting against Mr. Pound's ignorance and
indiscrimination. I have answered that this is always true of mushroom
nations—this fixed imperception of the qualities and culture of all other
nations. And then there are some of us who come from races of ancient
culture to whom Mr. Pound's ravings sound but the torturing of an infe-
riority complex." However, she pointed out, "All this has nothing to do
with editing a magazine" and "as long as Mr. Pound sends us work by
Yeats, Joyce, Eliot, de Bosschere—work bearing the stamp of originality
and permanence—we have no complaint of him as an editor. If we are
slightly jarred by his manner of asking for alms, or by any other personal
manifestation, we can take care of that outside the magazine. We need
no commiseration for our connection with Mr. Pound. We are not blind
deficient children."[54]

Immediately following Heap's article was an unsigned piece entitled
"Pounding Ezra," which Anderson later acknowledged was written by
Ben Hecht. Hecht contended that as a critic Pound displayed a "sane,
clear-visioned, cultured mind," but that his role as a critic and mentor
to others superseded his importance as a poet. "Perhaps Pound's place,"
Hecht mused, "is, as others have fervently pointed out, in the literary
politics of the day rather than in its literature." Hecht characterizes Pound
as "some Pied Piper luring his swarm of literary rodents out of their con-
ventional stables to their doom." However, the crux of Hecht's comments
was what he saw as "the elusive boredom" of Pound's poetry. "His style
appeals to me not as the cunning mask for ideas but as inflections bor-
rowed, as posturings filched for a moment from a scholastic wardrobe
trunk." Writing that Pound "has always about him the air of a mimic"
and that he was an "exquisite showman minus a show," Hecht dismissed
him as a major poet.[55]

These attacks in the November 1918 issue were followed in December
by another All-American number, perhaps indicating a decline in Pound's
influence with Anderson and Heap. By that time, Pound had completed
most of the work he would do for the journal. The February–March 1919

issue, devoted chiefly to Remy de Gourmont, had been completed in December. Pound would officially resign as foreign editor in May of 1919, as he had stated. It is easy to believe Pound left because, as he publicly announced, he wanted more time and money for his creative work. The funds promised for the *Little Review* by his guarantor John Quinn were due to end that month. In addition, the constant tension over legal troubles concerning the publication of Joyce's *Ulysses*, as we shall see, was exasperating to Pound. Most likely the foreign editorship of the *Little Review* was a burden Pound was glad to leave behind.

However, it is also evident that Pound was not happy with the loss of authority he seemed to suffer in the wake of the attacks by Heap and Hecht, along with the persistent drumbeat of criticism he received from *Little Review* readers. Undoubtedly, Pound saw this criticism as the limited judgment of his intellectual inferiors, and it hardly dented his confidence in his powers, both as an artist and critic. When Pound left, it was without any serious rancor on his part, and the new foreign editor, John Rodker, was his own hand-picked successor. However, Rodker would in no way wield the influence—and controversy—Pound had, and the vacuum remaining was filled by Heap. Heap was the dominant influence ruling the next ten years until the *Little Review*'s demise in 1929. She wrote in the *Little Review* that it was "of no interest" to her whether the American public came to appreciate art "early or late or never," and she would not try to "lure or lead or goad or shame them" to accept it. She was declaring her independence from the missionary zeal Pound and Anderson had demonstrated toward the reading public. It was not that Heap shied away from controversy; her writing was provocative and caustic, yet she often displayed a bemused detachment from the criticism she received. To what extent this masked her underlying depression is impossible to say, but in the pages of the *Little Review*, Heap's measured and often witty replies to her critics were a stark contrast to Pound's sarcasm and Anderson's outbursts. One reason for Heap's attitude may be that she did not share the pessimism of her co-editors concerning the state of art in America. "I cannot understand Ezra Pound and Margaret Anderson," she wrote in the December 1917 issue, "when they become impatient with the American public because it won't take Art. I believe if you leave the right kind of food out the right kind of animals will get it—if they are hungry." Addressing the belief that only Europeans have superior artistic

sensibilities, Heap made the point that "Americans always talk and act as if all individuality, all nationality and race-consciousness, were inevitably washed away in the Atlantic from everyone who dared come to America. If there is to be Art in America, no fear; Art will have its way." Heap did warn, however, "The appalling and unholy thing is a nation that is satisfied and thinks it can exist without Art."[56]

As she became the dominating editorial influence after Pound's departure, Heap demonstrated a judicious selection of those she considered the true artists of New York while continuing to publish work from abroad. The fact that she was the driving force behind the two All-American numbers testified to her conviction that Americans were producing genuine art that deserved an audience. Many of these American authors were published in the *Little Review* while Pound was still foreign editor. This illustrates that despite the central role given to Ezra Pound in various accounts of the *Little Review*, Anderson and Heap remained firmly in charge. The fact that Pound's comments on American work ranged from condescending approval to outright insult had little impact on the two women. Heap and Anderson had a levelheaded firmness in the face of Pound's persistent grumbling and occasional furies and retained this attitude, as we shall see, in the tumultuous wake of the *Ulysses* trial, where they battled not only the courts and the Society for the Suppression of Vice but Pound as well.

A close examination of the obscenity trial Anderson and Heap endured for the serialization of James Joyce's *Ulysses* speaks volumes concerning two issues: the social tensions concerning lesbians at this critical period of transition and the connection between modernism and certain esoteric schools of thought in vogue at that time. The general anxiety about lesbians, and by extension, Anderson and Heap, had a political component. The equation of the spread of lesbianism with the emergence of modern feminism permeated the writing of physicians and social critics as well as average citizens. The *Ulysses* case was undoubtedly an example of the effort to suppress literature considered to be "obscenity," but the dynamics of the trial revealed it was also very much an attempt to silence the "New Woman," a threatening sexual creature. At the same time, the text of *Ulysses* itself can be interpreted as a source of Joyce's interest in Western esoteric subjects.[57]

The trial of Anderson and Heap cannot be divorced from attacks on feminists and anxiety about female sexuality. The evidence for this comes

from the primary source of attack on the two women. Though the New York Society for the Suppression of Vice formally brought obscenity charges against them, and the Court of Special Sessions convicted them, the angriest assault on Anderson and Heap can be found in the correspondence of their attorney, John Quinn. Quinn's discovery of his clients' lesbianism brought forth an explosion of misogynist fury that, to a certain extent, accounted for his self-defeating legal strategy in the courtroom. The entire saga of Anderson, Heap, and Quinn illustrates how the effort to bring together separate spheres in life and literature could lead, as it did in this case, not to the integration of dichotomous categories but a bitter collision.[58]

John Quinn was well known in New York art circles; his private collection of modern art was massive. In *My Thirty Years' War*, Anderson recalled dining with Quinn in his Central Park West apartment. "Every inch of space from baseboard to ceiling was covered with modern sculpture. [Constantin] Brâncuşi's 'Child in the World' stood out grotesquely in the confusion."[59] If Anderson's observation brings to mind the Victorian love of conspicuous consumption, it is because Quinn was in many respects a transitional figure between Victorianism and modernism. The son of an Ohio baker, he collected art in the same way many Gilded Age tycoons did as an expression of status. Quinn's parents were Irish immigrants, and he was interested in sponsoring Irish authors; he served as Joyce's agent in America. Money sent to Pound by Quinn was meant to pay Joyce for work published in the *Little Review*. Quinn was very much a social conservative. His interest in "modern" art did not necessarily endear him to radical thought, particularly concerning political rebellion or sexual freedom. In a revealing letter to Pound, Quinn expressed his disgust with the pseudo-Bohemianism of Washington Square. "It is a vulgar, disgusting conglomeration of second and third rate artists and would be artists, of I.W.W. [Industrial Workers of the World] agitators, of sluts, kept or casual, clean and unclean, of Socialists, of poetasters and pimps, of fornicators and dancers and those who dance to fornicate—but hell, words fail me to express my contempt for the whole damn bunch."[60]

Quinn was also clearly making a connection between political radicalism and sexual promiscuity. When he began his association with the *Little Review*, he was unaware that it was edited by two lesbians who included "Red Emma" as one of their dearest friends. After his first visit

to Anderson, he wrote Pound, "Miss Anderson is a woman of taste and refinement and good looking." However, he did have his suspicions about Heap, "a typical Washington Squarite." "I only saw her once," he wrote, "and if she has not got bobbed hair it should be."[61] Several months later, Quinn was still impressed with Anderson and even included Heap in his praise of their work. Anderson, he gushed, was a "damn attractive young woman, one of the handsomest I have ever seen, very high-spirited, very courageous and very fine. And, I think it is all to their credit that they are making this uphill fight decently and almost alone. I don't know that I have seen any two women who were less maudlin, less sentimental and slushy about it, and more courageous."[62]

Quinn was not celebrating female autonomy; he doubted, he wrote Pound, that any two women could make a success out of a magazine like the *Little Review*. In his scenario Anderson and Heap were the two fine and upright but helpless heroines of a Victorian novel. Anderson, the beauty, required a hero to save the magazine. However, the hero was a Freudian modernist intent on mixing business with pleasure. "Miss A is a very beautiful woman," he wrote in the same letter. "I have no doubt that she could get a good 'backer' if she was willing to have him be a 'fronter' first."[63] For their part, Anderson and Heap expressed doubts about Quinn. They had serious misgivings about his "aesthetic judgment" and were annoyed with his propensity to give them constant advice. Pound, who was the receptor of each party's summation of the other, became worried that the entire arrangement might be jeopardized by "personal bickerings with sexual undertones."[64] His concern was justified. When Quinn discovered that Anderson and Heap were lesbians and that as Joyce's agent he must defend them against obscenity charges, sexual undertones erupted with violent intensity.

In late 1917 Pound received the first three chapters of *Ulysses* from Joyce. Although he immediately sensed censorship obstacles, he was in favor of publication. Despite the seizure of their magazine because of Wyndham Lewis's "Cantleman's Spring-mate," Anderson and Heap were also willing to risk printing *Ulysses*. Anderson wrote years later that when she came across the sentence "Ineluctable modality of Being, sea-sprawn, sea-wracked signature of all things I read," she said to Heap, "This is the most beautiful thing we'll ever have . . . We'll print it if it's the last effort of our lives." To *Little Review* readers she announced, "WE are

about to publish a prose masterpiece."[65] When Quinn saw the first install-
ment, he was livid. Although he was a patron of Joyce, he thought *Ulysses*
was "toilet room literature, pissoir art," and that specific passages would
"subject it to damnation in thirty seconds by any court or jury." In a letter
to Pound about the *Ulysses* issue, Quinn indicated that he was aware of
Anderson's lesbianism. Anyone reading the entire issue, he wrote, "would
say that the person or persons responsible for the selection of that number
suffered from sex mania or the obsession of sex, or that they were taking
out on paper and in type what they should have taken out between some
man's or woman's legs." In a supreme twist of irony Quinn wrote, "Those
who are sexually satisfied don't take it out on paper. Vide Havelock Ellis
works passim."[66] Quinn's mention of Havelock Ellis is a clue here; the
British sexologist spent much of his career studying homosexuality, spe-
cifically lesbianism. In this letter, Quinn pinpointed a central response
toward lesbians in the early twentieth century: they were viewed as simul-
taneously sexually insatiable and frigid. Throughout Quinn's association
with Anderson and Heap, their frequent dismissal of his opinions angered
him. He complained to Pound that Anderson was like most other women
in not appreciating free advice. "I don't give a damn for her morals or
lack of morals, but I object to her lack of politeness."[67] Quinn would
come to see Anderson's sexuality as the reason for her indifference to
authority and her next confrontation with the law—her "abnormality"
had forced the issue. He wrote that he "was through" with Anderson and
Heap; by the end of that year he informed them that he would no longer
pay contributors to the *Little Review*. Pound's departure from the *Little
Review* followed Quinn's, and Anderson and Heap continued to publish
Ulysses without any assistance from either. In early 1919, the Post Office
suppressed the January and May issues of the *Little Review* for obscenity.

The Postal Inspectors were not the only people disgusted by *Ulysses*;
many *Little Review* subscribers registered their disapproval. One reader
asserted that the two women had become advocates for "abnormal art . . .
sexual perverted cheap Bowery vileness."[68] Others complained that they
could not understand the novel. "Really now, Joyce! What does he think
he is doing? I swear I've read his *Ulysses* and haven't found out yet what
it is about, who is who or where. Each month is worse than the last."[69]
Another subscriber argued that it was not prudery that led her to dislike
the novel, but the description of "natural functions" that were better left

alone.[70] Heap dryly responded, "Yes, I think you must be right. I once knew a woman so modest that she didn't wear underwear; she couldn't stand its being seen in the wash."[71]

The controversy brought to a halt the revenue from publishing houses advertised in the magazine; some specifically cited the legal troubles of *Ulysses* for the termination of their accounts. Anderson fought back by writing "To the Book Publishers of America," an angry editorial in which she defiantly observed, "We have managed to keep alive in spite of an unsympathetic and ignorant public, a jeering press, and a censor that expects the worse of any effort dedicated to the best."[72] The reaction of Anderson and Heap to both advertisers and readers demonstrated their self-image and priorities as editors. They were determined to publish what they wanted, regardless of the criticism they received. They realized this stance was financially dangerous; if they antagonized enough people they would be out of business. However, as Anderson pointed out in her "Cantleman's Spring-mate" editorial, if they were not in conflict with popular tastes, there was no reason for the *Little Review* to exist. It was this stance that made them feel perfectly justified in defying Pound and infuriating Quinn.

After Pound's departure, Heap wrote directly to Joyce for the first time. She expressed concern over the slow delivery of chapters rather than the possible obscenity of the content. In January of 1920, she writes that she felt "much like a robber in starting this letter . . . [T]here has always been such a note of ownership in Ezra Pound's attitude toward you and your work that we have held back, with a little amusement, from breaking in even when there has been a necessity for us to express our pleasure and pride in printing you, or our anger and disgust at the suppression." She informed Joyce that the May issue had been burned by the Post Office, which also threatened to permanently suppress the *Little Review* if they did not "stop pulling that stuff."[73] The same month Heap was writing Joyce another issue was confiscated. When she wrote him with this news Heap admitted, "We laughed so much reading proof on that episode that we forgot to think 'obscenity.' The flowery passages are too good—I shall be sorry when Bloom finishes his day."[74] However, after twenty-three installments over two years and nine months, Joyce's protagonist Leopold Bloom would never complete his day in the pages of the *Little Review*.

In the summer of 1920, the *Little Review* was confiscated again, and this issue led to formal obscenity charges and a trial. The themes of *Ulysses* cannot be divorced from the attack on its publishers. "Nausicaa," the *Ulysses* chapter that led to the legal attack on Anderson and Heap, is the story of Leopold Bloom's encounter with the young Gerty MacDowell on Sandymount Beach. Joyce fashioned Gerty's character as a parody of both Victorian womanhood and literature. Joyce's use of voice is crucial to understanding his intention in "Nausicaa." It "comically subverts the possibility and desirability" of the traditional Victorian heroine's virtue.[75] The critical scene in the chapter that led to obscenity charges was when Bloom masturbates while looking at Gerty, purposefully leaning back to expose herself. The sexual charge of the scene is not confined to Bloom's orgasm; it includes the satisfaction Gerty experiences "watching Bloom watch her."[76] Just as Anderson's lesbianism disqualified her from Quinn's Victorian model, Gerty MacDowell failed the purity requirement that defined her nineteenth-century fictional sisters.

On October 18, 1920, the New York Society for the Suppression of Vice under the leadership of John Sumner formally pressed charges against Anderson and Heap for circulating obscenity through the mail. Despite his lack of affection for Anderson and Heap, John Quinn defended the *Little Review* for the sake of Joyce. When Anderson and Heap met with Quinn in his office shortly after the charges were filed, the lawyer exploded in a fit of rage and told them they belonged in jail. Anderson was somewhat nonplused by Quinn's outburst and suggested the *Little Review* would get another lawyer, "knowing that no power on earth could have wrested that power from him." "One didn't argue with John Quinn," she wrote in her autobiography. "One enjoyed his performances too much. He was better than a prima donna. No woman would throw such obvious scenes or look around so hopefully for the applause of her audience."[77]

During this period, Quinn's letters to Pound make constant and increasingly vitriolic statements connecting their sexuality to the trial. "I have no interest at all," he wrote in the fall of 1920, "in defending people who are stupidly and brazenly and Sapphoistically and pederastically and urinally, and menstrually violate [sic] the law, and think they are courageous. . . . THEY ARE BORES. They are too damn fresh. They stand for no principle. They are cheap self-advertisers. All pederasts want to go into court. Bringing libel suits is one of the stigmata of buggery. The bugger and

the Lesbian constantly think in terms of suits and defenses.[78] In his view, Anderson and Heap had deliberately and wantonly broken the law. By extension, he believed their sexual proclivities had forced the entire case. The equation of lesbianism with litigation underlined Quinn's fundamental conviction that the real offense was their sexuality. By the time of the pretrial hearing, Quinn's attitude became one of pure misogyny. He wrote Pound a description of women who had come to the hearing in support of Anderson and Heap. "There was Heap plus Anderson, plus heaps of other Heaps and Andersons. Some good looking, some indifferent. The two rows of them looking as though a fashionable whorehouse had been pinched and all its inmates hauled into court, with Heap in the part of the brazen madam. The women," he continued, "seemed about as interested and excited about what was going to happen as though they expected to be raped. Nothing but a rape could excite them so much."[79]

Quinn's comments degenerated into violence by the time of the hearing. He suggested that any woman in court was there due to prurient interest in Anderson or Heap or the sexual aspects of *Ulysses*. Legal, literary, or intellectual concerns could not account for their participation; hence, they were branded whores or lesbians. The large number of women who attended in support of Anderson and Heap and were by implication endorsing resistance to the male-dominated legal system constituted a powerful presence in the courtroom. This galled Quinn, who responded by attempting to reimpose his authority through the invocation of rape. Quinn lashed out in what came to be a sexual war, where his enemies and clients were one and the same.

In the hearing, Quinn asserted that the judge should distinguish between two types of "filth." There was, he argued, "the strong hard filth of a man like Joyce" compared to the filth produced by "a soft flabby man like Wilde." The filth of Joyce, he continued, was a deterrent to sexual indulgence while Wilde's unquestionably led to "corruption." To demonstrate his thesis, Quinn asserted: "If a young man is in love with a woman and his mother should write to him, 'My boy, the woman you are infatuated with is not real . . . she sweats, she stinks, she is flatulent. Her flesh is discolored, her breath is bad. She makes ugly noises when she eats and discharges other natural functions,' [this] would not send the aforesaid beloved son into the arms of that fairy but would be more likely to turn him from her in disgust."[80] These remarks, Quinn later wrote

Pound, were directly addressed to Anderson, Heap, and their supporters. If they came to court for the truth, he wrote, he would "give it to them unvarnished."[81] Quinn also argued that *Ulysses* could not corrupt anyone who could not understand the admittedly difficult novel. Those who could understand it ("Heaps and Andersons") could do so only because they were already corrupted. The judge disagreed: no one could misunderstand "the episode where the man went off in his pants." The *Little Review* went to trial.[82]

According to Richard Ellman, this was not necessarily seen by Joyce, who "had a penchant for litigation," as bad news, and he was dreaming of "a trial of *Ulysses* as successful as that of Madame Bovary."[83] In a letter to Joyce, Pound described Anderson and Heap as incompetents who "messed and muddled, never to their own detriment."[84] Joyce was unmoved by Pound's and Quinn's attempts to discredit the two women, and Anderson and Heap were determined to proceed regardless of the consequences. Despite the obscenity charge, they published the next installment of *Ulysses*. In the December 1920 number, they launched an attack against the notion that art could be judged in a courtroom. "The heavy farce and sad futility of trying a creative work in a court of law appalls me," wrote Heap in her article, "Art and the Law." She subtly introduced the duplicity of laws protecting sexual "innocence" written by less than pure politicians. "The society for which Mr. Sumner is agent, I am told, was founded to protect the public from corruption. When asked 'What public?' its defenders spring to the rock on which America was founded— the cream puff of sentimentality—and answer chivalrously, 'Our young girls.' So," Heap continued, "the mind of the young girl rules this country? In it rests the safety, progress and luster of a nation. One might have guessed it . . . but—why is she given such representatives? I recall a photograph of the United States Senators, a galaxy of noble manhood that could only have been assembled from far-flung country stores where it had spat and gossiped and stolen prunes." The *Ulysses* case was "truly ironical," Heap pointed out, because the *Little Review* was being prosecuted "for printing the thoughts in a young girl's mind."[85] Heap put her finger on the hypocrisy of censorship based on the pretense of protecting "young girls." Female sexuality, whether in twentieth-century America or the character of Gerty MacDowell, was the crux of male anxiety and the resulting sentimental cant surrounding the purity of women.

The trial was held in February 1921 in a Special Sessions court before three judges, two of whom, according to Anderson, slept through the entire proceedings. The initial proceedings demonstrated both the attempt to silence "New Women" and the refusal to acknowledge the right of women to be exposed to any material deemed sexual. Quinn did not permit Anderson or Heap to testify, a strategy Anderson saw as an attempt to render them inconspicuous, meek, and silent. When the Assistant District Attorney announced that he would read the offending passage aloud, one of the judges objected. He thought the passage should not be read in the presence of a young woman such as Anderson. Anderson later wrote that the judge regarded her with "a protective paternity" and "refused to allow the obscenity to be read in [her] hearing." When Quinn informed him she was the publisher, the judge responded he was sure she "did not know the significance of what she was publishing."[86] The offending passage was read, and the court recessed for a week to enable the judges to read the entire chapter.

When the trial resumed Quinn repeated his argument that the lasciviousness of *Ulysses* was a deterrent to filth rather than a corrupting influence. He argued that only those familiar with the city of Dublin could understand what was really happening in the book and that the erratic punctuation—which he attributed to Joyce's poor eyesight—made it incomprehensible to everyone else. Finally, Quinn argued that he did not understand *Ulysses* and offered the opinion that "Joyce has carried his method too far in this experiment." "Yes," responded one judge, "it sounds like the ravings of a disordered mind. I can't see why anyone would want to publish it." After this exchange, Anderson began to stand up and respond to the judge's statement. She was stopped, however, by Heap pounding her in the ribs with the admonition, "don't try and talk; don't put yourself in their hands."[87]

The two women were found guilty of obscenity, fined one hundred dollars, forced to promise not to publish any further chapters, and fingerprinted. Anderson did contemplate refusing to have her fine paid for her by a sympathetic benefactor, writing, "If I had refused to permit the payment of the fine I might have circulated some intelligent propaganda about *Ulysses* from a jail cell."[88] Anderson and Heap had faced a hostile prosecution, unsympathetic judges, and a defense attorney who thought they were guilty. It went against Anderson's grain,

but she agreed with Heap not to speak. In *"Ulysses in Court"*—an article written during the trial—Anderson stated, "I am determined, during this unnecessary hour in court, to adopt the philosophy of self-preservation. I will protect my sensibilities and my brain cells by being unhearing and untalkative."[89] Both women were deliberately disengaging themselves from this "heavy farce," as Heap phrased it.[90] This withdrawal was not acquiescence to the judicial system or John Quinn. They were symbolically repatriating themselves (as they would later physically do by moving to Paris later in the decade) from the rules of a society unable to come to terms with the uncomfortable questions raised by modernism in both art and life.

Contemporary journalists were not the only ones to ridicule Anderson and Heap. As late as the 1990s, scholars continued to paint the two women as incompetent. It is revealing that though portions of Quinn's correspondence to Pound have been published, the most violent woman-hating passages were deleted, and in biographies of the principals, we are left with the image of a bad-tempered but perhaps unfairly overburdened attorney attempting to do right by his well-meaning but misguided clients. One biography of Pound portrays Quinn as the heroic rescuer of Anderson and Heap, who are described as "two damsels in distress."[91] Timothy Materer, the editor of the published Pound/Quinn correspondence, has argued that Anderson and Heap were "impractical" and ungrateful for Quinn's efforts to rescue them.[92] It is striking that after Anderson and Heap's misadventure with *Ulysses*, Sylvia Beach, another American lesbian, successfully found a publisher for the book in France. Announcing this to *Little Review* readers the year after their trial, Heap simply commented, "We limp from the field."[93] The Joyce trial is of interest in the larger story of Anderson and Heap not only because of their central roles in an important historical event in literary history but also because Joyce was well read in Western esoteric works. References to occult schools of thought make appearances in *Ulysses*, linking Anderson and Heap's Joycean sojourn to their mystical Gurdjieffian journey. In the first work that unveiled Joyce's schemata, Stuart Gilbert argues that "it is impossible to grasp the meaning of *Ulysses*, its symbolism and the significance of its leitmotifs without an understanding of the esoteric theories which underlie the work."[94] Among the schools of thought, concepts, and people that grace *Ulysses*, Buddhism, Rosicrucianism, medieval mystics, Karma,

metempsychosis, Theosophy, Kabbalah, alchemy, Gnosticism, Pythagore-anism, Hermes Trismegistus, and the Seal of Solomon have been identified by Gilbert and scholars who have followed. In *Occult Joyce: The Hidden Ulysses* Enrico Terrinoni argues that the "Nausicaa" chapter itself is an example of an occult text. The chapter, he claims, is full of everything, including "magic divination, astrology, metempsychosis, vampires, and finally satanic allusions."[95]

Perhaps most central to Joyce's esoteric slant was Theosophy. Many scholars argue his references to actual individuals known as "the Dublin Theosophists"—W. B. Yeats, A. E. (George Russell), and John Eglinton—in *Ulysses* were sarcastic exercises in caricature. Phrases such as "Yogibogeybox," "cross-legged under an umbrel umbershoot," "Aztec logos," and "pineal glands aglow" in the "Scylla and Charyb-dis" chapter seem to ridicule the Theosophists and their beliefs. Never-theless, as Bonnie Kime Scott has pointed out, "Both Joyce and Joyce scholars have given more attention to his differences with the Dublin Theosophists than to his considerable debts. Despite several serious objections and a great deal of camouflage, Joyce took the Dublin The-osophists quite seriously." Kime-Scott notes that Joyce was "eager to find out what they could contribute to his art and literary career." The most notable Dublin Theosophist was, of course, Yeats. The prickly relationship between the two Irish bards has been well documented. While Joyce's biographer Richard Ellmann does not accept Joyce as an esoteric author, he writes that Joyce "continued to mull over such themes as historical periodicity, the soul's urge to repeat its pattern in a new body, and the reducibility of existence to certain unchanging laws." Joyce also accepted Yeats's and Pound's view of artists, particu-larly poets as the "spiritual elite."[96]

Joyce's brother Stanislaus believed that Joyce saw Theosophy as an "interim religion." Joyce's library included *Buddhist Catechism* by Henry Olcott (Madame Blavatsky's lieutenant) and Walter Adams's *The House of Hidden Places: A Clue to the Creed of Early Egypt*. In *Ulysses*, Joyce references Joachim of Flora, a twelfth-century Abbott, and the seventeenth-century German mystic Jacob Boehme. One of Boehme's books was entitled *The Signature of All Things*, which Joyce quotes in his first chapter in *Ulysses*, the very sentence that had so enchanted Ander-son. Boehme used the correspondences of Hermes as a literary device, a

method that also dominates *Ulysses*. Most of Joyce's references to the occult and esoteric were cryptic but frequent enough to prompt speculation by scholars about his interest, particularly his abundant references to Hermes and the Emerald Tablet, prompting one critic to argue that Joyce's thoughts "are Hermetic."[97] Central to Hermeticism is the relationship between the microcosm and macrocosm, esoteric correspondences between human and divine reflected in the famous saying of Hermes in the Emerald Tablet, often repeated by George Gurdjieff: "As above, so below." Anderson herself later wrote, "I think that I really thought of Gurdjieff, at first, as a sort of Hermes teaching his son Tat. I felt that the essence of the Emerald Tablet itself might be made understandable to us through Gurdjieff's method of teaching."[98]

The thoughts of Leopold Bloom and Stephen Daedalus explicitly underscore the fundamental axiom of Hermeticism—as above, so below—all things are connected one to another by mutual correspondences, in a chain that extends from the highest to the lowest. The "1,1, and 1.1" Stephen refers to are, according to Ralph Jenkins, Joyce's use of Theosophical forms of the body—"the mind body, the astral body and the physical body."[99] Gurdjieff would argue that these bodies are represented by the "fakir," the "monk," and the "yogi." The Gurdjieffian goal was a man who had synthesized all these aspects into "The Fourth Way" School. One achieves ascension to the Fourth Way by, among other things, "self-remembering," an active attempt to note every thought and action analogous to Joyce's stream of consciousness technique. The purging of negative traits through self-remembering and other types of disciplines led to the shedding of one's false personality, which in turn would lead to the ultimate goal of the communion of one's essence with the "absolute" or highest power in the universe.

Like Joyce, Anderson and Heap were asking the most basic questions—the nature of the universe, the meaning of life, the truth about human beings. Like Stephen Daedalus, they were intellectual dissenters on a sacred mission. As Robert Crunden has written of Anderson and Heap, "The history of Stephen Daedalus proved important to them less for its contribution to literature than for its contribution to their acceptance of mystical religion. Joyce never intended any such thing, but then the history of modernism, like history in general, was full of unintended consequences."[100]

LESBIAN LITERATURE, WOMEN WRITERS, AND MODERNIST MYSTICISM

The *Little Review's* contemporary and historical reputation as a sponsor of modernism was primarily the result of the prodigious publication of work by the "men of 1914"—Joyce, Pound, and Eliot.[1] Anderson and Heap's role in promoting female modernists during this same period has been largely overlooked. After Pound left the *Little Review* in 1919, work by Gertrude Stein, Djuna Barnes, Mina Loy, Dorothy Richardson, May Sinclair, Mary Butts, and "the first American Dada," Baroness Elsa von Freytag-Loringhoven, appeared in its pages. Stein, Barnes, and Loy (and Heap as well) authored several contributions to the *Little Review* that explored lesbian themes, an important element of female modernism. These women all neatly fit Terry Castle's notion of "the apparitional lesbian" of this period, a figure who is "elusive, vaporous, difficult to spot—even when she is there, in plain view."[2] Most of these women had long-term affiliations with other women that were more abiding than their relationships with the men in their lives. In the span of Heap's and Anderson's professional careers, webs of relationships were central to the

work they published in the *Little Review*. Heap worked studiously to get Stein's novel, *The Making of Americans*, published; Sinclair promoted Richardson's work; Barnes and Heap were lovers; Loy and Barnes were best friends and neighbors. Another important element in many of these women's writing was the spiritual and esoteric. The mysticism of May Sinclair's and Mary Butts's fiction, and the inspired "madness" of Baroness Elsa von Freytag Loringhoven's poetry, intrigued Anderson and Heap. As Heather Ingman writes, "It is apparent that many female modernists drew on their spiritual experiences to challenge received notions of gender and sexuality."[3]

Anderson's first mention of homosexuality in the *Little Review* was her 1915 essay on Edith Ellis, but references to lesbianism became more pronounced after Heap joined the magazine. This happened at the very same time that the subject became increasingly visible to the public. Prior to the early twentieth century, fiction based on intense female friendships with romantic overtones frequently appeared in a variety of magazines. Magazines such as the *Ladies Home Journal*, *Century*, *Strand*, and *Harper's* treated the subject without "self-consciousness."[4] As Lillian Faderman notes, in the late nineteenth century, these stories were not considered threatening because the term "lesbian" had only recently been created and was known only to medical theorists. The relationships described between women were seen as a rehearsal for a woman's later and inevitable marriage to a man; examples of this fiction continued to appear into the early twentieth century.[5] As time went on, however, such stories evaporated from the view of the general reading public or, where they appeared, portrayed the protagonists as evil, victimized, or both. Growing public awareness of the writings of sexologists such as Otto Weininger and Havelock Ellis gave scientific credence to the existence of both male and female homosexuals. The popularization of Freud, who asserted that women were sexual creatures, made any intimate friendship between women potentially sexual.

In her study of marriage in the early twentieth century, Christina Simmons writes that by 1920 there was "a surprisingly extensive commentary on female homosexuality."[6] In fact, by the twenties, there appeared to be a backlash against the sexuality of women who were not interested in marriage. The rise of what was termed "companionate marriage" resulted in articles and marriage manuals advocating replacing the rigid conventions of nineteenth-century sex relations with a more relaxed and intimate

view of matrimony. Husbands and wives were to be friends and partners; the sexual satisfaction of the wife was considered a crucial element for a successful marriage. As a result, friendships between women were seen as increasingly unnecessary and frequently suspect. Women were encouraged to emphasize the importance of husbands in their lives, relegating female friends to a station of considerably less importance. Lesbians, as we saw from John Quinn's letters, were viewed as women who were unable to achieve "normal" sexual satisfaction and therefore preyed on vulnerable heterosexual women. As Christina Simmons writes, the recognition of sexual inequality "engendered in the culture a male fear of resistance, often expressed as a fear of lesbianism."[7]

In publishing writing with lesbian themes Anderson and Heap were not necessarily operating in an atmosphere of acceptance—the attitude of bohemian Greenwich Village "freethinkers" was at best ambivalent. The male inhabitants of the Village were consumed by the Freudian notion of women as sexual creatures and by the sexual implications of companionate marriage. Among bohemian men (who controlled the mores of the Village, despite their occasional pretense to sexual egalitarianism), sexual love between women was never validated as equal to heterosexual intercourse. The growing weight of negative public discourse concerning lesbianism and its superficial acceptance by many male Villagers made the publication of lesbian-related material a bold gesture in the early 1920s.[8]

The most forthright pieces with lesbian themes in the *Little Review* came from the pen of Heap herself. In the April 1917 issue, Heap reviewed the autobiographical work *I, Mary MacLane*, a sequel to *The Story of Mary MacLane* published in 1902. In the first book, MacLane wrote of being in love with another woman whose presence inspired "a convulsion and a melting within."[9] The sequel, however, illustrated a knowledge of professional sexual theorists and their labeling of lesbianism as a sickness. In *I, Mary MacLane*, the author writes, "I have lightly kissed and been kissed by lesbian lips." Yet "I am too personally fastidious . . . to walk in direct repellant roads of vice even in the freest moods."[10] Heap began her review: "When I heard that there was to be a new Mary MacLane book I was full of excitement, remembering vaguely her first book. 'What has the world done to you?' I thought as I went rapidly and curiously through the pages." The 1917 book proved very disappointing to Heap. It was, she wrote, "surprisingly ungrown, surprisingly commonplace . . . surprisingly

not a surprise." Addressing MacLane's change in attitude concerning her sexuality, Heap wrote, "She lovingly cherishes her free analytical mind and then in chapters like 'I Am Someway the Lesbian Woman' and 'I Am not Respectable and Refined nor in Good Taste,' she refutes her free analytical mind . . . A grown mind does not question the integrity of its emotions." Heap concluded, "Mary MacLane has created nothing. She has given us an anatomical drawing of her life . . . some imagination, honesty, and humor." The newspapers, she predicted, "will take it up; it will be praised and jeered and quoted by wits and half-wits; moral fossils will refuse to sell it and others to read it. Lady writers will say 'she has made a contribution to literature.' She has made a contribution, but it would seem rather to sexual theory."[11]

While Heap had no problem openly discussing books or plays with homosexual content, the two works of fiction she published in the *Little Review* with lesbian themes do not bear her name. In the prose poem "I Cannot Sleep"—printed with an "Unsigned" credit—Heap wrote, "That woman's hands scare me / I am glad I shall never have to be her lover / I know they leave her arms and crawl about over things in the night / Lean faded spiders."[12] In the second piece, a short story entitled "Karen," Heap signed the work "Os-Anders," leading Faderman to assume the author was Anderson. From Heap's letters to Florence Reynolds, it is clear that she did not want anyone to know she was the author. She instructed Reynolds, "Don't tell anyone that I wrote Karen until later—never anyone who could tell my family."[13] Indeed, Heap's family might have recognized the characters. The story, which appeared in the *Little Review*'s Spring 1922 issue, is the tale of a Norwegian immigrant on a Midwestern farm. Karen is in love with a woman, Dorothea. Grief-stricken by Dorothea's death, Karen marries Dorothea's husband to be close to her beloved's surroundings and possessions. The husband dies after a thirteen-year unconsummated marriage. Cruelly treated by her stepdaughters, who hint that they know her secret, Karen later falls seriously ill. Heap's Karen is a deftly drawn masculine woman who is lonely and unhappy. She dresses in "heavy men's clothes, the trousers put down into the boot tops." Her isolation is deeply felt. "There was something about her that made people shun her."[14] "Karen" differed from the few published lesbian stories because the main character is a sympathetic figure. The fact that it was written in 1922 after the quantity of lesbian

fiction was drying up indicates that Heap and Anderson were not intimidated by the public debate on lesbianism. In her study of lesbian magazine fiction in the early twentieth century, Faderman observes that the ultimate moral of these stories was that "women could not find satisfaction with each other, and some terrible disaster would befall those who tested the truth. The few lesbian stories that did not emphasize this moral appeared only in 'art' magazines such as the *Little Review*."[15]

Another lesbian short story, "Chance Encounter," written by Winifred Bryher, the longtime companion of the poet H. D., appeared in the Autumn/Winter 1924–25 issue.[16] The narrator's infatuation with another woman is described amid the exotic locales of Greece and Egypt, two countries that fascinated H. D., leaving little doubt that she was the model for Bryher's object of desire. The narrator—who spends a great deal of time simply waiting for her beloved to pass by—states, "If I said she was as beautiful as a stem of Sicilian papyrus she would probably laugh."[17] For a short time, Richard Aldington, who was married to H. D., contributed "Myrrhine and Konallis," a twelve-part prose poem that described an affair between two women in ancient Greece. Headings of various sections of the poem were given provocative titles such as "The Wine of Lesbos," and "After the Orgy."[18] May Sinclair wrote in *The Egoist* that although "the love is lesbian," "Myrrhine and Konallis" was "a sequence of the most exquisite love poems in the language."[19]

Anderson's use of a dialogic approach to criticism extended to publishing a piece that mocked something she and Heap truly valued. She printed a lampoon of Aldington's poem by Sue Golden entitled "Murine and Kola-Kola." Heap followed Golden's parody with an uncharacteristically defensive statement: "Yes, how sad it all is that some minds have to jeer at everything in the world, from Helen's beauty to Bernhardt's 'wooden leg.'"[20] Another interesting representation of women with a possible lesbian theme was the reproduction of two sculptures by the Russian artist Chana Orloff. The May-June 1920 issue printed three sculptures: "Maternité," a pregnant woman; "The Amazon," a woman on horseback; and "Danseuses," two women dancing together. A commentary by Muriel Ciolkowski accompanying the reproductions stated, "It occurred to me that *Little Review* readers would be sensible to the charm and wit of 'L'Amazone,' novel to the sculpturer especially."[21]

The contributions of Gertrude Stein are an example of both overt and covert references to lesbian sexuality in the journal. Stein was the most famous lesbian of Parisian avant-garde circles, yet her work was often, according to literary scholars, "encoded" to disguise lesbian themes. An example of such codes can be seen in Stein's first publication in the *Little Review*, "Vacation in Brittany," which appeared in the Spring 1922 issue. The short prose piece begins, "Little fool little stool little fool for me. / Little stool little fool little stool for me. / And what is a stool. / That was the elegant name for a cow."[22] Scholars today have noted the repeated use of the word "cow" in Stein's pieces, including a well-known short story, "A Wife Has a Cow." The term "cow" is a code for a variety of meanings, ranging from nurturance to orgasm.[23] Another Stein contribution, "Bundles for Them: A History of Giving Bundles," which appeared in the Spring 1923 number, was more overt: "If you hear her snore / It is not before you love her / You love her so that to be her beau is very lovely. . . ."[24]

Although Anderson wrote to Stein soliciting material, Stein's contributions came mainly through the efforts of Heap. Stein's work was mentioned in the premier issue of the *Little Review* in March 1914, but in the form of a critical essay by George Soule that ridiculed her work. Anderson agreed with the assertion that Stein's work was "unreadable." Her dislike of the writer's creative efforts was compounded by Stein's and Anderson's dislike of one another. Stein was offended that the *Little Review* did not pay contributors. She told Anderson so, which only angered the editor. Anderson also felt that Stein's self-image as a genius was "slightly insane."[25] Anderson wrote to a friend that Stein and Heap "got on marvelously." Indeed, Heap was genuinely impressed by Stein.[26] In *The Autobiography of Alice B. Toklas*, Stein wrote, "Gertrude Stein then and always liked Jane Heap immensely. Margaret Anderson interested her much less."[27]

The eight short stories and one play Djuna Barnes published in the *Little Review* between 1918 and 1921 were crucial in establishing her early reputation as an author with a unique, if quite dark, perspective. It seems clear that printing Barnes's work was entirely the decision of Anderson and Heap rather than Pound. Shari Benstock has observed that Pound "had little sympathy for her work, felt that her reputation was exaggerated and 'in need of deflation.'"[28] This is corroborated by the fact

that there are no substantive references to Barnes by Pound in his *Little Review* correspondence with Anderson.

Barnes was born in upstate New York in a highly eccentric and possibly incestuous family. The towering figure in her life was her grandmother Zadel, an intense personality and a published journalist. She was also a spiritualist who conjured up, among others, Franz Liszt, Jack London, and Lord Kitchener. Barnes began her career as a freelance journalist writing for New York newspapers. She soon developed into a poet, artist, short story writer, playwright, and novelist. Her first published book, *The Book of Repulsive Women* (1915), a series of lesbian poems, made a splash in Greenwich Village. In the Village, she joined the Provincetown Players, forming a close friendship with her fellow *Little Review* contributor Mina Loy and a more complicated one with Anderson and Heap.

It is evident from Anderson's autobiography that she was not entirely fond of Barnes. When they first published her work, Anderson wrote, "Djuna and the *Little Review* began a friendship which might have been great had it not been that Djuna felt some fundamental distrust of our life—of our talk." Barnes displayed an "intense maternity," Anderson claimed, which "covered the resentment for the first year or so." She would bring Anderson and Heap the "first strawberries of spring and the last oysters of winter, but to the more important luxuries of the soul she turned an unhearing ear." Barnes described herself to Anderson as "reserved," but Anderson concluded that she was in fact "unenlightened" and "not on speaking terms with her own psyche."[29] Still, Anderson's difficulty relating to Barnes personally did not stop her from publishing Barnes's work. Heap's enthusiasm about Barnes's work may have been due to its dark themes—and the widespread rumor that she and Barnes were having an affair at some point during the journal's tenure in New York may have influenced her support.[30]

Critics have argued a great deal about the place of Barnes in the modernist canon. Like Dorothy Richardson, she was compared to Joyce and declared a lesser talent. However, feminist critics examining the themes of gender and sex within Barnes's work find her a fascinating example of how modernism itself can be re-evaluated through the prism of feminist literary perspectives. The themes of her early stories published in the *Little Review* are relentlessly grim—murder, suicide, illness, betrayal, infidelity, and incest plague the lives of the people Barnes

created. They are dark, unsympathetic characters, often with grotesque physiques; relations between the sexes are manipulative and frequently masochistic. The stories focus more on women than men and often deal with strained and damaged relationships within families. Most of the protagonists are strong-willed women and the men are weak and pompous. In "The Robin's House" (September–December 1920), Nelly Grissard—a spiritualist and phrenologist—treats her lover with such disdain he fakes suicide just to see her reaction. In "A Night Among the Horses" (December 1918), a groom treated cruelly by his fiancée is trampled to death by his beloved horses. In "Beyond the End" (December 1919), a tubercular woman brings home a dying child she conceived in a sanatorium, pushing her husband to suicide. In "The Finale" (June 1918), a rodent steals the favorite scarf of a deceased man as mourners stand over his corpse. In *Decadent Culture in the United States*, David Weir writes that Barnes is an example of pre–World War I New Yorkers who "began to renew interest in the cultural decadence that had circulated among artistic circles in the late nineteenth century." Weir refers to Barnes's lesbian-themed *Book of Repulsive Women*— where she takes on the "classic decadent narrative for the purpose of exploring female pleasure. . . ."[31]

The characters in Barnes's short stories refer to religion but in an uncertain, hopeless fashion. In the story "Oscar" (April 1920), Ulric Straussmann—one of two unpleasant men that Emma Gonsberg is involved with—asks her, "What is it that you want?" She answers, "I think it's religion, but it's probably love."[32] In "Beyond the End," when Julie Anspacher's husband asks, "Have you a religion, Julie?" she replies, "I don't know. I don't think so. I've tried to believe in something external, something that might envelope this and carry it beyond—that's what we demand of our faiths isn't it?"[33] In "Katrina Silverstaff" (January 1921), a woman who takes a door-to-door Bible salesman, Castillion Rodkin, as her lover, states plainly, " 'We must talk about religion.' And with an awkwardness unusual to him he asked, 'Why?' 'Because,' she said in a strained voice, making a hurt gesture, 'it is so far from me.' "[34] All of Barnes's characters here yearn for the transcendent but are doomed never to realize it, due in large part to the long shadows of their own intrinsically malevolent natures that they are incapable of escaping. Louis Kannenstine argues that Katrina "is seeking her apotheosis in the very reverse terms of apotheosis

that she is out to attain—a state of spiritual exaltation in her own madness and through the degradation of another."[35]

Later in life, Barnes did not look favorably on the work she had published in the *Little Review*. When Anderson was putting together material for the *Little Review Anthology* in 1952, she wrote to Barnes for permission to include "A Night Among the Horses" and the poem "Lament of Women." Barnes replied, "I so heartily dislike parts of each that I must say no." Among her early stories there was only one Barnes cared for, "Aller et Retour," but she could not recall if it had been published in the *Little Review*. She wrote Anderson, "I feel it a grave disservice to letters to re-issue merely because one may have a name for later work or for the unfortunately praised earlier work, or for the purposes of nostalgia or 'history' which might more happily be left interred."[36] Anderson wrote back saying she was sorry Barnes did not like her early work. In a somewhat miffed tone she stated that she was also sorry "that you regard such an anthology as merely nostalgic. . . . On the contrary, it is an important historical record of an important historical epoch in American letters."[37] Barnes later agreed to have her story "The Valet" (May 1919) published in the anthology.

If Barnes's work was dark and brooding, that of the British author and artist Mina Loy was playful and provocative. Her work represents a potent amalgamation of feminist protest, linguistic experiments, spiritual endeavor, and overt sexuality. Her first American poems appeared in *Others*; her debut in the *Little Review* was in the September–December 1920 issue with her poem "Lions' Jaws." This was followed by a manifesto entitled "Psycho-Democracy" (Autumn 1921) and her long poem "Anglo-Mongrels and the Rose" (Spring 1923, Autumn–Winter 1923–24).

A Futurist, Christian Scientist, painter, poet, and lampshade entrepreneur, Loy and her body of work have been excavated and admired in recent years—including as the subject of rock songs.[38] Born in London in 1882 to a Hungarian Jewish immigrant and a middle-class British Protestant, Loy frequently felt like an outsider in her homeland. She studied art in Paris and Berlin and moved to Florence in 1907, where she befriended Mable Dodge and Gertrude Stein.[39] Loy became enamored of the Futurist movement, having affairs with both Filippo Marinetti and Giovanni Papini. Ultimately disillusioned with the misogynistic tendencies of Futurism, Loy forcefully expressed her dissatisfaction in "Feminist Manifesto"

and "Lions' Jaws," a satire of the movement, with sly references to her involvement. Loy moved to New York in 1916, where she became a member of Dadaist circles. Djuna Barnes became one of her most intimate friends. She was also a frequent visitor to Anderson's and Heap's Greenwich Village apartment. When Anderson and Heap went to court during the *Ulysses* trial, Loy sat behind them in the Jefferson Street courthouse as a sign of support.

When Loy moved to Paris in the twenties, she lived in the same building as Barnes and continued socializing with Anderson and Heap. Loy was also the only heterosexual in Djuna Barnes's playful paean to lesbians, *Ladies Almanac*, appearing as Patience Scalpel.[40] Aside from Anderson herself, of all of the *Little Review's* women writers, Loy was the most forthright in her unapologetic espousal of feminism. In her 1914 "Feminist Manifesto," she proclaimed, "The Feminist Movement as instituted at present is inadequate." "Leave off," she wrote, "looking to men to find out what you are not. Seek within yourselves to find what you are. As conditions are at present constituted you have the choice between Parasitism, Prostitution, or Negation."[41] Loy's solution to the sexual oppression of women was "the unconditional surgical destruction of virginity throughout the female population at puberty."[42] While some stunned readers took this statement at face value, Rachel Potter perceives this as a prime example of Loy's humor. She writes, "Loy's wry recommendation that pubescent girls be surgically divested of their assets irreverently dismantles the idea of feminine purity."[43] Loy also promoted a positive attitude toward sex that was controversial at the time. In "Feminist Manifesto" Loy stated that there "was nothing impure in sex—except the mental attitude toward it." Rectifying this attitude, she wrote, "will constitute an incalculable & wider social regeneration than it is possible for our generation to imagine."[44]

In her poem "Psychic Evolution" Loy addressed "Criminal Lunacy" and "Cosmic Neurosis," the latter of which she defined as fear-based on "inhibitive social and religious precepts." In "Psycho-Democracy," she uses the vocabulary of the occult to describe politics. "Power is a secret society of the minority whose hold on the majority lies in the esoteric or actual value of social ideas."[45] Unlike Pound or Yeats, who saw an aristocratic secret society of artists as an entry into secret knowledge, Loy saw such posturing as dangerous. The goal for Loy was "to vindicate

Humanity's claim to Divine Destiny."[46] Loy's political and spiritual beliefs advance the model of progress that "takes place as individuals remove the mask of materiality, recognize the fictiveness of the physical realm, and move collectively toward a higher cosmic consciousness."[47] Loy was also influenced by Eastern mysticism and Bergsonianism, which predisposed her to Christian Science in 1909 (she remained a believer until she died in 1966). She first became attracted to Christian Science in Florence when her daughter became ill and a practitioner of the religion seemed to help the child. (In Florence, there were many bohemian followers of Mary Baker Eddy, including Gertrude Stein and her family.) The appeal of Christian Science may be the source of Loy's belief in an underlying scientific view of the universe.[48] The connection between politics and spirituality is evident in Loy's poetry in the *Little Review*, particularly "Anglo-Mongrels and the Rose."

Mina Loy was indeed an original. Modern scholars are finding her work a fascinating vehicle for uncovering the role of women artists in the avant-garde. Carolyn Burke writes, "Although Loy's radicalism was disconcerting in her own time, contemporary readers are rediscovering her elliptical, fragmented images of a modern woman's psychosexual experience as the revisionary histories of both modernism and feminism are gradually pieced together."[49] Loy, later in life, seems to evade those determined to rescue her from oblivion, and even in her early years, she seemed indifferent to any lack of appreciation, telling Carl Van Vechten, "I have a fundamental masculine conceit that ascribes lack of appreciation of my work to want of perspicacity in the observer."[50]

A more sedate writer than Loy, but just as invested in a spiritual lens, Dorothy Richardson, whose work was serialized in the *Little Review*, was one of the most prolific female modernists. She wrote thirteen novels, published from 1915 to 1935, collectively entitled *Pilgrimage*. The fifth novel of *Pilgrimage*, *Interim*, was published serially in the *Little Review* from June 1919 to April 1920. Each novel charts the journey of Richardson's autobiographical heroine, Miriam Henderson. Richardson's early-middle-class childhood security was devastated by her father's bankruptcy and her mother's suicide, and she was forced into jobs such as governess, tutor, and dental assistant. Her heroine, Miriam, follows a similar course; she lives in London as a boarder in a series of houses whose claustrophobic atmospheres contrast with a picturesque view of the large, expansive city.

Indeed, as Richardson's patron and friend Winifred Bryher believed, if people wanted "to know what England was like between 1890 and 1914, they must read *Pilgrimage*."[51] May Sinclair, an admirer of Richardson, reviewed the first three novels of *Pilgrimage* in a groundbreaking article published simultaneously in the *Little Review* and *The Egoist* in April 1918. In "The Novels of Dorothy Richardson" Sinclair was the first critic to utilize William James's term "stream of consciousness" to describe the technique employed to reveal the inner mind of a character. "Miss Richardson has not plunged deeper than Mr. James Joyce in his *Portrait of the Artist as a Young Man*," she writes, but "it is as if no other writer had ever used their senses so purely and with so intense a joy in their use."[52]

The comparison of *Pilgrimage* to the work of James Joyce would come up in future criticism; however, Richardson as a woman writer was also compared by later critics to Virginia Woolf. Woolf had read both *Ulysses* and *Interim* in the *Little Review* and admired—with certain qualifications—the boldness of their departures. Woolf's particular connection to Richardson's work was not merely implementing the stream of consciousness technique but also using it to investigate female consciousness. The inner workings of a woman's psyche became inseparable from the question of a feminist consciousness in the work of Richardson and Woolf. Reviewing a later work by Richardson, Woolf wrote, "She has invented . . . a sentence . . . of a more elastic fibre than the old, capable of stretching to the extreme, of suspending the frailest particle, of enveloping the vaguest shapes . . . It is a woman's sentence."[53] Feminist literary critics have grappled with the debate over language and gender, asking, "Is anatomy linguistic destiny?"[54] Dorothy Richardson certainly thought so. Her heroine, Miriam, states, "By every word they use men and women mean different things."[55] Miriam Henderson, as Gillian Hanscombe and Virginia Smyers write, "thunders one of the most feminist cries in all twentieth-century literature—'I wouldn't have a man's *consciousness* for anything.'"[56] Critics have perceived Miriam's attitude toward men in *Pilgrimage* as ranging from "simultaneously attracted and repulsed" to one of utter indifference.[57] In his 1918 *Dial* review of *Honeycomb*, the third novel in the *Pilgrimage* series, Randolph Bourne writes, "To Miriam men are scarcely more than a distant earthquake registered on the seismograph of her wonder and perfect uncomprehendingness."[58] In *Interim*, however, there is more than ample evidence that Miriam often has hostile thoughts

about men. In the chapter that appeared in the August 1919 issue, Miriam attends a public lecture and thinks to herself, "Most men . . . used their knowledge like a code or weapon to crush someone." They did so because they liked the "suggestion of their superior knowledge."[59] In a particularly interesting passage, Miriam reflects on a group of Canadian medical interns living in her London boarding house. "Being doctors and still students they ought to be the most hateful and awful kind of men in relation to women, thinking and believing all the horrors of medical science—the hundred golden rules of gynecology. If they had been Englishmen they would have gone about making one want to murder them, but they did not . . . to Canadians, women were people."[60]

Richardson's tenure in London exposed her to a dazzling variety of intellectual influences that informed her worldview. As Gloria Fromm wrote in her biography of Richardson, she encountered "learned Russian Jews, anarchists, freethinkers, vegetarians, Cambridge philosophers, Anglican bishops, mystics, Quakers, scientists, writers. All of these and more worked their special effects, mixed with each other, and entered the life stream of a girl one would have scarcely noticed on a London street."[61] *Pilgrimage* "looks back in its narrative content to London in the 'long' turn of the century and articulates the often tense relationship between rationalism and mysticism, specifically of the interaction between socialism, feminism, and religion."[62]

Richardson's interest in mysticism and religion was explicitly geared to the Quaker faith. Before writing *Pilgrimage*, she lived in a Quaker commune in Sussex and wrote two books on the religion. She was attracted to Quakerism because of the emphasis on the inner light, as opposed to the institutional hierarchy of the Anglican Church, and the respect shown to women as equals. Howard Finn holds that Richardson engaged in a "conflation of mystic, feminist and socialist in the figure of the artist" which "has to be seen in the context of the convergence of Christian and socialist sects in the London of the 1880s and 1890s."[63] Richardson wrote that Quaker women were "entirely self-centered, self-controlled, proud and serene and withdrawn, yet not withholding." For them "the world is home and the home is the world."[64]

Like other writers in this chapter, Richardson was sustained by friendships with women, including H. D. and Winifred Bryher, the daughter of a shipping magnate, who assisted Richardson financially over the years with

a regular allowance. In her autobiography, *The Heart to Artemis*, Bryher compared Richardson to the French author Colette. "Both were true revolutionaries, fighting not for dogmas of any colour but for the elementary rights of an inarticulate body of women who were treated like slaves until the end of the First World War."[65]

Although she traveled in the company of lesbians, the question of Richardson's intimate involvement with women has been contested among scholars. She had an affair with H. G. Wells and was later married to Alan Odle, an artist fifteen years her junior, from 1917 to 1948. Biographical studies of Richardson have described an intense emotional relationship with Vera Leslie-Jones and alluded to the possibility of a sexual encounter. Joanne Winning in *The Pilgrimage of Dorothy Richardson* contends that Richardson was in love with Leslie-Jones and mentions "the possibility of a lesbian sexual relationship."[66] More significantly, Winning argues that in *Pilgrimage* itself, there exists "the thread of lesbian desire that operates just below the surface narrative of the text"; in fact, she argues, "If *Pilgrimage* does possess a 'master' narrative, I believe it is the embedded lesbian subtext that runs throughout its thirteen-novel length."[67] Perhaps more so than other examples of modernist heterosexual women who may or may not have had emotional/sexual relationships with other women and may or may not have incorporated those relationships into their art, the case of Richardson remains unclear. However, regardless of what Anderson and Heap thought of the question of what they were publishing, their appreciation of her work was deep enough to serialize *Interim* simultaneously with *Ulysses*.

Like Dorothy Richardson, May Sinclair was born into a comfortable middle-class family that was soon ruined and broken up by poverty. Also, like Richardson, she was immensely prolific, writing twenty-four novels, forty short stories, two books of poetry, two books of philosophy, and multiple critical essays whose range was truly astounding. She deeply explored such varied subjects as feminism, psychical research, Imagism, mysticism, psychoanalysis, and other explorations of the confluence of consciousness, art, and politics. Sinclair graced the pages of the *Little Review*, mainly with the serialization of her most popular novel, *Mary Olivier*, as well as with trenchant literary reviews that broke new critical ground. However, her reputation faded, and she is now a competitor for most forgotten feminist pioneer of the early modernist era.

Sinclair's 1904 novel *The Divine Fire*, a book some thought was a mischievous portrait of Ezra Pound, brought her first real public attention. Sinclair was important to Pound and other early Imagists. After Pound arrived in London, she introduced him to Ford Madox Ford and Harriett Monroe. She defended the Imagists, whom establishment poets criticized, and incorporated their precepts into her work. Pound included her poem "After the Retreat" in a 1915 issue of *The Egoist* dedicated to Imagism. Pound also introduced Sinclair to H. D., whose work Sinclair soon praised in print. Her review of H. D.'s piece "Two Notes" in *The Egoist* singles the poet out for special praise. "To me," Sinclair wrote, "H. D. is the most significant of the Imagists, the one for whom Imagism has most triumphantly 'come off.'" She continued, "What the Imagists are 'out for' is direct naked contact with reality. You must get closer and closer."[68] During this period, Pound also sought Sinclair's help in his effort to assist T. S. Eliot. Her groundbreaking essay, "Prufrock and Other Observations," solicited by Pound for publication in the *Little Review* in December of 1917, put Eliot on the map.

As noted above, Sinclair did much the same for Dorothy Richardson. Andrew Kunka and Michele Troy point out that "she helped confer legitimacy on Dorothy Richardson's prose by creating a theory that could frame in a positive light what many critics have previously disregarded as Richardson's unrestrained babbling."[69] In the immediate aftermath of her famous review of Richardson's *Pilgrimage,* Sinclair began her breakthrough work, *Mary Olivier: A Life,* serialized in the *Little Review* from January to May of 1919. Contemporary reviewers and modern critics have often compared Richardson's portrayal of Miriam in *Pilgrimage* to Sinclair's *Mary Olivier*. In a 1919 article in *The Dial*, Babette Deutsch reviewed Richardson's *The Tunnel* (the book that immediately followed *Interim*) and *Mary Olivier*, arguing that "for all their interesting differences, they use one method and achieve one end."[70] There were differences, though. Whereas Miriam ventures early toward broader horizons, Mary is ensnared and circumscribed by the jealous possessiveness of her mother. While both are spiritual seekers in their own way, Mary is truly the pursuer of "Reality." As an infant, Mary has mystical experiences: "A clear white light everywhere, like water, thin and clear . . . She saw the queer white light for the first time and drew in her breath with a sharp check."[71] As she grows, Mary becomes intellectually precocious, reading

Kant, Spinoza, and Locke while rebelling against her mother's Christianity. This religious mutiny coincides with her growing interest in being a writer, immersing herself in Idealism and reconciling a lost love with her endless quest for Reality. However, not all critics saw the heroine as a model of spiritual growth. One of the more barbed accounts was from the Gurdjieff disciple Katherine Mansfield, who wrote, "In the beginning Mary is two, but at the end she is still two."[72]

Although Pound solicited Sinclair to write the Eliot appraisal for the *Little Review*, it seems unlikely he invited *Mary Olivier* for publication. The story of Mary Olivier, a young woman struggling to break free from a suffocating mother and the tyranny of Victorian morality, probably held little fascination for Pound. However, it might have greatly attracted Anderson, who could easily identify with striving for independence from an overbearing mother—the heroine fights with her mother, as Anderson did, for example, for the right to read certain books. While Anderson may have been interested in both Sinclair's content and technique, Heap was less impressed. After the novel's serialization had concluded in the *Little Review*, Heap wrote a critique that is of interest not only because it demonstrates her powers as a critic but also because it reveals her own personal distance from the heroine—a figure thought of by others as a rebel. "Mary Olivier, who is supposed to be an 'exceptional being,'—mentally, spiritually, physically—also an artist, is frustrated at every turn by her weak beautiful mama—her life deferred for forty years. May Sinclair has very successfully portrayed this type of mother—the carnivorous flowers, but she seems to forget that carnivorous flowers devour only insects." Heap continues, "Mary Olivier may be to some readers all that May Sinclair puts her up to be, but to me she is the prototype of the American college woman—always young, always untouched, with mind and heart of some psychic rubber from which tragedy, experience, intuitions bounce off, leaving them forever buoyant athletic debutantes of life, at whatever age you meet them . . . minds, voices, gestures, bodies ungrown and oblivious of grace and contours of sex. I call them unfertilized eggs."[73]

Sinclair was sufficiently annoyed by Heap's review to write her a personal letter of complaint. "I was surprised to find jh taking the crass & attentive view of the least intelligent of my British reviewers. I would have thought it was obvious that this book was the history of our escape from the Mother, the 'Carnivorous flower.' Mary manages to do all the things

that matter, most in spite of opposition. From the very beginning, her inside life was absolutely untouched. You seem to consider this soundness a sign of sex deficiency—there again I would have thought it obvious that Mary had rather more, if anything, than less, of the normal equipment."[74]

The allusion to sexuality here is interesting. In Sinclair's view, the "Life-Force" or reproductive capacities of women are intimately connected to moral superiority and inspired genius. A woman such as Mary Olivier (who Sinclair freely admitted was based at least partly on herself) could ultimately sublimate sexuality into artistic creativity. Sinclair's personal life no doubt contributed to this view; she never married or had children. Like Mary Olivier, her relationships with men that may have ended in marriage were thwarted by Sinclair's sense of obligation to her mother. The themes of *Mary Olivier* elaborate on the way underlying family tensions, some of them rooted in themes of sexual frustration and desire, were a particular obstacle to women's pursuit of their dreams. Sinclair's interest in psychoanalysis (she was invited to join the board of the Medico-Psychological Clinic in London in 1913) accounts for the subterranean dynamics of family life she explores in her work.

Sinclair held a somewhat complicated view of feminism, considering her wide range of intellectual and artistic interests. There were feminist themes in many of her fictional works, including her earliest novels *Audrey Craven* (1897), *Mr. and Mrs. Neville Tyson* (1898), *The Helpmate* (1907), and *The Judgment of Eve* (1908). More specifically, Sinclair supported the British suffragists of the early twentieth century. She joined the Women Writers' Suffrage League and Women's Freedom League, wrote articles supporting the vote, and collected money on the London streets for the cause. Sinclair's 1905 article in the *New York Times Saturday Review*, "Superman: A Symposium" introduced American audiences to the phrase "Superwoman." In 1908, Sinclair published an article in the periodical *Votes for Women* in which she wrote, "The Nineteenth Century was an age of material cocksureness and of spiritual doubt. The Twentieth Century will be the age of spiritual certainty . . . [which will] come through the coming revolution by the release of long captive forces—by the breathing in among us of the spirit of Life, the genius of enfranchised womanhood."[75] Sinclair couches feminism in the language of her philosophical Idealism. She was, as Jim Gough writes, the "Idealist-Feminist

Philosopher" who was "creating a full communion with the Life Force, like mystics, poets and musicians—and the suffragist."[76]

Idealism was a philosophy that permeated all of Sinclair's interests; her philosophical treatises *A Defense of Idealism* (1917) and *The New Idealism* (1922) were efforts to explore her magnified awareness. Babette Deutsch, in her review of *Mary Olivier,* wrote that the novel "reads like a fictional transcription of Miss Sinclair's *Defense of Idealism.*"[77] In her introduction to *Defense of Idealism,* Sinclair defends her decision to include a chapter on Mysticism, anticipating that readers "may even look on its inclusion as an outrageous loading of the dice." Egging on her critics, she writes, "To them I can only reply that that is why I have given to Mysticism a place apart."[78] Another aspect of Sinclair's work is demonstrated by the "spooky stories" that appear in two books, *Uncanny Stories* (1923) and *The Intercessor* (1931). These ghost stories shed light on her view of and history with the otherworldly: Sinclair believed she saw a ghost as a child, and as an adult, she attended séances and was elected to the Society for Psychical Research in 1914. Rebecca Neff has pointed out that *Uncanny Stories* "provides an impressive link between the nineteenth-century fascination with Spiritualism, Theosophy, and Psychical Research and the modern revival of interest in parapsychology, faith healing and mind control."[79] Neff argues that the "flashes of Reality" described in *Mary Olivier* were Sinclair's own experiences, "which she early associated with the workings of the unconscious. These recurring incidents prompted her continuing interest in those powers variously called intuitive, psychic, mystic, and initiated a personal quest for ultimate reality."[80] In Sinclair's story "The Finding of the Absolute," James Spaulding—an Idealist—cannot reconcile evil with his belief in Absolute Goodness. Spaulding, "like Sinclair, rejected the God of Christianity because He is not metaphysical enough."[81] When Spaulding dies, he has a personal encounter with his hero Kant; they chat about metaphysical concepts of Space, Time, and the Categorical Imperative, among other subjects.[82]

It is possible that most Sinclair scholars deliberately avoid dealing in depth with her "spooky stories," fearing that her precarious attachment to modernism might be lessened further. In *Defense of Idealism* Sinclair wrote, "There is a certain embarrassment in coming forward with an Apology for Idealistic Monism at the present moment. You cannot be quite sure whether you are putting in an appearance too late or too

early."[83] Indeed, for May Sinclair the experience of being too late or too early was one she never resolved in her life or letters.

Admired by many of her contemporaries, Mary Butts, like Sinclair, has only recently been examined in depth by current scholars. Butts seems to be "the most neglected of the female modernists" published in the *Little Review.* Her biographer writes, "Mary Butts was no marginal figure on the Modernist scene . . . [yet] again and again she has slipped through the net of literary histories of the period, often appearing as an inaccurate footnote."[84] Butts deeply shared May Sinclair's interest in "spooky stories." Her critical essay "Ghosties and Ghoulies: Uses of the Supernatural in English Fiction" demonstrates that Butts was a voracious reader of these stories. She praised Sinclair's *Uncanny Tales,* observing that the work had "a most persuasive enchantment." However, Butts's interest in the occult was much more personal than Sinclair's.

Mary Butts was born in 1890 at her family's home, Salterns, in Dorset, a place that would figure prominently in her thought and work. Her great grandfather, Thomas Butts, was a friend and patron of William Blake, and over forty original Blake illustrations hung in the home where Mary grew up. Her father died when she was a child, but she received a decent education for girls at the time, attending school in St. Andrews, Scotland, and in 1914 graduated from the London School of Economics with a certificate in social science. Butts began a diary in 1916 when her affair with Eleanor Rogers was ending and she was falling in love with the poet John Rodker, who was in hiding to avoid wartime conscription. Her diary continued until a month before her death in 1937. She recorded a distinctly bohemian life in London and Paris in the circles of Pound, Sinclair, Stein, and Cocteau. In the twenties, Butts began a life-long habit of using opium, hashish, and heroin. Her drug addiction made her too unconventional for some modernist affiliates such as H. D, Bryher (who nevertheless admired her work), and Virginia Woolf, who disliked her and called her a member of "the underground."[85] Regardless, Butts did indeed cut a striking figure, described as having "carrot-colored hair, pale blue eyes, nearly translucent white skin, a single white jade earring . . . Crawling in and out of pubs, bars, cafes, under the influence of myriad substances, her persona no doubt in some ways dwarfed her work."[86]

Butts's fervent explorations into the occult made her particularly exceptional to her peers. Her second husband, Cecil Maitland, well known for

his interest in magic, introduced her to Aleister Crowley, aka "The Great Beast, 666." The couple even stayed at Crowley's infamous Abbey of Thelema in Cefalù, Sicily, in 1921; however, Butts did not remain enamored of Crowley, calling his den of witchcraft full of "profligacy and vice." She may have been exacting revenge because Crowley portrayed her in his novel, *Diary of a Drug Fiend*, as a "fat, bold, red-headed slut" who wrote the "most deplorably dreary drivel."[87] By the thirties Butts continued to be plagued by drugs and poverty. Late in life, she converted to Anglo-Catholicism.

Although Butts died at an early age, she produced five novels, three collections of short stories, one novella, an autobiography, poetry, and numerous critical reviews. Her work published in the *Little Review* included "Lettres Imaginaires" (Oct–Nov 1919), five chapters of her mystic novel *Ashe of Rings* (January–March, Autumn 1921), a number of poetry reviews, and the short story "Magic" (July–August 1920), which Roslyn Foy described as her "initial foray" into the supernatural and occult writing.[88] The depth of Butts's interest in the occult is evident in her diary. It is teeming with observations on the fourth dimension, Greek religion, Russian literature, T. S. Eliot, and the "Daimon," among other spiritual/literary references. One entry, on February 25, 1920, reads, "Have practiced automatic writing—were scrawls, but so far as I can tell, automatic."[89] The following spring she wrote more confidently, "Took an astral journey before going to sleep."[90] However, it was not a purely personal subject; the themes of mysticism and magic were fundamental to her work.

Her novel *Ashe of Rings*, which appeared in the *Little Review* in 1921 (published in book form by Contact Press four years later), illustrates how her biography and art were closely intertwined. The protagonist, Anthony Ashe, presides over his ancestral home on the seacoast of England. The name "Rings" refers to a mysterious set of concentric rings near the house, making it a "place of legend" where druid priests, Romans, Celts, and Saxons all conducted ancient rituals. A fairy tale full of references to the occult, paganism, and witchcraft, the novel weaves a complex story whose heroine is ultimately restored as the rightful heir to the ancient seat of her family's sacred land. Butts's inspiration for *Ashe of Rings* went back to her childhood. She was raised near an area known as Badbury Rings, "a mysterious set of prehistoric mounded circles" that had a profound

influence on her. As a youth, Butts had a mystical experience at Badbury Rings that she describes in her autobiography, *The Crystal Cabinet: My Childhood at Salterns* (1937): "That afternoon I was received. Like any other candidate for ancient initiations, accepted. Then in essence, but a process that time after time would be perfected in me. Rituals whose objects were knitting up and setting out and the makings of correspondence, a translation which should be ever valid, between the seen and unseen."[91] In the character of Valentine Ashe, the brother of the heroine Vanna, Butts makes clear connections to the Hermetic traditions so close to Yeats's heart: Basil Valentine was a renowned Renaissance alchemist. Butts's connection to the land, specifically to "a lost Albion," informed her life and work. While many artists saw in the end of the Great War a civilization destroyed, Butts saw a vanished realm in a uniquely personal way. Roslyn Foy writes that in *Ashe* the heroine, Vanna, "is the embodiment of an ancient priestess who authentically practices the ritual and magic that her ancestors so clearly bequeath to her. She is closely connected to the animism of the land. For her, divinity is inseparable from the land and is immanent in nature."[92]

Her first publication in the *Little Review* was "Lettres Imaginaires" (1919), which traces the bitter breakup of a relationship from the woman's perspective. It reveals the intense acrimony between the sexes. Hurt by her lover's rejection, Varya, the main character, writes, "I understand that I was a target for some sacred male encounter with its own might."[93] Like her contemporaries, Butts thought and wrote about the feminist philosophy of early twentieth-century England; very much like Sinclair, she intertwined the mystical themes of her work with a feminist foundation. Both Sinclair and Butts were avid readers of the work of the Classics scholar Jane Ellen Harrison, whose interpretation of Greek myths "links the decline of the Mother Goddess with the thwarting of women's creativity in the patriarchy, and argues that retrieving her power would liberate women's creativity and spirituality."[94] In her novels *Armed with Madness* (1928) and *The Death of Felicity Taverner* (1932), Butts's work, writes Heather Ingman, "combines Hellenic myth with legends of the Grail to align women with nature and position them as saviors of the land of England."[95] Butts was briefly the focal point of the "Berkeley Renaissance" in the late 1940s, and a further revival of interest was prompted by the publication of her biography and diary in 1998. Her fascination with magic

and paganism in particular have served as vehicles to rekindle interest in her art.[96]

The promotion of Dada and one of the most controversial American Dadaist poets, Baroness Elsa von Freytag- Loringhoven, cemented the *Little Review's* reputation as the most iconoclastic journal of the avant-garde.

Pound sent Anderson the "Dada Manifesto," written by Tristan Tzara, which Anderson published in the January–March 1921 issue. Although he admired the work of some individual Dadaists, including Tzara, Pound was not impressed by the movement as a whole. When he stepped down as foreign editor of the *Little Review*, Pound recommended the famous Dadaist Frances Picabia to replace him. However, he wrote Anderson in April 1921, "In taking Picabia, I do NOT suggest that you take Dadaism and all 'les petits dadas.' "[97] It was a suggestion Anderson and Heap had already ignored. The most prominent European and American Dadaists— along with their artistic offspring, the surrealists—would appear with great regularity in the *Little Review*.

Dada was not classifiable with any person, perspective, or design; it never demonstrated a single consistent platform; and it was continually fluid and fluctuating. It was an international movement springing up in urban areas of Switzerland, Germany, France, and the United States. Most art historians agree that the birth of Dada was a direct result of the artists' perception of the insanity and brutality of World War I. As a movement, Dada exalted chaos, discord, nihilism, and irrationality. Hans Arp, one of the founders of Dada and a contributor to the *Little Review*, believed that Dada aimed "to destroy the reasonable deceptions of man and recover the natural and unreasonable order. Dada wanted to replace logical non-sense of the men today by the illogically senseless."[98] The leading light of Dada was Tzara, who, it is said, picked the term out of the dictionary at random. Tzara argued, "Dada does not mean anything;" it was "a state of mind."[99]

The key figures of New York Dada were Frances Picabia, who made several extended visits to the city beginning in 1913; Marcel Duchamp, who moved there from France in 1915; and the New York transplant Man Ray, who spent most of his career in Paris. There was close communication between New York and Parisian Dada circles. Tzara's letters to Walter Arensberg, the wealthy art collector and friend of Duchamp, indicate that Tzara was consciously trying to forge an international movement.

In the early 1920s, the *Little Review* published the most famous Dadaists' writing and artwork, including that of Tzara, Picabia, Ray, André Breton, Louis Aragon, and Phillipe Soupault. Other writers not strictly defined as Dada but whose work had related elements, such as Guillaume Apollinaire, Jean Cocteau, and Fernand Léger, also had poetry and prose pieces published in the *Little Review*. Anderson wrote in the *Little Review* that Dada was a vital movement in the arts, though years later she flatly stated she detested it.[100]

However, one Dadaist artist commanded the respect of both Anderson and Heap: Elsa von Freytag-Loringhoven. She was, according to Anderson, "perhaps the only figure of our generation who deserves the epithet extraordinary."[101] She was a poet and artist who, for many, served as a flesh and blood incarnation of Dada; if there was an American Dada it was embodied in the work and life of the Baroness. Loringhoven's career and personality can serve as a prism through which we can examine issues of art, gender, sexuality, and poverty in the bohemian community. Anderson and Heap were fascinated by her unconventional yet deeply earnest use of costume as a statement of self. The intense quality of the Baroness's poetry led some to question her sanity. Heap no doubt felt an added attraction because of the debate over the role of madness and art, which had engrossed her since childhood. Freytag-Loringhoven's poetry, her aggressive sexuality, and her Nietzschean conviction of her superiority as an artist were factors that certainly impressed Anderson and Heap. These very same qualities seemed to have repulsed others. In an arena where radical politics, sexual freedom, and avant-garde art were supposed to be the norm, the Baroness was still a bit too much for many Villagers. Nevertheless, in spite of their feelings of being overwhelmed by her behavior at times, the two *Little Review* editors remained convinced of her genius. They were deeply aggrieved by her struggles and early death, which Anderson characterized as tragic.

Born in Germany in 1874 to a middle-class family, Freytag-Loringhoven studied drama in Berlin and art at Dachau as a young woman. After a peripatetic existence in Kentucky and Ohio, she made her way in 1913 to New York, where she met and married the Baron von Freytag-Loringhoven. When World War I erupted the baron returned to Germany where he was captured as a POW and subsequently committed suicide, leaving his widow alone and penniless. The Baroness moved to Greenwich Village

and lived in cold-water flats while supporting herself as an artist's model. She worked at the New York School of Art and the Ferrer School and posed for John Sloan, Robert Henri, George Bellows, William Glackens, Man Ray, Marcel Duchamp, and Beatrice Abbott. She appeared in Ray and Duchamp's *New York Dada* and posed nude for a Ray film, shaving her pubic hair. As more European artists arrived in New York, they gathered at Arensberg's salon, where the Baroness mingled and was one of the favorite objects of gossip.[102] Poverty was a chronic problem. At one point, she worked in a cigarette factory until co-workers, unnerved by her unusual garb and brash behavior, physically attacked her. She also spent her time writing, painting, and making sculptures out of objects she found in the city streets or shoplifted from department stores. Anderson wrote that the Baroness was so adept at escaping from paddy wagons that the police often let her go out of admiration for her skills. Her love of dogs intensified her predicament; she often kept several, feeding them by scavenging city garbage pails. Not only was her work described as Dada but her very person also seemed to embody the quintessence of the movement. Her poetry, ready-mades, and sculptures definitely attracted attention, but even her body and performance art personified the soul of Dada. She had established a unique and colorful brand, scathing, rancorous, audacious, combative, scandalous, and flabbergasting.

Anderson's description of the Baroness during her first visit to the *Little Review* office gives a vivid sense of her dramatic costumes. The Baroness "wore a red Scotch plaid suit with a kilt hanging just below the knees, a bolero jacket with sleeves to the elbows, and arms covered with a quantity of ten-cent-store bracelets—silver, gilt, bronze, green, and yellow." Anderson goes on to describe the Baroness's "high wide spats with a decorative furniture braid around the top. Hanging from her bust were tea balls from which the nickel had worn away. On her head was a black velvet Tam O'Shanter with a feather and several spoons—long ice cream-soda spoons. She had enormous earrings of tarnished silver and on her hands were many rings, on the little finger high peasant buttons filled with shot."[103]

This was apparently one of her milder fashion statements. The Baroness was seen in the Village wearing a coal scuttle for a hat, a vegetable grater for a brooch, and walking naked under a Mexican blanket. During that first visit to Heap and Anderson's office, the Baroness stole a

roll of stamps, but they took it philosophically. "Knowing her as we did later," explained Anderson, "it is safe to assume that she used them for decorative purposes."[104] Anderson was correct. When the Baroness attended the Provincetown Theatre's benefit for the *Little Review*, she appeared with lips painted black and postage stamps plastered on her yellow-painted face.

As Robert Reiss points out, the Baroness was mentioned in various autobiographies of Villagers of that era, but usually only as a "footnote . . . and then only as comic relief to otherwise sound narratives."[105] Indeed, most of the accounts of Freytag-Loringhoven concern such behavior as shaving her head, acting in a sexually aggressive fashion toward men, or being arrested for theft or indecent exposure. Two of her romances, a platonic one with Duchamp and a more notorious tangle with Williams Carlos Williams, were played out in her poetry, the pages of the *Little Review*, and memoirs about the Village in the age of Dada. The Baroness and Duchamp lived in the same apartment building for a while and engaged in prolonged discussions of art. She was clearly in love with Duchamp, revered his brilliance as an artist, and found him invaluable in sustaining her spirits.

Esoteric or occult interests within the Duchamp/Arensberg/Dreier sphere seem to have functioned through a self-perpetuating circle of influence. In *Alchemist of the Avant-Garde: The Case of Marcel Duchamp*, the art historian John Moffitt argues that Duchamp's career mirrored that of earlier occultist artists—in particular, he was a practicing alchemist—and also makes a case for occult interests in Duchamp's intimate New York assemblage. Arensberg was captivated with alchemy and cryptology; he wrote books arguing that Francis Bacon was the true Shakespeare and the founder of the Rosicrucian Brotherhood. Arensberg's compatriot, Katherine Dreier, was a Theosophist. Dreier and Duchamp founded the Société Anonyme in 1920. Moffitt assumes that because Arensberg and Dreier were financially and emotionally supporting Duchamp, their views must have influenced his work. However, he does not take into account the Baroness's beliefs in this interpretation. Although Moffitt addresses all of the familiar artists of the Arensberg/Dreier salons at length, the Baroness is not mentioned once in his three hundred and seventy-five-page book.

Duchamp, though he expressed appreciation of the Baroness's work, certainly did not reciprocate her romantic feelings. When she tired of his

indifference, she recorded her feelings in her first poem published in the *Little Review*. "Love—Chemical Relationship," dedicated to Duchamp, references his epic piece, *Large Glass*.

> Thou now livest motionless in a mirror!/
> Everything is a mirage in thee—thine world is glass-glassy!/
> Glassy are thine ears—thine hands—thine feet and thine face . . ./
> SO long must I love it until I myself will become glass . . .[106]

Although we have no way of knowing if "chemical" in the poem alludes to alchemy, it certainly does refer to Duchamp's well-known reserve—a coldness the effusive Baroness must have felt acutely.

If her relationship with Duchamp was unreciprocated, her romantic entanglement with William Carlos Williams was volatile. Many Villagers of this period described the Baroness's infatuation with Williams, who was also a *Little Review* contributor. Williams first became aware of the Baroness when he went to the *Little Review* office and saw her sculpture of Duchamp. He later wrote that the Dadaist structure looked to him "like chicken guts, possibly imitated in wax."[107] Williams expressed an interest in meeting the artist but was informed by Anderson and Heap that the Baroness was currently incarcerated in the Women's House of Detention for stealing an umbrella. They met on her release, he took her out to breakfast, and a volatile friendship was begun. Williams told the Baroness he was in love with her; she became obsessed with the poet, tirelessly pursuing him. Williams soon grew weary of her constant surveillance. He "flattened her," in his words, "with a stiff punch to the mouth," then made a complaint to have her arrested.[108] According to Anderson, Freytag-Loringhoven was deeply aggrieved by Williams' rejection; she dressed in a mourning crepe, stolen from a department store. The imbroglio with Williams exploded into a battle of the sexes, with local observers taking sides. Williams himself wrote, "All the old girls of Greenwich Village were backing her."[109] Anderson argued that Williams could have put a stop to the Baroness's pursuit by "treating her like a human being (as Marcel Duchamp did) and convincing her that it was no use. But instead he acted like a small boy and wrote her insulting letters in which his panic was all too visible."[110] Williams's biographer wrote that he was "comic, flippant, cruel, when he talked about the Baroness, but he really did admire her ability to survive and eat life whole."[111]

The Baroness exacted revenge on her erstwhile lovers in her poems. In "Graveyard Surrounding Nunnery," a poem sent to the *Little Review*, she unloaded on Duchamp, Williams, and her in-between flame, Robert Fulton Logan, a painter and teacher. The poem was not published, no doubt because it was accompanied by drawings of penises in a graveyard; this was too much for the editors, who feared further censorship.

Several critics surmise that the depth of her betrayal went beyond unrequited love. The Baroness's fury may have been stoked by the perception that Duchamp and Williams played as bohemians while she had the guts, as Heap so aptly put it, to be someone "who dresses Dada, loves Dada, lives Dada."[112] As Heap saw it, while Duchamp and Williams gloried in their macho bravado as society's outlaws, they came nowhere near the Baroness in her sheer grit, eking out a real artistic life. This was to be a running theme in the Baroness's art and love life, one she was not shy shouting about (literally) from the Village's streets to the pages of the *Little Review*.

The Baroness's poems, which numbered over twenty, and various other letters and commentary were published in the journal fairly consistently until 1922. A few—such as "Merk Mar Mustir" (December 1918), "The Cast-Iron Lover" (September 1919), and "Thee I Call Hamlet of the Wedding Ring" (January-March 1921)—created acute astonishment even among self-proclaimed makers of the "new." "Thee I Call Hamlet of the Wedding Ring," her eleven-page critique of Williams's "Kora in Hell," was pitiless in its mockery of Williams, his art, and his masculinity "that masqueraded in brutality: male bluff . . .

> In vino veritas.
> Try it-W.C.
> Ostrich-head in dollar heap
> . . . Hideous cripple . . . audacity of inexperience—cowardice of insincerity Carlos Williams—you wobbly-legged business satchel-carrying little louse![113]

Kuenzli writes that the Baroness's review was "arguably the most outrageous item the *Little Review* published in all its years of existence. Never had a male writer been so excoriated by a female critic."[114]

While worthy of heated gossip, the Williams controversy was not the only one associated with the Baroness. Her views on spirituality have

drawn the attention of some scholars. The most intriguing if ambiva-
lent piece of evidence of her spiritual proclivities is her 1917 sculpture
God, most often described as a piece of a contorted plumbing trap on
a wooden miter box. Susan Noyes Platt argues persuasively that some
modernists, including Heap, saw the American "Machine Age" as full
of potential for spiritual exploration and expression (see chapter 7).
The Baroness's work reveals a contemptuous attitude towards a spiri-
tual higher power—or at least toward any evidence that such a Being
manifests itself in human existence. Most of her poems that may seem
to have spiritual concerns often conflate God, religion, and Christianity
with sex.[115]

Anderson and Heap found themselves defending the Baroness from
attackers who responded with outrage to the printing of her poetry.
When the nine-page "Cast-Iron Lover" appeared in the September 1919
issue, it evoked heated complaints from incensed subscribers. Lola
Ridge alleged that the poem was "a retching assault upon art." "F. E.
R." (Florence Reynolds, Heap's former lover in Chicago) wrote, "How
can you who have had the honour of printing Yeats open your pages to
the work of the Baroness von Freytag-Loringhoven?"[116] Heap replied in
"The Reader Critic" section, "It's a bit too easy and a little sentimen-
tal, isn't it, to ask such questions? Yeats was born an old master. Do
you feel you 'understand' Yeats better than you do Elsa von Freytag?
We are not limiting ourselves to the seven arts. No one has yet done
much about the Art of Madness."[117] "F. E. R." wrote back, charging
Heap with being "glib" with the phrase "Art of Madness" and complain-
ing, "My question as to why you publish the work of Elsa von Freytag-
Loringhoven seems to me to be still unanswered. Will you kindly carry on
the discussion?"[118]

The discussion was to carry on in the form of a debate primarily
between Heap and the critic Evelyn Scott over the mental stability of the
Baroness and its impact on her work. In the December 1919 issue, Scott
argued that the Baroness was "as jh says . . . a mad woman." For Scott,
Freytag-Loringhoven's insanity explained the eccentric yet feverish qual-
ity of her poetry. "It is only in a condition of disease or mania," claimed
Scott, "that one may enjoy an absolutely exalted state, that numbness
of the sensibilities toward everything outside the single inspiration."[119]
Heap protested that Scott's interpretation misconstrued and distorted her

use of the word "madness." "It wouldn't be the art of madness if it were merely an insanity such as Miss Scott describes. In the case of Freytag-Loringhoven, I am not talking of mania and disease of numbed sensibilities . . . hers is a willed state. A woman of brains, of mad beauty . . . who has abandoned sanity may at all times enjoy an exalted state. Madness is her chosen state of consciousness."[120]

It is essential to remember Heap's youthful memories, sketching art on the grounds of the Topeka State Insane Asylum where her father worked. Her letters to Florence Reynolds in those summers of 1908–9 demonstrate a simple sympathy for the inmates and genuine empathy. In her defense of the Baroness, Heap argues that if madness is a willed state and the figure in question is an artist, then true art cannot help but follow. Furthermore, madness is a brave choice made by artists such as the Baroness, whose dedication to art meant true suffering in life, a clear contrast to Duchamp or Williams. The debate carried on into 1920 with Scott arguing that the Baroness was clinically insane and had "walked perilously near (if not passed over) the edge beyond which the vision of delirium melts into the blank self-enwrapped exaltation of trance."[121] Heap countered, "When a person has created a state of consciousness which is madness and adjusts (designs and executes) every form and aspect of her life to fit this state there is no disorder anywhere, and therefore no disease."[122] In a letter following Heap's comments, Freytag-Loringhoven herself stated, "jh understands me wonderfully-perfectly . . . Is it not necessary for emotions to come out—is it not necessary for emotional people to be like insane sometimes—to be more sane and steady and strong than others, weaker people after that? Is it not wonderful to be able to control that then, that emotion which otherwise would throttle you—but take it by the neck and make Art out of it—and be free?"[123] Scott would not give up, however. In the March 1920 issue she said of the Baroness's letter, "I cannot believe after reading this semi-intelligible prose that the mental processes of the Baroness ever achieve that completion of their cycle which results in thought."[124] Heap had grown weary of the debate. She felt frustrated by her inability to make her case clear to Scott. After this last volley Heap wrote, "I am glad to allow Miss Scott the last word. I withdraw quietly. I feel that I have been permitted a glimpse of the gentle mystic soul of an adding machine."[125]

Yet Heap could not resist countering when Harriet Monroe of *Poetry* joined the fray. In the Spring 1922 issue of the *Little Review*, Heap reprinted and responded to an editorial by Monroe in *Poetry* attacking the quality of Freytag-Loringhoven's verse. "The trouble is," charged Monroe, "the *Little Review* never knows when to stop. Just now it is headed straight for Dada; but we could forgive even that if it would drop Elsa von Freytag-Loringhoven on the way." Heap's response was a protracted defense of both Dada and the Baroness. She asked, "Is Miss Monroe against Dada because Dada laughs, jeers, grimaces, gibbers, denounces, explodes, introduces ridicule into too churchy a game? Dada has flung its crazy bridges to a new consciousness. They are quite strong to hold the few in this generation that will pass over. Dada is making a contribution to nonsense. However, we do intend to drop the Baroness—right into the middle of the history of American poetry!"[126]

Aside from her confidence in the Baroness's rightful place in the history of American poetry, Heap's comments are revealing in connecting Dada, the Baroness, and spirituality. She suggests to the staider Miss Monroe that poetry is "too churchy a game." Dada and the Baroness are sacrilegious in the institutional sense of the arts. However, the point of Dada's jeers and grimaces was not simply to denigrate but, in Heap's words, "to inspire bridges to a new consciousness." Anderson and Heap's roads to Dada, later surrealism, and Machine Age Aesthetics are direct paths to their conversion to Gurdjieff. Their journey was about a new consciousness—one that was intensely interior, disdainful of contemporary society, and indifferent to critics.

Freytag-Loringhoven found another supporter of her work in Djuna Barnes. It took a while for Barnes to warm up to the eccentric poet, but she became a crucial source of assistance during the remainder of the Baroness's life. When both women left the United States for Paris, Barnes supported the Baroness financially by selling a printer's copy of *Ulysses* that Joyce had given her. She also commissioned Freytag-Loringhoven to write her memoirs. Barnes was sincerely impressed by the Baroness's poetry. Anderson wrote that Barnes viewed it "as perhaps the best of any woman's of our time."[127]

The Baroness died in Paris in 1926 from gas fumes emitted by an open oven. Though suicide was suspected, the evidence seems to indicate it was an accident. As a memorial Barnes contributed several of the Baroness's

letters to her to *Transition* magazine, which also published the death mask of the poet as a tribute to the woman they called "the mother of Dada." Anderson was so moved by the pathos of Freytag-Loringhoven's accounts of poverty and loneliness in these letters that she reprinted one of them in both the last issue of the *Little Review* and in *My Thirty Years' War*. In this letter, the Baroness described being reduced to selling newspapers on the street: "I on the streets—freezing to boot, in such weather people do not buy. I wish you would give me some time for comfort—once! Stroke my hands—and give me 'cheer up.' Talk with me; listen to me. I am human and am not newspaper seller! I have no more time—must go to sell—I should like to laugh with you—to be gay, I can be that! It is my nature—that sounds ghastly now . . . that is the tragedy—I still feel deep in me glittering . . ."[128] The person of the Baroness can be viewed as a literal manifestation of the spirit of the *Little Review*—iconoclastic, sexually liberated, and flirting with madness as artistic expression. It is little wonder that both Anderson and Heap felt strongly attracted by both the work and personality of the first American Dada.

The publications of Stein, Barnes, Loy, Richardson, Sinclair, Butts and the Baroness that appeared in the *Little Review* demonstrate that Anderson and Heap had a specific interest in promoting female modernists despite the unpopularity some had with male writers, including Pound. In publishing these women, and in particular in publishing writing pertaining to lesbian issues, Anderson and Heap took a rebellious stance in relation to trends in both sexuality and literature in the early twentieth century—including literature published by other avant-garde little magazines. The unabashed feminism of Loy, Richardson, Sinclair, Butts and the Baroness went far beyond calls for suffrage to examine the heart of male/female relationships, expressing attitudes that would not be revisited until second-wave feminism. Many of these writers had obvious differences—the dark vision of Barnes, the humor of Stein and Loy, the rather conventional lives of Richardson and Sinclair, the uninhibited choices of Butts and Freytag-Loringhoven.

The theme of spirituality—Barnes's characters' awareness of their own damnation, Sinclair's visions, Richardson's Quakerism, Butts's magic and paganism, and even the Baroness's contemptuous view of God's cruel bequest to humankind—permeates the work of all these writers. As time progressed, material in the *Little Review* became increasingly iconoclastic

and esoteric. By the mid to late 1920s, the journal would turn more and more to avant-garde interests such as Machine Age Aesthetics and surrealism and the intersection between art and the esoteric would become more pronounced. George Ivanovich Gurdjieff would be mentioned for the first time in its pages.

7

GEORGE IVANOVICH GURDJIEFF: A MESSENGER BETWEEN TWO WORLDS

Anderson and Heap were clearly intrigued by the highly eclectic spiritual paths followed by the women published in the *Little Review*. They soon found a teacher who promulgated a complex but unified source of wisdom that made sense to many artists and writers in the early twentieth century. In addition, a series of financial and personal setbacks for both women set the stage for a new direction in their lives. They were exhausted and questioning their mission of introducing the finest of modern arts and letters to the American public. As Anderson saw it, the *Ulysses* trial was simply another nail in the coffin of her brazen enterprise—the magazine she had started a mere six years earlier. If Americans could not appreciate their herculean efforts to educate them, so be it; it was time to fold. Yet the *Little Review* would survive for another eight years and became increasingly radical as the decade of the twenties proceeded. Part of that success was due to their introduction to George Gurdjieff, who initially provided a spiritual school that introduced new departures in critiquing modernism.

By 1921 Anderson concluded that the *Little Review* had run its course. The oppressive combination of financial worries, the *Ulysses* trial, and the deterioration of her relationship with Heap reinforced her decision to withdraw from her creation after seven years. John Quinn had revoked his *Little Review* subsidy, and the financier and art patron Otto Kahn's promise of four thousand dollars evaporated, creating "a disaster" that mystified Anderson.[1] She proposed a plan to raise five thousand dollars by appealing to one thousand *Little Review* subscribers to donate five dollars each. It was unsuccessful. The journal then appeared in double rather than monthly issues, resulting in only four numbers from May of 1920 to March of 1921. The Autumn 1921 issue was reorganized as a quarterly with an increase in price from forty cents to two dollars for a single issue and from four dollars to seven dollars for a yearly subscription. The winter recession of 1921–22 undoubtedly aggravated hard times.

Anderson felt it was appropriate to end the *Little Review* with *Ulysses* since it was "the epoch's supreme articulation." Much to her surprise, Heap's response was "staggering resistance."[2] Anderson's version of the disagreement states that she had grown weary of the tension between them, but Heap argued that this very friction gave her the inspiration to create. That Anderson was genuinely distressed cannot be in dispute. In *Thirty Years*, she wrote, "I didn't know what to do about life—so I did a nervous breakdown that lasted many months."[3] Years later, Anderson clarified that she did not have "a real nervous breakdown, I exaggerated slightly in *Thirty Years'*," but that she was "exhausted" by her efforts to encourage Heap to write.[4]

There is evidence that Heap was spreading rumors that Anderson had suffered an actual nervous collapse. In July 1921, she wrote to Hart Crane saying that Anderson "was crazy."[5] As Crane wrote a friend, "It looks like the *Little Review* is done for, and perhaps poor Mart. Doesn't the way jh puts it make you feel rather uneasy. I wish I knew more details, whether it is mere rumpus that is all the matter, or whether Mart Anderson has worn herself out in vain assaults against the decision against her in the *Ulysses* trial. I wish I could get in touch with her direct, but as she hasn't answered any letter for the last six weeks she probably cannot write."[6] Crane's comments indicate that the strained relationship between the two women was public knowledge and that he felt he could not accept Heap's word concerning Anderson's health. "I happen to know too much inside

information on the two women's mutual relationships to feel certain of any direct truth about Mart from jh," he wrote Gorham Munson. "If you hear anything about them or their plans," he continued, "please let me know. You know my admiration and (yes) affection for Margaret Anderson is very strong and I detest nothing more than such as this thing jh just sent."[7] A few months later, Crane again wrote Munson stating he had received a postcard from Heap saying Anderson had recovered her "sanity."[8]

There was perhaps another reason that Anderson felt on the mend. In 1920 she met the French opera singer Georgette Leblanc. That year, the former star of the Paris stage arrived in New York and began a relationship with Anderson that lasted for over twenty years until Leblanc died in 1941. Leblanc was well known when she came to New York following the termination of an eighteen-year love affair with the Belgian playwright Maurice Maeterlinck. She had made her professional opera debut at the Opéra-Comique in 1893 with notable performances in Bruneau's *L'attaque du moulin* and in Bizet's *Carmen*. She began her collaboration with Maeterlinck in 1896, often playing characters written for her. From 1912 to 1913, LeBlanc sang at both the Manhattan Opera House in New York and the Boston Opera Company, where she sang the role of Mélisande in Debussy's opera *Pelléas et Mélisande*, based on Maeterlinck's play. She also acted in Marcel L'Herbier's 1924 experimental film *L'Inhumaine (The Inhuman Woman)*.

Leblanc had many admirers for her unusual beauty, intelligence, and abilities as a conversationalist. She was openly bisexual even during her long relationship with Maeterlinck. Patrick Mahoney, Maeterlinck's biographer, pointed to a "clearly autobiographical" novel written by Leblanc, *Choice for Life*, in which the protagonist reveals her preference for women over men. Leblanc, wrote Mahoney, was "noticeable to others . . . especially the way she would acquire ascendancy over some attractive young woman and retained it until she decided to give it up." Mahoney also repeated a story told to him by a British woman who was a houseguest of Maeterlinck and Leblanc at their Normandy chateau. After everyone retired for the evening, the woman received visits from both hosts who "separately paid calls by knocking at her door and asking permission for her favors."[9] Leblanc came to New York after Maeterlinck left her and married a younger woman. Anderson and Leblanc were introduced

by their mutual friend Allen Tanner; Anderson was thunderstruck, and their long relationship began. Anderson tended towards hyperbole when describing the various women in her life. Still, her account of her first impressions of Leblanc indicates she firmly believed their meeting was pre-ordained. In *The Fiery Fountains*, Anderson wrote, "We cannot have met by chance, Georgette and I, since we knew at once that we were to join hands and advance through life together. Ah, I said, when I first saw her marvelous mystic face: this is the land I have been seeking, I left home long ago to discover it."[10]

Georgette Leblanc was entirely unlike Jane Heap; lavishly feminine, she cut a figure of glamour that was the antithesis of Heap's masculine countenance. Her friend Jean Cocteau described her poetically as "the model for a lyric saint—one of those strange great beings who move through the crowd, headless and armless, propelled only by the power of their soul, as immutable as the Victory Samothrace."[11] Where Heap was acerbic and depressed, Leblanc exuded gentleness and optimism. Anderson wrote, "To Georgette there was no human conflict, between friends, which couldn't be resolved by a glance between understanding eyes."[12] One reason for Leblanc's natural sense of tolerance of others may have had to do with her age; when they met, she was fifty-one years old—twenty years older than Anderson. This age difference was something Anderson asserted the two "never thought of."[13]

Heap predictably was not happy with Anderson's new relationship. Anderson complained that Heap was "spreading nasty rumors" about Leblanc around New York, causing mutual friends to turn against her. Determined to start a new life, Anderson wrote Tanner, "Beginning with Jane I'm finished with the whole lot of them."[14] In the summer of 1922, Anderson and Leblanc escaped New York to a rented house in Bernardsville, New Jersey. Staying with them was Tanner and the modernist composer George Antheil, soon to be famous for his score for the avant-garde film *Ballet Mécanique*. Also accompanying them was Leblanc's personal assistant, a woman named Monique, a former Belgian schoolteacher who was so entranced by Leblanc's performances that she came to work for her, and stayed until Leblanc's death.

Heap would soon take command of both the *Little Review* and other aspects of Anderson's responsibilities. Anderson's sister Lois, her companion for the summer idyll on Lake Michigan, was a divorced mother of

two sons, Tom and Fritz Peters. Plagued by mental illness for significant stretches of her life, Lois had turned the children over to Anderson and Heap, who legally adopted them. Fritz, who later wrote of his unorthodox upbringing, stated that Anderson flitted in and out of their lives after commencing her relationship with LeBlanc. The boys were supervised mainly by Heap. This may seem like an odd decision by Heap, who had never exhibited a maternal side, but her commitment during this period of the boys' s lives was firm.[15]

Although their romantic relationship had ended, Anderson and Heap made their first trip to Paris together in the spring of 1923. Anderson wrote, "May 1923 was one of those springs where everyone was in Paris." She described the famous debut of Cocteau's *Les Maries de la Tour Eiffel* and the disapproving boos he received, as well as other avant-garde happenings.

> Juan Gris was making beautiful dolls. Gertrude Stein was buying Andre Masson. Man Ray was photographing pins and combs, sieves, and shoe trees. Ferdinand Léger was beginning his cubists' cinema, *Ballet Mécanique*, with music by Antheil. The Boeuf-sur-le-Toit (names by Cocteau) had a negro saxophonist, and Milhaud and Jean Weiner were beginning to worship American jazz. The Comte de Beaumont presented his *Soirées de Paris*, including Cocteau's *Roméo et Juliet* with Yvonne George. The Dadaists gave performances at the Théâtre Michel where the rioting was so successful that André Breton broke Tzara's arm. Ezra Pound made an opera of Villon's poetry and sung in the old Salle Pleyel (where Chopin fainted long ago). Yes, everyone was in Paris that wonderful spring.[16]

They visited with several past and present contributors to the journal who were now expatriates. Both *My Thirty Years' War* and Heap's letters chronicled their meetings with Ezra Pound, James Joyce, Constantin Brâncuşi, Tristan Tzara, Gertrude Stein, Cocteau, André Gide, and Ernest Hemingway, among others. Anderson's impressions were somewhat harsh toward many of her collaborators. Joyce, Cocteau, and Brâncuşi are all afforded sympathetic treatment, but she was taken aback by Pound and what she described as his nervous and self-conscious behavior. His photographs, she recalled, could not have warned her of his "high Rooseveltian voice" or his "agitation," which reminded her of "watching a large baby perform its repertoire of physical antics gravely,

diffidently, without human responsibility for the performance."[17] Heap was not much better; she described Hemingway as "a rabbit—white and pink face, soft brown eyes that look at you without blinking. As for his love of boxing and bullfighting—all that thrashing up the ground with his hind legs."[18]

Later that year, Anderson and Heap would soon be thrown from *Little Review* concerns and personal dramas into the world of mysticism. George Ivanovich Gurdjieff was influencing scores of intellectuals and artists abroad. In 1923 his message came to America, and the two women seized on it with the passion of converts; it was a philosophy and a guru that influenced them for the rest of their lives. They were not alone in the discontent that led them to a seemingly sweeping departure from life as they knew it. The women were very much affected by the political tensions of the moment. The insanity of the Great War and the post war miseries depleted the forces of political rebels. Their fury at the Goldman trial leading to eviction from their home and suppression of "Cantleman's Spring-mate" left them exhausted and sorrowful. They were among other rebels who began to withdraw from the seemingly ineffectual practice of politics. The social liberalism of the twenties was marred by the ascendency of Republican presidencies, the Scopes and Sacco-Vanzetti trials, and the reemergence of the Ku Klux Klan. Political activism was increasingly relegated to the sphere of hopeless earthly concerns that ultimately led nowhere. Or, as James Webb concludes, "an entire milieu was introverting."[19]

Once Heap and Anderson became aware of Gurdjieff and his philosophy, they quickly adopted his principles. While staying at Brookhaven, they read *Tertium Organum: The Third Canon of Thought: A Key to the Enigmas of the World* by P. D. Ouspensky and concluded that they "had found a contemporary author with a great mind."[20] The book is replete with references to the fourth dimension and the argument that humans must expand their consciousness to advance to even greater heights on the evolutionary scale. Ouspensky, a mathematician, and philosopher, met Gurdjieff in Russia in 1915 and crisscrossed the country during the pre-Revolution turmoil with his small band of followers. His later book *In Search of the Miraculous: Fragments of an Unknown Teaching* details their meeting and is considered one of the best expositions of Gurdjieff's thought. *Tertium Organum* was published in 1920, and the following

year Ouspensky traveled to London, where he was financially supported by Lady Rothermere.

In London, Ouspensky met A. R. Orage, the editor of the *New Age* journal and a onetime contributor to the *Little Review*. Orage became intrigued with Ouspensky's account of Gurdjieff's teachings. When Gurdjieff came to London in 1922, Orage accepted his teachings wholeheartedly and served, according to Heap, as a "John the Baptist" for Gurdjieff.[21] In the fall of 1922, Gurdjieff established the Institute for the Harmonious Development of Man in France near Fontainebleau-Avon. Orage resigned as editor of the *New Age* and, along with other followers, moved there from England to immerse himself in Gurdjieff's teachings. Gurdjieff soon ordered him to go to America, form a group devoted to his teachings, and, not incidentally, recruit interested parties for much-needed cash.

Two circumstances made Orage crucial to Anderson and Heap's road to Gurdjieff. As editor of the *New Age*, he was not an unknown quantity. They had corresponded for years, and he had contributed to the *Little Review's* 1918 Henry James issue. He had also written sympathetically about the travails of the *Little Review's* publication of *Ulysses* in the *New Age*. Orage was both a Theosophist and Nietzschean; he had already written two books on Nietzsche, including the first full-length treatment of his thought in English. Orage, Anderson, and Heap had been feasting on the same intellectual and esoteric fodder and were immediate fellow travelers in the Gurdjieffian universe. Once converted, they never looked back.

Gurdjieff has always been a mystery figure to those who have tried to trace his origins and the influences that merged to produce what he called "the Work." The novelist Henry Miller described him as "a cross between the Gnostics of old and the latter day Dadaists."[22] His "Fourth Way" groups were somewhat similar to other associations such as Yeats's Hermetic Order of the Golden Dawn in that they emphasized the transfer of ancient knowledge via mentors who had already absorbed it. Gurdjieff's followers have historically been reluctant to advertise his thought publicly and much of his esoteric philosophy has been passed down verbally within groups. The exact date of his birth has been disputed, with accounts speculating it was anywhere from 1866 to 1877. He was born to an Armenian mother and Greek father on the border of Russia and Turkey, in present-day Armenia. In his autobiography, *Meetings with Remarkable Men,* he tells us that as a young man he traveled

extensively throughout the world with a small group of compatriots called "Seekers of Truth," traversing Europe, the Middle East, India, and Tibet, searching for esoteric knowledge taught by masters of the "Hidden Wisdom." The Seekers, he wrote, encountered the Sarmoung Brotherhood order, an ancient monastery founded in 2500 BC on the border of Pakistan and Afghanistan. While Gurdjieff criticized Theosophy, scholars have noted striking parallels between his purported background and those of Helen Blavatsky, who also claimed far and wide travels leading to connection with the "Masters of Ancient Wisdom." Both also engaged in what David C. Lane calls "genealogical disassociation," deliberately making it difficult to verify their supposed origins, travels, and the adepts they claimed to have met.[23] Although both philosophies were offshoots of the occult revival in the late nineteenth century and Western esotericism, one significant difference is that while Blavatsky claimed to be in touch with the Masters, Gurdjieff insinuated that he was one of them.

The Fourth Way refers to Gurdjieff's belief that the three traditional paths to self-realization—the ways of the Monk, Yogi, and Fakir, corresponding to the emotional, intellectual, and physical centers of human beings—were destined to fail. If properly attained, his way, the Fourth Way, incorporated all the elements of mind, body, and emotion, making it the only course for a genuine and thorough transformation. At its most basic, Gurdjieff's philosophy states that people in their daily lives function on a level little better than "sleepwalking." Exercising no absolute freedom, they operate as unconscious automatons throughout life. Crucial to Gurdjieff's language is the metaphor of the machine. Individuals use their mechanical somnambulism to hide their genuine, authentic personalities; it acts as a buffer to conceal their essence. They must work ceaselessly observing their own character to determine the most troubling aspects, the combined effect that keep them imprisoned in this sleeplike state. To do this successfully, individuals must unite in a group under the leadership of a sage who provides directions, including shocks to awaken them. "The Work," as the Fourth Way is also called, involves a variety of methods including manual labor, dance, and psychological exercise, all of which create friction for pupils that leads to "intentional suffering" and hence "objective consciousness," Gurdjieff's term for the highest level of transformation.[24]

Gurdjieff's psychological scheme has nine basic animal "types" people must learn and identify within themselves to understand their essence and purge themselves of the negative traits blocking them from illumination. Gurdjieff himself assigned these animal types to his followers. Each person had an inner and outer animal that described their idiosyncrasies. Anderson's outer animal was a yak, which she described as "a strong animal capable of killing when angered—going berserk."[25] Her inner animal was a tapeworm, "a lazy animal who seeks a comfortable place for himself and then feeds on other people's efforts." What Anderson's reaction to these labels was when she received them is hard to say, but years later, she described her tapeworm identification as "very true, I'm sure."[26]

For both Anderson and Heap, Gurdjieffian principles served as another tool in their search for self-knowledge. It enabled them to take the inventories of one another they had engaged in with psychoanalysis during their Brookhaven discussions to new heights. Gurdjieff undertook a psychological rather than a theoretical approach, similar in method to Anderson and Heap's idol Nietzsche. As we have seen, one of the reasons Nietzsche had such allure for the two women was his divorce of philosophy from metaphysics—the road to the Superman was through the will to power exhibited by each individual. Like Nietzsche in his will to power or Bergson in his vitalism, Gurdjieff claimed the road to self-realization was through an inner evolution—the conscious work on oneself. Both Nietzsche and Gurdjieff emphatically stated that Seekers must verify their own experiences—not depend on the Master to validate their success. Gurdjieff explicitly told Anderson, "I cannot develop you. I create conditions in which you develop yourself."[27]

Gurdjieff used a cosmological scheme to further elucidate his interpretation of human psychology. He argued that there were seven types of cosmoses or stages of evolution related to what he called The Ray of Creation, each based on a musical note determined by the Law of Octaves. The Law of Three were the three forces of "affirming, denying, and reconciling," similar to the Christian trinity and Hegel's dialectic. As achieved individually via immersion in the Fourth Way, these processes would lead, Gurdjieff argued, to a collective mass consciousness that would alter the course of the universe—hopefully derailing it from its apparent destructive path.

Theodore Roszak has described Gurdjieff, Blavatsky, and Rudolph Steiner as occult evolutionists who implemented "the first Western effort to ground psychotherapy in the evolutionary image."[28] However, their conception of evolution contained dramatic differences from Darwin's strict theory. Whereas Darwin saw evolution as mechanical, random, and devoid of creativity, Gurdjieff, Nietzsche, and Bergson reconfigured it as intentional and innovative. As individuals evolve, they connect to the divine mind and can influence the universe. Gurdjieff referenced the Hermetic tradition in his writings; his cosmology reflected the sentiment of "as above, so below" written on the legendary Emerald Tablets of Hermes Trismegistus incorporating the micro (man) and macro (universe) into his teaching. According to Gurdjieff, the tragedy of the cosmos is that only a small group of Seekers will find their way here, as the mass of humanity cares not. The superiority of the Nietzschean Superman that Anderson endorsed in the early years of the *Little Review* and the creative evolution of Bergson and Pound's secret society of initiated artists all paved the way to Gurdjieff. Gurdjieff taught that spiritual initiation into his tradition had taken place over the centuries through the prism of art and literature, as revelations had been preserved and handed down in written texts and in the oral traditions of communities and adepts—now Anderson and Heap had a new community with new texts.

Gurdjieff's writings were collected into three books published after his death under the title *All and Everything*. In addition to *Meetings with Remarkable Men*, he also authored *Life Is Real, Only Then, When I Am*, and *Beelzebub's Tales To His Grandson—An Objectively Impartial Criticism of the Life of Man*. He began his magnum opus, *Beelzebub's Tales*, which comes to over twelve hundred pages, in 1924 and completed it four years later. His students, including Anderson and Heap, read chapters aloud while Gurdjieff observed their demeanor and commented on their progress. Heap and Orage were tasked with editing it for publication in 1950, one year after his death, and it is now considered the bible of Gurdjieffian thought. Beelzebub is a banished extraterrestrial returning from exile with his grandson Hassein and faithful servant Ahoon in their spaceship Karnak on their way home to the planet Karatas. Due to youthful rebellions, Beelzebub was exiled by God (His Endlessness) to Mars, which he leaves on six occasions to visit Earth where he observes the trials of the "three centered beings." These sojourns are hundreds of years

apart, taking the protagonist to Atlantis, ancient Babylon, Afghanistan in the seventeenth century, Russia during the Revolution, and America in 1922. Beelzebub is considered a hero because he tries to help the three centered earthlings fulfill their cosmic destiny. His Endlessness rewards him by terminating his banishment and returning him to his home planet in the center of the universe. On the way, Beelzebub relates the lessons of his sojourn to his grandson in hope that he will understand the composition of the universe and feel compassion for the foibles of humanity.

Beelzebub's Tales is an allegory on several levels. First, the journey is a metaphor for life—the outward voyage parallels the inner transformation, the wise Master who learned his own lessons from the travails of exile schools a naive youth. The *Tales* have been described as similar to Gilgamesh and Odysseus: long wanderings punctuated by painful experiences, lessons learned, and returning home. The story in the book is also an allegory of the fall and redemption of humankind, with the lessons learned applicable not only to the hero but to all.

The *Tales* resonated with Anderson and Heap due to their understanding of *Ulysses;* it was as though Leopold Bloom was placed in a Jules Verne story. In *Tales*, Beelzebub was to Bloom as Hassein was to Stephen. Reading the *Tales* does not guarantee understanding. Gurdjieff recommended reading the text three times; however, many veteran followers have claimed that it takes several readings before achieving genuine comprehension, if then. This is partly due to Gurdjieff's creation of his own vocabulary and his penchant for interminable sentences. In the chapter "Art," for example, he writes, "Not only absolutely nothing whatever reached them of all the various fragments of general knowledge already then known on Earth, which the learned beings the Adherents-of-Legominism indicated the lawful divergences from the sacred law of Heptaparaparshinokh, or, as they called it the Law of Sevenfoldness, but in the interval of time between these two civilizations of theirs being-rumination has so deteriorated that they now already do not know nor even suspect the existence of such an all-universal law on their planet."[29]

As Gary Lachman writes, "The outrageous claims, the jaw-breaking neologisms, and boa constructor syntax are enough to put off the average person, and even the most dedicated Seekers have a difficult time discovering what Gurdjieff is trying to say, let alone understanding it.[30] Gurdjieff's students argue that he deliberately made it difficult; indeed, he makes that

clear in the first chapter of *Tales* when he writes that his intention is "to destroy mercilessly without any compromises whatsoever in the mentation of the reader, the beliefs and views, by centuries rooted in him, about everything existing in the world."[31] Like Joyce, Gurdjieff employed allegories, myths, and parables in his writing; his deliberate acts of obfuscation are reminiscent of Joyce's boast that *Ulysses* would confuse scholars for years to come. Satire, humor, and wordplay were also standard practices of both writers—Gurdjieff employed the trope of "the sly man" as an example of someone who understood the Fourth Way. Both employed the concept of the trickster, the mythological character who possesses esoteric knowledge, to disrupt conventions and flaunt disobedience to social norms. The tricksters Hermes and Odysseus, who gained knowledge of esoteric wisdom during their travels, were central to the work of both men. Stephen's proclamation in *Ulysses* that "history is the nightmare from which I am trying to awake" corresponded to Gurdjieff's "terror of the situation," or the weight of centuries of iniquitous social, political, and religious tradition.

When Orage arrived in New York in December of 1923, he found willing adherents in Anderson and Heap and other Village inhabitants; his easy erudition was an attractive feature to the American literati. In addition to being intellectually akin to Anderson and Heap, Orage was highly skilled in gathering converts. Anderson stated bluntly that he "was the most persuasive man I have ever known."[32] Orage's task at hand was to give introductory talks on Gurdjieff's philosophy and pave the way for a visit from the Master himself in January. When Gurdjieff arrived in early 1924, he commanded attention by directing performances of one of his physical disciplines to enlightenment—dancing.

The dances were very specific steps choreographed by Gurdjieff and performed to the music he composed. Gorham Munson described the types of performances he attended with Anderson and Heap; they included "two sets of six 'obligatory exercises,' the Initiation of a Priestess, several Dervish dances, a pilgrimage movement called 'measuring the way by one's length,' several women's dances, the Big Seven dance, the 'stop exercise,' and a number of folk and manual labor dances."[33] Anderson wrote, "Orage would discuss the dances, explaining that they were taken from and based upon, sacred temple dances which Gurdjieff had seen in the monasteries of Tibet, and their mathematics were said to

contain exact esoteric knowledge."[34] Whatever their origins, the dances had a profound influence on those who saw them. They "had a strange impact that can only be described as awakening," recalled Munson. "The design and the detail were extraordinarily precise, and one could well believe that they were an exact language to convey knowledge."[35] Hart Crane, who was briefly swayed by Gurdjieff, wrote to his mother that he had witnessed: "some astonishing dances and psychic feats . . . I can't possibly begin to describe the elaborate theories and plan of this institution, nor go into the details of this single demonstration, but it was very, very interesting—and things were done by amateurs which would stump the Russian ballet, I'm sure."[36] In a letter to Florence Reynolds, Heap conveyed a similar sentiment: "Now dear it doesn't matter whether there is a Swedish Ballet or a Russian Art Theatre or any of these things. Gurdjieff is the thing. But that's too much for a letter. The intelligentsia is koo-koo and dazed—Orage spoke again the other night. I told you about the demonstration called 'movement' didn't I? No advertising—no admission—and people go about with their eyes fried and their tongues out—trying to get an invitation."[37]

Among those who found themselves just as enamored of Gurdjieff as Anderson, Heap, Munson, and Crane were Mabel Dodge Luhan, Jean Toomer, Muriel Draper, Waldo Frank, and Herbert Croly. However, not everyone was convinced of Gurdjieff's powers. Heap, aware of the skeptics, was unmoved. She wrote to Reynolds, "Let the man be a charlatan or a devil—but we have had the leap and the hippodrome of new ideas and sights, I don't rave about this—I have been waiting for it."[38] By the time Heap had written Reynolds, both she and Anderson had met the Master himself. Anderson wrote of her first glimpse of Gurdjieff backstage after a performance, indicating the personal charisma that many others commented on. "I had just time to look carefully at a dark man with an oriental face," she wrote, "whose life seemed to reside in his eyes. He had a presence impossible to describe because I had never encountered another with which to compare it." Both she and Heap, Anderson wrote, "immediately recognized Gurdjieff as the kind of man [they] had never seen—a seer, a prophet, a messiah?"[39] A massive man with a shaved head, handlebar mustache, and, according to almost everyone who encountered him, intensely dark, hypnotic eyes, Gurdjieff was indeed a formidable figure. In *The Fiery Fountains*, Anderson wrote, "We looked upon this man . . . as

a messenger between two worlds, a man who could clarify for us a world we had hoped to fathom."[40]

Anderson and Heap decided to follow Gurdjieff to France to study at the Institute for the Harmonious Development of Man, with Tom and Fritz in tow. Leblanc had also converted to Gurdjieff's teachings and sailed with Anderson to her homeland in the spring of 1924. Heap, who had made peace with Anderson about her relationship with Leblanc, followed them to France in the summer. Anderson later wrote, "We knew the import of our decision: we had prepared to 'cast our nets aside' and follow."[41] The Institute was an eighteenth-century chateau sometimes called "the Prieuré," meaning "Prioress," due to the fact it was a former Carmelite monastery. The grounds consisted of seventy-five acres that overwhelmed the women when they arrived. Heap wrote Florence Reynolds, "The place is too lovely—lovely chateau, old furniture and many fountains." She described a "feast" prepared with "a whole sheep buried in the ground in ashes, much wine."[42] Replete with cows, goats, and chickens, the expansive grounds were on the edge of a forest. The structures included the Study House and a Turkish bath; favored guests slept in "the Ritz," a sumptuously furnished wing, while students settled in the spartan section called the Monks' Corridor. The Study House was the center of instruction—a large building capable of holding up to three hundred people who could watch performances of Gurdjieff's dances on a specially constructed stage. One visitor described it as an eastern-influenced theater where the center was marked by "a fountain, illuminated by constantly changing coloured lights, and making pleasant music; the floor carpeted with costly Eastern rugs. Around the walls are divans, with here and there an alcove with rich tapestries. The windows are painted over with Arabic designs, and soft light comes from hidden electric globes."[43]

Anderson and Heap joined a group of roughly sixty disciples, mostly emigrants from the Russian Revolution, along with a cluster of British converts to Gurdjieff. In addition to Orage, the Prieuré had housed other prominent literary figures, most notably Katherine Mansfield. Mansfield had been suffering from tuberculosis, searching for a cure until Orage, who had published Mansfield's work in *The New Age,* convinced her to go to the Prieuré in the summer of 1922. Ouspensky recounted a conversation in which Mansfield told him, "You know that I have long since looked upon all of us without exception as people who have suffered shipwreck

and have been cast upon an uninhabited island, but who do not yet know of it. But these people here know it. The others, there in life, still think that a steamer will come for them tomorrow and that everything will go on in the old way. These already know that there will be no more of the old way. I am so glad that I can be here."[44] In a letter to her husband John Middleton Murry, she wrote, "One has, all the time, the feeling of having been in a wreck and by mercy of Providence got ashore—somewhere . . . Simply everything is different. Not only languages but food, people, music, methods, hours—all. It's a real new life . . ."[45]

In January 1923, Mansfield died at the Institute and was buried near Avon near where Gurdjieff was later laid to rest. One woman who tended to Mansfield was Olga Ivanovna Lazovich Hinzenberg, a trained dancer from Montenegro who met Gurdjieff in Russia and followed him to France via Constantinople. When Anderson and Heap arrived, she was there, demonstrating Gurdjieff's dance movements and becoming especially friendly with Heap. She left that same year for the United States, where she met and married Frank Lloyd Wright, who had given Anderson one hundred dollars in 1914 to help establish the *Little Review*. Hinzenberg would later help run Wright's Taliesin in Wisconsin and later Taliesin West in New Mexico, incorporating Gurdjieffian tenets among the student architects there.[46]

On arriving at the Prieuré, Anderson and Heap delved deeper into Gurdjieff's teachings, observing the Work's unique approaches to enlightenment that many visitors have recorded. As in the Nietzschean will to power, Gurdjieff's edict to his students to work on their weaknesses to achieve objective consciousness included unpleasant experiments. E. Bechhofer Roberts, a journalist for *Century Magazine*, published an article about the Institute one month before Anderson and Heap arrived and described the trials Gurdjieff put his pupils through. In "The Forest Philosophers," he described a place where students master themselves first by breaking their mechanical habits. He observed that in the case of Orage, who was a chain smoker, Gurdjieff "promptly cut off his tobacco. If anyone expresses a preference for sweet food, he is suddenly put on an unsweetened diet or is surfeited with food that is all sweet, until he sickens of it . . . If a man is proud, Gurdjiev (sic) humiliates him deliberately before all the other pupils. If he has a special affection or aversion, it must be eradicated. There was for instance, a man in the Institute who when he

entered, hated the sight of blood; he was at once set the task of slaughtering the animals for the stock-pot."[47]

Outsiders who heard of these practices roundly denounced Gurdjieff as a money-grubbing fake. Mary Butts, a Seeker herself, wrote in her diary that "he induced women of beauty & wealth to clean the drains & live on refuse at the price of sixteen guineas a week." D. H. Lawrence, who once visited the Institute, called it a "rotten false, self-conscious place of people playing a sickly stunt."[48] Taken all together, Gurdjieff's approach seems to justify Theodore Rozack's description of "therapy by ordeal."[49] By his admission his tactic was to "step on the corns" of his students; without painful recognition of the mechanical nature of their false personalities, they would never find their essence or climb the ladder of evolution.

Anderson and Heap arrived shortly before Gurdjieff had a serious car accident and were not given individual instruction. They were, however, assigned to light duties in the gardens and kitchen. Anderson's nephew Fritz Peters later recollected this period in his book *My Journey with a Mystic*. The Master engaged in several conversations with the eleven-year-old, making Peters feel understood by an adult for the first time. Specifically assigned by Gurdjieff to mow the considerable expanse of lawns, Peters recalled that "He did not do this by threats, promises of rewards, or by asking me. He told me to mow the lawns. He told me it was important. I did it." He later realized that this labor taught him to get over his "horror" of physical work. He recalls that he had "simply one aim[:] . . . to be like Gurdjieff," describing him as "strong, honest, direct and uncomplicated—an entirely 'no-nonsense individual.'"[50] Later assigned to be Gurdjieff's personal assistant, he saw the Master as an essentially benevolent force who presided as the paterfamilias, surveying the grounds and his students in his red tasseled fez and carpet slippers, smoking Gauloise cigarettes and imbibing significant quantities of Turkish coffee.

After a day of chores there was a communal dinner where the assignments continued in the evening, albeit with a Dionysian twist. After a meal of Persian soup, lamb, calf brains, chicken, rice, and figs, Gurdjieff performed his "Toasts to the Idiots." "Idiots" referred to a range of twenty-one archetypes; students were led in an exercise to discover their own particular brand of Idiot. The categories included including "Enlightened Idiot," "Compassionate Idiot," 'Swaggering Idiot," and "Born Idiot." This toast was made with quantities of vodka or

Gurdjieff's favorite beverage, Armagnac, as each student was instructed to do shots around the table. As in many accounts of Gurdjieff there is conflicting testimony on whether students were forced against their will to consume the spirits. Nevertheless, Orage defended the practice by saying, "Gurdjieff, who had an unusual capacity for drink, made a careful distinction between ordinary drinking and conscious drinking which could free the 'I' to think, feel, talk and act; that is, to expose 'essence.' "[51] The practice was in accordance with his overall approach—to cause discomfort and friction.

After dinner, the movement exercises and dances that Anderson and Heap observed in New York were demonstrated for students and visitors. Gurdjieff created over one hundred exercises accompanied by the music he wrote with the assistance of Thomas de Hartmann, a Russian composer who had an esteemed reputation in his native land, particularly for his 1907 ballet *The Pink Flower*, which had been performed by Nijinsky in Moscow. The discipline of dancing was intended to refine the practice of self-observation and to reincorporate the three centers of the mind, body, and emotion into the fourth-way path. These dances made an impression on professional practitioners; Lincoln Kirstein, the co-founder with George Balanchine of the New York City Ballet, wrote in the introduction to his book on Nijinsky, "As in everything I do, whatever is valid springs from the person and ideas of George I. Gurdjieff."[52]

Although Anderson would at times claim fatigue and even uncharacteristic self-doubt, she threw herself into Gurdjieff's program without reservation. She wrote, "To understand—that was the necessity. Understand your nature and the nature of your type. All the qualities which had composed our superiority now emerged unrelated to that need of being born again." The religious language of being "born again" was not incidental; Anderson clearly stated, "If anyone had asked me exactly what I wanted to find out, and if I could have answered as simply as a child, I would have said I want to know what is God."[53] Although she does not overtly connect the early religious curiosity of her Protestant youth to Gurdjieff, all of these experiences may have established a Christian foundation that helped make Gurdjieff's ideas seem familiar. Gurdjieff himself said the Fourth Way was based on Christian principles or characterized as "esoteric or inner" Christianity. Referring to her Gurdjieffian quest, Anderson described herself as immersed in a "pilgrim's progress."[54]

While Anderson wrote prolifically about Gurdjieff in her last two auto-biographies and her book *The Unknowable Gurdjieff*, it was Heap who would become the more astute student. She impressed the Master with her nuanced understanding of his thought and emerged as a leader among his students. He would eventually send her to London to teach groups, which she did for the next thirty years until her death. Heap wrote nothing about Gurdjieff for publication, but her teaching notes have been preserved by her students, who idolized her and reproduced them in privately printed books.[55] When Gurdjieff taught he often spoke in aphorisms, and many of Heap's comments recorded by her students follow suit. We see in these comments the same droll, sometimes caustic manner she displayed when she was jh in the *Little Review*:

> People go straight from being infantile to being senile with no pause to be an adult.
>
> The world has been destroyed by fire and has been destroyed by flood but this time a sea of human mud is rising.
>
> When you meet this work, you must leave the bride at the altar and the dead disinterred.[56]

To some observers, Gurdjieff was little more than a self-serving, obnoxious fraud who bamboozled Anderson and Heap along with other members of the literati. Since then, many contemporaries and others have characterized Gurdjieff as a con artist who deliberately referred to Americans as "sheep to be shorn" while he taught them spiritual advancement.

Why were so many artists besotted with him? Part of the allure was the person of Gurdjieff himself; nearly everyone who encountered him had the same impression as Anderson: he seemed to embody a "messiah." Pamela Travers, the author of the *Mary Poppins* books and a lifelong follower, wrote of her meeting with him in 1938, "He was a serene, massive man who looked at one with a long, contemplative, all-knowing glance. I felt myself in a presence."[57] Katherine Hulme, who would later join an all-women Gurdjieff study group with Anderson and Heap, recalled, "He looked like a broad-shouldered Buddha radiating such power that all the people between him and me seemed dead."[58] The reference to Buddha appeared more than once in recollections; Frank Lloyd Wright used similar imagery, writing, "He affected us strangely as though some oriental buddha had come alive in our midst. Notwithstanding a superabundance

of personal idiosyncrasy, George Gurdjeef [sic] seems to have the stuff in him of which our genuine prophets have been made."[59]

Max Weber noted that many religions have used the "legitimation strategy" in which faith is underscored by various appeals, including those of charisma and rationality. The appeal of Gurdjieff's charisma as a factor has already been noted. The appeal of rationality is used by religious traditions that argue their systems are based on scientific evidence. This strategy was used by Victorians experiencing a crisis of faith as they attempted to meld centuries of belief with the assault of industrialization. As James R. Lewis notes, "Given the rhetorical strength of science in contemporary society, an appeal to a concord between science and religion would seem an attractive way to provide a warrant for religious claims. This is in fact what we observe in a vast array of religious traditions." Lewis points out that "adherents of dozens of new religious movements, esoteric and New Age currents all affirm that science is in fact in agreement with their own world views. Their scriptures are scientific documents, their practices in agreement with the latest advances in neurology or particle physics, and their cosmologies resonant with the most up-to-date discoveries in the natural sciences."[60] This was an appeal for Anderson. "Gurdjieff would teach as a science—an exact science of man and human behavior—a supreme science of God, world, man—based on sources outside the scope, reach, knowledge or conception of modern psychologists."[61] Another appeal to rationality for Gurdjieff students was they were told to verify his teachings with their own experience.

There were other more pedestrian enticements; Gurdjieff students may have studied at the Institute, but they came and left on their own accord. They were not expected to have a monasterial tenure, give up their careers, or rearrange their personal lives. Finally, what of his egregious personal behavior? Many observers including William James have noted that religious teachers were often eccentric or at worse psychopathic. It is clear that Ouspensky, who eventually ended his personal relationship with Gurdjieff yet continued to teach his method, was able to separate the behavior of the unholy guru from his teachings. Given their experience with all varieties of quirky and maladjusted artists—Pound being exhibit A—it is not difficult to imagine Anderson and Heap doing likewise.

Gurdjieffian students then and now are highly educated, erudite, cosmopolitan, and accomplished individuals. Many of the studies written about

Gurdjieff since his death have been sophisticated treatments by scholarly practitioners in physics, metaphysics, comparative religion, literature, music, film, and theater. Much of this work has dealt with his teachings in the context of specific religious categories such as Sufism, Theosophy, and Gnosticism. Gurdjieff's psychological theories have influenced prominent psychotherapists such as Charles T. Tart and Robin Skynner, especially his views on multiple subjectivities, defense mechanisms, rationalization, and compartmentalization. Cognitive Behavioral Therapy, which emphasizes the impact of thoughts on behavior, has much in common with Gurdjieff's approach. Many of his concepts, particularly "self-remembering," are similar to those of the contemporary Mindfulness Movement, founded by Jon Kabat-Zinn and popularized by Eckhart Tolle, among others. Even Gurdjieff's writings, abstract and bizarre as they appear to many, have resonance with literary scholars. Paul Beekman Taylor describes *Beelzebub's Travels* as "a modernist text . . . not unlike *Ulysses* or *Finnegan's Wake*."[62] Roger Lipsey argues that the challenges of Gurdjieff's writing are unfairly lambasted. He writes, "In a century when intellectuals have prized difficulty—difficult texts like *Ulysses*, difficult theories like deconstruction, difficult technologies of all description—Gurdjieff was still too difficult, perhaps because he presented not just an intellectual but a moral and existential difficulty: he asks us who we are, he founds his insistent interrogation on ideas and insights which are in part discontinuous with Western culture, and he is impolite."[63] Gurdjieff's system has profoundly influenced the arts, culture, and scholarship, a record that makes it difficult to dismiss as yet another bogus guru.[64]

Anderson's conversion to Gurdjieff led to a radically different interpretation of art. "My dissatisfaction coincided with the new experience we were just beginning. As I look back at what now happened to me, I see that this experience was as inevitable as the one which made me start the *Little Review* in the first place. And now it wasn't the *Little Review* that mattered; and it wasn't Art that mattered any longer."[65] She wrote these words in the early fifties; by the time of her third autobiography, published in 1969, Anderson was waxing even more philosophically. "In spite of my hallucinatory love of Art," she wrote, "I can at least write of how Gurdjieff's teaching led me to a different understanding." Art was no longer "man's highest aspiration, it is merely one of his greatest pleasures." It did not "lead to the evolution of the soul." Art was like being

in love hence, "not to be taken too seriously. Being in love is a situation of frenzy, trance or madness. Real love is something else. Art is also a trance and frenzy. But, as Gurdjieff said, it began by being something else—a revelation concerning the development of the soul. The Art we know today—have known for how many centuries?—has lost its motivation and message."[66] This was an exaggeration on Anderson's part; the certitude of a recent convert was no doubt at play. Nevertheless, until her death she was still writing of the ecstasy that certain books and music had brought her, while simultaneously cleaving to Gurdjieff's teachings.

Anderson's engagement with Gurdjieff led to an increasing disengagement with the *Little Review* and Heap became its chief steward. Perhaps because she was an artist herself, Heap still believed in the *Little Review's* mission and did not share Anderson's increasingly depressing view on the futility of art. Under her tutelage, the journal became increasingly radical, emphasizing reproductions of avant-garde art, sculpture, modernist architecture, and new literary and artistic schools such as surrealism and Machine Age aesthetics. Some of her editorial decisions from 1921 to 1922 prefigured Gurdjieffian themes, while after her stay at the Prieuré, we see explicit connections between her new philosophy and her editorial decisions. After Anderson's valiant assaults against the status quo in the world of the avant-garde, it was the ascension of Heap that led to the *Little Review* fulfilling its promise as a truly revolutionary journal.

The Heap Era

The Autumn 1921 number of the *Little Review* announced a new direction for the journal; the word "REORGANIZED" appeared in bold letters on the title page. The issue was described as a "protest" by international writers and artists against the magazine's prosecution in the *Ulysses* case. Those protesting included Francis Picabia, Jean Cocteau, Constantin Brâncuşi, Paul Morand, and Ezra Pound. Pound was, in fact, named "Collaborator" on the title page, where Anderson was still listed as editor and Heap as associate editor. Once again, Pound was involved with the *Little Review*, but this time his influence was slight and his tenure brief. This was partly due to his reluctance to take on any new responsibilities to guarantee time for his own creative work. Nevertheless, Pound's move to Paris in 1921, and his interest in promoting new artistic trends there, were responsible for his return to the *Little Review*. The Autumn 1921 issue was called the "Brâncuşi number" because it contained twenty reproductions of the Romanian sculptor's abstract work, accompanied by an appreciative essay by Pound.

Pound's desire that his *Little Review* burden be kept to a minimum was behind his suggestion that Francis Picabia serve in the official capacity as foreign editor. Anderson and Heap agreed, and Picabia's name appeared on the masthead—though, interestingly enough, under Pound's. No doubt Anderson felt some of the pressures on her lift after she and Heap compromised by issuing the *Little Review* as a quarterly. Although Anderson later complained that the *Little Review* never got anything from Picabia "except a Picabia number," his official designation as foreign editor indicated that the *Little Review* was taking off in new directions. Picabia was making a name for himself in Paris as a Dadaist and later led the transition, along with other artists such as Duchamp, Marius de Zayas, and Max Ernst, from Dada to surrealism.

Despite the *Little Review's* recent setbacks, the Autumn 1921 issue demonstrated that the scrappy little magazine was not running on its final fumes and it foreshadowed a torrent of the most genuinely avant-garde work done on the international stage. In the twenties Heap issued numbers that included every movement from Cubism, surrealism, Russian Constructivism, and De Stijl architecture to Bauhaus, modern theater design, and Machine Age aesthetics. They included innovators such as André Breton, André Masson, Matthew Josephson, Man Ray, Joseph Stella, Max Ernst, Hans Arp, Max Jacob, George Grosz, Wassily Kandinsky, László Moholy-Nagy, and Vladimir Tatlin, among many others. When Heap took over as the primary editor in the early twenties, reproductions and photographs of the works of these movements and artists often took up ten to twenty pages. Some issues were dedicated to a single artist, as with the Autumn 1921 Brâncuşi number; there were also numbers dedicated to Picabia (Spring 1922), Joseph Stella (Autumn 1922), and Juan Gris (Autumn and Winter 1924–25). These numbers included both multiple reproductions and detailed essays on the work of each artist. Other numbers were arranged around other themes: the Exiles number (Spring 1923), the French number (Autumn and Winter 1923–24), and the Surrealist number (Spring–Summer 1926). Heap seemed so pleased with the thematic tenor of upcoming issues she even named a number when it had no theme, the "Miscellany number" (Winter 1922).

By the early twenties, another new element can be found among *Little Review* contributors: people who were under the sway of Gurdjieff, aware of him, or who would soon also be avid followers, including Muriel

Draper, Hart Crane, Gorhum Munson, and most notably Jean Toomer. In the Spring 1922 number, Heap published two poems by Muriel Draper, "Loose Leaf Products" and "America." A friend of Gertrude Stein and Mable Dodge Luhan and, some say, the lover of Mina Loy, Draper was best known as a salon hostess in London and New York in the early twentieth century. She was also the author of *Music at Midnight* (1929), which described the salon she presided over in London between 1911 and 1915. However, it was New York in the twenties where she made her mark with her involvement in the Harlem Renaissance and her friendships with others in Anderson and Heap's circle such as George Antheil, Lincoln Kirstein, and Jean Toomer.

Along with Kirstein and Munson, Draper also became a Gurdjieffian. Toomer belonged to the same Gurdjieff group in New York as Draper, and it has been speculated that Draper wrote *Music at Midnight* in a writing group to which she and Toomer belonged.[1] Toomer became a disciple shortly before the publication of his novel *Cane* after meeting Margaret Naumberg, the wife of Waldo Frank. Gorhum Munson and Hart Crane became interested in Gurdjieff at the same time as Anderson and Heap; all left anecdotes of how mesmerized they were by the dance performances in New York.

Toomer described the psychological turmoil he and his fellow bohemian artists suffered in this period, describing himself as "a bit of chaos dressed in formal attire." He wrote, "Our psyches were split and chaotic. Our spirits were shrunken. Our souls were empty. To compensate for this emptiness, to avenge our tortured slow deaths, we had grown fangs and sacks of poison; and we used these fangs—race fangs, sex fangs, class fangs, national and religious fangs, all manner of personal fangs—with typical man-insanity against each other."[2] He continues, "[Then] a pamphlet of the Gurdjieff Institute came into my hands . . . It was no wonder that I went heart and soul into the Gurdjieff work. Here was a work that gave man direction and helped him move on the way out of the chaos of modern civilization . . . Here was work whose scope was greater and more complete than anything I had dreamed of. Here, in fine, was truth."[3]

Toomer made three contributions to the *Little Review*; the first was "Fern," part of the novel *Cane*, published in full the following year. "Fern" was the story of a mysterious African American woman, a combination of a romantic encounter fused with the spiritual in a realistically

written story. "Her eyes," wrote Toomer, which were "unusually weird and open, held me. Held God . . . I felt strange, as I always do in Georgia, particularly at dusk. I felt that things unseen to men were tangibly immediate. It would not have surprised me had I had a vision."[4] His second short story, "Easter," appeared in the Spring 1925 issue. "Easter," as the title indicates, was also spiritual in nature; it is a somewhat disjointed account of hundreds of people awaiting the resurrection of Christ, leading one critic to conclude, "The crusade is spiritual and personal, but Toomer undercuts its religious significance by emphasizing church politics."[5] A particularly interesting piece by Toomer was "Oxen Cart and Warfare" in the Autumn–Winter 1924–25 number, which was a review of *The White Oxen* and other stories by Kenneth Burke. Burke and Toomer were friends, and for a while, Burke appeared to show interest in Gurdjieff, although he and Waldo Frank also began to mock it quietly. The review was negative and in its conclusion explicitly mentioned Burke's reference to Gurdjieff. It was a distinctly Gurdjieffian review, taking Burke to task for failing to balance the faculties of intellect and emotion. Toomer criticized Burke for his interest in "technical mechanism" and ended his review with a long quote from the final pages of his story "Prince Llan," which frequently mentions Gurdjieff as a spiritual advisor: "I bare my teeth at the yapping of the senses; I devote myself, rather, to seeing how, if a given thing is so, often things follow. Yet how strange that at this point, rising as I have above my own uneasiness, having found this rock on which to enforce myself, I should receive word from Gurdruff [sic]."[6]

Toomer went to Fontainebleau shortly after Anderson and Heap arrived. He established, with varying degrees of success, Gurdjieff groups in Harlem, Chicago, Wisconsin, California, and Pennsylvania. Later in life he converted to Quakerism. Nellie McKay, his biographer, argues that Toomer was put off by Gurdjieff's treatment of disciples and his loose ethics with other people's money. The Spring 1922 (Picabia) issue truly began the new era. Heap provided a forum for a series of *Little Review* numbers that published and commented on several avant-garde movements from the Cubists to Dada to surrealism. The French poet Guillaume Apollinaire's groundbreaking study of the Cubists, *Les Peintres Cubistes*, was published first in French in 1913 but was translated in the *Little Review* through the three issues of 1922 (Spring, Autumn, and Winter) as "Aesthetic Meditations." Apollinaire's work was important on a variety of

levels. Known better for his poetry than his criticism, Apollinaire in his "Meditations" included ruminations on a series of artists such as Picasso, Picabia, Braque, Gris, Metzinger, Duchamp, and Marie Laurencin, all individuals whose work was reproduced in the *Little Review*. He pinpointed the revolutionary departure of the Cubists, the variety of their work, and their connection to the esoteric, writing that the artist "quickly becomes accustomed to the bondage of the mysterious."[7]

Apollinaire was explicitly promoting the metaphysical aspects of the new art form. He incorporated the recent work of mathematicians in his criticism, stating, "Today scholars no longer hold to the three dimensions of the euclidean geometry. The painters have been led quite naturally and, so to speak, by intuition, to preoccupy themselves with possible new measures of space . . . the fourth dimension."[8] Here he is referencing the work of Charles Hinton (see chapter 2), who invented the "tesseract" or four-dimensional cube as a method for visualizing a new concept of space. In Apollinaire's view, there was a connection between such space and spiritual practice; he referred to artists as "adepts" because "great art" was "religious art."[9] While the history of the fourth dimension includes the work of mathematicians and physicists, it was also appropriated by spiritualists who saw it as proof of the astral plane where spirits reside. Books and articles on the fourth dimension were copious from the late nineteenth century to the beginning of the twentieth, initially due to the occult revival in the late Victorian era.

Heap's own knowledge of the fourth dimension undoubtedly came from P. D. Ouspensky's *Tertium Organum*, which acknowledged Hinton's work and devoted several chapters to the concept. Apollinaire's criticism was not only innovative; it was also prescient—in "Meditations," he coined the term Orphism, based on Orpheus—the poet and musician in the religion of ancient Greece—as a type of Cubism that would serve as a link to a new radical abstract art in color and form. Marjorie Perloff has written that Apollinaire's comments on the role of the fourth dimension and non-Euclidean geometry were responsible for "startling insights . . . insights no one else had fully formulated."[10] Heap was undoubtedly pleased that in his review of various artists, Apollinaire included laudatory remarks about the painter and printmaker Marie Laurencin and advocated for women artists. This section of his review commented on women artists in the sixteenth century, observing "Women bring to art a

new vision full of the joy of the universe"; of Laurencin's work, he wrote, "Her art dances like Salomé."[11]

Surrealism, whose name was first coined by Apollinaire in 1917, was, like Cubism, a revolutionary form of art with origins in the esoteric. Like so many other -isms published in the *Little Review*, surrealism had its roots in the Symbolist movement of the nineteenth century and even earlier occult origins. Celia Rabinovitch writes. "Surrealism consciously identified with the rejected lineage of occultism, transmuted throughout history from Graeco-Roman pagan origins to medieval alchemy and eso-tericism, expressed in the symbolist era of the late nineteenth century through the idea of correspondence between the natural and supernatural worlds."[12] Conventional interpretations of the twentieth-century develop-ment of surrealism hold that it was derived from the dwindling embers of Dada. More nuanced explanations contend that it led straight to the expi-ration of Dada. An extremely fractious collection of artists and writers initially squared off in two groups, with Tzara, Picabia, Marcel Arland, and Robert and Sonia Delaunay in one corner and André Breton, Philippe Soupault, Louis Aragon, and Paul Éluard in the other. Heap published all of them and others, taking Anderson's approach in the early years of the *Little Review* of publishing artists warring against their enemies to an international level.

Despite initial sympathies with Dadaism, Breton led a rebellion from the then-current craze of the avant-garde to create the more bizarrely viewed sphere of surrealism. In *Les Champs Magnétiques* (*The Magnetic Fields*, 1920), Breton and Soupault introduced their approach of activating the unconscious by juxtaposing irrational images via automatic writing. By 1923 the break between rival camps was complete, with public fisticuffs and lawsuits. The following year Breton's group emerged victorious in the battle to become the controlling authority of the movement with the publication of his "Surrealist Manifesto." He threw down the gauntlet of ownership with explicit definitions of surrealism as delineated by his fac-tion. His definition was "pure psychic automatism. . . . Thought dictated in the absence of all control exerted by reason, and outside all aesthetic or moral preoccupations." "With even more justification," he writes, "we could have used SUPERNATURALISM, employed by Gerard de Nerval in the dedication of Filles de Feu. In fact, Nerval appears to have possessed to an admirable extent the spirit to which we refer."[13]

Breton's reference to Nerval's *Filles de Feu* (*Daughters of Fire*) connects surrealism with a view of spirituality that directly leads us to Gurdjieff. Nerval was a nineteenth-century Romantic poet who influenced Rene Daumal, a surrealist poet and critic. In Paris in 1930 Daumal met Alexandre de Salzman and Jeanne de Salzman, two followers of Gurdjieff going back to his days in Russia. He soon became enamored of Gurdjieff's philosophy, and his most famous work, *Mount Analogue: A Novel of Symbolically Authentic Non-Euclidean Adventures in Mountain Climbing*, shows that influence. As a surrealist, Daumal was also inspired by Alfred Jarry, who published in the *Little Review* and was "excommunicated" from Breton's group in 1929 for being insufficiently loyal.

Many self-proclaimed surrealists found themselves mesmerized by the movement's provocative leaders only to become increasingly disenchanted with, if not downright disturbed by, what they saw as an emerging outlandishness that seemed to be expanding exponentially. Matthew Josephson, the founder of the little magazine *Secession*, was another participant/observer and another eventual surrealist outcast. In his memoir, *Life Among the Surrealists*, Josephson wrote of observing the development of both the Dadaists and surrealists; drew deft portraits of Tzara, Breton, and Aragón; and described the "decline and fall of Dada." He argued that the tremendous rivalry among the leaders meant that Tzara, Breton, and Aragon were deeply suspicious of one another. "Tzara," Josephson wrote, "wanted to keep Dada' pure'; that is, purely destructive in its action, always ready for a big joke, and keeping its powder dry for new surprise attack." Breton attacked Tzara in print, writing that he was "en route toward a new faith that would be derived from the romantic traditions and the 'proto-Surrealists' literature of France." Josephson claimed that he tried to remain neutral in the contretemps, although "they kept changing sides so rapidly that one could not distinguish friend from foe."[14] His observations of the new group ventured from admiration to puzzlement and finally to disgust. Egoism, drug addiction, and what he considered the superfluities of automatic writing led to a highly critical appraisal in the Surrealism Issue (Spring–Summer 1926) of the *Little Review*. The issue contained work by Aragon, Soupault, and Eluard and reproductions of the work of Max Ernst, Robert Delaunay, Andre Masson, and Man Ray. Although they were not surrealists, the issue included reproductions of Braque, Modigliani, and Juan Gris. Aragon's contribution, "A Man,"

was a good example of the school—"IT IS BETTER TO KILL ONE'S FATHER THAN TO EAT NUTS or all other evidence: I think only by evidence. Having shaken my head with my two hands I read in the same apparatus before the fall of the dice clickety click. IT IS BETTER TO EAT ONE'S FATHER THAN TO KILL NUTS."[15]

In the same issue, Heap published two searing criticisms of surrealism: G. Ribemont-Dessaignes' s "In Praise of Violence" and Josephson's "An Open Letter to My Friends." G. Ribemont-Dessaignes exclaimed, "The strong hands which lead surrealism will, no doubt, withdraw, someday followed by loud laughter. But there may be then so many clouds of whipped cream that the whole world will have again put on its white cloak of the centuries of comfort, in the insipid asphyxia of prudish suns and moons in corsets."[16] In "An Open Letter to my Friends," Josephson wrote, "Super-Realists. Chameleons, rattler! Even as one begins to scold you the colors change, and a new 'movement' is underway." He continued, "As we billet this new artistic organism in the *Little Review* (alphabetized encyclopedia of the twentieth century) word comes that it is no longer among the living. After the exquisite uproar of Dada, which was incontestably a miraculous side-show for the world, this super-realism is the faint, ugly whine of a decrepit engine."[17] In his autobiography, Josephson recalled his *Little Review* salvo: "I attacked the Surrealists of Paris, some of whom were included in the French section of the same issue. Certainly, I had experienced a great change of heart toward the esthetic nihilists who had so long fascinated me . . . I now expressed a vehement dislike for their anti-social and irrational tendencies, as for their preoccupations with nightmare and daydreams: all the spiritist séances and pseudo-Freudian experiments." As a result, "André Breton, the Surrealist 'pope,' turned livid on reading my offending remarks and pronounced me eternally damned, that is, excommunicated."[18]

In keeping with Anderson's approach to imagism and other movements, Heap published Dada and surrealism simultaneously with criticism of them both. Like her former coeditor, the more readers Heap irritated, the happier she seemed. Nevertheless, as Heap said in defending her right to publish what she pleased, "We have printed more isms than any other ten journals and have never caught one. Our pages are open to isms, ists, ites . . . we have been after the work, not the name . . . our drooling critics, in true American fashion, became sea-sick over a name . . . we are enjoying ourselves."[19]

When she returned to New York from Paris in the summer of 1925, Heap was persuaded to mount a special exhibition of her lifelong passion—theater. Heap was aided in this by Tzara and Frederick Kiesler, the Austrian-American architect and theater designer who had also been influenced by the surrealists Heap's plans, as she outlined them to Florence Reynolds, were modest: about twenty exhibits from five countries that would include models of theatrical sets, "drawings of sets, costumes, masks, photographs, etc."[20]

She worried about the price tag of transporting European work to New York. However, letters to Reynolds seemed confident that charging admission and selling the *Little Review* as a catalog would cover the expenses. She wrote, "I am only worrying about the things I bring with me."[21] Amazingly, however, the size of the exhibit swelled to over fifteen hundred contributions from fifteen countries, including Russia, France, Sweden, Poland, Holland, and Latvia. It was, according to the art historian Susan Noyes Platt, "the decade's largest and most comprehensive exhibition of stage design based on mechanical principles.[22] The size of the production prevented the Little Review Gallery Heap had established in 1925 from mounting Kiesler's work, and the financial support for the show fell through. Nevertheless, an impressive network of groups such as the Theatre Guild, the Provincetown Playhouse the, Greenwich Village Theater, and the Neighborhood Playhouse contributed to present the exposition.

The entire issue of Winter 1926 was dedicated to the International Theatre Exposition in New York, with considerable emphasis on costuming and set design. The Theatre Exhibition was highly eclectic, including for instance the famed puppeteer and Provincetown Playhouse alum Remo Bufano, whose article "The Marionette in Theatre" lauded the superiority of puppets over human actors, and the costume designer Comte Etienne de Beaumont, who wrote of the 1924 "Soirées de Paris," a five-week-long series of ballets, plays, and performances he commissioned with assistance from Cocteau, Picasso, and Tzara. Kiesler's contribution, "Debacle of the Modern Theatre," was a condemnation of the current state of affairs. "We have no contemporary theatre," he declared. "No agitator's theatre, no tribunal, no force which does not merely comment on life but shapes it."[23]

A. R. Orage, still working as Gurdjieff's representative, contributed "A Theater for Us," arguing, "Practically all modern plays consist of a

triangle surrounded by three minor geometrical figures. Is it inconceivable what the *next* evolutionary step must be."[24] He described a by-the-book suggestion of how a play's construction should represent the Gurdjieffian concept of humans as "three centered beings," termed "pivots" here— mind, emotion, and body, personified by various characters such as an animal, poet, child, savage, etc. This would serve to prove Gurdjieff's contention that humans—or, more aptly phrased, "automatons"—would consistently demonstrate their lack of will as they are pulled apart by their three "appetites." Such a production on the stage "would be highly entertaining, might be extremely instructive and ought to be truly illuminating."[25] One may argue that Orage's contribution was somewhat extraneous to theater criticism; regardless, the Theatre Issue was provocative and demonstrated an international and sophisticated approach to genuinely new philosophies of theater.

During the course of the mid- and late twenties, both Anderson and Heap traveled between Europe and America, but as time went on Anderson spent most of her time in France, living with Leblanc and writing her first autobiography, *My Thirty Years' War*. Heap established the Little Review Gallery on Fifth Avenue and attempted to become an art dealer in America for European artists. Established in 1925, the Gallery only lasted for two years, but it exerted a major influence over the contents of the final *Little Review* numbers. Three of what would be only five remaining issues of the *Little Review* from 1925 to 1929 were intimately connected with what Heap was trying to do with her gallery. Hence, the final years of the *Little Review* remained concentrated on the visual arts.

A year before the International Theatre Exhibition issue, Heap announced plans for a "Machine Age Exposition" sponsored by the *Little Review*. "The Exposition," stated Heap, "will show actual machines, parts, apparatuses, photographs, and drawings of machines, plants, constructions, etc., in juxtaposition with paintings, drawings, sculpture, constructions, and inventions by the most vital of the modern artists."[26] She had already published Vladimir Tatlin's "Monument to the Third International" and Ferdinand Leger's groundbreaking essay, "The Esthetics of the Machine Age," in previous numbers as well as reproductions of Leger's work, making it possible to see the evolution of the European artists she was introducing to Americans. By the time of the Machine Exposition Heap was well on her way to a complete assimilation of Gurdjieff's views

and this art would become central to her views of spirituality. Proclaiming "The Machine is the Religious Expression of Today," the "Machine Age" issue was also significant because it introduced the work of Theo van Doesburg, a Dutch architect and writer whose *De Stijl* magazine was in the vanguard of European avant-garde architecture. Two years after announcing the exposition, Heap finally completed her massive project in 1927, and she published the sole *Little Review* issue of that year as a catalog for the exhibit. The issue reports that the production consisted of tractors from the International Harvester Co., a crankshaft from the Studebaker Co., a Carbon Resister Type Telemeter from the Department of Commerce, and an airplane model from Curtiss Aeroplane. Other items on display included ball bearings, oil burners, meat slicers, and various gears; architecture such as power plants, grain silos, and private Bauhaus homes; and visual works from such artists as Man Ray, Charles Demuth, Naum Gabo, and Jacques Lipchitz.

For Heap, the "Machine Age" in art corresponded to Gurdjieff's mechanical metaphors. Gurdjieff's machine analogies extended beyond the individual to a cosmology of the universe, complete with technical terms such as the "enneagram" and "hydrogen 24." He maintained that it was as essential to understand the mechanical operation of the universe as it was to understand one's soul. To Heap this not only made sense but it also had implications for the direction of art in the modern world. One year after her exposure to Gurdjieff, Heap wrote an essay in the *Little Review* that demonstrated how completely the marriage of the machine and art had captured Heap's imagination. "There is," wrote Heap, "a great new race of men in America; the Engineer. He has created a new mechanical world; he is segregated from men in other activities . . . it is inevitable and important to today's civilization that he makes a union with the artist. The affiliation of the Artist and Engineer will benefit each other in his own domain; it will end the immense waste in each domain and will become a new creative force.[27] This creative force, as Heap put it, also had spiritual implications: "The legitimate pursuit of the Western World has been the acquisition of wealth, enjoyment of the senses, and commercial competition. America is supposed to have come nearer to an achievement of these aims than any of the other countries. It is beginning to be evident that no nation can progress beyond our present state unless subjected to the creative will."[28]

While some reviewers were open to considering these new trends, others such as the critic Henry McBride were more circumspect. With more than a bit of skepticism, McBride wrote, "Provocative Jane Heap, editress of the *Little Review* which troubles New York three or four times a year, that is to say whenever it appears, with the suspicion that it is twenty years behind the times instead of twenty years ahead, is at it again." McBride reported that Heap "has arranged a strange art exhibition by the Russian Constructionists [sic] in her new gallery at 66 Fifth Avenue, and those who wish to accept or contend certain avowed aspirations of the time will be obliged to go there. . . . [They] play constructionally with the forms made familiar to many thousands of people in the industrial age. . . . [They] speak the language of the times . . . that is the language we would speak if we were 'pure souls.' "[29]

The Russian Constructivists were interested in minimizing the form of composition, favoring the construction by using modern materials. Originating out of the Russian Revolution, some viewed the movement as the labor of "cultural workers." It also dealt with questions of time and space, attempting to delineate the vital forces of the contemporary world. The 1927 Machine Age Exposition was the next to last issue of the *Little Review*. No issue was published during 1928, and by the following year Heap now agreed with Anderson that it was time to bring the little journal to an end. The final issue of the *Little Review* was entitled "Confessions and Questions," and the approach was to mail a questionnaire to every past contributor of the magazine reaching back to 1914. The form was also mailed to current friends who had never written for the magazine such as Leblanc, Janet Flanner, Solita Solano, Edith Sitwell, and Allan Tanner. The questions themselves reflected the changing preoccupations of both Heap and Anderson; Gurdjieff and the search for knowledge remarkably transcended concern or interest in the state of modern art. Among the ten questions asked were "What do you fear most from the future?," "What has been the happiest moment of your life?," "What do you consider your weakest characteristic?," and "What is your world view? (Are you a reasonable being in a reasonable scheme?)." The self-analytical character of the questions reflects a waning interest in what had been the significant preoccupations of Anderson and Heap during the tenure of the *Little Review*. Of the ten questions, only one was about art ("What is your attitude about art today?"), and it was near the bottom

of the list. This demonstrates the profound transformation of both editors from a life dedicated to art to one of introspection and personal evaluation. Many of the resulting answers likewise were sincere attempts to conform to the wishes of Heap and Anderson. Richard Aldington, Sherwood Anderson, Mary Butts, H. D., Jean Cocteau, Dorothy Richardson, Joseph Stella, and Mina Loy all dutifully numbered their answers and returned them to the *Little Review*. Emma Goldman did as well, but with the preface that she found the questions "terribly uninteresting."[30]

Goldman's response is not surprising, given what must have been her severe disappointment with Anderson in particular. The anarchist certainly must have wondered what had happened to the young woman who wrote passionate calls for the revolution in the early days of the *Little Review*. Some former contributors, such as Ben Hecht, William Carlos Williams, and Maxwell Bodenheim, used the occasion to write essays recounting their careers with references to the magazine's role. Others such as T. S. Eliot, Havelock Ellis, Wyndham Lewis, and Ford Madox Ford, wrote short notes of general condolence on the passing of the journal while avoiding the questions. Eliot recalled, "The *Little Review* was the only periodical in America which would accept my work, and indeed the only periodical there in which I cared to appear."[31] Natalie Barney and James Joyce responded by inviting Anderson and Heap to tea to discuss the questions. Joyce later canceled; whether the Barney invitation was accepted is not known. The most direct dismissal of the queries came from Djuna Barnes, who wrote back, "I am sorry, but the list of questions does not interest me to answer. Nor have I that respect for the public."[32] The most novel goodbye came from Gertrude Stein, who wrote a prose tribute to Heap entitled "An Appreciation of Jane": "Jane was her name and Jane was her station and Jane her nation and Jane her situation . . . Thank you for thinking how do you do thank you Jane thank you too thank you for thinking thank you for thank you."[33]

The opening editorials written by Anderson and Heap explain their reasons for finally ending the fifteen-year career of the *Little Review*. Anderson's essay clearly shows the profound shift in her interests. "Only artists had ideas . . . and of course only the very good ones. So, I made a magazine exclusively for the very good artists of the time. Nothing is more simple for me than to be the art arbiter of the world. I still feel the same way—with a rather important exception. As this number will show, even

the artist doesn't know what he is talking about. And I can no longer go on publishing a magazine in which no one really knows what he is talking about. It doesn't interest me.[34]

Directly appropriating Gurdjieffian language, Anderson wrote that she did not want to hear any more about "it's the artist who transforms life." "I know it," she continued. "But I'm not particularly interested at the moment in transformation. I want a little illumination."[35] Heap's farewell essay repeated Anderson's sentiments. It appears that this was one instance in which Anderson led Heap in the development of their ideas. Anderson had been ready to give up the *Little Review* several years before; she had doubted the efficacy of spending her life publishing an avant-garde magazine in the artistic climate of her milieu. She had other concerns, both personal and spiritual, that she wanted to nurture. Though Heap had suffered from the same frustrations as Anderson, she persisted in printing the journal. She thought it was possible to incorporate Gurdjieff's ideas with the cutting edge of modern art, and she diligently tried with the Theater and Machine Expositions. Yet, eventually, Heap came to the same conclusions as Anderson: art was "interesting only as a pronounced symptom of an ailing and aimless society."[36]

In her editorial, poignantly entitled "Lost: A Renaissance," Heap mused, "For years we offered the *Little Review* as a trial-track for racers. We hoped to find artists who could run with the great artists of the past or men who could make new records. But you can't get race-horses from mules. I do not believe that the conditions of our life can produce men who can give us masterpieces. Masterpieces are not made from chaos. If there is a confusion of life there will be a confusion of art." She continued, "Self-expression is not enough; experiment is not enough; the recording of special moments or cases is not enough. All the arts have broken faith or lost connection with their origin and function." In her final paragraph, Heap starkly distanced herself from her past life: "Perhaps the situation is not so hopeless as I have described it. Perhaps it doesn't matter. Or perhaps it would be more than an intellectual adventure to give up our obsessions about art, hopelessness, and *Little Reviews*, and take on pursuits more becoming to human beings."[37]

Heap's observation that art reflected the confused temper of the times was prescient. Published only months before the Wall Street crash, the final issue of the *Little Review* concluded as the rise of fascism and the

advent of global war appeared on the horizon. While many Gurdjieffians scattered to the winds during the war, core groups remained in Paris and London. In the coming decades Anderson and Heap went their separate ways while still adhering to their belief in Gurdjieff until their deaths. But in 1929 their focus was on the future, not the past. The *Little Review* had come to an end.

EPILOGUE

Post–*Little Review* Years

In her remaining forty-four years Anderson wrote three autobiographies, a *Little Review* anthology, and an unpublished novel about a lesbian love affair.[1] Though she had no career or steady income for the rest of her life, she traveled widely, lived in impressive dwellings, and concerned herself with her continuing quest for self-understanding.

Both Anderson and Heap combined trips back to New York with long-term residences in Paris during the thirties. Leblanc had been invited to do a tour in America, and Anderson was to act as her accompanist. Leblanc's career was in decline, however, and the promised concert dates were withdrawn. They held small concerts at the Theatre Club off Washington Square Park with their friend Louise Davidson, a theater director, as their manager before giving up and sailing back to France. The two women were able to survive initially because Leblanc was from a wealthy family that parsimoniously doled out funds and living spaces in their chateaux. Anderson recalled the family in detail with a combination of humor and dread. At first they stayed at the family's eleventh-century chateau in

Normandy; however, a series of family arguments, reconciliations, and upset plans shifted them to other chateaux, hotel apartments in Paris, and even—to Anderson's delight—an abandoned lighthouse.[2] Each woman earned some income by writing her autobiography: Anderson's *My Thirty Years' War* and Leblanc's *Souvenirs: My Years With Maeterlinck*.[3] During the thirties Anderson and Heap formed a small Gurdjieff study group in Paris with LeBlanc, Solita Solana, Katherine Hulme, and Louise David-son. They met with Gurdjieff himself, either in his apartment or a café he preferred. Heap emerged as one of his more adept students and in 1935 was told by Gurdjieff to go to London and form a group there.

In 1939 Leblanc was diagnosed with a cancerous tumor in her arm. Her illness coincided with the outbreak of the Second World War, and the two women, along with Leblanc's faithful companion Monique Serrure, attempted to escape the predicted bombing of Paris by traveling to the neutral country of Spain. Losing their passports, all three returned to France and settled in the small town of Le Cannet, two miles north of Cannes, where a three-room house called Chalet Rose became their new home. After an agonizingly long period of pain Leblanc died in the house in October 1941. Florence Reynolds, who had moved to Tarrytown, New York, to teach in Andrebrook, a private girl's school, communicated with Heap about Anderson's travails in wartime Europe. She told Heap she heard about Anderson via Solano and was concerned. On November 9, 1941, she wrote, "Janie, my Dear: . . . I feel so strange about Margaret. As long as Georgette was alive I could visualize their life—after all, taking care of someone who is ill follows a pattern known to almost everyone, but now it is as though she is in a vacuum and I have lost her completely. What is she doing? Is she trying to get here and what does that entail? Is she hungry, is she cold? Do you know what I mean?"[4] Anderson was devastated by Leblanc's death, and eight months later, while the war raged on, she returned with Monique to America. The two women were broke, and their passage on the *U. S. S. Drottningholm* was paid by the former *Little Review* contributor Ernest Hemingway. Hemingway was unassuming in response to Solano's anxiety and gratitude for his help with Ander-son's escape. He told her, "Don't ever worry because as long as any of us have money we all have money."[5]

Meanwhile Heap, now an expatriate in London, had met a new com-panion, Elspeth Champcommunal, a former editor of British *Vogue*.

Within a few years Heap found herself trying to run her groups under the shadow of the Battle of Britain. In the spring of 1938 she wrote to Reynolds, "Everyday I learn my gas attack lesson, printed in the paper and how to dig a trench in your garden, and then I laugh because we have no garden."[6] Heap was extremely philosophical concerning her situation: "There is no place to go if one's time is up, so why worry and spoil in the meantime."[7] More seriously, however, she wrote to Reynolds, "I feel the way you do about the Germans never before have I had this hate that wearing down process that they use that is just too disgusting."[8] She described one evening: "Elspeth knitting and I reading out loud, when heard a noise above the house, stood right up, and said 'Well, I ask you!' E. looked at me in surprise and said 'What?' then a rocking crash."[9] In response to Reynolds' repeated entreaties for Heap to come home she responded good humoredly, "Sorry I can't come home now, must wait for the invasion."[10] Later she wrote, "There is a crater in our street one block down that fills the street from curb to curb. It is impossible to imagine anything about it from photographs or descriptions. It is as if something came out of hell and blasted and blighted."[11] Shortly after that Champ-communal and Heap left London for the Gotten Farm Manor in the town of Chale on the Isle of Wight. However, the war still was not far from their day-to-day lives. In October 1940 Heap wrote Reynolds from the Manor, "I saw an air battle, 22 planes taking part. They passed over as I was going to the village. I waited under a wild crab apple tree in a hedge. They were making for a port. You could soon hear them drop down, anti-air guns roaring and then the fighter driving them back."[12]

After the war Heap continued her Gurdjieff teachings in London and opened a shop called The Rocking Horse that sold toys salvaged from Victorian houses. Working to repair these toys also instructed her students in a sort of mindful concentration necessary for their studies. Although she declared she had turned her back on the arts, she used plays, opera, and the reenactment of fairy tales complete with elaborate set designs. She also mounted "festivals" that coincided with the holidays of the year, complemented with exotic food and spices seemingly impossible to find during a time of post-wartime rations. Her student Nesta Brooking recalled, "Guitar playing, screen printing, and carpentry all added to the stretch for a purpose and were tested and explored in the larger spheres of festivals."[13] Her students remembered Heap as formidable but compassionate.

Brooking wrote, "One could sense Jane's sincerity of purpose—though the balance between her seeming harshness and unexpected kindness were more understood in retrospect!"[14] Heap's most famous student was Peter Brook, the British playwright, theatre, and film director, best known for *Mahabharata*, a nine-hour play based on a Hindu myth. In his autobiography Brook recalled meeting Heap for the first time in her Hamilton Terrace house in St. John Wood. "The teacher was Jane Heap. She was American, short, dressed like a man, with closely cropped gray hair . . . She was gentle, ferocious, and compassionate. Her idiom was a rich slangy vernacular from the Midwest, bringing an earthly common sense to everything she proposed; when need be she could give her listener a sudden shock, like the grand slam of the bat on a ping pong ball when it is close to the net. What is my biggest obstacle to real understanding? I asked Jane after a few weeks. The reply was instantaneous: Peter."[15]

On the deck of the *USS Drottningholm*, Anderson met the woman who would become her companion for the next thirteen years. In her third and final autobiography, *The Strange Necessity*, Anderson describes seeing Dorothy "Duffy" Caruso, the widow of Enrico Caruso, for the first time. "The second day at sea I was sitting on the promenade deck, trying to forget where I was and where I was going, seeing only the grave I was leaving behind. The sun was bright and at the open end of the promenade I saw a tall woman in blue—that summer blue of Cannes, always worn with a touch of red—leave her chair and walk across the deck. Her hair was gold, her eyes were bluer than her dress . . . eyes of a visionary or a mystic, I thought."[16] The two women struck up a conversation about poetry and Gurdjieff and were companions from that point on. Upon arriving in New Jersey, Anderson and Caruso were greeted at the dock by Flanner, who now had a new partner, Natalia Murray, and Solano, who also had a new love, Elizabeth Jenks Clark. When they saw Anderson come down the plank with Caruso, they were greatly relieved. Flanner commented, "There have never been such many happy endings since Gilbert and Sullivan!"[17]

Anderson and Caruso moved into a brownstone on the Upper East Side. On February 26, 1942, they invited Reynolds to a dinner that turned out to be a surprise birthday party for her. She wrote to Heap, "Cakes with candles and champagne, chicken and dumplings, can you imagine that? Margaret, Solita and Lynn [Elizabeth Clark] and Dorothy's

young daughter Jackie. All so pleasant and friendly. I felt so cherished and protected, so in another world. Margaret looked lovely."[18] Two years later Reynolds moved to Hollywood, California, to live with her sister Hattie; her letters indicate she did so due to illness. Her last extant letter to Heap is from March 1945, and she died in December 1949. Her sister wrote a note in her address book: "Ho [her nickname for Florence] died in St. Vincent Hospital Friday at 9:55 am Dec. 2, 1949. Starvation due to cancer."[19]

This circle of women had lives that had been intertwined with one another beyond the conventional bonds of friendship. Heap and Reynolds's letters from 1908 to 1909 were those of two pining lovers. Yet Reynolds accepted Anderson when she became involved with Heap and moved to New York. Heap then changed the salutations of her letters from "Dear Tiny Heart" to "Mother." "Mother" was the moniker Anderson also used in her letters to Reynolds. Reynolds continuously supported the *Little Review* over the years, from writing checks to carrying copies of the journal to Chicago bookstores. Her later letters use Gurdjieffian vocabulary, demonstrating that she accepted and assimilated Heap's conversion. Before she died, she set up a trust fund for Heap. In many ways the diminutive Reynolds lived for the larger-than-life Heap, following, accepting, and encouraging each new stage in her life. As a result, she was embraced by the larger group of Leblanc, Solano, Flanner, and Caruso.

In the fifties Anderson and Caruso moved to Riderwood, Maryland, where Caruso had a home. Now close to Washington, D. C., Anderson wrote frequently to Ezra Pound, who was incarcerated in St. Elizabeth's mental hospital. She clearly attempted to cheer him up, sending him work to translate, engaging in literary gossip, and promising visits, although it is not clear she ever followed through.[20] During this period Anderson finished her second autobiography, *The Fiery Fountains*, and edited *The Little Review Anthology*, a collection of the best of the journal. There were trips to France and continued meetings with the group of women who conducted a Gurdjieff study group for several years in Paris. As Heap drew deeper into teaching, she would not answer letters from friends; instead, Elspeth Champcommunal occasionally corresponded and wrote of their daily lives. In 1960 Anderson, reflecting about their relationship, wrote to Solano that she had written Heap "about certain

things of the past which I had never understood until now, and for which I had remorse. Thought of course she would answer such a letter, but no, not a word."[21]

In Maryland, Anderson and Caruso led fairly conventional lives. Anderson described herself as a happy recluse, busy with her writing and enjoying the cocktail hour before her favorite television shows came on.[22] This domestic idyll was shattered, however, when Caruso also fell ill with the same cancer as Leblanc and died the week before Christmas in 1955. In certain ways Caruso's death was more difficult for Anderson because, unlike Leblanc, Duffy was still a relatively young woman, and her death was sudden and unexpected. Shortly after her death, Anderson wrote Janet Flanner, "I am all right; but I hear myself walking through the house crying out loud like an animal, and I can't seem to stop—don't even want to stop, it's the only relief."[23] That Christmas Solano and her lover Elizabeth Clark traveled to Maryland and took Anderson to Clark's family estate in Morristown, New Jersey. The following April the three left together for France, and Anderson reestablished herself with Monique Serrure in the Chalet Rose where Leblanc had died. Caruso's will left enough money to Anderson that she was not pressed by financial insecurity. However, another blow was on the way: Monique died at age ninety-two in June 1961. Shortly afterward Anderson wrote to Solano, "4 o'clock, and I can use my typewriter because there's no one here to be disturbed. Oh, I didn't know it would be so terrible. Georgette died, but there was still Monique and together we could believe that she was still living. Duffy died, and there was still Monique . . . for the first time in my life I don't know what to do or how to endure what I'm feeling."[24]

In her last autobiography, Anderson described taking a walk every evening, writing that she was joined by her "ghost companions" with whom she conversed.[25] Not long after these losses came perhaps the most tremendous blow: she received word from Champcommunal in June 1964 that Heap had died due to complications from diabetes. In spite of their distance, Anderson was deeply shaken. She wrote to Allen Tanner, "Oh, oh a world without 'jh.' "[26] The years had done much to soften antagonisms of the past on other fronts, too. After hearing of Heap's death Djuna Barnes, Anderson's rival for Heap, wrote to Anderson, "Death bringing everything full circle, she's at home again; that house being yours, I send my sympathy."[27]

As the decade of the sixties progressed, Anderson finished her third autobiography, *The Strange Necessity*, in which her losses were poignantly described. Under the heading "My Atomic Age" Anderson wrote, "As after a final holocaust, nearly everyone who has made life wonderful for me has died. All my lovely companions nearly all—are faded and gone."[28] The book is also informative for revealing how Anderson, the radical bohemian of the twenties, was less than excited by the cultural revolution of the sixties. "I am tired," she wrote, "of 'new writing' and of 'powerful new novelists,' I am tired of today's new people; I'm tired of their lives, of their tastes, their reading, their language, their singing, their sedatives and their psychiatrists, their houses, their furniture, and their faces . . . What am I most tired of? Today's arid poets. What do I most loathe? Today's rancid sex books."[29] In an article a few years later Anderson wrote, "There exists a present-day phenomenon which must never be talked about. It is called Hippie . . . meaning noise for music, beards for beauty, and nervous breakdowns for civilized humanity . . . under such victimization one has to use a tight control."[30] The former radical anarchist was clearly not in step with the counterculture created by the new generation of bohemians.

In 1969 all three Anderson autobiographies were republished by Horizon Press. They garnered a review on the front cover of the *New York Times Book Review* written by Alfred Kazin. His account swayed back and forth between admiring Anderson's entire career and belittling her ability as a writer. "Miss Anderson," Kazin proclaimed "is a talker, not a writer." Noting her enthusiasm he continued, "in her seventies, she talks like the girls in my high school class." He concluded by stating she was a certain type—"a Midwestern feminist."[31] Anderson wrote Kazin a letter stating she also did not think of herself as a writer, "but lately I was beginning to think I was becoming one and now you are stripping me of that excitement." She then quoted Janet Flanner's estimation of *The Fiery Fountains*: "Her talent as a writer, her sure hasty touch in catching the right word and image, give her book a special rich quality." Nevertheless, she did not seem bitter, attaching a handwritten note at the end of the letter: "For all the most many thanks; and all the best wishes."[32] In addition to the republishing of her autobiographies, Anderson gained some financial security in her later years through the sale of Heap's *Little Review* papers to the University of Wisconsin for seventy thousand dollars, which

she split with Champcommunal. She gave away fifteen thousand to her sisters, nephews, and "two or three other hard up people."[33]

Although happy about the publication of her autobiographies, Anderson was frustrated and disappointed over her inability to get her autobiographical lesbian novel *Forbidden Fires* published. She originally began it as an effort to stop grieving over Caruso. The novel was based on Anderson's obsession with the aunt of a former flame, Gladys Tilden—the stage actress Josephine Plows-Day, also known as Aunt "Tippy." Plows-Day had performed in the company of Richard Mansfield in works by Shakespeare, Moliere, and Ibsen, whose words she invoked in conversation, obviously adding to Anderson's attraction. They met briefly in New York and Anderson was immediately smitten. Describing Plows-Day ("Audrey Leigh" in *Forbidden Fires*), Anderson's character "Margaret" observes, "She walked slowly towards us. There seemed to be a silence around her, as there would be for a heroine making her first entrance in a stage play . . . The long silver chain she wore swung to the rhythm of her walk with a sound of soft chimes. She seemed so incredibly lovely to me that when she gave me her hand, looking directly into my eyes and saying 'Ah,' I felt a little movement of pain in my heart."[34]

Also in the novel was Heap as Kaye, Leblanc as Claire, and Champcommunal as Eleanor. In *Forbidden Fires* "Margaret" faces her awakening with the bald statement, "I began by quickly accepting the fact that what had happened to me wasn't the kind of thing that happened to other people. Boys fell in love with girls, girls fell in love with boys, but for some reason I *didn't* fall in love with boys."[35] As Margaret declares her love, Audrey Leigh shrinks away in self-consciousness that "people have been talking." Anderson's character responds, "I've never had that absurd *Well of Loneliness* feeling of isolation and guilt—it seems tragic and unnecessary to me."[36] After debating the religious and philosophical implications of lesbianism in society, Audrey Leigh succumbs. At the conclusion of the book, Margaret uses Gurdjieffian terminology. "I shan't say it lasted forever. It had a deeper time, a time in height and depth. It gave us unbearable partings, unbelievable meetings, a full lifespan. It had its ending, but it never came to an end."[37]

Anderson was stymied trying to find a publisher; she sent the manuscript to Ben Hecht, who also tried unsuccessfully. She sent her manuscript to Jeannette Foster, the author of *Sex Variant Women in Literature*, asking

for any suggestion for publishers. Foster responded with praise for *Forbidden Fires*: "It is really a beautiful thing, not only in form, but in almost every word of its phrasing."[38] After recounting her own disastrous experiences with publishers, Foster suggested the Daughters of Bilitis and The Mattachine Society organizations, both of which published magazines.[39] The book was finally published by a lesbian paperback press, Naiad Press, in 1992. Although the romanticism of it would not appeal to lesbians of the 1990s, it remains an important historical document, an example of mid-century lesbian fiction that did not end in suicide or madness.

By the late sixties a weak heart and worsening emphysema forced Anderson to move from her beloved Chalet Rose into the Hotel La Reine des Prés in October 1967. Self-conscious about her looks, she did not want to go out in public and received visits only from old friends such as Solano and Clark. "I am literally too ruined," she wrote Solano, "especially in the face, all my medicines may be causing swelling of features."[40] Solano, Clark, and Flanner repeatedly begged Anderson to move to Orgeval, where Flanner's new lover Noel Murphy had a villa and where they all stayed. She refused, afraid of becoming a dependent with little autonomy; she felt she needed to keep her privacy and as much independence as she could. She kept up a busy correspondence with friends and her sisters, Lois and Jean, showing concern for others and a lack of self-pity for her own situation. She often recalled the early days of the *Little Review*, and in the year before her death even commented on a subject she remained silent about most of her life—her mother. To her sister Lois, Anderson wrote:

> In our young days Jean was no good to anybody and neither was I. I did nothing except to be interested in the L.R and in writing books. But you were sweet to everyone—especially to Dad, and he knew that you were the one who loved him, and he loved you. I see it all so clearly now, but I never thought of it at all then. The things I DIDN'T do now seem like crimes to me. And to think how good you were to mother at the end—when I was too busy and still too alienated from her, to think of her at all. As Gurdjieff said, "Only he who loves his mother and father." . . . oh dear, oh dear.[41]

Several months before her own death Anderson was "living a sort of wheel chair life, never leaving my room, trying not to leave my armchair."[42] By September 1973 she had been moved to the Anglo-American

Hospital. Her emphysema was clearly killing her. She wrote to Solano, "Thursday morning there is no longer any doubt, everyone sees at last that I am seriously dying, as I have seriously been trying to tell them . . . I suppose this is my last letter."[43] At the end of the letter was a handwritten note: "I love you so much. M."[44] A month later, on the night she died, she wrote, "I must never spend annoyer [sic] like this one, I can't breathe. The agony is so terrible I must write it."[45]

Solano was at her side and wrote to Anderson's sister Jean, describing her death gasping for breath as "agonizingly painful."[46] Ironically, the enthusiastic young woman who founded the *Little Review*, so often described and characterized as "breathless," literally died from want of oxygen. According to Solano there was no religious service but instead "many flowers" and "several friends from London."[47] Per her request, Anderson was buried in the same grave as Georgette and Monique in the Notre Dame des Anges Cemetery in Cannes. She was eighty-seven years old. One year later Flanner published a profile of Anderson in the *New Yorker* called "Life on a Cloud."[48] She wrote, "The demise of Margaret Anderson in southern France in the autumn of 1973 removed the last standing figure from that small circle of amateur American publishers— oddly all female—whose avant-garde output a half a century ago unexpectedly became a new kind of important international literature."[49]

Whether or not these women acknowledged it, on a conscious level they lived in a manner that later generations of lesbians would recognize— they were choosing their family, and as such their sense of responsibility for one another extended beyond mere friendship over decades. This included being lovers—Reynolds with Heap, Heap with Anderson, Anderson with Leblanc and Solano, Solano with Flanner. Although they had their moments of pique and jealousy, the fact that they ultimately remained supportive of each other for years on end is a testament to their love for one another on many levels. Writing about women in Paris in the twenties, Bertha Harris takes this web of relationships to a new level, describing them as a dominion among themselves. "They were American and English and French, but mostly American, but with the father's nationality in effect wiped out by the more profound nationality of their lesbianism."[50] And their legacy was remembered by those who lived where they began: in 2006 Anderson and Heap were inducted into the Chicago LGBT Hall of Fame.

It is curious that the entire fascinating story of Margaret Anderson and Jane Heap has gone largely unrecorded. Apart from some articles on the *Ulysses* trial, little magazines, or references in published accounts of LGBTQ history, the story of Anderson and Heap has not previously been told in its entirety. Nineteenth-century-born midwestern mavericks, they grew up to be iconoclastic rebels, flaunting their lesbianism, advocating causes ranging from anarchy and antiwar activism to feminism and free love, their lives and work shattered cultural, social, and sexual norms. As their paths crisscrossed America and Europe, two World Wars, and an incredible parade of the most celebrated artists of their time, they managed to transform themselves and their little journal into a major force for shifting—and not always welcome—perspectives on modern literature and art. Their fascination with a mystical guru, charlatan or not, only underscores their profoundly deep search for meaning in a world that, more often than not, seemed squarely set against them.

Gurdjieff's influence on the post-*Little Review* lives of Anderson and Heap has been explained away (when given any attention) as the result of the rigors of the *Ulysses* trial, the dissolution of their relationship, or a nervous breakdown by Anderson. However, since Gurdjieff-like influences can be seen prior to their actual knowledge of this mysterious figure, such explanations don't hold up. An examination of the *Little Review* from the debut number onward foreshadows a variety of influences that point to the compelling prospect of a later life of spiritual transformation. Seen through their identities as modernists, the pull of Gurdjieff was part of a continuous journey rather than a bizarre detour explained only by official censorship, broken relationships, or mental collapses. We can clearly connect Gurdjieff's psychology and cosmology in particular to the development of Anderson's and Heap's thoughts on modernism from the first issues of the *Little Review* until they ceased publication.

The end of their professional careers was a conscious decision in part because art and literature, modernist or not, failed to take them far enough on a journey that Anderson would describe as "transformative."[51] This was the view at the end of their careers; at the beginning we see a clear foreshadowing of a mystical incline that would lead them to Gurdjieff—he was in the right place in the right time. Without their prescient understanding of the important influence of modernism on both

individual human beings and modern culture at large, it is unlikely that Gurdjieff would have been their next step.

Furthermore, we can see a form of spiritual pursuit even before their modernist journey and *Little Review* careers. Anderson's description in her autobiographies of her life before Gurdjieff is replete with a religious vocabulary, and she believed that anyone with a basic foundation of spiritual interest should be open to Gurdjieff's message. While she railed against traditional Protestantism by arguing with her Sunday school-teaching aunt, she also allowed for the metaphysical endorsement that she was "aloof from natural laws" and the belief that she was under some greater protection. The same held for Heap, who wrote to Reynolds in 1908 that "everything beautiful was God and all things not beautiful not God."

The primary influences on both of them—Ralph Waldo Emerson, Friedrich Nietzsche, Oscar Wilde, Walter Pater, Walt Whitman, and Henri Bergson—appeared in the early years of the *Little Review* and were consistent with the strands of Gurdjieff's philosophy that they later embraced. The influence of Christian, ancient Greek, and pagan themes in the literature, art, and poetry of contributors from 1914 to 1916 also point to Gurdjieffian themes. Anderson made it clear that these same giants of nineteenth-century thought served as the foundation for the "new" in twentieth-century criticism. They all criticized traditional Christianity and with it the social norms of their day. Nietzsche, Pater, Wilde, and Whitman all believed, and guided Anderson and Heap to accept as true, that art has no moral purpose—hence their combative heroic fight over *Ulysses*. The epiphanies of James Joyce were presaged by Bergson's intuitive flashes, which Anderson championed as the basis for arguing that the critic was just as creative as the artist—a position also held by Pater, Wilde, and Nietzsche.

Even more sweeping, of course, was their radical agreement with these thinkers on the minefield of sexuality. They all decried false morality and supported the expression of sexuality within poetry, literature, and art. Whitman's biographer, as we have seen, views Whitman's "Cosmic Enthusiasm" as not only his expression in poetry but the basis for a new religion—or mysticism—that was particularly American. Anderson's radicalism concerning the political repression of gay Americans was expressed in her 1915 editorial "Mrs. Ellis's Failure," in which she referenced Wilde

and Edward Carpenter. This political assessment was extended the same year to Anderson's laudatory editorials on Emma Goldman, whom she described as a prophet and "practical Nietzschean." And Goldman, of course, shared Anderson's, Whitman's, and Wilde's prophetic belief that homosexuality should not only be decriminalized but accepted.

By 1917, when Ezra Pound signed on as foreign editor, he was already under the sway of a wide range of esoteric practices. This included the Eastern traditions of the Chinese ideogram and Japanese Noh as well as Western traditions such as the Rosicrucians, Orphism, Pythagorean Mathematics, and the Eleusinian Mysteries. Pound was not a follower of Gurdjieff, but his critical analysis of the "modern" French poets such as Jules Laforgue and Jean de Bosschère, some of them self-described mystics (or described by others as clearly esoteric in their preoccupations), was among his best received work in the journal. Whether his poetry is described as metaphysical occultism or in the tradition of alchemy, Pound espoused the concept of the artist as master of the soul. In the tradition of Pater, Wilde, Nietzsche, and Gurdjieff, and in the thoughts expressed by Anderson herself, the artist or "magus" was premised on a superior caste of the enlightened living among commonplace souls.

Pound's acerbic retorts to *Little Review* readers who seemed puzzled by his impenetrable choices as editor only underscored this belief. He saw modernism itself as a parallel to ancient secret societies of initiates who were a caste of priests that comprehended the esoteric and occult. W. B. Yeats went a step further than Pound in that he actually belonged to esoteric secret societies that practiced ceremonies and rituals. Part of Gurdjieff's appeal to Anderson, Heap, and their contemporaries was rituals like the Toasts of the Idiots, group readings of his manuscript *Beelzebub*, and dance movements that initiated his students. Gurdjieff's teachings and study groups such as the Rope also served as a secret society of sorts, drawing new members through attraction rather than promotion. And similar to Pound's role as a magus and Yeats' experience in various theosophical lodges, in Gurdjieff's world one could step outside into "the unreal world" and carry on a life they understood as illusion. Reality would be found in the fourth dimension—both spiritually and artistically. The later years of the journal merged the thought of Gurdjieff with the avant-garde world of Cubism, surrealism and Machine Age aesthetics that

reinforced the mechanical metaphors he claimed were key to comprehending both the human psyche and the fate of the cosmos.

While the obscenity trial of *Ulysses* may be the most historically significant episode of the *Little Review*, the most radical aspect of the journal's history was the intersection of lesbian and feminist themes—often intertwined with mysticism as well. Whether it was Heap's own contributions, Goldman's "prophetic" anarchism, Amy Lowell's and H. D's imagist poems, the dark vision of Djuna Barnes, the Baroness von Freytag-Loringhoven's creative madness, Mina Loy's "Cosmic Neurosis," May Sinclair's ghost stories, Dorothy Richardson's stream of consciousness, or Mary Butts's women acting as the savior of supernatural England, politically radical, feminist, lesbian, and mystical women writers placed a significant imprint on the history of the *Little Review*.

Anderson started the *Little Review* to have a personal magazine that would inspire a conversation. She accomplished that and more. While she may not have been aware of the tumultuous road ahead, her partnership with Heap broke new ground in promoting a radical articulation of literature, art, criticism, and sexuality that was essential for the revolutionary emergence of modernism. Anderson and Heap's investigation of the esoteric through a myriad of artistic influences paved the way for their turn to Gurdjieff. While illness and tragedies may have marred their later years, their allegiance to Gurdjieff remained steady. Although Anderson acknowledged that being a sojourner in Gurdjieff's world did not provide protection from unhappiness and regret, she felt that her life was an exceptional blend of synchronicities that made it unique and blessed. In one of the last passages in her final autobiography she wrote:

I wondered why I have wanted to write the story of my life. I know it first hand, but so incompletely that it has little meaning. It has been so happy and so sad, as happy as flowers, as sad as moonlight—a happy life that loves the saddest music. It has been a striving and a failing; a development and a diminution; it has been proud and egotistic, modest; aggressive and unassuming; alert and unconscious; hopeful, and I fear, lost. It has overflowed with thankfulness and remorse—a life like any other, but which has seemed to me so different, so special, as to be unique. The blessings I wanted were love and music, books and great ideas and beauty of environment. I have had them all, and to a degree beyond my asking, even beyond my imagining.[52]

NOTES

Introduction

1. Christine Stansell, *American Moderns: Bohemian New York and the Creation of a New Century* (New York: Metropolitan Books, 2000), 199.

2. For a comprehensive history of little magazines and their impact see Peter Brooker and Andrew Thacker, eds., *North America 1894–1960*, vol. 2 of *The Oxford Critical and Cultural History of Modernist Magazines* (Oxford: Oxford University Press, 2012).

3. Jane Heap, "Lost a Renaissance," *Little Review* (1929), 5–6.

4. Margaret Anderson, "Editorial," *Little Review* (Fall 1929), 3–4.

5. Hugh Kenner, *The Pound Era* (Berkeley: University of California Press, 1971), 281.

6. Jayne Marek, *Women Editing Modernism: "Little" Magazines and Literary History* (Lexington: University of Kentucky Press, 1995), 60–61.

7. Brooker and Thacker, *North America 1894–1960*, 1.

8. Mark S. Morrisson, *The Public Face of Modernism: Little Magazines, Audiences and Reception, 1905–1920* (Madison: University of Wisconsin Press, 2001), 133.

9. Robert Crunden, *Body and Soul: The Making of American Modernism* (New York: Basic Books, 2000), 400.

10. Crunden, *Body and Soul*, xvii.

11. Roger Lipsey, *The Spiritual in Twentieth Century Art* (Mineola, NY: Dover Publications, Inc., 1988), 463.

12. Henry Miller quoted in Fritz Peters, *My Journey with a Mystic* (Laguna Niguel, CA: Taylor Weber, 1986), 6.

13. See Pierre Bourdieu and Chris Turner. "Legitimation and Structured Interests in Weber's Sociology of Religion," In *Max Weber, Rationality and Modernity*, ed. Sam Whimster and Scott Lash (London: Routledge, 2014), 119–36.

14. Tom Gibbons, *Rooms in the Darwin Hotel: Studies in Literary Criticism and Ideas 1880–1920* (Nedlands: University Press of Western Australia, 1973), 79.

15. Margaret Anderson, "Sentence Reviews," *Little Review* (January 1915), 55.

16. Margaret Anderson, *The Fiery Fountains: Continuation and Crisis until 1950* (New York: Horizon Press, 1969), 108.

17. Edmund Wilson, *Shores of Light: A Literary Chronicle of the 1920s and 1930s* (Boston: Northeastern University Press, 1985), 494.

18. Malcolm Cowley, *Exile's Return: A Literary Odyssey of the 1920s* (New York: Penguin, 1994), 61.

19. Theodore Roszak, *Unfinished Animal: The Aquarian Frontier and the Evolution of Consciousness* (New York: Harper Colophon, 1977), 147.

20. Roszak, *Unfinished Animal*, 137.

21. For an accessible introduction to Hermes and the Emerald Tablet see Gary Lachman, *The Quest for Hermes Trismegistus: From Ancient Egypt to the Modern World* (Edinburgh: Floris Books, 2011).

22. For the impact of second Great Awakening evangelism see Paul E. Johnson, *A Shopkeeper's Millennium: Society and Revivals in Rochester, New York, 1815–1837* (New York: Hill and Wang, 1978) and Ann Braude, *Radical Spirits: Spiritualism and Women's Rights in Nineteenth-Century America.* (Bloomington: Indiana University Press, 2001.)

23. Peter Washington, *Madame Blavatsky's Baboon: A History of the Mystics, Mediums, and Misfits Who Brought Spiritualism to America* (New York: Schocken 1995), 256.

24. Arthur Versluis, "What is Esoteric? Methods in the Study of Western Esotericism," accessed June 25, 2020, http://www.esoteric.msu.edu/VolumeIV/Methods.htm.

1. The Buzz and the Sting

1. Janet Flanner, "Life on a Cloud," *New Yorker*, June 3, 1974, 44–53.

2. Margaret Anderson, *My Thirty Years' War* (New York: Horizon Press,1969), 108.

3. M. Anderson, *Thirty Years' War*, 5.

4. M. Anderson, *Thirty Years' War*, 3.

5. M. Anderson, *Thirty Years' War*, 4.

6. M. Anderson, *Thirty Years' War*, 3.

7. Julia K. Willis, " 'Critics and Connoisseurs,' Editors and Aesthetes: Marianne Moore, Margaret Anderson, and the Aesthetic" (PhD diss., Rutgers: The State University of New Jersey–New Brunswick, 1996), 190.

8. Michelle Erica Green, "Margaret Anderson Quotes," The Little Review, http://www.littlereview.com/mca/mcaquote.htm. (Accessed July 28, 2016).

9. Eunice Tietjens, *The World at My Shoulder* (New York: Macmillan, 1938), 64.

10. Janet Flanner, "Life on a Cloud," *New Yorker*, June 3, 1974, 44–67.

11. Floyd Dell, *The Homecoming* (New York: Farrar and Rinehart, 1933), 228.

12. Ben Hecht, *Child of the Century* (New York: Simon and Schuster, 1954), 233.

13. M. Anderson, *Thirty Years War*, 15

14. A profile of Arthur Anderson can be found in *Indianapolis and Its Resources: A Souvenir of the Indianapolis Sentinel* (Indianapolis: Indianapolis Sentinel, 1896), 26.

15. *Indianapolis and Its Resources*, 9–12.

16. Catherine Tumber, *American Feminism and the Birth of New Age Spirituality: Searching for the Higher Self, 1875–1915* (Lanham, MD: Rowman and Littlefield), 2002.

17. M. Anderson, *Fiery Fountains*, 106.

18. M. Anderson, *Fiery Fountains*, 106–7.

19. M. Anderson, *Thirty Years' War*, 11.

20. M. Anderson, *Fiery Fountains*, 20.

21. M. Anderson, *Thirty Years War*, 33.

22. M. Anderson, *Thirty Years' War*, 34.

23. M. Anderson, *Thirty Years' War*, 35.

24. M. Anderson, *Thirty Years' War*, 23.

25. Kathleen McCarthy, *Noblesse Oblige: Charity and Cultural Philanthropy in Chicago,1849–1929* (Chicago: University of Chicago Press, 1982), 75.

26. Bernard Duffey, *The Chicago Renaissance in American Letters* (East Lansing: Michigan State College Press, 1954), 130; Sue Ann Prince, *The Old Guard and the Avant-Garde: Modernism in Chicago, 1910–1940* (Chicago: University of Chicago Press, 1990); Liesl Olson, *Chicago Renaissance: Literature and Art in the Midwest Metropolis* (New Haven: Yale University Press), 2017.

27. Helen Lefkowitz Horowitz, *Culture and the City: Cultural Philanthropy in Chicago from the 1880's to 1917* (Lexington: University of Kentucky Press, 1976), 189.

28. Monroe has been traditionally described as old-fashioned and stodgy compared to *the Little Review* and other little magazines, an unfair characterization according to John Timberman Newcomb, who views *Poetry* as an example of avant-garde modernism in "Poetry's Opening Door: Harriet Monroe and American Modernism," in *Little Magazines and Modernism: New Approaches*, ed. Suzanne Churchill and Adam McKibble (New York: Routledge Press, 2016).

29. M. Anderson, *Thirty Years' War*, 43–44.

30. Sherwood Anderson, *Memoirs* (New York: Harcourt, Brace, 1942), 24.

31. Chad Heap, *Slumming: Sexual and Racial Encounters in American Nightlife* (Chicago: University of Chicago Press, 2009), 161.

32. Chad Heap, *Slumming*, 64.

33. Dell, *Homecoming*, 242.

34. S. Anderson, *Memoirs*, 234–35.

35. Estelle Freedman and John D'Emilio, *Intimate Matters: A History of Sexuality in America* (New York: Harper and Row, 1988), 288.

36. Chicago Vice Commission, "The Social Evil in Chicago," *The Rise of Urban America* (New York: Arno Press, 1970), 297.

37. Nancy Sahli, "Smashing: Women's Relationships before the Fall," *Chrysalis* (Summer, 1979): 17–27.

38. Margaret Anderson, "Mrs. Ellis's Failure," *Little Review* (March 1915), 18.

39. M. Anderson, "Mrs. Ellis's Failure," 18.

40. M. Anderson, *Thirty Years' War*, 33.

41. Margaret Anderson in a letter to Allen Tanner, August 9, 1964, Allen Tanner Collection, Harry Ransom Center for the Humanities, University of Texas, Austin, Texas.

42. Emma Goldman, *Living My Life* (Salt Lake City: Peregrinne Smith, 1982), 531.

43. M. Anderson, *Thirty Years' War*, 68.

44. Maxwell Bodenheim, *Blackguard* (Chicago: Covici-McGee, 1923), 136–37.

45. Bodenheim, *Blackguard*, 136–37.

46. Floyd Dell, Letter to Jackson Bryer, April 8, 1964, Private Collection; Maurice Browne, *Too Late the Lament* (Bloomington: Indiana University Press, 1956), 128.

47. Hecht, *Child of the Century*, 233.

48. Hecht, *Child of the Century*, 235.

49. M. Anderson, *Thirty Years' War*, 4.

50. Margaret Anderson, *The Strange Necessity: The Autobiography, Resolutions and Reminiscences to 1969* (New York: Horizon Press, 1969), 135.

51. Nina Van Gessel, "Margaret Anderson's Last Laugh: The Victory of My Thirty Years' War," *ESC: English Studies in Canada* 25, no. 1 (1999): 69.

52. Margaret Anderson, "Conversation," *Prose* (Spring 1971): 6.

53. Archivist, Office of the Registrar, Art Institute of Chicago, letter to the author, September 28, 1989.

54. "Honors for Jane Heap," *Topeka Capitol*, December 5, 1915.

55. Heap to Reynolds, August 18, 1908, in *Dear Tiny Heart: The Letters of Jane Heap and Florence Reynolds*, ed. Holly A. Baggett (New York: New York University Press, 2000), 23.

56. Heap to Reynolds, August 25, 1908, in Baggett, *Dear Tiny Heart*, 25.

57. Heap to Reynolds, September 2, 1908, in Baggett, *Dear Tiny Heart*, 27.

58. Heap to Reynolds, July 20, 1909, in Baggett, *Dear Tiny Heart*, 38.

59. Heap to Florence Reynolds, August 26, 1908, in Baggett, *Dear Tiny Heart*, 27.

60. Heap to Reynolds, July 19, 1909, in Baggett, *Dear Tiny Heart*, 35.

61. Heap to Reynolds, August 18, 1908, in Baggett, *Dear Tiny Heart*, 24.

62. Heap to Reynolds, July 20, 1909, in Baggett, *Dear Tiny Heart*, 38.

63. Heap to Reynolds, August 22, 1909, in Baggett, *Dear Tiny Heart*, 41.

64. Heap to Reynolds, July 26, 1909, in Baggett, *Dear Tiny Heart*, 40.

65. Box 5, The Florence Reynolds Collection Related to Jane Heap and the *Little Review*, Special Collections, University of Delaware, Newark, Delaware.

66. Harriet Monroe, "Water Color Exhibition Shows Many Exquisite Bits," *Chicago Sunday Tribune*, May 14, 1911.

67. "Honors for Jane Heap"; "About Miss Jane Heap, Artist," *Topeka Capitol*, October 25, 1914.

68. M. Anderson, *Thirty Years' War*, 103.

69. Robert McAlmon, *Being Geniuses Together, 1920–1930*, revised with additional material by Kay Boyle (San Francisco: North Point Press, 1984), 37.

70. M. Anderson, *Thirty Years' War*, 122–23.

71. M. Anderson, *Thirty Years' War*, 122.

72. M. Anderson, *Thirty Years' War*, 187.

73. Duffey, *The Chicago Renaissance*, 177.

2. Temples of Tomorrow

1. Margaret Anderson, "Announcement," *Little Review* (March 1914), 2–3.

2. M. Anderson, "Announcement" (1914), 2–3.

3. M. Anderson, "Announcement" (1914), 2–3.

4. See Alan C. Golding, "*The Dial, The Little Review,* and the Dialogics of Modernism," *American Periodicals* 15, no. 1 (2005), 42–55.

5. John Galsworthy, "A Letter," *Little Review* (March 1914), 1.

6. M. Anderson, *Thirty Years' War*, 46–47.

7. Margaret Anderson, "The Dark Flower and the Moralists," *Little Review* (March 1914), 6–7; Marguerite Swawite, "The Dark Flower," *Little Review* (May 1914), 30–33.

8. M.M., "Two Views of H. G. Wells," *Little Review* (April 1914); Francis Trevor, "Two Views of H. G. Wells," *Little Review* (April 1914), 1–14.

9. Sade Iverson, "Letters to the Little Review," *Little Review* (April 1914), 49. Iverson, in recognizing the pagan qualities of the journal, was in fact mocking Anderson, indicating her amusement at Anderson's enthusiasm.

10. See Alan Golding, "The Little Review," in *The Oxford Critical and Cultural History of Modernist Magazines: Volume II, North America, 1894–1960*, ed. Peter Brooker and Andrew Thacker (Oxford: Oxford University Press, 2012), 61–84.

11. Michael H. Levenson, *A Genealogy of Modernism: A Study of English Literary Doctrine, 1908–1922* (Cambridge: Cambridge University, 1984), xi.

12. Dell, *Homecoming*, 19.

13. Margaret Anderson, "Home as an Emotional Adventure," *Little Review* (December 1914), 51–54; *Thirty Years' War*, 38.

14. M. Anderson, "Announcement" (1914), 2.

15. Margaret Anderson, "Ethel Sidgwick's Succession," *Little Review* (March 1914), 34.

16. Sherwood Anderson, "The New Note," *Little Review* (March 1914), 23. "The New Note" was Sherwood Anderson's first piece of published writing. Years later, he credited Margaret Anderson as being the person who introduced him to the literary world.

17. S. Anderson, "New Note," 23.

18. S. Anderson, "New Note," 23.

19. Other titles include "The Prophet of a New Culture," "The Salvation of the World," "The Revolt of the Once Born," "Armageddon," "The Nietzschean Love of Eternity," "The Gospel According to Moore," "To The Innermost," "The Spiritual Dangers of Vers Libre," "The Sermon in the Depths," "Soul Sleep and Modern Novels," "The Dionysian Dreiser," "Hellencia," and "A Sorrowful Demon," all of which ran in the *Little Review* from 1914 to 1916.

20. Jennifer Rosenhagen-Ratner, *American Nietzsche: A History of an Icon and His Ideas* (Chicago: University of Chicago Press, 2011), 21.

21. Margaret Anderson, ed., *The Little Review Anthology* (New York: Hermitage House, 1953), 18.

22. George Foster Burnham, "The Prophet of a New Culture," *Little Review* (March 1914), 15–17.

23. Burnham, "Prophet," 15–17.

24. Rosenhagen-Ratner, *American Nietzsche*, 103. Rosenhagen-Ratner notes the importance of Anderson's role in inviting Foster, which resulted in "cultivating new audiences for his Nietzschean religion," 104.

25. Melvin Drimmer, "Nietzsche in American Thought, 1895–1925" (PhD diss., University of Rochester, 1965). vii-ix.

26. Duffey, *The Chicago Renaissance*, 139.

27. M. Anderson, *Thirty Years' War*, 36.

28. M. Anderson, *Thirty Years' War*, 158.

29. M. Anderson, *Thirty Years' War*, 37.

30. Margaret Anderson, "The Artist in Life," *Little Review* (June–July 1915), 20.

31. George Allen Morgan Jr., *What Nietzsche Means*, (New York: Harper Torch Books, 1941), 206.

32. M. Anderson, "Announcement" (1914), 2.

33. M. Anderson, *Fiery Fountains*, 104.

34. Frank Kermode, quoted in James McFarlane, "The Mind of Modernism," in *Modernism, 1890–1930*, ed. Malcolm Bradbury and James McFarlane (London: Penguin Books, 1976), 82.

35. Llewellyn Jones, "The Meaning of Bergsonism," *Little Review* (March 1914), 11.

36. M. Anderson, "Announcement" (1914), 2.

37. M. Anderson, *Little Review Anthology*, 11.

38. M. Anderson, "Announcement" (1914), 2.

39. Frederick Burwick and Paul Douglass, eds., *The Crisis in Modernism: Bergson and the Vitalist Controversy* (Cambridge: Cambridge University Press, 1992), 1.

40. Margaret Anderson, "aloof from natural laws," from *Thirty Years' War*, 5; Emerson, "aloof from all moorings," quoted in Alex Zakaras, *Individuality and Mass Democracy: Mill, Emerson, and the Burdens of Citizenship* (New York: Oxford University Press: 2009), 77.

41. Quoted in *Little Review* (March 1914), 2.

42. DeWitt Wing, "The Jewels of Lapidary," *Little Review* (March 1914), 42.

43. Arthur Versluis writes: "More than anyone else of his time, Whitman represented an antinomian, world-embracing mysticism of the kind that had a fair number of European manifestations but was in Whitman made particularly American." *The Esoteric Origins of the American Renaissance* (New York: Oxford University Press, 2001), 148.

44. *Little Review* (May 1914), 51.

45. Michael Robertson, *Worshipping Walt: Whitman's Disciples* (Princeton, NJ: Princeton University Press, 2008), 99.

46. Linda Dowling, *Hellenism and Homosexuality in Victorian Oxford* (Ithaca, NY: Cornell University Press, 1994), xi–xvi. Heather Love argues that Pater actually invested in the status of failure and victimization. Love, "Forced Exile: Walter Pater's Queer Modernism," in *Bad Modernisms*, eds. Douglas Mao and Rebecca L. Walkowitz (Durham: Duke University Press, 2006).

47. Douglas Mao and Rebecca L. Walkowitz, eds., *Bad Modernisms* (Durham: Duke University Press, 2006), 163.

48. Robertson, *Worshipping Walt*, 182–84.

49. John Addington Symonds actually collaborated with Ellis on *Sexual Inversion*, but their partnership was not revealed until years later.

50. Antony Copley, *A Spiritual Bloomsbury: Hinduism and Homosexuality in the Lives and Writings of Edward Carpenter, E. M. Forster, and Christopher Isherwood* (Oxford: Lexington Books), 68. In a series of essays and books—*Towards Democracy* (1883), *Homogenic Love* (1896), *The Art of Creation* (1904), *The Intermediate Sex* (1908), and *Intermediate Types Among Primitive Peoples* (1914)—Carpenter, like Whitman, entwined spirituality, sexuality, and democracy. His book *Intermediate Types Among Primitive People* argued that intermediate types in the past were priests and prophets who could function in the same roles in modern times. In other words, according to Robertson, "he produced a series of works that argued Urnings [the term Carpenter used for homosexuals] could serve as pathfinders on the way to a democratic socialist millennium." Robertson, *Worshipping Walt*, 182–84.

51. Jeffrey Weeks, *Sex, Politics, and Society: The Regulation of Sexuality Since 1800* (London: Longman, 1981), 261.

52. Ellis was also the author of *Three Modern Seers*, a triple biography of Nietzsche, Hinton, and Carpenter, as well as a playwright, her play "Heaven's Jester" was published in the *Little Review*.

53. Mary Stearns, "Mrs. Ellis's Gift to Chicago," *Little Review* (March 1915), 13.

54. M. Anderson, "Mrs. Ellis's Failure," 18.

55. M. Anderson, "Mrs. Ellis's Failure," 19.

56. Jonathan Katz, *Gay/Lesbian Almanac: A New Documentary* (New York: Harper and Row, 1983), 363–64.

57. M. Anderson, "Announcement" (1914), 2.

58. M. Anderson, "Announcement" (1914), 16.

59. Margaret Anderson, "To the Innermost," *Little Review* (October 1914), 2. It may not have been a concern to Anderson because women in Illinois acquired presidential suffrage in 1912.

60. Margery Currey, "A Feminist of One Hundred Years Ago," *Little Review* (March 1914), 25.

61. Cornelia Anderson, "Some Contemporary Opinions of Rachel Varnhagen," *Little Review* (March 1914), 28.

62. Floyd Dell, "The Lost Joy," *Little Review* (March 1914), 10.

63. M. H. Partridge, "The Feminist Discussion," *Little Review* (March 1914), 22.

64. Clara Laughlin, "Women and the Life Struggle," *Little Review* (April 1914), 20–24.

65. Margaret Anderson, "A New Winged Victory," *Little Review* (April 1914), 9.

66. M. Anderson, "New Winged Victory," 9.

67. Margaret Anderson, "Incense and Splendor," *Little Review* (June 1914), 1–2.

68. Margaret Anderson, "The Renaissance of Parenthood," *Little Review* (July 1914), 6.

69. Ellen Key, *The Renaissance of Motherhood* (New York: G. P. Putnam's Sons, 1914), v.

70. M. Anderson, "Renaissance," 12–13.

71. Margaret M. Caffrey, *Ruth Benedict: Stranger in This Land* (Austin: University of Texas Press, 2013).

72. Caffrey, *Ruth Benedict*, 115. For a variety of perspectives on the question of Nietzsche and Women, see Paul Patton, ed., *Nietzsche, Feminism and Political Theory* (New York: Routledge, 1993); Pauline Johnson, "Nietzsche Reception Today," *Radical Philosophy* 80 (1996): 24–33; Kelly A. Oliver and Marilyn Pearsall, eds., *Feminist Interpretations of Friedrich Nietzsche* (State College: Penn State Press, 2010).

73. M. Anderson, "Renaissance," 14.

74. Key, *The Renaissance*, 183

75. Ellen Key, *The Woman Movement* (New York: Putnam and Sons, 1912), 79.

76. Key, *The Renaissance*, 10–11.

77. Key, *The Renaissance*, 153.

78. M. Anderson, "Mr. Comstock and the Resourceful Police," *Little Review* (April 1915), 3–4.

79. Madeline Gray, *Margaret Sanger: A Biography of the Champion of Birth Control* (New York: Marek, 1970), 115.

80. M. Anderson, *Little Review Anthology*, 12.

3. Political and Literary Radicals

1. M. Anderson, *Thirty Years' War*, 129.

2. Margaret Anderson, "The Challenge of Emma Goldman," *Little Review* (May 1914), 6–9.

3. M. Anderson, "Emma Goldman," 6.

4. M. Anderson, "Emma Goldman," 9.

5. Llewellyn Jones, "The Russian Novel," *Little Review* (April 1914); George Soule, "The Possessed," *Little Review* (June 1914); Maurice Lazar, "Dostoevsky's Novels," *Little Review* (July 1914); Alexander Kaun, "Two Biographies: Verlaine and Tolstoy," *Little Review* (July 1914); Maximilian Voloshin, "Birth of a Poem," *Little Review* (November 1914); Alexander Kaun, "Sanin," *Little Review* (April 1915); George Soule, "Pavlowa," *Little Review* (April 1914); Kaun, "Ante-Bellum Russia," *Little Review* (October 1915).

6. Maria Carlson, *No Religion Higher Than Truth: A History of the Theosophical Movement in Russia, 1875–1922* (Princeton, NJ: Princeton University Press, 1993), 3.

7. Carlson, *Theosophical Movement in Russia*, 5.

8. Carlson, *Theosophical Movement in Russia*, 3.

9. Kaun, "Verlaine and Tolstoy," *Little Review* (July 1914), 53–58.

10. V. I. Lenin, "Proletary No. 35 (September 11, 1908)," *Lenin Collected Works* (Moscow: Progress Publishers, 1973).

11. Emma Goldman, *The Social Significance of the Modern Drama* (New York: Cosimo, Inc., 2005), 152.

12. Margaret Anderson, "The Immutable," *Little Review* (November 1914), 22.

13. Emma Goldman, *Living My Life: An Autobiography of Emma Goldman* (Salt Lake: Peregrine Smith, 1982), 530.

14. Goldman, *Living My Life*, 530.

15. Goldman, *Living My Life*, 350.

16. M. Anderson, *Thirty Years' War*, 70–71.

17. M. Anderson, *Thirty Years' War*, 70–71.

18. Goldman, *Living*, 351.

19. Goldman, *Living My Life*, 548.

20. M. Anderson, "The Immutable," 19.

21. M. Anderson, "Armageddon," *Little Review* (September 1914), 3.

22. M. Anderson, *Thirty Years' War*, 75. The FBI acknowledges having a file on Anderson as a result of her editorials during this period but refused a request to see the files under the Freedom of Information Act on the grounds of "invasion of privacy," and the revelation of a "confidential source." FBI, Chicago Field Office, letter to author, September 13, 1989. An appeal of the decision was denied by the Department of Justice, Office of Information and Privacy: Letter to author, March 27, 1990.

23. M. Anderson, "Toward Revolution," *Little Review* (December 1915), 5.

24. M. Anderson, "The Labor Farce," *Little Review* (September 1916), 17.

25. M. Anderson, "Labor Farce," 17.

26. Goldman, *Living My Life*, 577.

27. M. Anderson, "The Labor Farce," 19.

28. Lillian Heller Udell, "The Philosophy of Voltairine de Cleyre," *Little Review* (October 1914), 44–45.

29. M. Anderson, "The Challenge of Emma Goldman," 9; M. Anderson, "The Immutable," 22.

30. M. Anderson, "The Immutable," 19.

31. M. Anderson, *Thirty Years' War*, 81.

32. M. Anderson, *Thirty Years' War*, 81.

33. Harry Hansen, *Midwest Portraits: A Book of Memories and Friendships* (New York: Harcourt, Brace and Co., 1923), 105.

34. M. Anderson, *Thirty Years' War*, 92.

35. Lawrence Langner, *The Magic Curtain: The Story of a Life in Two Fields, Theatre and Invention* (New York: E. P. Dutton, 1951), 84.

36. M. Anderson, *Thirty Years' War*, 92; *Chicago Daily News*, August 5, 1915.

37. M. Anderson, *Little Review* (June–July 1915), 62.

38. Hi Simmons to Margaret Anderson, September 3, 1915, Hi Simmons Papers, Hanna Holborn Gray Special Collections Research Center, University of Chicago Library, Chicago, Illinois.

39. Margaret Anderson to Hi Simmons, September 5, 1915, Simmons Papers.

40. Anderson to Simmons, September 5, 1915, Simmons Papers.

41. Anderson to Simmons, September 5, 1915, Simmons Papers.

42. Anderson to Simmons, September 5, 1915, Simmons Papers.

43. M. Anderson, *Thirty Years' War*, 100.

44. M. Anderson, *Thirty Years' War*, 101–2.

45. M. Anderson, *Thirty Years' War*, 101–2. Mark S. Morrisson argues that Anderson's use of advertisers in the first two years reflects a "mass consumer culture" that existed in the *Little Review* in spite of the otherwise elite content of the journal. As advertisers began to dry up she shifted to a heavier use of subscriptions. The circulation figures for the *Little Review*

have been estimated between 1,500 to 3,000. Morrisson, "The Public Face of Modernism," 243n22; Brooker and Thacker, *North America 1894–1960*, 17.

46. Bernard Duffey, *The Chicago Renaissance in American Letters: A Critical History* (East Lansing: Michigan State College Press, 1954), 139.

47. Goldman, *Living My Life*, 531.

48. For this analysis of Anderson, see Margaret S. Marsh, *Anarchist Women, 1870–1920* (Philadelphia: Temple Press, 1981), 42.

49. Marsh, *Anarchist Women*, 42.

50. Margaret Anderson, "Art and Anarchy," *Little Review* (March 1916), 3–6.

51. Candace Falk, *Love, Anarchy, and Emma Goldman: A Biography* (New Brunswick, NJ: Rutgers University Press, 2019), 170–71.

52. Terence Kissack, *Free Comrades: Anarchism and Homosexuality in the United States, 1895–1917* (Oakland, CA: AK Press, 2008), 12.

53. Kissack, *Free Comrades*, 4.

54. Falk, *Emma Goldman*, 180.

55. Falk, *Emma Goldman*, 181. See also C. Brid Nicholson, *Emma Goldman: Still Dangerous* (Montreal: Black Rose Books, 2010) for the argument that Goldman was bisexual.

56. Candace Falk, *Love, Anarchy and Emma Goldman: A Biography* (New York: Holt, Rinehart and Winston, 1984), 99.

57. Kissack, *Free Comrades*, 134.

58. Margaret Anderson, "Challenge," *Little Review* (May 1916), 6.

59. See Steven Quincey-Jones, "Dora Marsden and the "WORLD-INCLUSIVE I": Egoism, Mysticism and Radical Feminism," in *Modernist Women Writers and Spirituality*, ed. Elizabeth Anderson, Andrew Radford, and Heather Walton (London: Palgrave Macmillan, 2016), 185–99.

60. M. Anderson, "Art and Anarchy," 5.

61. David Weir, *Anarchism and Culture: The Aesthetic Politics of Modernism* (Amherst: University of Massachusetts, 1997), 156. See also Alan Antliff, *Anarchist Modernism: Art, Politics, and the First American Avant-Garde* (Chicago: University of Chicago Press, 2001).

62. M. Anderson, *Thirty Years' War*, 126.

63. M. Anderson, *Thirty Years' War*, 127, 133–34.

64. M. Anderson, *Thirty Years' War*, 134.

65. Margaret Anderson, "Home as an Emotional Adventure," *Little Review* (December 1914), 51–54. In 1929 Anderson wrote Goldman while she was in exile in St. Tropez and awaiting the publication of her autobiography *Living My Life*. Anderson's anarchism had clearly waned by that point—she exclaimed to Goldman, "You'll probably be very rich in a few months!!" Margaret Anderson to Emma Goldman, 1929, Emma Goldman Papers, UC Berkeley Library, Berkeley, CA.

66. Paul Bradley Bellew, "'At the Mercy of Editorial Selection': Amy Lowell, Ezra Pound, and the Imagist Anthologies," *Journal of Modern Literature* 40, no. 2 (2017): 22–40; Andrew Thacker, "Amy Lowell and H. D.: The Other Imagists," *Women: A Cultural Review*, 4 (1), (1993), 49–59; Helen Carr, *The Verse Revolutionaries: Ezra Pound, HD and the imagists* (New York: Random House, 2013); A. David Moody, *Ezra Pound: Poet: I: The Young Genius 1885–1920*, Vol. 1, (Oxford: Oxford University Press, 2007); Jean Gould, *Amy: The World of Amy Lowell and the Imagist Movement* (New York: Dodd Mead, 1975).

67. Margaret Anderson, letter to Amy Lowell, May 1914, Amy Lowell Collection, Houghton Library, Harvard University, Cambridge, Massachusetts.

68. Amy Lowell, "Miss Columbia: An Old-Fashioned Girl," *Little Review* (June 1914), 36.

69. Anderson to Lowell, July 1914, Lowell Collection.

70. Anderson to Lowell, August 1914, Lowell Collection.

71. Lowell to Anderson, October 1914, Lowell Collection.

72. Lowell to Anderson, October 5, 1914, Lowell Collection.

73. Lowell to Anderson, November 1914, Lowell Collection.

74. Lowell to Anderson, November 29, 1914, Lowell Collection.

75. Charles Ashleigh, "Des Imagistes," *Little Review* (July 1914), 17.

76. Ashleigh, "Des Imagistes," 16.

77. Aldington, "A Young American Poet," *Little Review* (March 1915), 23.

78. Eunice Tietjens, "The Spiritual Dangers of Vers Libre," *Little Review* (November 1914), 25–29.

79. Tietjens, "Spiritual Dangers," 25–29.

80. Arthur Ficke, "In Defense of Vers Libre," *Little Review* (December 1914), 19–20.

81. Llewellyn Jones, "Aesthetics and Common Sense," *Little Review* (December 1914), 18. Charles Hinton was the son of James Hinton, who was such a prominent spiritual influence on Havelock and Edith Ellis.

82. Margaret Anderson, "Editor's Note: 'Poetry versus Imagism,'" *Little Review* (September 1916), 27.

83. Margaret Anderson, "Amy Lowell's Contribution," *Little Review* (December 1914), 29.

84. Anderson published H. D.'s "At Croton" in the Spring Issue of 1923.

85. Timothy Materer, *Modernist Alchemy: Poetry and the Occult* (Ithaca, NY: Cornell University Press, 1995), 91. See his chapter "H. D.'s Hermeticism: Between Jung and Freud." Also see Susan Stanford Friedman, *Psyche Reborn: The Emergence of H. D.* (Bloomington: Indiana University Press, 1981); Cassandra Laity, *HD and the Victorian fin de siècle: Gender, Modernism, Decadence* (Cambridge: Cambridge University Press, 2009); Kendra Langeteig, "Visions in the Crystal Ball: Ezra Pound, HD, and the Form of the Mystical," *Paideuma 25*, no. 1–2 (1996), 55–81; Elizabeth Anderson, *HD and Modernist Religious Imagination: Mysticism and Writing* (London A&C Black, 2013); Diana Collecott, *HD and Sapphic Modernism 1910–1950* (Cambridge: Cambridge University Press, 1999). See also H. D.'s *Notes on Thoughts and Visions* (San Francisco: City Lights Publishers, 2001), which addresses Greek, Christian, Egyptian, Hebrew, and pagan themes.

86. Materer, *Modernist Alchemy*, 91.

87. George Lane, "Some Imagist Poets," *Little Review* (May 1915), 30.

88. John Gould Fletcher, "Three Imagists Poets," *Little Review* (May 1916), 33.

89. Collecott, *H. D. and Sapphic Modernism*, 3.

90. Lowell to Anderson, December 18, 1914, Lowell Collection.

91. Lowell to Anderson, December 18, 1914, Lowell Collection.

92. Lowell to Anderson, December 18, 1914, Lowell Collection.

93. M. Anderson, *Thirty Years' War*, 60.

94. M. Anderson, *Thirty Years' War*, 60.

95. M. Anderson, *Thirty Years' War*, 60.

96. M. Anderson, *Thirty Years' War*, 61.

97. Amy Lowell to Jane Heap, March 15, 1915, Lowell Collection.

98. Margaret Anderson, "The Poet Speaks," *Little Review* (April 1916), 11–12.

99. M. Anderson, "Poet Speaks," 11–12.

100. Anderson to Lowell, December 1915, Lowell Collection.

101. Lowell to Anderson, February 17, 1916, Lowell Collection.

102. Lowell to Anderson, April 10, 1916, Lowell Collection.

103. Lowell to Anderson, April 10, 1916, Lowell Collection.

104. Lowell to Anderson, April 10, 1916, Lowell Collection.

105. Lowell to Anderson, April 10, 1916, Lowell Collection.

106. Lowell to Anderson, August 1916, Lowell Collection.

107. Gould, *Amy*, 82, 352.

108. See Lillian Faderman, "Which, Being Interpreted Is as May Be, or Otherwise: Ada Dwyer Russell in 'Amy Lowell's Life and Work,'" in *Amy Lowell, American Modern*, eds., Adrienne Munich and Melissa Bradshaw (New Brunswick: Rutgers University Press, 2004), 59–76; Jaime Hovey, "Lesbian Chivalry" in Amy Lowell's *Sword Blades and Poppy Seed*," in *Amy Lowell, American Modern*, 77–89; Jean Radford, "A Transatlantic Affair: Amy Lowell and Bryher," in *Amy Lowell, American Modern*, 43–58.

109. Lowell to Anderson, April 10, 1916, Lowell Collection. Lowell wrote to Anderson, "I have already got a new subscriber for you in Mrs. Lionel Marks (Josephine Preston Peabody), who tells me she has subscribed to *The Little Review* on the strength of seeing a copy here."

110. Lowell to Anderson, April 10, 1916, Lowell Collection.

111. Amy Lowell, *Tendencies in Modern American Poetry* (Boston: Houghton Mifflin 1917), v.

112. Lowell, *Modern American Poetry*, vi.

113. Lowell, *Modern American Poetry*, v–vi.

114. Quoted in Diana Collecott, "'Another Bloomsbury': Women's Networks in Literary London," in Maria Camboni, ed., *Networking Women: Subjects, Places, Links Europe-America; Towards a Re-writing of Cultural History 1890–1939. Proceedings of the International Conference, Macerata, March 25–27, 2002* (Rome: Edizioni di Storia e Letteratura, 2004), 17. For Sinclair see Suzanne Raitt, *May Sinclair: A Modern Victorian* (Oxford: Clarendon Press, 2000).

115. Collecott, "Another Bloomsbury," 17.

4. Interregnum

1. M. Anderson, *Thirty Years' War*, 110.

2. M. Anderson, *Thirty Years' War*, 107. Gabriele D'Annunzio was an Italian playwright involved with Eleanor Duse and Sarah Bernhardt, both actresses. After writing four plays for Duse, he promised her the leading role in La Città Morta—but reneged and gave it to Bernhardt.

3. M. Anderson, *Thirty Years' War*, 107.

4. Jane Heap (R.G.), "Potatoes in the Cellar," *Little Review* (May 1916), 25–26.

5. Heap, "Potatoes," 25–26.

6. Heap, "Potatoes," 25–26.

7. Heap to Reynolds, July 20, 1909, in Baggett, *Dear Tiny Heart*, 38.

8. Jane Heap, "And," *Little Review* (October 1916), 6–8. Ignacy Paderewski was a famous Polish virtuoso pianist highly popular in both Europe and the United States.

9. Heap, "And" (October 1916), 6–8.

10. Heap, "And" (October 1916), 6–8.

11. Heap, "And" (October 1916), 6–8.

12. Jane Heap, "And," *Little Review* (November 1916), 6–7.

13. M. Anderson, *Thirty Years' War*, 115.

14. M. Anderson, *Thirty Years' War*, 118.

15. M. Anderson, *Thirty Years' War*, 120.

16. M. Anderson, *Thirty Years' War*, 120–21.

17. M. Anderson, *Thirty Years' War*, 115–29.

18. M. Anderson, *Thirty Years' War*, 120.

19. M. Anderson, *Thirty Years' War*, 124.

20. This aspect of Heap's teaching has been emphasized in interviews I conducted in May 1996 with two of her former students—Anna Lou Stalevey at the Two Rivers Gurdjieff commune, Aurora, Oregon; and John Lester, Heap's physician in Bend, Oregon. The British film director Peter Brook writes of his memories as a Heap pupil in post-war London in his autobiography *Threads of Time* (Washington, DC: Counterpoint, 1998). The letters of Michael Currier Briggs to Jane Purse in the Florence Reynolds Collection, University of Delaware, also reveal detailed memories of Heap as a Gurdjieff leader.

21. M. Anderson, *Thirty Years' War*,' 131

22. M. Anderson, *Thirty Years' War*, 144.

23. Margaret Anderson, "A Real Magazine," *Little Review* (August 1916), 1, 2.

24. M. Anderson, "Real Magazine," 1, 2.

25. Goldman, *Living My Life*, 580.

26. M. Anderson, *Thirty Years' War*, 120

27. M. Anderson, *Thirty Years' War*, 126.

28. M. Anderson, *Thirty Years' War*, 128.

29. M. Anderson, *Thirty Years' War*, 136.

30. Sue Anne Prince, in *The Old-Guard and the Avant-Garde: Modernism in Chicago* (Chicago: University of Chicago, 1990), also points out a remarkable group of "organizations, clubs and societies." For a direct comparison see Eric Homberger, "Chicago and New York: Two Versions of American Modernism," in *Modernism: A Guide to European Literature, 1890–1930*, ed. James McFarlane, 156; Leslie Fishbein, *Rebels in Bohemia: The Radicals of the Masses, 1911–1917* (Chapel Hill: University of North Carolina Press, 1984); Margaret C. Jones, *Heretics and Hellraisers* (Austin: University of Texas Press, 1993); Mabel Dodge Luhan, *Movers and Shakers* (Albuquerque: University of New Mexico Press, 1985); Chad Heap, *Slumming* (Chicago: University of Chicago Press, 2010); Stansell, *American Moderns*; Steven Watson, *Strange Bedfellows: The First American Avant-Garde* (New York: Abbeville, 1991); Casey Blake Nelson, *Beloved Community: The Cultural Criticism of Randolph Bourne, Van Wyck Brooks, Waldo Frank, and Lewis Mumford* (Chapel Hill: University of North Carolina Press, 1990).

31. M. Anderson, *Thirty Years' War*, 115.

32. M. Anderson, *Thirty Years' War*, 143.

33. M. Anderson, *Thirty Years' War*, 140–43; William Carlos Williams, *I Wanted to Write a Poem*, ed. Edith Heal (Boston: Beacon Press, 1958), 33.

34. M. Anderson, *Thirty Years' War*, 156.

35. Susan Glaspell, *The Road to the Temple* (New York: Frederick A. Stokes, 1941), 235–36.

36. Jane Heap, "The Caliph's Design," *Little Review* (December 1919), 39.

37. Heap to Reynolds July 1917, in Baggett, *Dear Tiny Heart*, 51.

38. Margaret Anderson, "War," *Little Review* (April 1917), 24.

39. Jane Heap, "The Foes of Our Household," *Little Review* (October 1917), 42.

40. Jane Heap, "The War, Madmen!," *Little Review* (March 1917), 15; Jane Heap, "The Price of Empire," *Little Review* (March 1917), 17.

41. Jane Heap, "Reader Critic," *Little Review* (August 1917), 23.

42. Jane Heap, "Push-Face," *Little Review* (June 1917), 4–7.

43. Fishbein, *Rebels in Bohemia*; Thomas A. Maik, *The Masses Magazine (1911–1917): Odyssey of an Era* (New York: Garland Publishing, 1994).

44. For background on the Comstock Law see Helen Lefkowitz Horowitz, *Rereading Sex: Battles over Sexual Knowledge and Suppression in Nineteenth-Century America* (Vintage Press: New York, 2002). For analysis of the *Little Review*'s later collision with the Comstock

Law and *Ulysses* see Kevin Birmingham, *The Most Dangerous Book: The Battle for James Joyce's Ulysses* (New York: Penguin, 2014).

45. Ezra Pound, "The Classics Escape," *Little Review* (March 1918), 32–34.

46. Margaret C. Anderson v. Thomas G. Patten 247 F. 382 (1917) (Postmaster of the City of New York), United States District Court, Southern District of New York, November 2, 1917, https://cite.case.law/f/247/382/ accessed December 22,2022.

47. Margaret Anderson, "Judicial Opinion (Our Suppressed October Issue)," *Little Review*, (December 1917), 46–49.

48. M. Anderson, "Judicial Opinion," 46–49.

49. Heap to Reynolds, July 1917, in Baggett, *Dear Tiny Heart*, 48.

50. Heap to Reynolds, July 1917, in Baggett, *Dear Tiny Heart*, 48.

51. Heap to Reynolds, July 1917, in Baggett, *Dear Tiny Heart*, 48.

52. Heap to Reynolds, July 1917, in Baggett, *Dear Tiny Heart*, 48.

53. Heap to Reynolds, July 1917, in Baggett, *Dear Tiny Heart*, 48.

54. Margaret Anderson, "Announcement," *Little Review* (April 1917), 24.

55. M. Anderson, *Thirty 'Years" War*, 190.

56. M. Anderson, *Thirty Years' War*, 191.

57. Pound to Anderson, February 2, 1918, in *Pound/The Little Review: The Letters of Ezra Pound to Margaret Anderson*, ed. Thomas L. Scott, Melvin Friedman, with the assistance of Jackson Bryer (New York: New Directions, 1988), 181–82.

58. M. Anderson, *Thirty 'Years" War*, 206.

59. M. Anderson, *The Fiery Fountains*, 108–9.

60. M. Anderson, *Thirty Years' War*, 186.

61. M. Anderson, *Thirty Years' War*, 186–87.

62. Anderson to Djuna Barnes, November 29, 1951, Djuna Barnes Papers, Special Collections and Archives, Hornbake Library, University of Maryland, College Park, Maryland.

63. Anderson to Tanner, September 23, 1959, Allen Tanner Collection, Harry Ransom Center for the Humanities, University of Texas, Austin, Texas.

64. Heap to Reynolds, July 1917, Reynolds Collection.

65. Heap to Reynolds, August 18, 1918, Reynolds Collection.

66. Heap to Reynolds, August 28, 1918, Reynolds Collection

67. Heap to Reynolds, October 21, 1918, Reynolds Collection

68. Heap to Reynolds, October 21, 1918, Reynolds Collection.

69. Edmund Wilson, *The Twenties*, Leon Edel, ed., (New York: Farrar, Strauss, and Giroux, 1975), 85; Field, 192–93.

5. Pound, Yeats, Eliot, and Joyce

1. Margaret Anderson, ed., *Little Review Anthology* (New York: Hermitage House, 1953), 12.

2. Thomas Scott and Melvin Friedman, "Introduction," in Ezra Pound, *Pound/The Little Review*, ed. Scott and Friedman (New York: New Directions, 1988), xviii.

3. Pound to Anderson, November 29, 1916, in *Pound/The Little Review*, 4.

4. Pound to Anderson, January 26, 1917, in *Pound/The Little Review*, 6, 8.

5. Pound to Anderson, January 26, 1917, in *Pound/The Little Review*, 6, 8.

6. M. Anderson, *Thirty Years' War*, 136.

7. M. Anderson, "Announcement" (1917), 1.

8. Pound's other major contributors were Wyndham Lewis and Ford Madox Ford. However, their fictional work was primarily based on social commentary issues, (e.g., gender relationships) not relevant to the esoteric discussion in the *Little Review*.

9. There is disagreement over the precise focus of Pound's intellectual and creative interest in esoteric schools. Demetres Tryphonopoulos defines Pound's poetry as "metaphysical occultism" and therefore "very different from theurgy or the practice of the occult arts." Demetres P. Tryphonopoulos, *The Celestial Tradition: A Study of Ezra Pound's Cantos* (Waterloo, ON: Wilfrid Laurier University Press, 1992), 53.

10. Materer, *Modernist Alchemy*, 50–57.

11. Materer, *Modernist Alchemy*, 35.

12. James Longenbach, "Pound Among the Women," *Review* (1990), 147.

13. M. Anderson, *Little Review Anthology*, 232. Pound's prose pieces published in the *Little Review* include "Jodindranath Mawhwor's Occupation" (May 1917), "An Anachronism at Chinon" (June–July 1917), "Aux Étuves de Wiesbaden A. D. 1451" (August 1917), and "Stark Realism This Little Pig Went to Market (A Search for a National Type)." His poems include "L'Homme Moyen Sensuel," "Das Schöne Papier Vergeu Det," and "Moeurs Contemporaines" (Nov 1918).

14. Pound to Anderson, June 11, 1917, in *Pound/The Little Review*, 65

15. Pound to Anderson, June 11, 1917, in *Pound/The Little Review*, 69.

16. Pound to Anderson, June 11, 1917, in *Pound/The Little Review*, 69.

17. Pound, "Modern French Poets," *Little Review* (February 1918), 10. See also Jane Hoogestraat, "'Akin to Nothing but Language:' Pound, LaForgue, and Logopoeia," *English Literary History* (Spring 1988): 259–85. The article addresses Pound's coining of the word "logopoeia" after discovering Jules Laforgue (1860–1887).

18. Pound, "Modern French Poets," 54–55, 58–59.

19. Pound, "The Chinese Character as Written Medium for Poetry," *Little Review Anthology*, 198.

20. W. B. Yeats, "William Butler Yeats to American Poets," *Little Review* (April 1914), 47–48.

21. James Longenbach, *Stone Cottage: Pound, Yeats and Modernism* (Oxford: Oxford University Press, 1990), xii.

22. Longenbach, *Stone Cottage*, 77.

23. Longenbach, *Stone Cottage*, 258.

24. Heap to Reynolds, November 5, 1918, in *Dear Tiny Heart*, 65.

25. Longenbach, *Stone Cottage*, 54.

26. Peter Ackroyd, *T. S. Eliot: A Life* (New York: Simon and Schuster, 1984), 81.

27. Lyndall Gordon, *Eliot's Early Years* (Oxford: Oxford University Press, 1977), 15.

28. Donald J. Childs, "Fantastic Views": T. S. Eliot and the Occultation of Knowledge and Experience," *Texas Studies in Literature and Language* (December 22, 1997), 360.

29. Ackroyd, *T. S. Eliot*, 113. The "asylum" was Gurdjieff's Institute for the Harmonious Development of Man; dancing was a Gurdjieffian technique designed to elevate consciousness

30. T. S. Eliot, "Commentary," *Criterion* 14, no. 55 (January 1935), 261.

31. Ezra Pound, "Editorial," *Little Review* (May 1918), 30.

32. Ezra Pound, "Unanimism," *Little Review* (April 1918), 26.

33. Mrs. O. D. J., "Reader Critic," *Little Review* (June 1917), 27.

34. Louis Puttelis, "Reader Critic," *Little Review* (July 1917), 28.

35. I. E. P., "Reader Critic," *Little Review* (July 1917), 25.

36. H. C. L. "Reader Critic," *Little Review* (September 1917), 33.

37. V. H. "Reader Critic," *Little Review* (September 1917), 24.

38. An Old Reader, "Reader Critic," *Little Review* (September 1917), 31–32.

39. Maxwell Bodenheim, "Reader Critic," *Little Review* (June 1917), 28.

40. Amy Lowell to Anderson, May 1917, Lowell Collection.

41. Heap, "Reader Critic" (August 1917), 104.

42. Heap, "Reader Critic" (June 1917), 27.

43. Margaret Anderson, "What the Public Doesn't Want," *Little Review* (August 1917), 21.

44. Anderson to Lowell, May 14, 1918, Lowell Collection.

45. Jane Heap, letter to Mitchell Dawson, March 2, 1918, Mitchell Dawson Papers, Newberry Library, Chicago, Illinois.

46. "XT" and Morris Reisen, "Reader Critic," *Little Review* (July 1918), 59–60.

47. Ezra Pound, "Cooperation," *Little Review* (July 1918), 54–56.

48. Pound, "Cooperation," 54–56.

49. Pound to Anderson, April 30, 1918, *Pound/The Little Review*, 212.

50. Harriet Monroe, "An International Episode," *Little Review* (November 1918), 35.

51. Edgar Jepson, "The Western School," *Little Review* (September 1918), 4–5.

52. Monroe, "An International Episode," 34–35.

53. Jane Heap, "The Episode Continued," *Little Review* (November 1918), 35–37.

54. Heap, "Episode Continued," 35–37.

55. Ben Hecht [Unsigned], "Pounding Ezra," *Little Review* (November 1919), 37–40.

56. Jane Heap, "Notes on Books and Plays," *Little Review* (December 1917), 15–17.

57. See Holly Baggett, "Lesbian Modernism and Mysticism: How the Trial of Joyce's *Ulysses* Led Two Lesbians to God," *Sapphist and Sexologists: Histories of Sexualities, Volume II*, edited by Mary McAuliffe and Sonja Tiernan (Newcastle upon Tyne: Cambridge Scholars Publishing, 2009), 26–40.

58. See Holly Baggett, "The Publication of *Ulysses*: The Trials of Margaret Anderson and Jane Heap" in *A Living of Words: American Women in Print Culture*, edited by Susan Albertine (Knoxville: University of Tennessee Press, 1995), 169–88.

59. M. Anderson, *Thirty Years' War*, 208.

60. Quoted in B. L. Reid, *The Man from New York: John Quinn and His Friends* (New York: Oxford University Press, 1968), 285.

61. John Quinn to Ezra Pound, June 2, 1917, John Quinn Memorial Collection, New York City Public Library, New York, New York.

62. Quinn to Pound, October 31, 1917, Quinn Memorial Collection.

63. Quinn to Pound, October 31, 1917, Quinn Memorial Collection.

64. James J. Wilhelm, *Ezra Pound in London and Paris, 1908–1925* (University Park: Penn State University Press, 1990), 194.

65. Margaret Anderson, "James Joyce in the *Little Review*," *Little Review* (January 1918), 2. It is important to note differences in the *Little Review* text of *Ulysses* and the 1922 book published by Sylvia Beach. For studies of "genetic criticism" of the journal text, see Clare Hutton, *Serial Encounters: Ulysses and the Little Review* (Oxford: Oxford University Press, 2019) and Mark Gaipa, Sean Latham, and Robert Scholes, eds., *The Little Review Ulysses* (New Haven: Yale University Press, 2015).

66. Quinn to Pound, March 14, 1918, Quinn Memorial Collection.

67. Quinn to Pound, March 14, 1918, Quinn Memorial Collection.

68. R. McC., "Reader Critic," *Little Review* (June 1918), 65.

69. S. S. B., "Reader Critic," *Little Review* (June 1918), 57.

70. Helen Bishop, "Reader Critic," *Little Review* (May–June 1920), 73–74.

71. Jane Heap, "Reader Critic," *Little Review* (May–June 1920), 73–74.

72. Margaret Anderson, "To the Book Publishers of America," *Little Review* (December 1919), 65.

73. Heap to Joyce, January 9, 1920, James Joyce Collection, Rare and Manuscript Collections, Cornell University Library, Ithaca, New York.

74. Heap to Joyce, February 1920.

75. Kimberly Devlin, "The Romance Heroine Exposed: 'Nausicaa' and *The Lamp-lighter*," *James Joyce Quarterly* (Summer 1985): 383.

76. Devlin, "Romance Heroine Exposed," 383. For additional scholarship on Gerty exploring gender and sexuality, see Suzette Henke's "Gerty MacDowell: Joyce's Sentimental Heroine," in *Women in Joyce*, eds. Suzette Henke and Elaine Unkeless (Urbana: University of Illinois Press, 1982), where Gerty is viewed as a victim of gendered commercial culture; and a reworking of that same article in "Joyce's Naughty Nausicaa: Gerty MacDowell Refashioned," *Papers on Joyce* 10/11 (2004–5): 85–103. In the abstract for her later article, Henke writes, "This paper extends and significantly reshapes" her previous essay and "ultimately sees Joyce unmask consummate fakery on both sides of the gender divide." John Bishop goes further beyond the binary of Bloom's masculinity and Gerty's femininity, arguing their difference is not one of an "oppositional relation," but rather "sequential compliments or asymmetrical reflections—everything that might be said about Gerty during her spectacular coitus with Bloom might also be said of Bloom as well." Bishop, "A Metaphysics of Coitus in 'Nausicaa,'" in *Ulysses En-Gendered Perspectives: Eighteen New Essays on the Episodes*, ed. Kimberly Devlin and Marilyn Reizbaum (Columbia: University of South Carolina, 1999), 198. See also Jules David Law, "'Pity They Can't See Themselves': Assessing the 'Subject' of Pornography in 'Nausicaa,'" *James Joyce Quarterly* (Winter 1990): 219–39; Phillip Sicker, "Unveiling Desire: Pleasure, Power and Masquerade in Joyce's 'Nausicaa' Episode," *Joyce Studies Annual* 14 (2003): 92–131; Adam Parkes, "Literature and Instruments for Abortion: 'Nausicaa' and the '*Little Review*' Trial," *James Joyce Quarterly* 34, no. 3 (1997): 283–301.

77. M. Anderson, *Thirty Years' War*, 215.

78. John Quinn to Ezra Pound, October 16, 1920, John Quinn Papers, Special Collections, Northwestern University Library.

79. Quinn to Pound, October 21, 1920, Quinn Papers.

80. Quinn to Pound, October 21, 1920, Quinn Papers.

81. Quinn to Pound, October 21, 1920, Quinn Papers. Timothy Materer, ed., *The Selected Letters of Ezra Pound to John Quinn: 1915–1924* (Durham, NC: Duke University Press, 1991), 9, 174.

82. Quinn to Pound, October 21, 1921, Quinn Papers.

83. Richard Ellmann, *James Joyce* (New York: Oxford Press, 1959), 502. As an interesting sidebar as to what constitutes obscenity, the 1933 trial Judge John H. Woosley established an "erection test," where he and two friends read the book to see if they were aroused—if that was the case, the book could be judged obscene. "Fortunately," writes Eric Berkowitz, "for subsequent generations of literature students and professors, *Ulysses* had no visible effect on the three readers, although Woolsey wrote it sometimes made him nauseous." Eric Berkowitz, *The Boundaries of Desire, A Century of Bad Laws, Good Sex and Changing Identities* (Berkeley: Counterpoint, 2015), 163.

84. Pound to Joyce, October 28, 1920, in *Pound/Joyce: The Letters of Ezra Pound to James Joyce*, ed. Forrest Read (New York: New Directions, 1967), 184–85.

85. Jane Heap, "Art and the Law," *Little Review* (September–December 1920), 5–6.

86. M. Anderson, *Thirty Years' War*, 219–21.

87. Margaret Anderson, "Ulysses in Court," *Little Review* (January–March 1921), 24.

88. M. Anderson, *Thirty Years' War*, 226.

89. M. Anderson, "Ulysses in Court," 24.

90. Heap, "Art and the Law," 5.

91. Wilhelm, *Ezra Pound in London and France*, 198.

92. Materer, *Ezra Pound to John Quinn*, 9, 174.

93. Jane Heap, "Ulysses Again," *Little Review* (Autumn 1922), 34. Histories of *Ulysses* and obscenity law include Birmingham, *The Most Dangerous Book*; Paul Vanderham, *James*

Joyce and Censorship: The Trials of Ulysses (London: Macmillan, 1998); and Edward De Grazia, *Girls Lean Back Everywhere: The Laws of Obscenity and the Assault on Genius* (New York: Random House, 1992). The title "Girls Lean Back" was taken from Heap's 1920 editorial "Art and the Law," 6. She wrote, "Girls lean back everywhere, showing lace and silk stockings; wearing low cut sleeveless blouses, breathing bathing suits; men think thoughts and have emotions about these things everywhere—seldom as delicately and imaginatively as Mr. Bloom—and no one is corrupted."

94. Stuart Gilbert, *James Joyce's Ulysses: A Study* (New York: Vintage Books, 1955), 42–43.

95. Enrico Terrinoni, *Occult Joyce: The Hidden in Ulysses* (Newcastle Upon Tyne: Cambridge Scholars Publishing, 2009), 141, 143.

96. Richard Ellmann, *Eminent Domain: Yeats among Wilde, Joyce, Pound, Eliot, and Auden*, (Oxford: Oxford University Press, 1967), 36. He wrote, "Joyce rooted his work in natural acts as intently as Yeats in esoteric experience. Yet the arc of each man was wide enough to include the other, and neither escaped the other's gravitational pull," 29.

97. William York Tindall, "James Joyce and the Hermetic Tradition," *Journal of the History of Ideas* (January 1954): 23–39.

98. M. Anderson, *Fiery Fountains*, 111.

99. Ralph Jenkins, "Theosophy in Scylla and Charybdis," in *Modern Fiction Studies* (1969), 35–48.

100. Crunden, *Body and Soul*, 395. For other works examining Joyce and the esoteric see John Coggrave, "Joyce and the Occult," in *Literary Modernism and the Occult Tradition*, ed. Leon Surette and Demetres P. Tryphonopoulos (Orono, ME: National Poetry Foundation, 1996); Robert D. Newman "Narrative Transgression and Restoration: Hermetic Messengers in *Ulysses*," *James Joyce Quarterly* 29, no. 2 (1992): 315–37, and "Transformatio Coniunctionis: Alchemy in Joyce's *Ulysses*," in *Ulysses: The Larger Perspective*, ed. Robert D. Newman and Weldon Thornton (Newark: University of Delaware Press, 1987):168–86; John S. Rickard, "Isis on Sandymount," *James Joyce Quarterly* 20, no. 3 (Spring 1983): 356–58; Hayward Ehrlich, "Joyce, Yeats, and Kabbalah," in *Joyce on the Threshold*, ed. Anne Fogarty and Timothy Martin (Gainesville: University Press of Florida, 2005), 60–87; and Colleen Jaurretche, *The Sensual Philosophy: Joyce and the Aesthetics of Mysticism*, (Madison: University of Wisconsin Press, 1997).

6. Lesbian Literature, Women Writers, and Modernist Mysticism

1. The other "man" of 1914, Wyndham Lewis, was also well represented in the *Little Review*. While foreign editor, Pound sent Lewis's "Imaginary Letters" in a series lasting several months.

2. Terry Castle, *The Apparitional Lesbian*, (New York: Columbia University Press, 1993), 2.

3. Heather Ingman, "Religion and the Occult in Women's Modernism," in *The Cambridge Companion to Modernist Women Writers*, ed. Maren Tova Linett (Cambridge: Cambridge University Press, 2010), 200.

4. Lillian Faderman, "Lesbian Magazine Fiction in the Early Twentieth Century," *Journal of Popular Culture* (Spring 1978): 800–801. Faderman's argument is based on Carroll Smith-Rosenberg, "The Female World of Love and Ritual," *Signs*, 1, no. 1 (1975), 1–24.

5. The examples Faderman gives are Jeannette Lee, "The Cat and the King," *Ladies Home Journal*, October 1919, 67–68; Helen Hull, "The Fire," *Century*, November 1917, 105–13; and Catherine Wells, "The Beautiful House," *Harper's*, March 1912, 503–10.

6. Christina Simmons, "Companionate Marriage and the Lesbian Threat," *Frontiers: A Journal of Women Studies* 4, no. 3 (1979), 56.

7. Simmons, "Companionate Marriage," 54–55.

8. See Lillian Faderman, *Odd Girls and Twilight Lovers: A History of Lesbian Life in Twentieth Century America*, (New York: Penguin Press, 1992), and Chad Heap, *Slumming*, for a comparison of Chicago's Towertown and Greenwich Village.

9. Quoted in Jeanette Foster, *Sex Variant Women in Literature: A Historical and Quantitative History* (Tallahassee, FL: Naiad Press: 1985), 246.

10. Foster, *Sex Variant Women*, 261.

11. Jane Heap, "I, Mary MacLane," *Little Review* (April 1917), 1–2.

12. Jane Heap, "I Cannot Sleep," *Little Review* (Winter 1922), 3.

13. Heap to Reynolds, June 27, 1922, Reynolds Collection.

14. Jane Heap, "Karen," *Little Review* (Spring 1922), 23.

15. Faderman, "Lesbian Magazine Fiction," 811–12.

16. Winifred Bryher was the pen name of Annie Winifred Ellerman. The daughter of the wealthy British shipping magnate, John Ellerman, Bryher was a popular author of historical novels. She assisted artists in need such as Joyce and the Baroness Freytag von Loringhoven. Her memoir *The Heart to Artemis* describes the social circles of Paris in the twenties and thirties.

17. Winifred Bryher, "Chance Encounter," *Little Review* (Autumn–Winter 1924–25), 37.

18. Richard Aldington, "Myrrhine and Konallis," *Little Review* (November 1916), 1.

19. Quoted in Richard Eugene Smith, *Richard Aldington* (Boston: Twayne Publishers, 1977), 53.

20. Jane Heap, "So This is Art!", *Little Review* (January 1917), 27.

21. Muriel Ciolkowski, "Chana Orloff," *Little Review* (May–June 1920), 52.

22. Gertrude Stein, "Vacation in Brittany," *Little Review* (Spring 1922), 6.

23. Elizabeth Fifer, "Is Flesh Advisable? The Interior Theater of Gertrude Stein," *Signs* (Spring 1979), 472–83; Linda Simon, *The Biography of Alice B. Toklas* (New York: Avon Books, 1978), 316.

24. Other *Little Review* contributions by Stein include "B. B., or the Birthplace of Bonnes" (Autumn 1922); "Idem the Same—A Valentine to Sherwood Anderson" (Spring 1923); "Juan Gris" (Autumn and Winter 1924–25); and her answer to "Confessions and Questions" (Spring 1929).

25. Margaret Anderson, *The Strange Necessity* (New York: Horizon Press, 1969), 39.

26. Margaret Anderson, letter to Solita Solano, Sept. 7, 1972, Janet Flanner and Solita Solano Papers, Library of Congress, Washington, DC.

27. Gertrude Stein, *The Autobiography of Alice B. Toklas* (New York: Vintage Books, 1960), 221.

28. Shari Benstock, *Women of the Left Bank: Paris, 1900–1940* (Austin: University of Texas Press, 1986), 232.

29. M. Anderson, *Thirty Years' War*, 181.

30. Philip F. Herring, *Djuna: The Life and Work of Djuna Barnes* (New York: Viking Adult, 1995), 127. There is a note from Heap to Barnes saying, "Mart doesn't know you stayed here once. Hurrah." Jane Heap to Djuna Barnes, n.d., Barnes Papers.

31. David Weir, *Decadent Culture in the United States: Art and Literature against the American Grain, 1890–1926* (Albany: State University of New York Press, 2008), 151, 183.

32. Djuna Barnes, "Oscar," *Little Review* (April 1920), 15.

33. Djuna Barnes, "Beyond the End," *Little Review* (December 1919), 11.

34. Djuna Barnes, "Katrina Silverstaff," *Little Review* (January 1921), 32.

35. Louis F. Kannenstine, *The Art of Djuna Barnes: Duality and Damnation* (New York: New York University Press, 1977), 78, 95.

36. Djuna Barnes, letter to Margaret Anderson, April 30, 1952, Barnes Papers.

37. Anderson to Barnes, May 8, 1952, Barnes Papers.

38. Thea Lenarduzzi, "The Many Faces of Mina Loy," *Times Literary Supplement,* September 11, 2011. Billy Corgan of Smashing Pumpkins and Thurston Moore of Sonic Youth have penned odes to Loy.

39. For a study of the influence of location and exile on Loy's work see Cristanne Miller, *Cultures of Modernism: Marianne Moore, Mina Loy, & Else Lasker-Schüler: Gender and Literary Community in New York and Berlin* (Ann Arbor: University of Michigan Press, 2007).

40. Mary Galvin's *Queer Poetics* includes a chapter on heterosexual Loy alongside lesbians Lowell, Barnes, H.D., and Stein. Mary Galvin, *Queer Poetics: Five Modernist Women Writers* (Westport, CT: Greenwood Press, 1999).

41. Mina Loy, "Feminist Manifesto," in *The Last Lunar Baedeker: Poems of Mina Loy,* ed. Roger Conover (Highlands, North Carolina: The Jargon Press, 1982), 269–70.

42. Loy, "Feminist Manifesto," 269–70.

43. Rachel Potter, *Modernism and Democracy: Literary Culture, 1900–1930* (Oxford: Oxford University Press, 2006), 167. For another view see Natalya Lusty, "Sexing the Manifesto: Mina Loy, Feminism and Futurism," *Women: A Cultural Review* (November 2008), 245–60.

44. Loy, "Feminist Manifesto," 271.

45. Loy, "Feminist Manifesto."

46. Loy, "Feminist Manifesto," 269–71.

47. Lara Vetter, "Theories of Spiritual Evolution, Christian Science, and the 'Cosmopolitan Jew': Mina Loy and American Identity," *Journal of Modern Literature* (Fall 2007), 49.

48. See Richard Cook, "'The Infinitarian and Her Macro-Cosmic Presence': The Question of Mina Loy and Christian Science," in *Mina Loy: Woman and Poet,* ed. Maeera Schreiber and Keith Tuma (Orono, ME: National Poetry Foundation, 1998).

49. Carolyn Burke, "The New Poetry and the New Woman: Mina Loy," Diane Wood Middlebrook, and Marilyn Yalom, eds., *Coming to Light: American Women Poets in the Twentieth Century* (Ann Arbor: University of Michigan Press, 1985), 38.

50. Quoted in Roger Conover, *The Last Lunar Baedeker: Poems of Mina Loy* (Highlands, NC: Jargon, 1982), xv-xvi. For a study of Loy that also includes Stein and Barnes, see Alex Goody, *Modernist Articulations: A Cultural Study of Djuna Barnes, Mina Loy and Gertrude Stein* (New York: Palgrave, 2007).

51. Quoted in Thomas F. Staley, *Dorothy Richardson* (Boston: Twayne Publishers, G. K. Hall & Co., 1976), 13.

52. May Sinclair, "The Novels of Dorothy Richardson," *Little Review* (April 1917), 5–7.

53. Quoted in Sandra Gilbert and Susan Gubar, *The War of the Words,* Vol. 1 of *No Man's Land: The Place of the Woman Writer in the Twentieth Century* (New Haven, CT: Yale University Press, 1988), 248.

54. Gilbert and Gubar, *War of the Words,* 227.

55. Gilbert and Gubar, *War of the Words,* 258.

56. Gillian Hanscombe and Virginia Smyers, *Writing for their Lives: The Modernist Women, 1910–1940* (Boston: Northeastern University Press, 1987), 52.

57. Staley, *Dorothy Richardson,* 79.

58. Randolph Bourne, "An Imagist Novel," *The Dial* (May 1918), 451–53.

59. Dorothy Richardson, "Interim," *Little Review* (August 1919), 19.

60. Dorothy Richardson, "Interim," *Little Review* (October 1919), 46.

61. Gloria Fromm, *Dorothy Richardson: A Biography* (Urbana, University of Indiana Press, 1977), 29.

62. Howard Finn, "'In the Quicksands of Disintegration Faiths': Dorothy Richardson and the Quakers," *Literature and Theology* (March 2005), 35.

63. Finn, "Dorothy Richardson and the Quakers," 39.

64. Quoted in Eva Tucker, "Dorothy Richardson and the Quakers," *Pilgrimages: The Journal of Dorothy Richardson Studies,* 1 (2008), 25, 128–29.

65. Winifred Bryher, *The Heart to Artemis: A Writer's Memoirs* (Ashfield, MA: Paris Press, 2006), 34.

66. Joanne Winning, *The Pilgrimage of Dorothy Richardson* (Madison: University of Wisconsin Press, 2000), 24.

67. Winning, *Dorothy Richardson,* 9, 133.

68. May Sinclair, "Two Notes," *The Egoist* (June 1915), 88.

69. Andrew Kunka and Michele K. Troy, *May Sinclair: Moving Towards the Modern* (Hampshire, England: Ashgate, 2006), 4. They add that this review alone demonstrates that "Sinclair is essential to our historical understanding of modernism's development," 3–4.

70. Babette Deutsch, "Freedom and the Grace of God," *The Dial* (November 1919), 441.

71. Quoted in Foster, *Sex Variant Women,* 100–101.

72. Katherine Mansfield, "The New Infancy," *Athenaeum* (June 1919), 493.

73. Jane Heap, "May Sinclair's *Mary Olivier*," *Little Review* (December 1919), 31.

74. May Sinclair to Jane Heap, April 22, 1920, Little Review Collection, Archives, University of Wisconsin Libraries, Milwaukee, Wisconsin.

75. May Sinclair, "How it Strikes a Mere Novelist," *Votes for Women* (December 24, 1908), 211.

76. Jim Gough, "May Sinclair: Idealism-Feminism and the Suffragist Movement," *Rhetor: Journal of the Canadian Society for the Study of Rhetoric,* 3 (2009), 14.

77. Deutsch, "Grace of God," 443.

78. Deutsch, "Grace of God," xvi.

79. Rebecca Kinnamon Neff, "May Sinclair's Uncanny Stories as Metaphysical Quest," *English Literature in Transition 1880–1920,* 26, no. 3 (1983), 187.

80. Neff, "May Sinclair's Uncanny Stories," 189. See also Richard Bleiler, "May Sinclair's Supernatural Fiction" in *Moving Towards the Modern.*

81. Neff, "May Sinclair's Uncanny Stories," 187.

82. Two other short stories—"Jones's Karma" and "The Mahatma's Story"—demonstrate Sinclair's interest in Eastern religions, specifically Hinduism.

83. May Sinclair, *A Defence of Idealism: Some Questions and Conclusions,* x.

84. Nathalie Blondel, *Mary Butts: Scenes from the Life—A Biography* (Kingston, NY: McPherson & Company, 1998), xv.

85. Quoted in Roslyn Reso Foy, *Ritual, Myth, and Mysticism in the Work of Mary Butts: Between Feminism and Modernism* (Fayetteville: The University of Arkansas Press, 2000), 5. See also Amy Clukey, "Enchanting Modernism: Mary Butts, Decadence, and the Ethics of Occultism," *Modern Fiction Studies* 60, no. 1 (Spring 2014), 78–107.

86. Hanscombe and Smyers, *Writing for their Lives,* 47.

87. Quoted in Colin Wilson, *Aleister Crowley: The Nature of the Beast* (London: The Aquarian Press, 1987), 127–145.

88. Foy, *Ritual, Myth, and Mysticism,* 146n14.

89. Blondel, *Mary Butts,* 141.

90. Blondel, *Mary Butts,* 181.

91. Mary Butts, *The Crystal Cabinet: My Childhood at Salterns* (London: Methuen & Co., 1937), 266; Ingman, "Religion and the Occult."

92. Foy, *Ritual, Myth, and Mysticism*, 42.

93. Mary Butts, "Lettres Imaginaires," *Little Review* (Oct.–Nov.), 1.

94. Butts, "Lettres Imaginaires," 193.

95. Ingman, "Religion and the Occult," 197.

96. For other scholarship on Butts see Robin Blaser, "*Imaginary Letters* by Mary Butts: Afterword," *The Fire: Collected Essays of Robin Blaser*, ed. Miriam Nichols (Berkeley: University of California Press, 2000); Andrew J. Radford, "Defending Nature's Holy Shrine: Mary Butts, Englishness, and the Persephone Myth," *Journal of Modern Literature* 29, no. 3 (Spring 2006): 126–49; Bradley Buchanan, "Armed with Questions: Mary Butts's Sacred Interrogative," *Twentieth Century Literature* 19, no. 3 (Autumn, 2003): 360–87; Jane Garrity, "Selling Culture to the 'Civilized': Bloomsbury, British Vogue, and the Marketing of National Identity," *Modernism/Modernity* 6, no. 2 (1999): 29–58; Jennifer Kroll, "Mary Butts's 'Unrest Cure' for the Waste Land," *Twentieth Century Literature*, 45, no. 2 (Summer, 1999): 159–73.

97. Pound to Anderson, April 20, 1921, *Pound/The Little Review*, 265.

98. Quoted in Dawn Ades, "Dada and Surrealism," in *Concepts of Modern Art: From Fauvism to Postmodernism, ed. Nikos Stangos* (New York: Thames and Hudson, 1990), 114.

99. Tristan Tzara quoted in George Heard Hamilton, *Painting and Sculpture in Europe, 1880–1940* (Kingsport, TN.: Kingsport Press, 1983), 365.

100. Anderson to Jackson Bryer, April 3, 1964, Private Collection of Jackson Bryer.

101. M. Anderson, *Little Review Anthology*, 341.

102. Irene Gammel, *Baroness Elsa: Gender, Dada, and Everyday Modernity–A Cultural Biography* (The MIT Press, Cambridge, MA, 2002), 168.

103. M. Anderson, *Thirty Years' War*, 178.

104. M. Anderson, *Thirty Years' War*, 179.

105. Robert Reiss, " 'My Baroness': Elsa von Freytag-Loringhoven," in *New York Dada*, ed. Rudolf E. Kuenzli (New York: Willis, Locker, & Owens, 1986), 81.

106. Baroness Freytag Loringhoven, "Love—Chemical Relationship," *Little Review* (June 1918), 58–59.

107. William Carlos Williams, *The Autobiography of William Carlos Williams* (New York: New Directions, 1967), 165.

108. Williams, *Autobiography*, 169.

109. Williams, *Autobiography*, 168.

110. M. Anderson, *Thirty Years' War*, 210.

111. Reed Whittemore, *William Carlos Williams: Poet from Jersey* (Boston: Houghton Mifflin Co., 1975), 162.

112. Jane Heap, "Dada," *Little Review* (Spring 1922), 46.

113. Freytag-Loringhoven, "Thee I Call 'Hamlet of the Wedding Wing': Criticism of William Carlos Williams's 'Kora in Hell,' " Part 1, *Little Review* (January–March 1921), 48–49.

114. Quoted in Gammell, *Baroness Elsa*, 271.

115. For example, see "King Adam," "Cathedral," "History Dim," and "Moving Picture and Prayer," among others, in *Body Sweats: The Uncensored Writings of Elsa von Freytag-Loringhoven*, ed. Irine Gammell and Suzanne Zelazo (Cambridge, MA: MIT Press, 2011).

116. F.E.R., "Reader Critic," *Little Review* (October 1919), 56.

117. Jane Heap, "Reader Critic," *Little Review* (October 1919), 56.

118. F.E.R., "Reader Critic," *Little Review* (November 1919), 64.

119. Evelyn Scott, "Reader Critic," *Little Review* (December 1919), 48.

120. Jane Heap, "Reader Critic," *Little Review* (December 1919), 49.

121. Evelyn Scott, "The Art of Madness," *Little Review* (January 1920), 26.

122. Jane Heap, "The Art of Madness," *Little Review* (January 1920), 26.

123. Else Freytag-Loringhoven, "The Art of Madness," *Little Review* (January 1920), 28.

124. Evelyn Scott, "The Last Word," *Little Review* (March 1920), 43.

125. Jane Heap, "The Last Word," *Little Review* (March 1920), 47.

126. Heap, "Dada," 46.

127. M. Anderson, *Thirty Years' War*, 182.

128. Else Freytag-Loringhoven, "Confessions and Questionnaire," *Little Review* (Spring 1929), 34–35.

7. George Ivanovich Gurdjieff

1. M. Anderson, *Thirty Years' War*, 228.

2. M. Anderson, *Thirty Years' War*, 230.

3. M. Anderson, *Thirty Years' War*, 231.

4. Anderson to Jackson R. Bryer, April 3, 1964, Private collection of Jackson R. Bryer.

5. Brom Weber, ed., *The Letters of Hart Crane, 1916–1932* (Berkeley: University of California Press, 2020), July 21, 1921, 61.

6. Crane to Munson, July 21, 1921, in Weber, *Letters of Hart Crane*, 61.

7. Crane to Munson, July 21, 1921, in Weber, *Letters of Hart Crane*, 61.

8. Crane to Munson, July 21, 1921, in Weber, *Letters of Hart Crane*, 64.

9. Patrick Mahoney, *Maurice Maeterlinck: Mystic and Dramatist; A Reminiscent Biography of the Man and His Ideas* (Washington, D.C.: Institute for the Study of Man, 1984), 25.

10. M. Anderson, *Fiery Fountains*, 6.

11. M. Anderson, *Fiery Fountains*, 6.

12. M. Anderson, *Fiery Fountains*, 59.

13. M. Anderson, *Fiery Fountains*, 9.

14. Anderson to Allen Tanner, Tanner Collection, nd.

15. Peters later wrote two autobiographies combined in *My Journey with a Mystic*. While grateful for his introduction to Gurdjieff that remained with him throughout his adult life, Peters writes an unflattering portrait of Heap, who abandoned him to his father; the father also avoided taking any responsibility for his son. Peters went on to become a novelist, writing one of the earliest gay novels, *Finistère,* published in 1951, which received a favorable review by Gore Vidal ("Murder of Innocence," *Saturday Review of Literature* 34, no. 8 (February 1951), 13–14). The novel was about a young American who travels to France after his mother's divorce and begins to investigate his sexuality. It was republished in 2006.

16. M. Anderson, *Thirty Years' War*, 256.

17. M. Anderson, *Thirty Years' War*, 257–58.

18. M. Anderson, *Thirty Years' War*, 243.

19. James Webb, *The Harmonious Circle: The Lives and Work of G. I. Gurdjieff, P. D. Ouspensky, and Their Followers* (Boston: Shambhala Press, 1987), 266.

20. M. Anderson, *Fiery Fountains*, 109.

21. Heap to Reynolds, January 1924, in Baggett, *Dear Tiny Heart*, 90.

22. Peters, *My Journey with a Mystic*, 6.

23. K. Paul Johnson, *Initiates of Theosophical Masters* (Albany: State University of New York Press, 1995), 158.

24. The most significant contemporary author who is a Gurdjieffian but who writes about the "Work" through a scholarly prism in a variety of forms (monographs as well as works of fiction) is Jacob Needleman, professor of philosophy at San Francisco State University. See Needleman and George Baker, eds., *Gurdjieff: Essays and Reflections on the Man and His Teaching* (New York: Continuum Press, 1996). Paul Beekman Taylor, whose mother was a Gurdjieff disciple and who was raised in part by the Gurdjieffian poet Jean Toomer, has

written several scholarly works, most important here *Gurdjieff and Orage: Brothers in Elysium* (York Beach, ME: Samuel Weiser, 2001) and *Gurdjieff's America: Mediating the Miraculous* (Lighthouse Editions LTD, 2004). James Moore, a lifelong Gurdjieffian and the author of two monographs, *Gurdjieff: A Biography* (Shaftesbury: Element Books, 1999) and *Gurdjieff and Mansfield* (Boston: Routledge and Kegan Paul, 1981), as well as an autobiography that is quite forthright about the internecine warfare within Gurdjieffian circles, *Gurdjieffian Confessions: A Self Remembered* (Hove, UK: Gurdjieff Studies, LTD, 2005), is a valuable resource. For an opposite viewpoint, see all the work of William Patrick Patterson, one of the more prolific Gurdjieffian authors, especially Patterson and Barbara C. Allen, *Ladies of the Rope: Gurdjieff's Special Left Bank Women's Group* (Fairfax, CA: Arete Communications, 1999). Patterson's work is slavishly devotional, while Peter Washington's widely reviewed book *Madame Blavatsky's Baboon: A History of Mystics, Mediums and Misfits Who Brought Spiritualism to America* (New York: Schocken Books, 1995), is palpable in its contempt for Gurdjieff. One of the earliest accounts of Gurdjieff's life, work, and followers, James Webb's *The Harmonious Circle*, still stands as a balanced, well-researched monograph. Sophia Wellbeloved's *Gurdjieff: The Key Concepts* (London: Routledge, 2003) is an accessible resource for explaining Gurdjieff's most basic ideas. Recent fields of inquiry address specific aspects or influences of Gurdjieff's thought, such as Mohammad Tamdgidi's *Gurdjieff and Hypnosis: A Hermeneutic Study* (New York: Palgrave Macmillan, 2009) and Anna T. Challenger's *Philosophy and Art in Gurdjieff's Beelzebub: A Modern Sufi Odyssey* (Amsterdam, New York: Rodopi, 2002). For the most recent complete bibliography of Gurdjieff works see J. Walter Driscoll, *Gurdjieff: A Reading Guide*, 4th Edition, 2017, http://www.gurdjieff-bibliography. com, accessed December 29, 2022.

25. Anderson to Solita Solano, October 21, 1964, Flanner and Solano Papers.

26. Anderson to Solano, July 11, n.y., Flanner and Solano Papers.

27. M. Anderson, *Fiery Fountains*, 119

28. See Theodore Roszak, *Unfinished Animal*, 137–151.

29. George Gurdjieff, *Beelzebub's Tales to His Grandson: All and Everything, First Series, Second Book*, EP Dutton & Company, 1973. 83.

30. Gary Lachman, *In Search of P. D. Ouspensky: The Genius in the Shadow of Gurdjieff* (Quest Books: Wheaton IL 2004), 307, ft 13.

31. *Beelzebub's Tales*, Book One, 2.

32. M. Anderson, *Fiery Fountains*, 109. Orage arrived in the United States in December of 1923 and, according to Louise Welch, "went straight from the boat to the office of the *Little Review* on East 11th Street, near Fifth Avenue, where its founders and editors, Margaret Anderson and Jane Heap awaited him . . . Soon telephones began ringing at studios and literary warrens in Greenwich Village and Chelsea to inform the world of arts and letters that Orage had arrived." Louise Welch, *Orage with Gurdjieff in America* (Boston: Routledge and Kegan Paul, 1982), 1.

33. Gorham Munson, *The Awakening Twenties: A Memoir-History of a Literary Period* (Baton Rouge: Louisiana State University Press, 1985), 209.

34. M. Anderson, *Fiery Fountains*, 112.

35. Munson, *The Awakening Twenties*. 255.

36. Weber, *Letters of Hart Crane*,177.

37. Heap to Reynolds, February 1, 1924, in Baggett, *Dear Tiny Heart*, 93.

38. Heap to Reynolds, February1, 1924, in Baggett, *Dear Tiny Heart*, 93.

39. M. Anderson, *Fiery Fountains* 110–11.

40. M. Anderson, *Fiery Fountains*, 111.

41. M. Anderson, *Fiery Fountains*, 114.

42. Heap to Reynolds July 19, 1924, in Baggett, *Dear Tiny Heart*, 98.

43. E. C. Bowyer, "New Life Cult: 'The Master' on His Forest School, *Daily News*, February 1923.

44. P. D. Ouspensky, *In Search of the Miraculous* (New York: Harcourt Brace, 1949), 386.

45. Mansfield to Murry October 23, 1922, *The Collected Letters of Katherine Mansfield*, vol. 5, ed., Vincent O'Sullivan and Margaret Scott (Oxford: Oxford University Press, 2008), 307.

46. See Roger Friedland and Harold Zellman, *The Fellowship: The Untold Story of Frank Lloyd Wright and the Taliesin Fellowship* (New York: Harper Perennial, 2007).

47. C. E. Bechhofer Roberts "The Forest Philosophers," *Gurdjieff International Review* 1, no. 4 (Summer 1998), https://www.gurdjieff.org/roberts.htm (accessed April 12, 2021).

48. Mary Butts, *The Journals of Mary Butts*, ed. Nathalie Blondel (New Haven, CT: Yale University Press, 2002), 212, Mabel Dodge Luhan, *Lorenzo in Taos* (London: Secker Press, 1933), 128.

49. See Roszak, *Unfinished Animal*, 6.

50. Peters, *My Journey with a Mystic*, 26.

51. Learning Institute for Growth, Healing and Transformation, "Drugs, Alcohol and Food*," Gurdjieff and the Fourth Way: A Critical Appraisal*, http://gurdjiefffourthway.org/pdf/drugs.pdf (accessed April 21, 2021.)

52. Quoted in Moore *Gurdjieff*, 352.

53. M. Anderson, *Fiery Fountains*, 124.

54. M. Anderson, *Fiery Fountains*, 134.

55. Jane Heap, *The Notes of Jane Heap* (Aurora OR :Two Rivers Press, 1994) and *Jane Heap/Notes* (Aurora OR: Two Rivers Press, 2003.

56. Heap, *Jane Heap/Notes*, 89, 95.

57. Margaret Croyden, "Getting in Touch with Gurdjieff," *New York Times Magazine*, July 29, 1979, 30.

58. Katherine Hulme, *Undiscovered Country: In Search of Gurdjieff*, (Boston: Little, Brown and Company, 1966,) 64.

59. Frank Lloyd Wright, "Gurdjeef at Taliesin", *Gurdjieff International Review* 8, no. 1 (Fall 2004).

60. James R. Lewis, "Introduction," in *Handbook of Religion and the Authority of Science*, Vol. 3 of *Brill Handbooks on Contemporary Religion*, ed. James R. Lewis and Olav Hammer (Leiden: Brill, 2010), 5.

61. M. Anderson, *The Fiery Fountains*, 112.

62. Taylor, *Gurdjieff's America*, 240.

63. Roger Lipsey, "Gurdjieff Observed," *Gurdjieff International Review* 3, no. 1 (Fall 1999).

64. Gurdjieff has also found his way into popular culture. Some Gurdjieffian discussion boards have also mentioned the films *The Matrix* and *Groundhog Day* as examples of his ideas in popular culture—though it is unlikely the creators made any Gurdjieffian connections. Many also point to John Fowles' novel *The Magus* as an example of Gurdjieff's philosophy. Jazz great Keith Jarrett was a serious follower; the British pop singer Kate Bush referred to Gurdjieff in her 1991 hit song, "Them Heavy People."

65. M. Anderson, *Fiery Fountains*, 103–104.

66. M. Anderson, *Strange Necessity*, 130.

8. The Heap Era

1. Celia Swanson, "Conversation Pieces: Circulating Muriel Draper's Salon," *Journal of Modern Literature* 36, no. 4 (Summer 2013): 24.

2. Darwin T. Turner, ed., *The Wayward and the Seeking: A Collection of Writings by Jean Toomer* (Washington, DC: Howard University Press, 1980), 130.

3. Turner, *Writings by Jean Toomer*, 131.

4. Jean Toomer, "Fern," *Little Review*, (Autumn 1922), 28.

5. Brian Joseph Benson and Mabel Mayle Dillard, *Jean Toomer* (Boston: Twayne Publishers, 1980), 110.

6. Jean Toomer, "Oxen Cart and Warfare," *Little Review* (Autumn–Winter 1924–25), 44, 48.

7. Guillaume Apollinaire, "Aesthetic Meditations," *Little Review* (Spring 1922), 7.

8. Apollinaire, "Aesthetic Meditations," 17.

9. Apollinaire, "Aesthetic Meditations," 14.

10. Marjorie Perloff, review of Guillaume Apollinaire, *The Cubist Painters*, trans. Peter Read, *Modernism/modernity* 12, no. 5 (January 2005), 523. For more about the fourth dimension in the avant-garde, see Bohn, "Probing the Fourth Dimension," chap. 2 in *The Rise of Surrealism: Cubism, Dada, and the Pursuit of the Marvelous* (Albany: State University of New York Press, 2002); Linda Henderson, *The Fourth Dimension and Non-Euclidean Geometry in Modern Art*, (Princeton: Princeton University Press, 1983.)

11. Guillaume Apollinaire, *Little Review* (Winter 1922), 56.

12. Celia Rabinovitch, *Surrealism and the Sacred: Power, Eros, and the Occult in Modern Art* (Boulder, CO: Westview Press, 2002), 5.

13. André Breton, *Manifestoes of Surrealism*, trans. Richard Seaver and Helen R. Lane (Ann Arbor: University of Michigan Press, 1974), 25.

14. Matthew Josephson, *Life Among the Surrealists: A Memoir* (New York: Holt, Rinehart and Winston, 1962), 147–51.

15. Louis Aragon, "A Man," *Little Review* (Autumn–Winter, 1923–1924), 18.

16. G. Ribemont-Dessaignes, "In Praise of Violence," *Little Review* (Spring–Summer 1926), 40–41.

17. Matthew Josephson, "A Letter to My Friend," *Little Review* (Spring–Summer 1926),17–18.

18. Josephson, *Life*, 291–92.

19. Quoted in Bryer, "Trial-Track," 442.

20. Heap to Reynolds, July 15, 1925, in Baggett, *Dear Tiny Heart*, 106.

21. Heap to Reynolds, August 15, 1925, Reynolds Collection.

22. 2 Susan Noyes Platt, "Mysticism in the Machine Age: Jane Heap and the Little Review," *Twenty/One* 1, no. 1 (Fall 1989): 33.

23. Kiesler, "Debacle of the Modern Theatre," 61.

24. Alfred Orage, "A Theatre for Us," *Little Review* (Winter, 1926), 30–32.

25. Orage, "Theatre for Us," 30–32.

26. Jane Heap, "The Machine Age Exposition," *Little Review* (Spring 1925), 22.

27. Heap, "Machine Age Exposition," 22.

28. Heap, "Machine Age Exposition," 22.

29. Susan Noyes Platt, *Modernism in the 1920s: Interpretations of Modern Art in New York from Expressionism to Constructivism* (Ann Arbor, MI: UMI Research Press, 2002), 126.

30. Goldman, "Confessions and Questions," *Little Review* (Spring 1929), 36–37.

31. T. S. Eliot, "Confessions and Questions," *Little Review* (Spring 1929), 90.

32. Djuna Barnes, "Confessions and Questions," *Little Review* (Spring 1929), 17.

33. Stein, "Confessions and Questions," 10.

34. M. Anderson, "Editorial," 3–4.

35. Anderson, "Editorial," 3–4.

36. Jane Heap, "Lost: A Renaissance," *Little Review* (1929), 5–6.

37. Heap, "Lost: A Renaissance," 5–6.

Epilogue

1. Anderson's lesbian novel was not published until 1999. Anderson, *Forbidden Fires*, ed. Mathilda M Hills (Tallahassee: Naiad Press, 1999).

2. Descriptions of her life in these dwellings appear in M. Anderson, *The Fiery Fountains* and *The Strange Necessity*.

3. Georgette Leblanc, *Souvenirs: My Life with Maeterlinck*, trans. Janet Flanner (New York: E. P. Dutton, 1932); M. Anderson, *My Thirty Years' War*. Anderson's contract with Covici, Friede, Inc. for *Thirty Years' War* states she would receive five hundred dollars in advance and ten percent of the retail price for the first five thousand copies sold. August 30, 1929, Allen Tanner Collection.

4. Reynolds to Heap, November 9, 1941, in Baggett, *Dear Tiny Heart*, 150.

5. Reynolds to Heap, February 25, 1941, in Baggett, *Dear Tiny Heart*, 142.

6. Heap to Reynolds, March 29, 1938, in Baggett, *Dear Tiny Heart*, 130.

7. Heap to Reynolds, March 29, 1938, in Baggett, *Dear Tiny Heart*, 130.

8. Heap to Reynolds, March 29, 1938, in Baggett, *Dear Tiny Heart*, 129.

9. Heap to Reynolds, February 27, 1941, in Baggett, *Dear Tiny Heart*, 143.

10. Heap to Reynolds, February 27, 1941, in Baggett, *Dear Tiny Heart*, 143.

11. Heap to Reynolds, December 1941, in Baggett, *Dear Tiny Heart*, 136–37.

12. Heap to Reynolds, October 6, 1940, in Baggett, *Dear Tiny Heart*, 133.

13. Nesta Brooking, Richard Lester, Annie Lou Staveley, *Jane Heap as Remembered by Some of Those She Taught* (Aurora, Oregon: Two Rivers Press, 1988), 11–12.

14. Brooking et al., *Jane Heap*, 10.

15. Brook, *Threads of Time*, 60.

16. M. Anderson, *The Strange Necessity*, 180.

17. Solano letter to Anderson, n.d., Flanner and Solano Papers.

18. Reynolds to Heap, February 26, 1944, in Baggett, *Dear Tiny Heart*,167.

19. Baggett, *Dear Tiny Heart*, 174.

20. See Pound, *Pound/The Little Review*, 316–30.

21. Anderson to Tanner, April 2, 1960, Tanner Collection.

22. M. Anderson, *The Strange Necessity*, 19.

23. Anderson to Flanner, January 7, 1956, Flanner and Solano Papers.

24. Anderson to Solano, June 21, 1961, Flanner and Solano Papers.

25. M. Anderson, *The Strange Necessity*, 219.

26. Anderson to Tanner, July 15, 1964, Tanner Collection.

27. Barnes to Anderson, June 23, 1964, Barnes Papers.

28. M. Anderson, *The Strange Necessity*, 23.

29. M. Anderson, *The Fiery Fountains*, 18.

30. M. Anderson, "Chambre d'hôtel," *Prose*, Fall 1973, 9.

31. Alfred Kazin, "A Life Led as a Work of Art" *New York Times*, August 16, 1970.

32. Anderson to Kazin, August 15, 1970. Anderson sent a copy of her letter to Solano. Flanner and Solano Papers.

33. Anderson to Solano, July 11, 1972, Flanner and Solano Papers.

34. M. Anderson, *Forbidden Fires*, 33.

35. M. Anderson, *Forbidden Fires*, 37.

36. M. Anderson, *Forbidden Fires*, 48.

37. M. Anderson, *Forbidden Fires*, 108.

38. Jeanette Foster to Margaret Anderson, June 8, 1960, printed in the appendix to M. Anderson, *Forbidden Fires*, 157.

39. The Daughters of Bilitis published *The Ladder* and The Mattachine Society published *One*.

40. Anderson to Solano, February 1, 1972, Flanner and Solano Papers.

41. Anderson to Lois Karinsky, October 3, 1972, Little Review Collection.

42. Anderson to Solano, March 12, 1972, Flanner and Solano Papers.

43. Anderson to Solano, October 19, 1973, Flanner and Solano Papers.

44. Anderson to Solano, September 21, 1973, Flanner and Solano Papers.

45. Anderson to Solano, October 19, 1973 Flanner and Solano Papers; Solano to Jean Palmer, October 1973, Little Review Collection.

46. Solano to Jean Palmer, October 1973, Little Review Collection.

47. Solano to Palmer, October 1973, Little Review Collection.

48. Flanner, "Life on a Cloud," 44–53.

49. Flanner, "Life on a Cloud," 44. Solano died in 1975 and Flanner three years later.

50. Bertha Harris, "The More Profound Nationality of Their Lesbianism: Lesbian Society in Paris in the 1920's," in *Amazon Expedition: A Lesbian Feminist Anthology*, ed. Phyllis Birkby, Bertha Harris, Jill Johnston, Esther Newton, and Janet O. Wyatt (New York: Changing Times Press, 1973), 79.

51. Anderson used the word "transformational," M. Anderson, *The Unknowable Gurdjieff* (London: Arkana, 1991), 30.

52. M. Anderson, *The Strange Necessity*, 222.

BIBLIOGRAPHY

Archival Sources

Margaret C. Anderson Collection. Harry Ransom Center for the Humanities, University of Texas, Austin, Texas.

Amy Lowell Collection. Houghton Library. Harvard University, Cambridge, Massachusetts.

Djuna Barnes Papers. Special Collections and Archives. Hornbake Library, University of Maryland, College Park, Maryland.

Emma Goldman Papers. UC Berkeley Library, Berkeley, California.

Janet Flanner and Solita Solano Papers. Library of Congress, Washington, DC.

Hi Simmons Papers. Hanna Holborn Gray Special Collections Research Center, University of Chicago Library, Chicago, Illinois.

James Joyce Collection. Rare and Manuscript Collections. Cornell University Library, Ithaca, New York.

John Quinn Memorial Collection. New York City Public Library, New York, New York.

Little Review Collection. Archives Department. University of Wisconsin Libraries, Milwaukee, Wisconsin.

Mitchell Dawson Papers. Newberry Library, Chicago, Illinois.

John Quinn Papers. Special Collections. Northwestern University Library, Evanston, Illinois.

The Florence Reynolds Collection Related to Jane Heap and the *Little Review*. Special Collections. University of Delaware, Newark, Delaware.

Allen Tanner Collection, Harry Ransom Center for the Humanities, University of Texas, Austin, Texas.

Primary Sources

"About Miss Jane Heap, Artist." *Topeka Capital*, October 25, 1914.

Aldington, Richard. "Myrrhine and Konallis." *Little Review*, November 1916.

———. "A Young American Poet." *Little Review*, March 1915.

Anderson, Cornelia. "Some Contemporary Opinions of Rachel Varnhagen." *Little Review*, March 1914.

Anderson, Margaret. "Amy Lowell's Contribution." *Little Review*, December 1914.

———. "Announcement." *Little Review*, March 1914.

———. "Announcement," *Little Review*, April 1917.

———. "Armageddon." *Little Review*, September 1914.

———. "Art and Anarchy." *Little Review*, March 1916.

———. "The Artist in Life." *Little Review*, June–July 1915.

———. "Challenge." *Little Review*, May 1916.

———. "The Challenge of Emma Goldman." *Little Review*, May 1914.

"Chambre d'hôtel." *Prose*, Fall 1973: 5–12.

———. "Conversation." *Prose*, Spring 1971: 5–21.

———. "The Dark Flower and the Moralists." *Little Review*, March 1914.

———. "Editor's Note: 'Poetry versus Imagism.'" *Little Review*, September 1916.

———. "Editorial." *Little Review*, Fall 1929.

———. "Ethel Sidgwick's Succession." *Little Review*, March 1914.

———. *The Fiery Fountains*. New York: Horizon, 1969.

———. *Forbidden Fires*. Edited by Mathilda M. Hills. Tallahassee: Naiad Press, 1999.

———. "Home as an Emotional Adventure." *Little Review*, December 1914.

———. "The Immutable." *Little Review*, November 1914.

———. "Incense and Splendor." *Little Review*, June 1914.

———. "James Joyce in the Little Review." *Little Review*, January 1918.

———. "Judicial Opinion (Our Suppressed October Issue)." *Little Review*, December 1917.

———. "The Labor Farce." *Little Review*, September 1916.

———, ed. *Little Review Anthology*. New York: Hermitage House, 1953.

———. "Mother Earth." *Little Review*, March 1915.

———. "Mr. Comstock and the Resourceful Police." *Little Review*, April 1915.

———. "Mrs. Ellis's Failure." *Little Review*, March 1915.

———. *My Thirty Years' War*. New York: Horizon, 1969.

———. "A New Winged Victory." *Little* Review, April 1914.

———. "The Poet Speaks." *Little Review*, April 1916.

———. "A Real Magazine." *Little Review*, August 1916.

———. "The Renaissance of Parenthood." *Little Review*, July 1914.

———. "Sentence Reviews." *Little Review*, January 1915.

———. *The Strange Necessity: The Autobiography, Resolutions and Reminiscences to 1969*. New York: Horizon, 1969.

———. "To the Book Publishers of America." *Little Review*, December 1919.

———. "Toward Revolution." *Little Review*, December 1915.

———. "Ulysses in Court." *Little Review*, January–March 1921.

———. *Unknowable Gurdjieff*. London: Arkana, 1991.

———. "War." *Little Review*, April 1917.

———. "What the Public Doesn't' Want." *Little Review*, August 1917.

Anderson, Sherwood. *Memoirs*. New York: Harcourt, Brace, 1942.

———. "The New Note." *Little Review*, March 1914.

Apollinaire, Guillaume. "Aesthetic Meditations." *Little Review*, Spring 1922.

Aragon, Louis. "A Man." *Little Review*, Autumn–Winter 1923–24.

Ashleigh, Charles. "Des Imagistes." *Little Review*, July 1914.

Barnes, Djuna. "Beyond the End." *Little Review*, December 1919.

———. "Confessions and Questions." *Little Review*, Spring 1929.

———. "Katrina Silverstaff," *Little Review*, January 1921.

———. "Oscar." *Little Review*, April 1920.

Bishop, Helen. "Reader Critic." *Little Review*, May–June 1920, 73–74.

Bodenheim, Maxwell. "Reader Critic." *Little Review*, June 1917.

Bourne, Randolph. "An Imagist Novel." *Dial*, May 1918.

Bowyer, E. C. "New Life Cult: 'The Master' on His Forest School." *Daily News*, February 1923.

Breton, André. *Manifestoes of Surrealism*. Translated by Richard Seaver and Helen R. Lane. Ann Arbor: University of Michigan Press, 1974.

Bryher, Winifred. "Chance Encounter." *Little Review*, Autumn–Winter 1924–25.

———. *The Heart to Artemis: A Writer's Memoirs*. Ashfield, MA: Paris Press, 2006.

Burnham, George Foster. "The Prophet of a New Culture." *Little Review*, March 1914.

Butts, Mary. "Lettres Imaginaires." *Little Review*, October–November 1919.

Chicago Vice Commission. "The Social Evil in Chicago." In *The Rise of Urban America*. New York: Arno, 1970.

Ciolkowski, Muriel. "Chana Orloff." *Little Review*, May–June 1920.

Croyden, Margaret. "Getting in Touch with Gurdjieff." *New York Times Magazine*, July 29, 1979.

Currey, Margery. "A Feminist of One Hundred Years Ago." *Little* Review, March 1914.

Dell, Floyd. "The Lost Joy." *Little Review*, March 1914.

Deutsch, Babette. "Freedom and the Grace of God." *Dial*, November 1919.

Eliot, T. S. "Commentary." *Criterion* 14, no. 55, January 1935.

———. "Confessions and Questions." *Little Review*, Spring 1929.

F. E. R. "Reader Critic." *Little* Review, October 1919.

———. "Reader Critic." *Little Review*, November 1919.

Ficke, Arthur Davison. "In Defense of Vers Libre." *Little Review*, December 1914.

Flanner, Janet. *Janet Flanner's World: Uncollected Writings, 1932–1975*. Edited by Irving Dratman. New York: Harcourt Brace Jovanovich, 1979.

———. "Life on a Cloud." *New Yorker*, June 3, 1974.

Fletcher, John Gould. "Three Imagists Poets." *Little Review*, May 1916.

Freytag-Loringhoven, Elsa. "The Art of Madness." *Little Review*, January 1920.

———. "Confessions and Questionnaire." *Little Review*, Spring 1929.

———. "Love—Chemical Relationship." *Little Review*, June 1918.

———. "Thee I Call 'Hamlet of the Wedding Wing': Criticism of William Carlos Williams's 'Kora in Hell.'" Part 1. *Little Review*, January–March 1921.

Goldman, Emma. "Confessions and Questions." *Little Review*, Spring 1929.

———. *Living My Life: An Autobiography of Emma Goldman*. Salt Lake City: Peregrine Smith, 1982.

———. *The Social Significance of the Modern Drama*. New York: Cosimo, 2005.

Gurdjieff, George. *Beelzebub's Tales to His Grandson*. All and Everything, series 1. New York: E.P. Dutton Co., Inc., 1973. Heap, Jane. "And," *Little* Review, October 1916.

———. "And." *Little Review*, November 1916.

———. "The War, Madmen!" *Little Review*, March 1917.

———. "Art and the Law." *Little Review*, September–December 1920.

———. "The Art of Madness." *Little Review*, January 1920.

———. "The Caliph's Design." *Little Review*, December 1919.

———. "Dada." *Little Review*, Spring 1922.

———. "The Episode Continued." *Little Review*, November 1918.

———. "The Foes of Our Household." *Little Review*, October 1917.

———. "I Cannot Sleep." *Little Review*, Winter 1922.

———. "I, Mary MacLane." *Little Review*, April 1917.

———. *Jane Heap/Notes*. Aurora, OR: Two Rivers Press, 2003.

———. "Karen." *Little Review*, Spring 1922.

———. "The Last Word." *Little Review*, March 1920.

———. *Life is Real Only Then, When "I Am."* All and Everything, series 3. New York: E.P. Dutton, 1973., 1999.

———. "Lost: A Renaissance." *Little Review*, Fall 1929.

———. "The Machine Age Exposition." *Little Review*, Spring 1925.

———. "May Sinclair's Mary Olivier." *Little Review*, December 1919.

———. *Meetings with Remarkable Men*. All and Everything, series 2. New York: E.P. Dutton, 1973.

———. *The Notes of Jane Heap*. Aurora, OR: Two Rivers Press, 1994.

———. "Notes on Books and Plays." *Little Review*, December 1917.

———. [R. G., pseud.]. "Potatoes in the Cellar." *Little Review*, May 1916.

———. "The Price of Empire," *Little Review*, March 1917.

———. "Push-Face." *Little Review*, June 1917.

———. "Reader Critic." *Little Review*, June 1917.

———. "Reader Critic." *Little Review*, August 1917.

———. "Reader Critic." *Little Review*, October 1919.

———. "Reader Critic." *Little Review*, December 1919.

———. "Reader Critic." *Little Review*, May–June 1920.

———. "So This is Art!" *Little Review*, January 1917.

———. "The War, Madmen!" Little Review, March 1917.

———. "Ulysses Again." *Little Review*, Autumn 1922.

H. C. L. "Reader Critic." *Little Review*, September 1917.

H. D. *Notes on Thought and Vision*. San Francisco: City Lights Publishers, 2001.

Hecht, Ben [Unsigned]. "Pounding Ezra." *Little Review*, November 1919.

"Honors for Jane Heap." *Topeka Capitol*, December 5, 1915.

I. E. P. "Reader Critic." *Little Review*, July 1917.

Indianapolis and Its Resources: A Souvenir of the Indianapolis Sentinel. Indianapolis: Indianapolis Sentinel, 1896.

Iverson, Sade. "Letters to the Little Review." *Little Review*, April 1914.

Jepson, Edgar. "The Western School." *Little Review*, September 1918.

Jones, Llewellyn. "Aesthetics and Common Sense." *Little Review*, December 1914.

———. "The Meaning of Bergsonism." *Little Review*, March 1914.

———. "The Russian Novel." *Little Review*, April 1914.

Josephson, Matthew. "A Letter to My Friend." *Little Review*, Spring–Summer 1926.

———. *Life Among the Surrealists: A Memoir*. New York: Holt, Rinehart and Winston, 1962.

Joyce, James. *Ulysses*. New York: Random House, 1961.

Katz, Jonathan. *Gay/Lesbian Almanac: A New Documentary*. New York: Harper and Row, 1983.

Kaun, Alexander. "Ante-Bellum Russia." *Little Review*, October 1915.

———. "Sanin." *Little Review*, April 1915.

———. "The Subhuman." *Little Review*, April 1915.

———. "Two Biographies: Verlaine and Tolstoy." *Little Review*, July 1914.

Kiesler, Frederick. "Debacle of the Modern Theatre." *Little Review*, Winter 1926.

Laughlin, Clara. "Women and the Life Struggle." *Little Review*, April 1914.

Lane, George. "Some Imagist Poets." *Little Review*, May 1915.

Lazar, Maurice. "Dostoevsky's Novels." *Little Review*, July 1914.

Lenin, V. I. "Proletary No. 35 (September 11, 1908)." In *Lenin: Collected Works*. Moscow: Progress Publishers, 1973.

Lowell, Amy. "Miss Columbia: An Old-Fashioned Girl." *Little Review*, June 1914.

Loy, Mina. "Anglo-Mongrel and he Rose." *Little Review*, Autumn–Winter 1923–24.

———. "Feminist Manifesto." In *The Last Lunar Baedeker: Poems of Mina Loy*, ed. Roger Conover, 269–71. Highlands, NC: The Jargon Press, 1982.

———. "Lions' Jaws." *Little Review*, September–December 1920.

———. "Pyscho-Democracy." *Little Review*, Autumn 1921.

Mansfield, Katherine. *The Collected Letters of Katherine Mansfield*. Vol. 5, *1922*, edited by Vincent O'Sullivan and Margaret Scott. Oxford: Oxford University Press, 2008.

———. "The New Infancy." *Athenaeum*, June 1919.

M. M. "Two Views of H. G. Wells." *Little Review*, April 1914.

Monroe, Harriet. "An International Episode." *Little Review*, November 1918.

Mrs. O. D. J. "Reader Critic." *Little Review*, June 1917.

An Old Reader [pseud.]. "Reader Critic." *Little Review*, September 1917.

Orage, Alfred. *A. R. Orage's Commentaries on G. I. Gurdjieff's "All and Everything: Beelzebub's Tales to His Grandson."* Edited by C. S. Nott. Aurora, OR: Two Rivers Press, 1999.

———. "A Theatre for Us." *Little Review*, Winter 1926.

Ouspensky, P. D. *In Search of the Miraculous*. New York: Harcourt Brace, 1949.

Partridge, M. H. "The Feminist Discussion." *Little Review*, March 1914.

Pound, Ezra. "The Chinese Character as Written Medium for Poetry." In *Little Review Anthology*, ed. Margaret Anderson, 190–206. New York: Horizon, 1963.

——. "The Classics Escape." *Little Review*, March 1918.

——. "Cooperation." *Little Review*, July 1918.

——. "Editorial." *Little Review*, May 1918.

——. "Modern French Poets." *Little Review*, February 1918.

——. *Pound/Joyce: The Letters of Ezra Pound to James Joyce*. Edited by Forrest Read. New York: New Directions, 1967.

——. *Pound/The Little Review: The Letters of Ezra Pound to Margaret Anderson*. Edited by Thomas L. Scott and Melvin Friedman, with the assistance of Jackson Bryer. New York: New Directions, 1988.

Puttelis, Louis. "Reader Critic." *Little Review*, July 1917.

Ribemont-Dessaignes, G. "In Praise of Violence." *Little Review*, Spring–Summer 1926.

Richardson, Dorothy. "Interim." *Little Review*, August 1919.

——. "Interim." *Little Review*, October 1919.

R. McC. "Reader Critic." *Little Review*, June 1918.

Sahli, Nancy. "Smashing: Women's Relationships before the Fall." *Chrysalis*, Summer 1979.

Scott, Evelyn. "The Art of Madness." *Little Review*, January 1920.

——. "The Last Word." *Little Review*, March 1920.

——. "Reader Critic." *Little Review*, December 1919.

Sinclair, May. "How it Strikes a Mere Novelist." *Votes for Women*, December 24, 1908.

——. "The Novels of Dorothy Richardson." *Little Review*, April 1917.

——. "Two Notes." *Egoist*, June 1915.

Solano, Solita. *Gurdjieff and the Women of the Rope: Notes of Meetings in Paris and New York 1935–1939 and 1948–1949*. Oakland, CA: Book Studio, 2019.

——. "Dostoevsky—Pessimist? Book Review of 'The Possessed' by Fyodor Dostoevsky." *Little Review*, June 1914.

Soule, George. "Pavlowa." *Little Review*, April 1914.

——. "The Possessed." *Little Review*, June 1914.

S. S. B. *Little Review* (June 1918), 57.

Stearns, Mary. "Mrs. Ellis's Gift to Chicago." *Little Review*, March 1915.

Stein, Gertrude. "Confessions and Questions." *Little Review*, Spring 1929.

——. "Vacation in Brittany." *Little Review*, Spring 1922.

Swawite, Marguerite. "The Dark Flower." *Little Review*, May 1914.

Tietjens, Eunice. "The Spiritual Dangers of Vers Libre." *Little Review*, November 1914.

Toomer, Jean. "Fern." *Little Review*, Autumn 1922.

——. "Oxen Cart and Warfare." *Little Review*, Autumn–Winter 1924–25.

Trevor, Francis. "Two Views of H. G. Wells." *Little Review*, April 1914.

Udell, Lillian Heller. "The Philosophy of Voltairine de Cleyre." *Little Review*, October 1914.

V. H. "Reader Critic." *Little Review*, September 1917.

Voloshin, Maximilian. "Birth of a Poem." *Little Review*, November 1914.

Williams, William Carlos. *The Autobiography of William Carlos Williams*. New York: New Directions, 1967.

——. *I Wanted to Write a Poem*. Edited by Edith Heal. Boston: Beacon, 1958.

Wing, DeWitt. "The Jewels of Lapidary." *Little Review*, March 1914.

Wright, Frank Lloyd. "Gurdjeef at Taliesin." *Gurdjieff International Review* 8, no. 1 (Fall 2004).

X. T. and Morris Reisen. "Reader Critic." *Little Review*, July 1918.

Yeats, W. B. "William Butler Yeats to American Poets." *Little Review*, April 1914.

Secondary Sources

Ackroyd, Peter. *T. S. Eliot: A Life*. New York: Simon and Schuster, 1984.

Ades, Dawn. "Dada and Surrealism." In *Concepts of Modern Art: From Fauvism to Postmodernism*, edited by Nikos Stangos, 30–35. New York: Thames and Hudson, 1990.

Anderson, Elizabeth. *H. D. and Modernist Religious Imagination: Mysticism and Writing*. London: A and C Black, 2013.

Antliff, Alan. *Anarchist Modernism: Art, Politics, and the First American Avant-Garde*. Chicago: University of Chicago Press, 2001.

Bacigalupo, Massimo. "Pound as Critic." In *The Cambridge Companion to Ezra Pound*, edited by Ira B. Nadel, 188–203. New York: Cambridge University Press, 1998.

Baggett, Holly A. *Dear Tiny Heart: The Letters of Jane Heap and Florence Reynolds*. New York: New York University Press, 2000.

———. "Lesbian Modernism and Mysticism: How the 1921 Trial of Joyce's *Ulysses* Drove Two Lesbians to God." In *Sapphist and Sexologists*, edited by Mary McAuliffe and Sonja Tiernan, 26–40. Vol. 1 of *Histories of Sexualities*. Newcastle upon Tyne: Cambridge Scholars Publishing, 2009.

———. "The Publication of *Ulysses*: The Trials of Margaret Anderson and Jane Heap." In *A Living of Words: American Women in Print Culture*, edited by Susan Albertine, 169–88. Knoxville: University of Tennessee Press, 1995.

Bellew, Paul Bradley. "'At the Mercy of Editorial Selection': Amy Lowell, Ezra Pound, and the Imagist Anthologies." *Journal of Modern Literature* 40, no. 2 (2017): 22–40.

Bennett, John G. *Gurdjieff: A Very Great Enigma*. New York: Samuel Weiser, 1973.

———. *Witness: The Story of a Search*. Rev. ed. Santa Fe: Bennett Books, 1997.

Benson, Brian Joseph, and Mabel Mayle Dillard. *Jean Toomer*. Boston: Twayne Publishers, 1980.

Benstock, Shari. *Women of the Left Bank: Paris, 1900–1940*. Austin: University of Texas Press, 1986.

Berkowitz, Eric. *The Boundaries of Desire, A Century of Bad Laws, Good Sex and Changing Identities*. Berkeley: Counterpoint, 2015.

Birmingham, Kevin. *The Most Dangerous Book: The Battle for James Joyce's Ulysses*. New York: Penguin, 2014.

Bishop, John. "A Metaphysics of Coitus in 'Nausicaa.'" In *Ulysses En-Gendered Perspectives: Eighteen New Essays on the Episodes*, edited by Kimberly Devlin and Marilyn Reizbaum, 185–209. Columbia: University of South Carolina, 1999.

Blaser, Robin. "*Imaginary Letters* by Mary Butts: Afterword." In *The Fire: Collected Essays of Robin Blaser*, edited by Miriam Nichols, 164–76. Berkeley: University of California Press, 2000.

Bleiler, Richard. "May Sinclair's Supernatural Fiction." In *May Sinclair, Moving Towards the Modern*, edited by Michele K. Troy and Andrew J. Kunka, 15–34. London: Routledge, 2006.

Blondel, Nathalie. *Mary Butts: Scenes from the Life—A Biography*. Kingston, NY: McPherson, 1998.

Bodenheim, Maxwell. *Blackguard*. Chicago: Covici-McGee, 1923.

Bohn, Willard. *The Rise of Surrealism: Cubism, Dada, and the Pursuit of the Marvelous*. Albany: SUNY Press, 2002.

Bourdieu, Pierre and Chris Turner. "Legitimation and Structured Interests in Weber's Sociology of Religion." In *Max Weber, Rationality and Modernity*, edited by Sam Whimster and Scott Lash, 119–36. London: Routledge, 2014.

Braude, Ann. *Radical Spirits: Spiritualism and Women's Rights in Nineteenth-Century America*. Bloomington: Indiana University Press, 2001.

Brook, Peter. *Threads of Time*. Washington, DC: Counterpoint, 1998.

Brooker, Peter, and Andrew Thacker, eds. *North America 1894–1960*. Vol. 2 of *The Oxford Critical and Cultural History of Modernist Magazines*. Oxford: Oxford University Press, 2012.

Brooking, Nesta, Richard Lester, and Annie Lou Staveley. *Jane Heap as Remembered by Some of Those She Taught*. Aurora, OR: Two Rivers Press, 1988.

Browne, Maurice. *Too Late the Lament*. Bloomington: Indiana University Press, 1956.

Breton, André, and Philippe Soupault. *The Magnetic Fields: New York*. New York: New York Review of Books, 2020.

Burwick, Frederick, and Paul Douglass, eds. *The Crisis in Modernism: Bergson and the Vitalist Controversy*. Cambridge: Cambridge University Press, 1992.

Bryer, Jackson R. *A Trial Track for Racers: Margaret Anderson and the Little Review*. Madison: University of Wisconsin, 1965.

———. "Joyce, *Ulysses*, and the *Little Review*." *South Atlantic Quarterly* 66 (1967): 148–64.

Buchanan, Bradley. "Armed with Questions: Mary Butts's Sacred Interrogative." *Twentieth Century Literature* 19, no. 3 (Autumn 2003): 360–87.

Burke, Carolyn. "The New Poetry and the New Woman: Mina Loy." In *Coming to Light: American Women Poets in the Twentieth Century*, edited by Diane Wood Middlebrook and Marilyn Yalom, 37–57. Ann Arbor: University of Michigan Press, 1985.

Butts, Mary. *The Crystal Cabinet: My Childhood at Salterns*. London: Methuen, 1937.

———. *The Journals of Mary Butts*. Edited by Nathalie Blondel. New Haven, CT: Yale University Press, 2002.

Carlson, Maria. *No Religion Higher Than Truth: A History of the Theosophical Movement in Russia, 1875–1922*. Princeton, NJ: Princeton University Press, 1993.

Carr, Helen. *The Verse Revolutionaries: Ezra Pound, H. D. and the Imagists*. New York: Random House, 2013.

Castle, Terry. *The Apparitional Lesbian*. New York: Columbia University Press, 1993.

Challenger, Anna T. *Philosophy and Art in Gurdjieff's Beelzebub: A Modern Sufi Odyssey*. Amsterdam, New York: Rodopi, 2002.

Chauncey, George. "From Sexual Inversion to Homosexuality: Medicine and the Changing Conception of Female Deviance." *Salmagundi* 58/59 (Fall 1982/Winter 1983): 122–32.

Childs, Donald J. "Fantastic Views: T. S. Eliot and the Occultation of Knowledge and Experience." *Texas Studies in Literature and Language* 39, no. 4 (December 22, 1997): 357–74.

Clukey, Amy. "Enchanting Modernism: Mary Butts, Decadence, and the Ethics of Occultism." *Modern Fiction Studies* 60, no. 1 (Spring 2014): 78–107.

Coggrave, John. "Joyce and the Occult." In *Literary Modernism and the Occult Tradition*, edited by Leon Surette and Demetres P. Tryphonopoulos, 97–117. Orono, ME: National Poetry Foundation, 1996.

Collecott, Diana. " 'Another Bloomsbury': Women's Networks in Literary London," in Maria Camboni, ed., *Networking Women: Subjects, Places, Links Europe-America: Towards a Re-writing of Cultural History 1890–1939. Proceedings of the International Conference, Macerata, March 25–27, 2002*, 58–73. Rome: Edizioni di Storia e Letteratura, 2004.

———. *H. D. and Sapphic Modernism, 1910–1950*. Cambridge: Cambridge University Press, 1999.

Conover, Roger, ed. *The Last Lunar Baedeker: Poems of Mina Loy*. Highlands, NC: Jargon, 1982.

Cook, Richard. " 'The Infinitarian and Her Macro-Cosmic Presence': The Question of Mina Loy and Christian Science." In *Mina Loy: Woman and Poet*, edited by Maeera Schreiber and Keith Tuma, 457–65. Orono, ME: National Poetry Foundation, 1998.

Copley, Antony. *A Spiritual Bloomsbury: Hinduism and Homosexuality in the Lives and Writings of Edward Carpenter, E. M. Forster, and Christopher Isherwood*. Oxford: Lexington Books, 2006.

Cott, Nancy. *The Grounding of Modern Feminism*. New Haven, CT: Yale University Press, 1987.

Cowley, Malcolm. *Exile's Return*. New York: Penguin, 1994.

Crunden, Robert. *Body and Soul: The Making of American Modernism: Art, Music and Letters in the Jazz Age, 1919–1926*. New York: Basic Books, 2000.

de Grazia, Edward. *Girls Lean Back Everywhere: The Laws of Obscenity and the Assault on Genius*. New York: Random House, 1992.

de Hartmann, Thomas, and Olga de Hartmann. *Our Life with Mr. Gurdjieff*. Reprint, London: Penguin Arkana, 1997.

Dell, Floyd. *Homecoming: An Autobiography*. New York: Farrar and Rinehart, 1933.

Devlin, Kimberly. "The Romance Heroine Exposed: 'Nausicaa' and *The Lamplighter*." *James Joyce Quarterly* 22, no. 4 (Summer 1985): 383–96.

Devlin, Kimberly, and Marilyn Reizbaum, eds. *Ulysses En-Gendered Perspectives: Eighteen New Essays on the Episodes*. Columbia: University of South Carolina, 1999.

Dowling, Linda. *Hellenism and Homosexuality in Victorian Oxford*. Ithaca: Cornell University Press, 1994.

Drimmer, Melvin. "Nietzsche in American Thought, 1895–1925." PhD diss., University of Rochester, 1965.

Driscoll, J. Walter. *Gurdjieff: A Reading Guide*, 4th Edition, 2017, http://www.gurd jieff-bibliography.com., accessed December 29, 2022.

Duffey, Bernard. *The Chicago Renaissance in American Letters: A Critical History*. East Lansing: Michigan State College Press, 1954.

Ehrlich, Hayward. "Joyce, Yeats, and Kabbalah." In *Joyce on the Threshold*, edited by Anne Fogarty and Timothy Martin, 60–87. Gainesville: University Press of Florida, 2005.

Ellmann, Richard. *Eminent Domain: Yeats among Wilde, Joyce, Pound, Eliot, and Auden.* New York: Oxford University Press, 1967.

———. *James Joyce.* New York: Oxford University Press, 1959.

Faderman, Lillian. "Lesbian Magazine Fiction in the Early Twentieth Century." *Journal of Popular Culture* 11, no. 4 (Spring 1978): 800–817.

———. *Odd Girls and Twilight Lovers: A History of Lesbian Life in Twentieth Century America.* New York: Penguin, 1992.

———. "Which, Being Interpreted Is as May Be, or Otherwise: Ada Dwyer Russell in Amy Lowell's Life and Work.'" In *Amy Lowell, American Modern,* edited by Adrienne Munich and Melissa Bradshaw, 59–76. New Brunswick, NJ: Rutgers University Press, 2004.

Falk, Candace. *Love, Anarchy, and Emma Goldman: A Biography.* New Brunswick, NJ: Rutgers University Press, 2019.

Ferguson, Suzanne. "Djuna Barnes's Short Stories: An Estrangement of the Heart." *The Southern Review* 5, no. 1 (January 1969): 26–41.

Fields, Andrew. *Djuna: The Formidable Miss Barnes.* Austin: University of Texas Press, 1985.

Fifer, Elizabeth. "Is Flesh Advisable? The Interior Theater of Gertrude Stein." *Signs* 4, no. 3 (Spring 1979): 472–83.

Finn, Howard. "'In the Quicksands of Disintegration Faiths': Dorothy Richardson and the Quakers." *Literature and Theology* 19, no. 1 (March 2005): 34–46.

Fishbein, Leslie. *Rebels in Bohemia: The Radicals of the Masses, 1911–1917.* Chapel Hill: University of North Carolina Press, 1984.

Foster, Jeanette. *Sex Variant Women in Literature: A Historical and Quantitative History.* Tallahassee: Naiad, 1985.

Foy, Roslyn Reso. *Ritual, Myth, and Mysticism in the Work of Mary Butts: Between Feminism and Modernism.* Fayetteville, AR: University of Arkansas Press, 2000.

Francis, Elizabeth. *The Secret Treachery of Words: Feminism and Modernism in America.* Minneapolis: University of Minnesota Press, 2002.

Freedman, Estelle, and John D'Emilio. *Intimate Matters: A History of Sexuality in America.* New York: Harper and Row, 1988.

Friedland, Roger, and Harold Zellman. *The Fellowship: The Untold Story of Frank Lloyd Wright and the Taliesin Fellowship.* New York: Harper Perennial, 2007.

Friedman, Susan Stanford. *Psyche Reborn: The Emergence of H. D.* Bloomington: Indiana University Press, 1981.

Fromm, Gloria. *Dorothy Richardson: A Biography.* Urbana: University of Indiana Press, 1977.

Gaipa, Mark, Sean Latham, and Robert Scholes, eds. *The Little Review "Ulysses."* New Haven, CT: Yale University Press, 2015.

Galvin, Mary. *Queer Poetics: Five Modernist Women Writers.* Westport, CT: Greenwood, 1999.

Gammel, Irene. *Baroness Elsa: Gender, Dada, and Everyday Modernity—A Cultural Biography.* Cambridge, MA: MIT Press, 2002.

Gammel, Irine, and Suzanne Zelazo, eds. *Body Sweats: The Uncensored Writings of Elsa von Freytag-Loringhoven.* Cambridge, MA: MIT Press, 2011.

Garrity, Jane. "Selling Culture to the 'Civilized': Bloomsbury, British Vogue, and the Marketing of National Identity." *Modernism/Modernity* 6, no. 2 (1999): 29–58.

Gibbons, Tom. *Rooms in the Darwin Hotel: Studies in Literary Criticism and Ideas 1880–1920*. Nedlands: University Press of Western Australia, 1973.

Gibson, Matthew, and Neil Mann, eds. *Yeats, Philosophy, and the Occult*. Liverpool: Liverpool University Press, 2016.

Gilbert, Stuart. *James Joyce's "Ulysses": A Study by Stuart Gilbert*. New York: Vintage Books, 1955.

Gilbert, Sandra, and Susan Gubar. *The War of the Words*. Vol. 1 of *No Man's Land: The Place of the Woman Writer in the Twentieth Century*. New Haven, CT: Yale University Press, 1988.

Glaspell, Susan. *The Road to the Temple*. New York: Frederick A. Stokes, 1941.

Golding, Alan C. "*The Dial, The Little Review*, and the Dialogics of Modernism." *American Periodicals* 15, no. 1 (2005): 42–55.

———. "The Little Review." In *North America, 1894–1960*, edited by Peter Brooker and Andrew Thacker, 61–84. Vol. 2 of *The Oxford Critical and Cultural History of Modernist Magazines*. Oxford: Oxford University Press, 2012.

Goody, Alex. *Modernist Articulations: A Cultural Study of Djuna Barnes, Mina Loy and Gertrude Stein*. New York: Palgrave, 2007.

Gordon, Lyndall. *Eliot's Early Years*. Oxford: Oxford University Press, 1977.

Gough, Jim. "May Sinclair: Idealism-Feminism and the Suffragist Movement." *Rhetor: Journal of the Canadian Society for the Study of Rhetoric* 3 (2009): 1–17.

Gould, Jean. *Amy: The World of Amy Lowell and the Imagist Movement*. New York: Dodd, Mead, 1975.

Gray, Madeline. *Margaret Sanger: A Biography of the Champion of Birth Control*. New York: Marek, 1970.

Hamilton, George Heard. *Painting and Sculpture in Europe, 1880–1940*. Kingsport, TN: Kingsport Press, 1983.

Hanscombe, Gillian, and Virginia Smyers. *Writing for their Lives: The Modernist Women, 1910–1940*. Boston: Northeastern University Press, 1987.

Hansen, Harry. *Midwest Portraits: A Book of Memories and Friendships*. New York: Harcourt, Brace, 1923.

Harper, George Mills, ed. *Yeats and the Occult*. Toronto: Macmillan of Canada, 1975.

Harris, Bertha. "The More Profound Nationality of Their Lesbianism: Lesbian Society in Paris in the 1920s." In *Amazon Expedition: A Lesbian Feminist Anthology*, edited by Phyllis Birkby, Bertha Harris, Esther Newton, Jill Johnston, and Jane O' Wyatt, 77–88. New York: Times Change Press, 1973.

Heap, Chad. *Slumming: Sexual and Racial Encounters in American Nightlife*. Chicago: University of Chicago Press, 2009.

Hecht, Ben. *Child of the Century*. New York: Simon and Shuster, 1954.

Henderson, Linda. *The Fourth Dimension and Non-Euclidean Geometry in Modern Art*. Princeton, NJ: Princeton University Press, 1983.

Henke, Suzette. "Gerty MacDowell: Joyce's Sentimental Heroine." In *Women in Joyce*, edited by Suzette Henke and Elaine Unkeless, 132–49. Urbana: University of Illinois Press, 1982.

———. "Joyce's Naughty Nausicaa: Gerty MacDowell Refashioned." *Papers on Joyce* 10 and 11, no. 5 (2004–5): 85–104.

Herring, Phillip F. *Djuna: The Life and Work of Djuna Barnes.* New York: Viking Adult, 1995.

Homberger, Eric. "Chicago and New York: Two Versions of American Modernism." In *Modernism: A Guide to European Literature, 1890–1930,* edited by Malcolm Bradbury and James McFarlane, 151–61. London: Penguin, 1976.

Hoogestraat, Jane. "'Akin to Nothing but Language:' Pound, LaForgue, and Logopoeia." *English Literary History* (Spring 1988): 259–85.

Horowitz, Helen Lefkowitz. *Culture and the City: Cultural Philanthropy in Chicago from the 1880s to 1917.* Lexington: University of Kentucky Press, 1976.

———. *Rereading Sex: Battles over Sexual Knowledge and Suppression in Nineteenth-Century America.* New York: Vintage, 2002.

Hovey, Jaime. "'Lesbian Chivalry' in Amy Lowell's *Sword Blades and Poppy Seed.*" In *Amy Lowell, American Modern,* edited by Adrienne Munich and Melissa Bradshaw, 77–89. New Brunswick, NJ: Rutgers University Press, 2004.

Hulme, Kathryn. *Undiscovered Country: A Spiritual Journey.* Boston: Little, Brown 1966.

Hutton, Clare. *Serial Encounters: Ulysses and the Little Review.* Oxford: Oxford University Press, 2019.

———. "Yeats, Pound, and the *Little Review,* 1914–1918." *International Yeats Studies* 3, no. 1 (2018): 33–48.

Ingman, Heather. "Religion and the Occult in Women's Modernism." In *The Cambridge Companion to Modernist Women Writers,* edited by Maren Tova Linett, 187–202. Cambridge: Cambridge University Press, 2010.

Jaurretche, Colleen. *The Sensual Philosophy: Joyce and the Aesthetics of Mysticism.* Madison: University of Wisconsin Press, 1997.

Jenkins, Ralph. "Theosophy in 'Scylla and Charybdis.'" *Modern Fiction Studies* 15, no. 1 (Spring 1969): 35–48.

Johnson, K. Paul. *Initiates of Theosophical Masters.* Albany: State University of New York Press, 1995.

Johnson, Paul E. *A Shopkeeper's Millennium: Society and Revivals in Rochester, New York, 1815–1837.* New York: Hill and Wang, 1978.

Johnson, Pauline. "Nietzsche Reception Today." *Radical Philosophy* 80 (1996): 24–33.

Jones, Margaret C. *Heretics and Hellraisers.* Austin: University of Texas Press, 1993.

Kannenstine, Louis F. *The Art of Djuna Barnes: Duality and Damnation.* New York: New York University Press, 1977.

Katz, Jonathan. *Gay/Lesbian Almanac: A New Documentary.* New York: Harper and Row, 1983.

Kenner, Hugh. *The Pound Era.* Berkeley: University of California Press, 1971.

Key, Ellen. *The Renaissance of Motherhood.* New York: G. P. Putnam and Sons, 1914.

———. *The Woman Movement.* New York: Putnam and Sons, 1912.

Kissack, Terence. *Free Comrades: Anarchism and Homosexuality in the United States, 1895–1917.* Oakland, CA.: AK Press, 2008.

Kroll, Jennifer. "Mary Butts's 'Unrest Cure' for *The Waste Land.*" *Twentieth Century Literature* 45, no. 2 (Summer 1999): 159–73.

Kunka, Andrew, and Michele K. Troy. *May Sinclair: Moving Towards the Modern.* Hampshire, UK: Ashgate, 2006.

Kuenzli, Rudolf E., ed. *New York Dada.* New York: Willis Locker & Owens Pub, 1986.

Lachman, Gary. *In Search of P. D. Ouspensky: The Genius in the Shadow of Gurdjieff.* Quest Books: Wheaton IL 2004.

———. *The Quest for Hermes Trismegistus: From Ancient Egypt to the Modern World.* Edinburgh: Floris Books, 2011.

Laity, Cassandra. *H. D. and the Victorian fin de siècle: Gender, Modernism, Decadence.* Cambridge: Cambridge University Press, 2009.

Langeteig, Kendra. "Visions in the Crystal Ball: Ezra Pound, H. D., and the Form of the Mystical." *Paideuma* 25, no. 1–2 (1996): 55–81.

Langner, Lawrence. *The Magic Curtain: The Story of a Life in Two Fields, Theatre and Invention.* New York: E. P. Dutton, 1951.

Law, Jules David. " 'Pity They Can't See Themselves': Assessing the 'Subject' of Pornography in 'Nausicaa.' " *James Joyce Quarterly* 27, no. 2 (Winter 1990): 219–39.

Leblanc, Georgette. *Souvenirs: My Life with Maeterlinck.* Translated by Janet Flanner. New York: E. P. Dutton, 1932.

Levenson, Michael H. *A Genealogy of Modernism: A Study of English Literary Doctrine, 1908–1922.* Cambridge: Cambridge University Press, 1984.

Lewis, James R. "Introduction." In *Handbook of Religion and the Authority of Science.* Vol. 3 of *Brill Handbooks on Contemporary Religion*, edited by James R. Lewis and Olav Hammer, 1–20. Leiden: Brill, 2010.

Lipsey, Roger. "Gurdjieff Observed." *Gurdjieff International Review* 3, no. 1 (Fall 1999), https://www.gurdjieff.org/lipsey1.htm. Accessed 1 February 2014.

———. *The Spiritual in Twentieth Century Art.* Mineola, NY: Dover Publications, 1988.

Longenbach, James. "Pound among the Women." *Review* 12 (1990): 135–58.

———. *Stone Cottage: Pound, Yeats and Modernism.* Oxford: Oxford University Press, 1990.

Love, Heather. "Forced Exile: Walter Pater's Queer Modernism." In *Bad Modernisms*, edited by Douglas Mao and Rebecca L. Walkowitz, 19–43. Durham: Duke University Press, 2006.

Lowell, Amy. *Tendencies in Modern American Poetry.* Boston: Houghton Mifflin, 1917.

Luhan, Mabel Dodge. *Lorenzo in Taos.* London: Secker Press, 1933.

———. *Movers and Shakers.* Albuquerque: University of New Mexico Press, 1985.

Lusty, Natalya. "Sexing the Manifesto: Mina Loy, Feminism and Futurism." *Women: A Cultural Review* 19, no. 3 (November 2008): 245–60.

Maddox, Brenda. *Yeats's Ghosts: The Secret Life of W. B. Yeats.* New York: Harper Collins, 2000.

Mahoney, Patrick. *Maurice Maeterlinck: Mystic and Dramatist; A Reminiscent Biography of the Man and His Ideas.* Washington, DC: Institute for the Study of Man, 1984.

Maik, Thomas A. *The Masses Magazine (1911–1917): Odyssey of an Era.* New York: Garland Publishing, 1994.

Douglas Mao and Rebecca L. Walkowitz, eds. *Bad Modernisms*. Durham: Duke University Press, 2006.

Marek, Jayne. *Women Editing Modernism: "Little" Magazines and Literary History*. Lexington: University of Kentucky Press, 1995.

Marsh, Margaret S. *Anarchist Women, 1870–1920*. Philadelphia: Temple Press, 1981.

Materer, Timothy. *Modernist Alchemy: Poetry and the Occult*. Ithaca, NY: Cornell University Press, 1995.

———, ed. *The Selected Letters of Ezra Pound to John Quinn: 1915–1924*. Durham: Duke University Press, 1991.

McAlmon, Robert. *Being Geniuses Together, 1920–1930*. Revised with additional material by Kay Boyle. San Francisco: North Point Press, 1984.

McCarthy, Kathleen. *Noblesse Oblige: Charity and Cultural Philanthropy in Chicago, 1849–1929*. Chicago: University of Chicago Press, 1982.

McFarlane, James. "The Mind of Modernism." In *Modernism: A Guide to European Literature, 1890–1930*, edited by Malcolm Bradbury and James McFarlane, 71–93. London: Penguin, 1976.

McKay, Nellie Y. *Jean Toomer, Artist: A Study of His Literary Life and Work, 1894–1936*. Chapel Hill: University of North Carolina Press, 1998.

Menand, Louis. "The Pound Error: The Master of Allusion." *New Yorker*, June 9, 2008.

Miller, Cristanne. *Cultures of Modernism: Marianne Moore, Mina Loy, and Else Lasker-Schüler: Gender and Literary Community in New York and Berlin*. Ann Arbor: University of Michigan Press, 2007.

Moffitt, John F. *Alchemist of the Avant-Garde: The Case of Marcel Duchamp*. Albany: State University of New York Press, 2003.

Monteith, Ken. *Yeats and Theosophy*. London: Routledge, 2014.

Moody, Anthony David. *The Young Genius 1885–1920*. Vol. 1 of *Ezra Pound, Poet: A Portrait of the Man and His Work*. Oxford: Oxford University Press, 2007.

Moore, James. *Gurdjieff: A Biography*. Shaftesbury, UK: Element, 1991.

———. *Gurdjieff and Mansfield*. Boston: Routledge and Kegan Paul, 1981.

———. *Gurdjieffian Confessions: A Self Remembered*. Hove, UK: Gurdjieff Studies, LTD, 2005.

Morgan, George Allen, Jr. *What Nietzsche Means*. New York: Harper Torch Books, 1941.

Morrisson, Mark. *The Public Face of Modernism: Little Magazines, Audiences and Reception, 1905–1920*. Madison: University of Wisconsin Press, 2001.

Mullin, Katherine. "Typhoid Turnips and Crooked Cucumbers: Theosophy in *Ulysses*." *Modernism/Modernity* 8, no. 1 (January 2001): 77–97.

Munich, Adrienne, and Melissa Bradshaw, eds. *Amy Lowell, American Modern*. New Brunswick, NJ: Rutgers University Press, 2004.

Munson, Gorham. *The Awakening Twenties: A Memoir-History of a Literary Period*. Baton Rouge: Louisiana State University Press, 1985.

Needleman, Jacob, and George Baker, eds. *Gurdjieff: Essays and Reflections on the Man and His Teachings*. New York: Continuum, 1998.

Neff, Rebeccah Kinnamon. "May Sinclair's Uncanny Stories as Metaphysical Quest." *English Literature in Transition, 1880–1920* 26, no. 3 (1983): 187–91.

Nelson, Casey Blake. *Beloved Community: The Cultural Criticism of Randolph Bourne, Van Wyck Brooks, Waldo Frank, and Lewis Mumford.* Chapel Hill: University of North Carolina Press, 1990.

Newcomb, John Timberman. "Poetry's Opening Door: Harriet Monroe and American Modernism." In *Little Magazines and Modernism: New Approaches*, edited by Suzanne Churchill and Adam McKibble, 103–22. New York: Routledge, 2016.

Newman, Robert D. "Narrative Transgression and Restoration: Hermetic Messengers in *Ulysses*." *James Joyce Quarterly* 29, no. 2 (1992): 315–37.

———. "Transformatio Coniunctionis: Alchemy in *Ulysses*." In *Joyce's "Ulysses": The Larger Perspective*, edited by Robert Newman and Weldon Thornton, 168–86. Newark: University of Delaware Press, 1987.

Nicholson, C. Brid. *Emma Goldman: Still Dangerous.* Montreal: Black Rose Books, 2010.

Oliver, Kelly A., and Marilyn Pearsall, eds. *Feminist Interpretations of Friedrich Nietzsche.* University Park, PA: Penn State University Press, 2010.

Olson, Liesl. *Chicago Renaissance: Literature and Art in the Midwest Metropolis.* New Haven, CT: Yale University Press, 2017.

Parkes, Adam. "Literature and Instruments for Abortion: 'Nausicaa' and the *Little Review* Trial." *James Joyce Quarterly* 34, no. 3 (1997): 283–301.

Patterson, William Patrick, and Barbara C. Allen. *Ladies of the Rope: Gurdjieff's Special Left Bank Women's Group.* Fairfax, CA: Arete Communications, 1999.

Patton, Paul, ed. *Nietzsche, Feminism and Political Theory.* New York: Routledge, 1993.

Perloff, Marjorie. Review of Guillaume Apollinaire, *The Cubist Painters*, translated by Peter Read. *Modernism/modernity* 12, no. 5 (January 2005): 521–23.

Peters, Fritz. *My Journey with a Mystic.* Laguna Niguel, CA: Taylor Weber, 1986.

Platt, Susan Noyes. "Mysticism in the Machine Age: Jane Heap and the *Little Review*." *Twenty/One* 1, no. 1 (Fall 1989): 18–44.

———. *Modernism in the 1920s: Interpretations of Modern Art in New York from Expressionism to Constructivism.* Ann Arbor, MI: UMI Research Press, 2002.

Potter, Rachel. *Modernism and Democracy: Literary Culture, 1900–1930.* Oxford: Oxford University Press, 2006.

Prince, Sue Anne. *The Old-Guard and the Avant-Garde: Modernism in Chicago.* Chicago: University of Chicago Press, 1990.

Quincey-Jones, Steven. "Dora Marsden and the "WORLD-INCLUSIVE I": Egoism, Mysticism and Radical Feminism." In *Modernist Women Writers and Spirituality*, edited by Elizabeth Anderson, Andrew Radford, and Heather Walton, 185–99. London: Palgrave Macmillan, 2016.

Rabinovitch, Celia. *Surrealism and the Sacred: Power, Eros, and the Occult in Modern Art.* Boulder, CO: Westview, 2002.

Radford, Andrew J. "Defending Nature's Holy Shrine: Mary Butts, Englishness, and the Persephone Myth." *Journal of Modern Literature* 29, no. 3 (Spring 2006): 126–49.

Radford, Jean. "A Transatlantic Affair: Amy Lowell and Bryher." In *Amy Lowell, American Modern*, edited by Adrienne Munich and Melissa Bradshaw 43–58. New Brunswick, NJ: Rutgers University Press, 2004.

Raitt, Suzanne. *May Sinclair: A Modern Victorian*. Oxford: Clarendon, 2000.

Rauve, Rebecca. "An Intersection of Interests: Gurdjieff's Rope Group as a Site of Literary Production." In "American Writers and France." *Twentieth-Century Literature* 49, no. 1, (Spring 2003): 46–81.

Reid, B. L. *The Man from New York: John Quinn and His Friends*. New York: Oxford University Press, 1968.

Reiss, Robert. "'My Baroness': Elsa von Freytag-Loringhoven." In *New York Dada*, edited by Rudolf E. Kuenzli, 81–101. New York: Willis, Locker, and Owens, 1986.

Rickard, John S. "Isis on Sandymount." *James Joyce Quarterly* 20, no. 3 (Spring 1983): 356–58.

Roberts, C. E. Bechhofer. 'The "Forest Philosophers."' *Gurdjieff International Review* 1, no. 4 (Summer 1998), https://www.gurdjieff.org/roberts.htm. Accessed 1 February 2014.

Robertson, Michael. *Worshipping Walt: Whitman's Disciples*. Princeton, NJ: Princeton University Press, 2008.

Rosenhagen-Ratner, Jennifer. *American Nietzsche: A History of an Icon and His Ideas*. Chicago: University of Chicago Press, 2011.

Roszak, Theodore. *Unfinished Animal: The Aquarian Frontier and the Evolution of Consciousness*. New York: Harper and Row, 1975.

Sahli, Nancy. "Smashing: Women's Relationships before the Fall." *Chrysalis* 10 (Summer 1979): 386–405.

Scott, Bonnie Kime. "James Joyce." In *The Gender of Modernism: A Critical Anthology*, edited by Bonnie Kime Scott, 196–204. Bloomington: Indiana University Press, 1990.

———. "Joyce and the Dublin Theosophists: Vegetable Verse and Story." *Eire-Ireland* 13, no. 2 (Summer 1978): 54–70.

———. *Women of 1928*. Vol. 1 of *Refiguring Modernism*. Bloomington: Indiana University Press, 1996.

Scott, Thomas, and Melvin Friedman. "Introduction." In Ezra Pound, *Pound/The Little Review*, ed. Scott and Friedman, xiii–xxxiv. New York: New Directions, 1988.

Selzer, Jack. *Kenneth Burke in Greenwich Village: Conversing with the Moderns, 1915–1931*. Madison: University of Wisconsin Press, 1996.

Shirley, John. *Gurdjieff: An Introduction to His Life and Ideas*. New York: Penguin, 2010.

Sicker, Phillip. "Unveiling Desire: Pleasure, Power and Masquerade in Joyce's 'Nausicaa' Episode." *Joyce Studies Annual* 14 (Summer 2003): 92–131.

Simmons, Christina. "Companionate Marriage and the Lesbian Threat." *Frontiers: A Journal of Women Studies* 4, no. 3 (1979): 54–59.

Simon, Linda. *The Biography of Alice B. Toklas*. New York: Avon Books, 1978.

Sinclair, May. *A Defence of Idealism: Some Questions and Conclusions*. New York: Macmillan, 1917.

Smith, Richard Eugene. *Richard Aldington*. Boston: Twayne Publishers, 1977.

Smith-Rosenberg, Carroll. "The Female World of Love and Ritual." *Signs* 1, no. 1 (1975): 1–24.

Smoley, Richard. "Meeting with a Remarkable Paradox." *Gnosis* (Summer 1991): 49–51.

Staley, Thomas F. *Dorothy Richardson.* Boston: Twayne Publishers, 1976.

Stansell, Christine. *American Moderns: Bohemian New York and the Creation of a New Century.* New York: Metropolitan Books, 2000.

Stein, Gertrude. *The Autobiography of Alice B. Toklas.* New York: Vintage Books, 1960.

Surette, Leon. *The Birth of Modernism: Ezra Pound, T. S. Eliot, W. B. Yeats, and the Occult.* Montreal: McGill-Queen's University Press, 1993.

Swanson, Cecily. "Conversation Pieces: Circulating Muriel Draper's Salon." *Journal of Modern Literature* 36, no. 4 (Summer 2013): 23–43.

Symons, Julian. *Makers of the New: The Revolution in Literature 1912–1939.* London: Andre Deutsch Limited, 1987.

Tamdgidi, Mohammad. *Gurdjieff and Hypnosis: A Hermeneutic Study.* New York: Palgrave Macmillan, 2009.

Taylor, Paul Beekman. *Gurdjieff's America: Mediating the Miraculous.* London: Lighthouse Editions Limited, 2004.

———. *Gurdjieff and Orage: Brothers in Elysium.* York Beach, ME: Samuel Weiser, 2001.

Terrinoni, Enrico. *Occult Joyce: The Hidden in Ulysses.* Newcastle upon Tyne: Cambridge Scholars Publishing, 2009.

Thacker, Andrew. "Amy Lowell and H. D.: The Other Imagists." *Women: A Cultural Review* 4, no. 1 (1993): 49–59.

Tietjens, Eunice. *The World at My Shoulder.* New York: Macmillan, 1938.

Tindall, William York. "James Joyce and the Hermetic Tradition." *Journal of the History of Ideas* 25, no. 1 (January 1954): 23–39.

Tryphonopoulos, Demetres P. *The Celestial Tradition: A Study of Ezra Pound's Cantos.* Waterloo, ON: Wilfrid Laurier University Press, 1992.

Tucker, Eva. "Dorothy Richardson and the Quakers." *Pilgrimages: The Journal of Dorothy Richardson Studies,* no. 1 (2008): 145–52.

Tumber, Catherine. *American Feminism and the Birth of New Age Spirituality: Searching for the Higher Self, 1875–1915.* Lanham, MD: Rowman and Littlefield, 2002.

Turner, Darwin T., ed. *The Wayward and the Seeking: A Collection of Writings by Jean Toomer.* Washington, DC: Howard University Press, 1980.

Vanderham, Paul. *James Joyce and Censorship: The Trials of Ulysses.* London: Macmillan, 1998.

Versluis, Arthur. *The Esoteric Origins of the American Renaissance.* New York: Oxford University Press on Demand, 2001.

———. "What is Esoteric? Methods in the Study of Western Esotericism." *Esoterica* 4 (2002): 1–15. http://www.esoteric.msu.edu/VolumeIV/Methods.htm.

Vetter, Lara. "Theories of Spiritual Evolution, Christian Science, and the 'Cosmopolitan Jew': Mina Loy and American Identity." *Journal of Modern Literature* 31, no. 1 (Fall 2007): 47–63.

Washington, Peter. *Madame Blavatsky's Baboon: A History of Mystics, Mediums and Misfits Who Brought Spiritualism to America*. New York: Schocken Books, 1995.

Watson, Steven. *Strange Bedfellows: The First American Avant-Garde*. New York: Abbeville, 1991.

Webb, James. *The Harmonious Circle: The Lives and Work of G. I. Gurdjieff, P. D. Ouspensky, and Their Followers*. Boston: Shambhala, 1987.

Weber, Brom, ed. *The Letters of Hart Crane, 1916–1932*. Berkeley: University of California Press, 2020.

Weeks, Jeffrey. *Sex, Politics, and Society: The Regulation of Sexuality since 1800*. London: Longman, 1981.

Weir, David. *Anarchism and Culture: The Aesthetic Politics of Modernism*. Amherst: University of Massachusetts Press, 1997.

———. *Decadent Culture in the United States: Art and Literature against the American Grain, 1890–1926*. Albany: State University of New York Press, 2008.

Welch, Louise. *Orage With Gurdjieff in America*. Boston: Routledge and Kegan Paul, 1982.

Wellbeloved, Sophia. *Gurdjieff: The Key Concepts*. London: Routledge, 2003.

Wexler, Alice. *Emma Goldman: An Intimate Life*. New York: Pantheon Books, 1984.

Whittemore, Reed. *William Carlos Williams: Poet from Jersey*. Boston: Houghton Mifflin, 1975.

Wilhelm, James J. *Ezra Pound in London and Paris, 1908–1925*. University Park: Penn State University Press, 1990.

Wilson, Colin. *Aleister Crowley: The Nature of the Beast*. London: Aquarian, 1987.

Wilson, Edmund. *Shores of Light: A Literary Chronicle of the 1920s and 1930s*. Boston: Northeastern University Press, 1985.

———. *The Twenties*. Edited by Leon Edel. New York: Farrar, Strauss, and Giroux, 1975.

Winning, Joanne. *The Pilgrimage of Dorothy Richardson*. Madison: University of Wisconsin Press, 2000.

Zakaras, Alex. *Individuality and Mass Democracy: Mill, Emerson, and the Burdens of Citizenship*. New York: Oxford University Press, 2009.

INDEX

Printed in the USA
CPSIA information can be obtained
at www.ICGtesting.com
LVHW051522190923
758673LV00014B/124/J